The Nationalization
of Culture

JANET MINIHAN

The Nationalization of Culture

*The Development of State Subsidies
to the Arts in Great Britain*

HAMISH HAMILTON

LONDON

First published in Great Britain 1977
by Hamish Hamilton Ltd
90 Great Russell Street London WC1B 3PT

Copyright © 1977 by Janet Oppenheim Minihan

SBN 241 89537 5

Printed in Great Britain by
Western Printing Services Ltd, Bristol

Acknowledgments

This study was begun as a doctoral dissertation at Columbia University, under the supervision of Professor Stephen E. Koss. I am indebted to him for his encouragement during all stages of the work, from the first draft chapters to the final preparation for publication. His advice, ranging from matters of style to problems of organization, has been invaluable. Professor Sheila Biddle, also of the Columbia University Department of History, read two versions of the study, and I am grateful for her insightful criticisms on each occasion. Most helpful, too, were the comments offered by the other Columbia University professors who participated in the dissertation defence: John D. Rosenberg, of the English Department; Allen Staley, of the Art History Department; and Trygve R. Tholfsen, of Teachers College. In numerous ways, the book has benefited from their suggestions. Errors of interpretation or fact are, of course, my own.

Research for the study was facilitated by the courtesy and ingenuity of several library staffs, including the Library of Congress, Butler Library of Columbia University, and in London, the libraries and archives of the British Museum, the Victoria and Albert Museum, and the Tate Gallery. A generous fellowship from Bryn Mawr College, awarded to me as an undergraduate several years earlier, enabled me to pursue research in London during the summer of 1974.

Permission was kindly granted by Faber & Faber to quote material from Geoffrey Whitworth's *The Making of a National Theatre*, by the Macmillan Press for extracts from articles by Lord Keynes, and the Labour Party for permission to quote material from two of the Labour Party pamphlets, *Labour and the New Social Order* (1918) and *Reconstruction in War and Peace* (1942).

My family helped in ways that are impossible to measure. My husband, who lived with the study for a number of years, per-

formed valiant morale services, accompanied by his unfailing sense of perspective and humour. And, lastly, I would like to dedicate this volume to my parents, with gratitude, for their enthusiasm and interest in my work has been a constant source of support.

Contents

Contents

Introduction

'There is an expense which enriches and adorns a state,—and an economy which impoverishes and degrades,' wrote Martin Archer Shee, portrait painter and future president of the Royal Academy, in the preface to his little volume of verse, *Rhymes on Art*, in 1805.

> It is the policy of a great nation to be liberal and magnificent; to be free of her rewards, splendid in her establishments, and gorgeous in her public works. These are not the expenses that sap and mine the foundations of public prosperity . . . they produce large returns of respect and consideration from our neighbours and competitors—of patriotic exultation amongst ourselves . . . they play upon all the chords of generous feeling —elevate us above the animal and the machine, and make us triumph in the powers and attributes of man.

'A drop from the ocean of our expenditure,' he estimated, 'would sufficiently impregnate the powers of taste, in a country naturally prolific in every department of genius.'[1]

In his plea for official encouragement of the arts in Great Britain, Shee wove together a number of related themes. He hailed the arts as instruments of national glory and honour, and praised their civilizing, ennobling influence. He hinted at the threat to man's humanity posed by the mechanization of labour, and linked the arts to his concern for taste and the tenor of national life. Arguments such as these would be marshalled repeatedly during the nineteenth and twentieth centuries, with variations and additions, sometimes urged, sometimes strenuously denied, as a league of writers, philosophers, statesmen,

[1] Martin Archer Shee, *Rhymes on Art; or, The Remonstrance of a Painter: in Two Parts. With Notes, and a Preface, including Strictures on the State of the Arts, Criticism, Patronage, and Public Taste*, 3rd ed. (London: William Miller, 1809), pp. xxii–xxv.

artists, and assorted cranks tried to decide what was the state's responsibility for the culture, the quality of life, of its citizens.

The development of governmental support for the arts in Great Britain is but one aspect of the growth of the British Government. A traditional and firmly ingrained dislike of powerful central authority, of meddlesome bureaucracy, had to be overcome before culture could be considered a legitimate concern of the state. Gradually, beginning early in the nineteenth century and extending through the Second World War, public attitudes concerning the role of the state have altered. Once loathed chiefly as the tax collector or impressment officer, it is now accepted by millions of people as the source of their education, health care, housing, and social security. Over the decades, as the state extended its supervision into areas once sacred to private initiative, managing industries and providing public services, national subsidies for the arts also grew in quantity and scope. In fact, encouragement of culture represented one aspect of the official response to increasingly complex social problems.

But state involvement in the arts has always differed from bureaucratic efforts to enforce sanitary codes, to run railways, or to organize the coal industry. Inextricably joined to the idea of a national culture are certain attitudes and emotions rarely aroused by other administrative problems. Throughout the nineteenth century and well into the twentieth, the debate over the nationalization of culture was inseparable from questions of national values, the future of industrialized society, and even of democracy itself. While some people clung to the arts as the final prop of an allegedly embattled upper-class culture, others regarded them as the only means of bridging the widening gulf between rich and poor. From the start, the question of state subsidies to the arts has been enmeshed in the fierce controversy over public education, and in the pursuit of such elusive concepts as taste, refinement, civilization, and morality. The most distinguished and controversial thinkers of the last two centuries have contributed to the ongoing debate over the quality of life in industrial Britain, and, for that reason, state support of culture has involved much more than economic issues. Over the years, it has assumed many guises—aesthetic, philosophical, sociological, ethical, and religious—depending on the participants in the debate and their respective purposes.

For the artist, the outcome of the debate was a matter of livelihood, and many went hungry, or changed professions, while theorists hotly disputed among themselves. So long as art remained the exclusive pastime of the wealthy, successive Governments paid little attention to the controversy. The transition from a select, largely aristocratic patronage to a middle-class, and finally a mass, audience was the prerequisite for official interest in the arts. With the change in the economic basis of art came changes in its production. No longer dependent on commissions from individual patrons, artists could create freely for the public market. Yet their new freedom was fraught with dangers, too, and many artists sensed that production for popular appeal was inconsistent with what they held to be their high and special calling. As the nineteenth century progressed, and as the very idea of culture came to imply utter opposition to the standards of the market-place,[1] artists had to face the contradiction inherent in the Romantic conception of their function. Were they society's guides and seers, mediators between man and nature, the 'unacknowledged legislators of the world', as Shelley proclaimed?[2] Or rather were they interpreters of a superior reality, misunderstood and scorned by society, whose vulgarity they, in turn, reviled? The clash of viewpoints has never been finally resolved, and both the assertion of the artist's social responsibilities and the aesthetic celebration of art for art's sake have helped to mould official attitudes towards cultural subsidies.

This essay traces the evolution of those attitudes from the beginning of the nineteenth century until the period after the Second World War, when Parliament at last made an extensive commitment to the arts. The study commences in the early nineteenth century because the years during and immediately after the Napoleonic Wars represented a decisive turning-point in parliamentary appropriations for art. In that period, several important grants to purchase works of art for the nation clearly marked the distinction between official state, or parliamentary, aid and the purely royal patronage that had previously constituted the

[1] Raymond Williams, *Culture and Society 1780–1950* (New York: Columbia University Press, 1958), p. 35.

[2] 'A Defence of Poetry', in *Political Writings Including 'A Defence of Poetry'*, ed. Roland A. Duerksen, Crofts Classics (New York: Appleton-Century-Crofts, 1970), p. 197.

sole support for art in Great Britain. Thereafter, Parliament gradually articulated an ever wider cultural policy, while royal patronage assumed a secondary importance for the encouragement of British art. Particular aspects of that unfolding national policy have been studied in detail. The founding of the National Gallery, the Schools of Design, the art unions, the controversy over the Tate Gallery—these are only a few of the subjects that have been examined in thorough and informative monographs. In this essay, I have sought to fit existing studies into a broad historical framework, showing how each step in the development of a public policy for art was influenced not only by preceding steps, but by the general concerns and anxieties of the era in which they were taken.[1]

For all their talk of cultural enrichment, British legislators were slow to appropriate funds to that end. Burke's vision of the state as a partnership in all science and all art[2] went largely unheeded, while theories of Government non-intervention, long since dead in connection with trade and industry, continued to inhibit official policies towards the arts. There was a real dread of any attempt by the state to control the content of art, as well as much uncertainty whether the Government's function was to guide public taste or merely to react to its demands. As mass culture became an identifiable phenomenon, the pressures on Parliament to protect artistic quality and the highest professional standards grew more urgent. As the amount of leisure time available to the working population increased, concern also mounted for the provision of healthy and instructive recreational facilities. Over more than a century, British statesmen, stimulated by wars and profound social change, learned to formulate policies dealing adequately with these issues.

[1] The emphasis throughout is on England, although most of the measures discussed also applied to Wales, and some were extended through special legislation to Scotland and Ireland. I have not, of course, been able to include all the possible subjects related to culture, but have chosen those which I found to be most illustrative of widespread attitudes, or which represented significant steps in the development of an official policy. Except for the Houses of Parliament, I have not dealt with issues related to public works, such as architectural competitions for new office buildings or law courts, where the question of public funding was never in doubt and where the debates, if any, revolved around matters of architectural style and personal taste. Nor have I explored the important question of state aid to literary artists.

[2] *Reflections on the Revolution in France*, ed. with an Introduction by Thomas H. D. Mahoney (New York: Liberal Arts Press, 1955), p. 110.

Marbles and Old Masters

[i]

The early nineteenth century, like nearly every other period in history, was a difficult time for artists. Although the art market of London was thriving, a comparatively small share of profits benefited British painters. These were the years when great continental collections, dispersed by revolution, the French army, and their owners' need for ready cash, found their way to England, creating great excitement and interest in the Old Masters.[1] Connoisseurs avidly collected the canvasses of Van Dyck, Correggio, and Rubens, neglecting the work of living artists at home. 'Few are inclined to encourage the productions of modern Art,' Shee lamented.[2] James Northcote, R.A., a student of Sir Joshua Reynolds, wrote bitterly, in a March 1807 issue of the weekly *Artist*, that:

> a melancholy spectacle has it offered to Englishmen, to view the pining arts of Britain beset and trampled by an army of connoisseurs and collectors of foreign pictures, strengthened by the most powerful assistance of dealers in this species of traffic, all arranged rank and file, and bidding defiance to every effort of our own country . . .
>
> This whole mass of operation . . . kept up perpetual war against the talents of all our living Artists, while an excess of

[1] John Pye, *Patronage of British Art, an Historical Sketch: comprising an account of the rise and progress of art and artists in London, from the beginning of the reign of George the Second* (London: Longman, Brown, Green, & Longmans, 1845), pp. 278–9; and W. B. Sarsfield Taylor, *The Origin, Progress, and Present Condition of the Fine Arts in Great Britain and Ireland*, 2 vols. (London: Whittaker & Co., 1841), 2: 369–74.

[2] Martin Archer Shee, *Elements of Art, A Poem: in Six Cantos; with Notes and a Preface; Including Strictures on the State of the Arts, Criticism, Patronage, and Public Taste* (London: William Miller, 1809), p. xviii.

adulation was bestowed on foreign works, and prices demanded and given for them as if they had been the productions, not of men, but angels. . . .[1]

Ever since the Reformation, British artists had struggled against certain disadvantages. As a patron of the arts, the Church of England could not hold a candle to the Church of Rome. Not only had it once authorized the smashing of priceless statuary and stained glass, but it also covered church walls with layers of whitewash to bury idolatrous paintings. Decades of Puritan anathemas, furthermore, had left many Englishmen, and even more Scotsmen, suspecting that most forms of artistic expression were ungodly. Adding to these obstacles, fashion in the eighteenth century preferred the work of continental artists and dictated that 'all the wealth of individuals disposable for the objects of virtu' should be diverted, as Shee complained, into channels 'from which our native arts can derive no advantage'.[2]

Allowance should be made for the exaggerated panic of painters at work in London at this time. Their prospects, nevertheless, were gloomy so long as the limited circle of art enthusiasts, patrons, and speculators was preoccupied with treasures from the continent. Successful portrait and landscape painters might still be well employed, and, in some cases, might even amass considerable wealth; but the average artist had long waits between commissions, when he was fortunate enough to get any. He could only hope that the growing popularity of engraved prints and lithographs would eventually extend the painter's clientele more widely through society.[3] Otherwise he might share the fate of James Barry who, having scornfully refused to paint anything but grand historical works that did not sell, died in utter poverty in 1806.

[1] James Northcote, 'On Originality; Imitators; and Collectors', *Artist*, no. 2 (21 March 1807), pp. 9–10.

[2] *Rhymes on Art*, pp. xv–xvi.

[3] Gerald Reitlinger, *The Economics of Taste*, vol. 1: *The Rise and Fall of Picture Prices 1760–1960* (London: Barrie & Rockliff, 1961), pp. 30–1, analyses the sociological composition of the chief buyers at two major London auctions in 1798 and 1800. He finds 2 dukes, 4 earls, 5 lords and a lady, 4 painters, 3 bankers, 6 art dealers, 6 gentlemen amateurs, and 10 merchants including 4 Members of Parliament. The merchants, Reitlinger explains, seem largely 'to have been speculators rather than collectors'.

British sculptors, by contrast, derived some profit from the Napoleonic Wars. Parliament voted funds to commission monuments in honour of numerous heroic officers killed in the wars, offering in some cases over £6,000 for the work. 'Hero after Hero crowned his life with glory, and vote after vote showered affluence on the Sculptors.'[1] Even these commissions, however, did not reflect full official confidence in British artistry. There was some talk of offering the greatest honour, the commission for a monument to Lord Nelson, to the Italian Canova. Although the commission was ultimately given to John Flaxman, the well-known English sculptor, the incident suggests the prejudice against British artists at this time. While individuals like Reynolds might enjoy great prestige and reputation, the work of British artists was generally held inferior to the continental school of painting and sculpture. Even British dancers could not compete for popularity with French ballerinas at the fashionable theatres of London.[2]

As for the theatrical profession, although eminent performers like David Garrick and the Kemble family strove to raise the quality of dramatic art, respectable people in certain religious and social circles shunned the theatre as a sink of iniquity, the meeting place of hooligans and whores. Nor were the manners of the audience the only obstacle confronting the drama: by an act of 1737, playwrights were subject to the Lord Chamberlain's powers of censorship. When Sir Robert Walpole sought to silence Henry Fielding's dramatic satire—a rare example of state intrusion in the realm of art and one prompted purely by political reasons—he helped to fill the English stage with vacuous trifles for many decades to come. In 1807, the playwright Elizabeth Inchbald lamented, 'A dramatist must not speak of national concerns, except in one dull round of panegyrick. He must not allude to the feeble minister of state, nor to the ecclesiastical coxcomb.'[3] Pantomimes, harlequinades, farces, and operettas were safe. They

[1] Prince Hoare, *Epochs of the Arts: Including Hints on the Use and Progress of Painting and Sculpture in Great Britain* (London: John Murray, 1813), p. 178.

[2] Mary Clarke, *The Sadler's Wells Ballet: A History and an Appreciation* (London: Adam & Charles Black, 1955), pp. 30–1; 'Theatrical Examiner', *Examiner*, no. 531 (1 March 1818), pp. 138–9.

[3] 'On the Abuse and Use of Novel-Writing', *Artist*, no. 14 (13 June 1807), p. 18.

left little room or appetite for serious drama, and the brawling, boozing audience did not much care.

In any case, serious drama was restricted to the two theatres which had received royal patents during the reign of Charles II. Only at the Theatres Royal in Drury Lane and Covent Garden could legitimate drama be performed, and the restriction remained in effect until 1843. The monopoly, as indeed it was, applied to five-act tragedy and comedy without music. It could be circumvented, the managers of other theatres realized, by adding music and songs to any drama they wanted to produce, and the resulting entertainment worked some interesting variations on the classics of the English stage.[1]

The theatre brought together a range of social classes under its roof, if not always in the pursuit of culture. In its crudest form, as travelling acts, sideshows, and circuses, the theatre in fact offered a genuinely popular lower-class entertainment. At the start of the nineteenth century, however, the arts in general still retained a predominantly upper-class appeal. Undoubtedly, the expansion of the audience for art, which became the most significant cultural development of the nineteenth century, was already beginning. Merchants, bankers, industrialists, and untitled gentlemen of property were becoming substantial patrons of art by the end of the eighteenth century, in many cases rivalling aristocrats in elegance and expenditure. But the wealthy middle-class collectors still looked to the aristocracy for guidance on the all-important questions of taste, and British artists still tended to see in the nobility their most significant source of patronage. Within a few decades, thousands of working-class enthusiasts would be spending their scant leisure time admiring works of art displayed in public museums. In the early 1800s, however, Old Masters hung in private galleries, and museums hardly existed in London or the major provincial towns.

In the meantime, numerous private associations of artists or societies for cultural purposes, formed in the late eighteenth and early nineteenth centuries, attest to the considerable interest which aristocrats, connoisseurs, gentlemen-scholars, and dilettanti took in the welfare of the arts. In the absence of cultural enterprises sponsored by the state, these societies served as the

[1] Allardyce Nicoll, 'The Theatre', in *Early Victorian England 1830–1865*, ed. G. M. Young, 2 vols. (London: Oxford University Press, 1934), 2: 267.

major source of artistic activity in the life of the country. Two music societies, the Ancient Concerts established in 1776 and the Philharmonic Society in 1813, relied on an upper-class subscription audience. The Ancient Concerts, founded for the performance of music at least twenty years old, often boasted a royal duke or an archbishop as director. The group of professional musicians who started the Philharmonic Society has won immortality by commissioning Beethoven's Ninth Symphony. While London lacked a permanent orchestra of high quality, the Philharmonic Society sought to provide occasions for the performance of symphonic and instrumental music by distinguished artists. It was not until 1823 that the Royal Academy of Music was opened in London, as the first professional music school in England. The particular project of Lord Burghersh (later the Earl of Westmorland), an eminent composer himself, the Academy has survived, sometimes over an arduous course, to the present. Choral festivals organized in several English towns during this period also derived much support from the local nobility and gentry.

There were numerous associations, too, that promoted the interests of sculptors and painters. One of the oldest of these was established in 1732, when a group of gentlemen 'of rank, fortune and education'[1] formed the Society of Dilettanti to promote in England a love for the *objets d'art* which they had admired in Italy. The society published books about classical antiquities, sponsored archaeological expeditions, and commissioned occasional paintings and sculpture. The Society for the Encouragement of Arts, Manufactures, and Commerce was launched in London in 1754, by a small number of noblemen and gentlemen, following the suggestion of William Shipley, who ran a drawing school in the Strand. It aimed to encourage both the fine and the inventive arts, and offered prizes for scientific discoveries useful to agriculture and industry, as well as for merit in painting, sculpture, and architectural designs. Out of funds derived from private sources, largely from annual subscriptions to the society, it was able to award, between 1754 and 1778, more than £16,000 for scientific endeavours and just over half that amount to the arts.[2]

[1] Taylor, *Present Condition of the Arts*, 2: 158.
[2] Pye, *Patronage*, pp. 60–4; and Taylor, *Present Condition of the Arts*, 2: 169–171.

The most prestigious of all British art associations was founded in December 1768, when George III gave his approval to plans for a Royal Academy of Arts. For decades, British artists had been urging the establishment of a Royal Academy of Arts on the French model. The Royal Academy in London, however, instead of providing a cause for celebration, from the start provoked bitterness and jealousy in the artistic profession. Born in controversy, the Royal Academy developed out of the contest for control of an earlier association in London, the Incorporated Society of Artists of Great Britain, which in 1760 had organized the first public exhibition of contemporary British painting. Rapidly, the Academy gained a special status above all other art associations, thanks to the active interest which the King took in its affairs and the marks of favour which he bestowed on it. George III granted the infant Academy several thousand pounds from the Privy Purse before it became self-supporting through the proceeds from its annual exhibition. Until the 1830s, furthermore, it enjoyed the use of rooms in Somerset House as another royal gift. Almost all of its presidents were knighted, and the honour of membership in the select Academy, the distinction of the initials 'R.A.' which only forty artists at a time could append to their names, made the rank of Academician an object of fierce competition and the crown of an artistic career. The Academy's rules, finally, ensured that it would eclipse all other art societies and exhibitions in London, for it required all aspirants to academic honours to show their works at the annual Academy exhibition. The Incorporated Society, as well as the smaller Free Society of Artists founded in 1761, relied on revenue from their annual exhibitions for continued existence, and they gradually declined as the Royal Academy grew in wealth and prestige. Outside the charmed circle of Royal Academy members and associates, the excluded artists keenly resented the Academy's privileged status, and projects for its reform were as numerous after 1768 as plans for its formation had been previously.

That the Royal Academy failed to solve all the problems besetting British artists was implicit in another effort, the establishment of the British Institution for Promoting the Fine Arts in 1805. Its founders included Sir George Beaumont, Thomas Hope, and Sir Thomas Bernard, all of whom had distinguished private art collections. They intended the Institution to stimulate interest

in British art by providing a gallery for the display and sale of works by artists of, or resident in, the United Kingdom.[1] The number of subscribers far exceeded the planners' expectations, and at one meeting alone, in June 1805, nearly £8,000 was raised for the project from numerous lords, gentlemen, bankers, clergymen, and Members of Parliament. With this support, the British Institution was able to purchase paintings from living artists and to organize exhibitions of current works by British artists. There were also shows entirely devoted to the works of famous artists of the British school. The first such exhibition, in 1813, exclusively featured paintings by Reynolds, lent to the Institution by private collectors. 'This was,' according to W. B. Sarsfield Taylor, 'the first public exhibition of the works of any individual British artist, and it still further assisted to demolish that absurd and unnatural prejudice against English intellect, which was now fast falling into ridicule and contempt with the rational and well-informed portion of society.'[2] After a few years, the Institution diverged from its strictly British emphasis and, during the summer, began to exhibit Old Masters, again on loan from the private collections of its benefactors. William Mulready, R.A., a young man when the Institution was founded, recalled that 'in his youth a student could see old masters only at the exhibits in the British Institution and in the auction room'.[3] Both George IV and William IV loaned paintings from the royal collections to the Institution's exhibits, but there was no other official support. About 1810, Perceval, the Prime Minister, refused an appeal for

[1] 'Galleries of English Paintings', *Artist*, no. 21 (1 August 1807), pp. 3–7; Edward Edwards, *The Administrative Economy of the Fine Arts in England* (London: Saunders & Otley, 1840), pp. 254–6; Pye, *Patronage*, pp. 302–6; and Taylor, *Present Condition of the Arts*, 2: 214–44.

Sir George Howland Beaumont, Bt., was an English connoisseur and collector, who used his social position and wealth, derived from Leicestershire coal fields, to befriend painters and men of letters. Thomas Hope, from a family of wealthy Amsterdam merchants, employed his large fortune in collecting ancient sculpture, vases, Italian paintings, and other works of art. He was a vice-president of the Society for the Encouragement of Arts. Sir Thomas Bernard devoted his principal efforts to philanthropy, particularly for the betterment of working-class conditions.

[2] *Present Condition of the Arts*, 2: 227.

[3] Winslow Ames, *Prince Albert and Victorian Taste* (New York: Viking Press, 1968), p. 174.

financial aid to the Institution, citing the expensive war which the country was then fighting.[1]

Although Britain's cultural life centred then, as always, in London, the arts were also struggling to assert themselves outside the metropolis. Liverpool's Academy of Art was founded in 1810, and the Liverpool Royal Institution, established in 1817, purchased a collection of early Italian masterpieces years before most English collectors paid any attention to so-called 'primitive' art.[2] The Royal Manchester Institution for the Promotion of Literature, Science and the Arts was formed in 1829, a private organization like those in Liverpool. Elsewhere, as in Birmingham and Norwich, art societies developed and often provided the only channels through which provincial artists could hope to display and sell their works. Everywhere the initiative came from independent societies, founded and maintained by the local nobility, gentry, and professional or business classes. Their energies had to suffice until the second half of the century, when municipalities began to undertake the responsibility for providing museums and galleries.

In Scotland, the Board of Trustees for the Encouragement of Manufactures administered the small annuity of £2,000 granted by Parliament to Scotland, according to financial arrangements in the Act of Union. As a result of changes in the tariff relations between the two countries, England owed Scotland a sum of money after the union. The sum was divided among several different establishments, including the Board of Trustees, which was subsequently founded in Edinburgh to promote Scottish industry.[3] Despite its original purpose, the Board took an increasing interest in the arts and, in the 1760s, opened a drawing school whose scope expanded to include the higher branches of art, as well as designs for trade and industry.[4] Parliamentary

[1] Hoare, discussing the incident in *Epochs*, pp. 13–15, gives no more precise date than 'about three years ago', or 1810.

[2] Anthony Blunt and Margaret Whinney, eds., *The Nation's Pictures: A Guide to the Chief National and Municipal Picture Galleries of England, Scotland and Wales* (London: Chatto & Windus, 1950), p. xx.

[3] *Parliamentary Papers* (Commons), 'Report from the Select Committee on Arts and Manufactures', 1835, 5:77. In all citations from *Parliamentary Papers*, page numbers refer to individual reports, bills, accounts, etc., as the materials in these volumes are paginated separately, not consecutively.

[4] Taylor, *Present Condition of the Arts*, 2: 311–13; and 'Report from the Select Committee on Arts and Manufactures', pp. 78–9.

support of art thus began, in a roundabout fashion, in Scotland. It persisted throughout the period when Parliament ignored requests for cultural subsidies in England and left the arts there to the mercies of royal patronage. These Scottish beginnings, however, deserve little fanfare. The annuity was granted for commercial purposes and, once granted in perpetuity, its administration over the years attracted the interest of few M.P.s. English legislators would doubtless have been surprised to learn that an important precedent was being modestly set north of the border.

Ireland had similar societies to encourage the arts. The Royal Dublin Society was founded in 1731 to assist the development of agriculture and manufactures, but like Scotland's Board of Trustees, expanded to include the fine arts. The Royal Irish Institution opened in 1813 with royal and aristocratic patronage and visions of imitating the British Institution, but it met an early death. The Royal Irish Academy, however, survived to receive a small annual grant from the Treasury.[1] As earlier with Scotland, annual parliamentary grants to Ireland were fixed at the time of union with Great Britain, but, evidently, rather flexibly. By 1823, the allegedly annual £10,000 vote for the Royal Dublin Society had dropped to £7,000, and even that was an object of contention. Joseph Hume, the Radical Member for Middlesex, generously endowed with the Radical suspicion of official corruption and waste, referred to the society as a 'mere job' and unsuccessfully proposed to reduce the grant by half.[2] A year later, when the grant once again came up for approval, Hume praised England's Society of Arts [for the Encouragement of Arts, Manufactures, and Commerce] for giving 'medals and rewards, without calling upon the public to defray the charge'. He was seconded by William Williams, the Member for Weymouth and Melcombe Regis Borough, who asserted 'the impolicy of supporting these institutions by the public money' and firmly announced his opinion that 'parliament should not interfere'.[3] Private activity on behalf of the arts was one thing; public definitely another.

[1] The Academy is listed in Parliament's financial accounts for 1822 as the recipient of a £300 grant. *Parliamentary Debates*, 2nd ser., 9 (1823): xxiv.

[2] *Parliamentary Debates* (Commons), 2nd ser., 8 (11 April 1823): 834–5. Hume was a consistent and outspoken advocate of Government economy. His attacks on the Estimates became famous.

[3] *Parliamentary Debates* (Commons), 2nd ser., 11 (19 March 1824): 1295, 1298.

Falling somewhere between private and public endorsement of the arts, royal patronage was traditionally the form of support most eagerly courted by European artists. The patronage which Louis XIV extended to the drama, ballet, and opera, in addition to the visual arts, established numerous cultural institutions on a firm and prestigious foundation in France. Frederick the Great founded the Berlin Court Opera, and German princes of widely varying means all prided themselves on promoting the cultural life of their states. On the continent, this tradition endured well into the nineteenth century. In England, it foundered in the middle of the seventeenth, when the reign of that eminent art collector, Charles I, came abruptly to an end. During the eighteenth century, leadership in matters of taste and culture passed to such patrons as the Earls of Pembroke and Burlington, and Horace Walpole.

There were, of course, gestures from time to time, such as those which monarchs must make in order to keep the royal household properly staffed. Artists were appointed as royal drawing master, surveyor of the king's pictures, historical painter to the king, and to any number of other posts created over the centuries.[1] The monarch occasionally conferred knighthood on a painter, architect, or sculptor, commissioned royal portraits, made donations to societies of artists, and allowed the royal name to head subscription lists. George III took slightly more interest in the visual arts than the first two Georges, as demonstrated by his support of the Royal Academy. For a few artists, he proved a steady patron. Benjamin West, the American painter, was employed for over thirty years on royal commissions, receiving an average yearly salary of £1,500 from the King.[2]

Of all the Hanoverians, however, George IV was the only one whose support of artists approached the grand scale of princely patronage. Both as Prince Regent and King, he lavished com-

[1] Some posts carried salaries, others merely an honorarium. Hoare, *Epochs*, pp. 144, 146, 150, discusses the various artistic appointments in the king's household and observes that, in most cases, the positions were purely nominal, demanding little actual employment and bestowed through favour, not merit. Another such position, the Poet Laureate, grew out of a royal pension to Ben Jonson in the seventeenth century.

[2] Pye, *Patronage*, pp. 228–33; Reitlinger, *Economics of Taste*, 1: 69; and William T. Whitley, *Artists and Their Friends in England 1700–1799*, 2 vols. (London and Boston: The Medici Society, [1928]), 1: 170, 220.

missions on architects, painters, and interior designers for work on his over-decorated royal residences. From the time he was a young man until the end of his life, he employed some of the most famous British painters and architects, including Gainsborough, Romney, Stubbs, Nash, and Lawrence. He purchased *objets d'art* in quantities, collecting everything from exquisite bric-a-brac to Gobelin tapestries and Old Masters, and the royal collections vastly expanded under his supervision. Whereas Parliament carefully counted pennies on the very rare occasions when the arts came under discussion, George IV's extravagance was notorious. As royal prerogative yielded to the authority of Parliament on issue after issue, the King seemed ever more determined to live in the style of a potentate. But his colossal expenditures only increased Parliament's efforts to control the royal finances and failed to accomplish much of lasting value for British art. Royal patronage, based as it was on one man's whims and fancies, was no substitute for state encouragement, embodied in permanent institutions certain of regular financial support.

One permanent institution, however, that developed in the second half of the eighteenth century was the British Museum, founded in 1753 when Parliament voted £20,000 to purchase Sir Hans Sloane's collection of books, manuscripts, and natural history specimens. The collection of the President of the Royal Society joined the Harleian manuscripts, which Parliament acquired for £10,000 from the widow of the second Earl of Oxford, together with the Cottonian Library, which had become public property earlier in the century, to form the basis of the British Museum.[1] With the new establishment, Parliament entered the field of museum administration. The Cottonian collection of priceless books and manuscripts, presented to the nation in 1700, was a library for scholars rather than a public museum, and, in any case, Parliament had made little effort to ensure its proper upkeep and accessibility. Britain's first national

[1] To raise the money needed to acquire the Sloane collection and a building sufficiently large to house the assembled materials, Parliament authorized a public lottery—a fact which somewhat scandalized the Victorians when they contemplated the origins of the venerable museum. See Edward Edwards, *Lives of the Founders of the British Museum; with notices of its chief augmentors and other benefactors, 1570–1870*, 2 vols. (London: Trübner & Co., 1870); and Edward Miller, *That Noble Cabinet: A History of the British Museum* (London: Andre Deutsch, 1973).

museum was moved into Montague House which opened to the
public in 1759, and the British Museum grew over the years,
through bequests, private generosity, and intermittent purchases
from Treasury funds. The latter were not always provided
generously. In 1823, the annual grant for the library was £350,
an absurdly small figure for the needs of a national library.[1]
Parliament did not provide grants for general maintenance until
1762,[2] and these do not seem to have been sufficient for the
purpose. John Wilson Croker, the Tory Member for Bodmin and
Secretary of the Admiralty, described Montague House in 1823
as a firetrap, more combustible than any other house in London
'(with the exception of the dirty old wooden-house at the corner
of Chancery-Lane, once inhabited by the celebrated Isaac Wal-
ton)'.[3] Work on a new museum building in Bloomsbury was
finally begun that year, after George IV's gift of his father's
library had forced Parliament to recognize the inadequacies of
existing arrangements.

The museum's affairs were directed by an unwieldy board of
trustees, including ex-officio members of the Government and
royal household, hereditary trustees representing the interests of
the principal benefactors, and a number of elective trustees.
Attendance at board meetings was so poor that the trustees in
1836–7 passed a resolution requiring at least one annual appear-
ance.[4] It is no surprise that the British Museum grew in a hap-
hazard fashion. The wonder is that it grew at all. From the start, it
suffered a crisis of identity; was it a library or a natural history
collection?[5] For many years, it was the only possible beneficiary
of generous collectors who wished to bequeath their life's work
to the nation, and its collections became increasingly diverse. In
1823, John Cam Hobhouse, the Radical Member for Westminster,
called it 'a piece of patchwork', and, even on its first centen-

[1] *Parliamentary Debates* (Commons), 2nd ser., 9 (20 June 1823): 1119–
1123.
[2] John S. Harris, *Government Patronage of the Arts in Great Britain* (Chicago:
University of Chicago Press, 1970), p. 285.
[3] House of Commons debate, 20 June 1823, 1123–4.
[4] William Dyce, *The National Gallery: Its Formation and Management con-
sidered in a Letter Addressed, by Permission, to H.R.H. The Prince Albert, K.G.,
&c., &c.* (London: Chapman & Hall, 1853), p. 36.
[5] In the spring of 1973, the library was finally separated from the rest of
the museum, and plans were announced to move it elsewhere.

nial, it was dubbed a 'warehouselike accumulation of miscellanies'.[1]

[ii]

For several decades, there was little to encourage art in the midst of the British Museum's assorted curiosities. It was not originally intended as an art gallery, and its first distinguished collection of *objets d'art* was not purchased until 1772, when Parliament approved a special grant of over £8,000 to obtain vases from Sir William Hamilton's collection.[2] Gradually, the museum acquired a collection of antiquities. In 1805, a select committee recommended that Parliament authorize the museum's trustees to purchase part of Charles Townley's collection of marble statues, bronzes, and terra cottas for £20,000,[3] and several years later the Phigalian Marbles from Arcadia were bought for the museum at a cost of £19,000. In 1816, by the most celebrated purchase of all, the Elgin Marbles became national property for £35,000.

That the Government decided to collect works of ancient art just when Napoleon had to be finally defeated and the monarchies of Europe restored is indicative of the inconsistency of official

[1] *Parliamentary Debates* (Commons), 2nd ser., 9 (1 July 1823): 1357; and Dyce, *National Gallery*, p. 55. At first the museum's collections were open to the public under strict limitations. Although admission was free, entrance tickets were necessary, and until 1810 less than one hundred tickets were issued on each of the few days a week that Montague House was open. Thereafter public admission was unlimited, and in 1824–5, 127,643 people viewed the collections. *Parliamentary Papers* (Commons), 'Report from the Select Committee on National Monuments and Works of Art', 1841, 6: 153; and Pye, *Patronage*, pp. 238–9.

[2] Miller, *Noble Cabinet*, p. 79. Sir William Hamilton, a descendant of Scotland's ducal Hamiltons and the husband of Nelson's mistress, was also British envoy extraordinary at the court of Naples for several decades. In Italy, he formed a veritable museum of vases, terra cottas, ancient glass, bronzes, ivories, gems, coins, and marbles.

[3] Charles Townley, a great-grandson of the sixth Duke of Norfolk, was another gentleman-collector. Like his friend Hamilton, he was a member of the Society of Dilettanti. In 1791, he became a trustee of the British Museum. See *Parliamentary Papers* (Commons), 'Report from the Committee to whom the Petition of the Trustees of the British Museum, respecting the Late Mr. Townley's Collection of Ancient Sculptured Marbles, was Referred', 1805, 3: 3–9.

attitudes towards the arts at this time. Around 1810, Perceval had cited the war as an excuse for leaving the arts to private benefactors, and yet, at the same time, a kind of international competition had developed in which Britain did not want to come last. While Parliament was reluctant to spend public money on ancient statues, it was somehow held to be a national disgrace if other countries managed to acquire them. In the case of the Aegina Marbles, the Prince of Bavaria outfoxed the agent of the British Museum by purchasing them at a private sale, and other continental sovereigns were also eager to adorn their private or national collections with classical antiquities.[1] The growing interest in archaeology, the prominence of Neo-classicism in architecture since the mid-eighteenth century, and the romantic love of ruins combined to create a ready market for ancient statues and architectural remains.

Great Britain, arbitrating the affairs of Europe in 1816, lagged sadly behind in the civilized arts, and the victor on the battlefield was threatened with dishonour in the art gallery. The Louvre, opened as a museum in 1793, was soon bursting with the art treasures which Napoleon brought back from his conquests. To the shame of many patriots, London could boast nothing comparable. Shee, in his inimitable rhymes, asked:

Shall Britain then, without a sigh, resign
To Gaul's proud sons the glories of the Nine;
Content, ambition's better laurel yield,
And fly, defeated in the graphic field![2]

The 1816 select committee, appointed to consider the purchase of the Elgin Marbles, concluded its report by observing 'how highly the cultivation of the Fine Arts has contributed to the reputation, character, and dignity of every Government by which they have been encouraged, and how intimately they are connected

[1] *Parliamentary Papers* (Commons), 'Report from the Select Committee on the Earl of Elgin's Collection of Sculptured Marbles', 1816, 3: 27, 28, 49.

[2] *Elements of Art*, p. 373. Also see *Rhymes on Art*, pp. liii–liv. Much of the Napoleonic plunder was returned to its native homes after 1815, and, admittedly, the English Government would not have done well to follow the Emperor's example too closely. Nonetheless, he had made Paris the centre to which art students and enthusiasts flocked from all over Europe, and Hoare, *Epochs*, pp. 151–2, recommended that England study how Napoleon encouraged the arts in France.

with the advancement of every thing valuable in science, litera-
ture, and philosophy'.[1] The observation was not new. British
artists and their patrons had been arguing along these lines for
decades, but it took the heightened sense of international rivalry,
stimulated by the long years of war with France, to rouse Parlia-
ment to action.

Even so, the legislators took their time. The Elgin Marbles
were the focus of keen public interest for a decade before Parlia-
ment finally decided to acquire them for the nation. When Lord
Elgin was appointed ambassador to Constantinople in 1799, he
suggested to Pitt and Lord Grenville that the Government might
be interested in financing an effort whose purpose was to make
available to British artists detailed drawings and cast reproduc-
tions of famous Athenian sculpture. He was told that the Govern-
ment was not 'justified in undertaking any expense of an indefinite
nature, particularly under the little probability that then existed
of the success of the undertaking'.[2] Even when it became clear
that the Ottoman Porte was indeed allowing Elgin to remove
large portions of sculpture from the Parthenon and other buildings
on the Acropolis, the British Government still showed no interest
in sharing Elgin's costs.

When the marbles arrived in London, at tremendous personal
expense to Lord Elgin, a fierce controversy arose over their
authenticity. A number of connoisseurs declared them to be
Roman imitations, and not the work of Phidias, as Elgin asserted.
The dispute dragged on for years, together with more personal
attacks on Elgin, who was accused of using his ambassadorial
position to obtain special favours from the Turkish Government.
Byron took the lead in denouncing the Earl as the plunderer and
despoiler of Athens, while others suggested that, since Elgin had
acquired the marbles in the public capacity of British ambassador,
they already belonged to the nation. In any case, Parliament was
in no hurry to buy so troublesome a collection.

By 1815, knowledgeable opinion had rallied to Elgin's side on
the question of authenticity, and he petitioned the House of
Commons to initiate an inquiry into the merits and value of his
collection as potential objects of public purchase. Nicholas
Vansittart, Chancellor of the Exchequer in the Liverpool ministry,
called for the establishment of a select committee on 23 February

[1] Report, p. 15. [2] Ibid., p. 17.

1816; duly appointed, it began hearing evidence by the end of the month.[1] Under the chairmanship of Henry Bankes, the Member for Corfe Castle and a trustee of the British Museum, the committee questioned Lord Elgin, connoisseurs, artists, and several of Elgin's associates at Constantinople. In addition to questions concerning the manner in which the Earl had obtained his collection, the committee sought to ascertain 'the Merit of the Marbles as works of Sculpture, and the importance of making them Public Property, for the purpose of promoting the study of the Fine Arts in Great Britain.'[2] Opinion on this question was nearly unanimous. Witness after witness claimed that the very presence of the marbles in England could exert a most beneficial influence on native art.

With no Raphael, Michelangelo, Rubens, or Rembrandt, no Poussin or Claude to its credit, British art had suffered for centuries from comparisons with the continent. Now, the Select Committee on the Elgin Marbles was told, the Government had the chance to purchase for the nation a collection of exemplary beauty, capable of guiding the British school to success in the grand style of art. John Flaxman delivered the opinion that 'works of such prime importance could not remain in the country without improving the public taste and the taste of the artists', and Sir Thomas Lawrence thought that they would materially assist in forming a national school of historical painting. Benjamin West, President of the Royal Academy, pronounced them 'of the highest importance in Art that ever presented itself in this Country, not only for instruction in professional studies, but also to inform the public mind in what is dignified in art'.[3] Such opinions from the most eminent and successful artists in the country could not

[1] *Parliamentary Debates* (Commons), 1st ser., 32 (23 February 1816): 823–4.

[2] Report, p. 3.

[3] Ibid., pp. 32, 38, 58. That antiquities can provide the ideal example for living art is so discredited a theory in the twentieth century that it is difficult to appreciate the enthusiasm with which artists and amateurs welcomed the Elgin Marbles and waited expectantly for them to work their magic on British art. Yet such expectations were widespread. Much of the Elgin collection had been open to the public in Elgin's London home and at Burlington House since 1807. Members of the Select Committee on the Elgin Marbles frequently asked witnesses whether they did not notice an improvement 'in the state of the arts in this country, since this Collection has been open to the Public?' Immediate results were clearly anticipated.

be ignored. The committee, mindful of its responsibility to British art, and to Great Britain's international reputation as a land of taste and culture, recommended that Parliament buy the Elgin Marbles for £35,000, vesting the collection in the trustees of the British Museum on behalf of the nation. The purchase price which the committee proposed was only a small part of Elgin's costs in assembling and transporting the collection.[1] It accurately reflected the ambivalence in official attitudes which for many years hampered the growth of state subsidies to art. While paying tribute, and not insincerely, to the substantial role played by the arts in civilized society, the House of Commons nonetheless firmly believed that expenditure on culture deserved low priority in budgetary considerations. The arts, most legislators concurred, should be fostered primarily by those who enjoyed them.

The state of the country's finances figured prominently in the House of Commons debate on the purchase of the Elgin Marbles. Several M.P.s, including Henry Brougham, pointed out the heavy national debt, public unrest over tax burdens and food shortages, and popular demands for all possible economy in government.[2] Advocates of the purchase retaliated by stressing the unique chance to acquire for Great Britain the priceless treasures of classical Greece. 'The opportunity would not again recur,' Henry Bankes warned the House. 'In no time had so large, so magnificent, and so well authenticated a collection of works of art of the best time, been produced, either in this or in any other country.' Lord Elgin, it was agreed, would have no difficulty finding princely purchasers, should Parliament refuse to buy his collection.[3] The most cogent speaker in favour of purchase was J. W. Croker, who introduced practical considerations when he claimed that possession of the marbles would even prove to 'the advantage of our manufactures, the excellence of which depended

[1] Elgin's expenses are summarized on p. 8 of the report.

[2] *Parliamentary Debates* (Commons), 1st ser., 34 (7 June 1816): 1030, 1039–1040. This was the principal cause for opposition to the purchase, although a few Members still refused to sanction what they considered an act of spoliation on Lord Elgin's part. The select committee had exonerated him from these charges, asserting that he had acted with perfect legality. It did suggest, however, that the Turkish government would not have cooperated with him so fully had he not been the British ambassador. Report, pp 3–6.

[3] Commons debate, 1029–31, 1039.

on the progress of the arts in the country'. 'It was money spent,' he said:

> for the use of the people, for the encouragement of arts, the increase of manufactures, the prosperity of trades, and the encouragement of industry; not merely to please the eye of the man of taste, but to create, to stimulate, to guide the exertions of the artist, the mechanic, and even the labourer. . . .[1]

The advocates of acquisition prevailed, and by a vote of eighty-two to thirty, the House of Commons authorized the further expansion of the national art collections.

Parliamentary enthusiasm for Grecian marbles, while often in need of prodding, was nonetheless the only substantial interest in art which the legislature expressed during the first two decades of the nineteenth century. The glories of the ancient world were, after all, very much part of any gentleman's intellectual baggage in this period. The classics dominated, if not monopolized, his education, and on the 'Grand Tour' he was likely to visit the famous ruins of Italy and Greece. Shee might warn that 'to preserve works of genius can never tend so much to the glory and prosperity of a state, as to produce them',[2] and Richard Cumberland, a playwright, might scornfully describe 'the bones and skeletons of the dead arts, collected by Mr. Townley, and purchased from the public purse';[3] nevertheless, for the time being, the reverence bestowed on ancient art was too profound to be shaken. For some people, ancient art represented nothing less than a record of the highest form of civilization ever achieved on earth. Others were merely glad to welcome the interest in classical statuary as a return to stylistic purity after years of Rococo

[1] Ibid., 1034. Another advocate of purchase was Charles Long, the Tory M.P. for Haslemere and Paymaster-General. His family were partners in a successful firm of West India merchants, and Long had the means to pursue a lifelong interest in the arts. He was elected a trustee of the British Museum in 1812 and was a member of the Select Committee on the Elgin Marbles. He collected paintings and sculpture, and enjoyed a reputation as judge of pictures and architecture, assisting both George III and George IV in decorating their palaces. A friend of the latter, he was created Baron Farnborough in 1826.

[2] *Rhymes on Art*, p. lvii.

[3] 'On Criticism, Virtu, and the Rewards of Poets and Painters', *Artist.* no. 10 (16 May 1807), p. 10.

ornamentation. Whatever the individual response, admiration for antiquities underlay the prevalent disregard of contemporary art in favour of museum pieces, and the general art-viewing public of the early nineteenth century expected art to imitate old, acclaimed models.

[iii]

The assumptions and prejudices evident during the parliamentary debates on the Elgin Marbles reappeared several years later, when the House of Commons took a momentous step in the development of its policy towards art and voted funds to establish the National Gallery. Like the Royal Academy, the National Gallery was born only after a very long pregnancy. Decades had passed while successive Governments ignored repeated suggestions for such an institution. In the 1770s, John Wilkes had demanded in Parliament that Sir Robert Walpole's distinguished collection of art be purchased as the basis of a national gallery, but the paintings were sold *en bloc* to Catherine the Great.[1] When in 1792 a Mr. Cumberland of Bristol wrote a pamphlet proposing a national gallery of sculpture, it was Josiah Wedgwood who offered a thousand pounds for the project.[2] Even the Royal Academy, it seems, could not persuade the Pitt Government in 1801 to provide £5,000 a year for a 'Gallery of British Honour' housing a permanent collection of the finest contemporary works.[3]

Private initiative, however, was busy setting an example for the Government. Sir Peter Francis Bourgeois, a wealthy painter who died in 1811, left his important art collection to Dulwich College, and the Dulwich Gallery became the first major public gallery in London when it opened in 1814.[4] The Bourgeois bequest was followed in 1816 by the magnificent gift of the seventh Viscount Fitzwilliam to Cambridge University. His bequest included books,

[1] *The National Trust Guide*, comp. Robin Fedden and Rosemary Joekes (London: Jonathan Cape, 1973), pp. 48–9.

[2] 'Report from the Select Committee on Arts and Manufactures', p. 105.

[3] Hoare, *Epochs*, p. 16.

[4] An earlier predecessor of a very different order was the Foundling Hospital in Bloomsbury. From the mid-eighteenth century, the public was allowed to view its collection of paintings, executed, and in many cases presented, by prominent British artists, including Hogarth and Gainsborough.

illuminated manuscripts, paintings, drawings, engravings by Rembrandt, and £100,000 which, together with the interest derived from it, subsequently furnished the handsome Fitz-william Museum. In 1818, Sir John Fleming Leicester (later Lord de Tabley) admitted the public to his extensive collection of paintings of the British school. The extraordinary act of opening a private gallery, entirely devoted to British painters, elicited an appreciative article in the Radical weekly *Examiner*. After praising Leicester's efforts to encourage British artists, the article launched into the inevitable comparison with official efforts. It called the opening of the Leicester gallery 'at once a satire on Government, and its example, that Government which unconscientiously creates sinecures of thousands a year for lazy, worthless courtiers and constitution-killers, but never expends a guinea in furtherance of British genius in Painting'.[1]

The House of Commons first seriously turned its attention to the subject of a national gallery in the early 1820s. In the course of a discussion concerning plans for the new British Museum building, Sir Charles Long mentioned that for want of space the museum had had to decline Sir George Beaumont's offer of his art collection. George Agar Ellis, the Whig Member for Seaford, thereupon took advantage of the opportunity to remark that 'the collection of Mr. Angerstein would be sold in the course of the next year, and if not looked after, would very probably go out of the country'. He intended 'to move for a grant in the next session, to be applied . . . to the purchase of this and other collections, for the formation of a national gallery'. Alexander Baring vigor-ously supported the proposal. 'There were collections now purchasable,' he said:

> which could never again be come at by the public. Vast quanti-ties of valuable works had been thrown into the hands of in-dividuals by the French Revolution, which must in the nature of things return again to the great cabinets and collections. And really, for a country of such inordinate wealth and power as this to be without a gallery of art, was a national reproach.[2]

[1] 'Sir J. F. Leicester's Gallery of British Paintings', *Examiner*, no. 539 (26 April 1818), pp. 269–70.

[2] *Parliamentary Debates* (Commons), 2nd ser., 9 (1 July 1823): 1358–60. Agar Ellis, a grandson of the third Duke of Marlborough, became Baron

Agar Ellis recorded in his diary that the House had 'cheered, & seemed on the whole favourably disposed' towards his suggested measures.[1]

In February 1824, Lord Liverpool's ministry moved to erase what Baring had termed a national reproach. With the payment of part of the Austrian loan, Frederick Robinson, Chancellor of the Exchequer,[2] was able to ask Parliament to sanction three special grants: £300,000 for repairs at Windsor Castle, £500,000 for the construction of new churches, and £57,000 for the purchase of the Angerstein collection. The Chancellor of the Exchequer took the occasion to lecture the House of Commons in language that must have been familiar to veterans of the Elgin Marbles debate:

> As a mere question of money, I do not say that objections may not be urged against any such proposition as that which I am about to submit . . . But taking a more enlarged view of the subject, looking at the intimate connexion of the arts, with all that adorns and ennobles man's nature, it appears to me to be consistent with the true dignity of a great nation, and with the

Dover in 1831. He generously patronized the arts and collected paintings of the British school. He was a trustee of the British Museum.

John Julius Angerstein, a Russian-born merchant, philanthropist, and lover of the arts, had established himself in London as a foremost collector of paintings by the early years of the century. Sir Thomas Lawrence advised him on the formation of the collection, and his gallery in Pall Mall was a favourite social gathering place. In his will, he left instructions for the sale of the collection, and after his death in 1823 there were rumours that it would be sold to the Tsar, the Prince of Orange, or the King of Bavaria. See Charles Holmes and C. H. Collins Baker, *The Making of the National Gallery 1824–1924. An Historical Sketch* (London: The National Gallery, 1924), pp. 49–50.

Alexander Baring, the Tory Member for Taunton, was head of the financial house of Baring Bros. & Co., which his father had founded. He was raised to the peerage in 1835 as Baron Ashburton. An art patron, he owned a particularly fine collection of paintings and was a trustee of the British Museum.

[1] Agar Ellis diary, quoted in Gregory Martin, 'The Founding of the National Gallery, Part II', *Connoisseur* 186 (May 1974): 27. Martin's articles on the establishment of the National Gallery, based on archival and manuscript materials, are particularly valuable. I have used Parts I–V, *Connoisseur* 186 (April–August 1974), in the discussions of the National Gallery which appear in the first two chapters of this study.

[2] Later Viscount Goderich, and subsequently Earl of Ripon.

liberal spirit of a free people, to give a munificent encourage-
ment to the support and promotion of the Fine Arts.

He announced that the Government had negotiated with the
Angerstein representatives and had reached 'an agreement for the
sale to the public of these pictures, for the sum of £57,000', in
order to lay 'the foundation of a National Gallery of works of
art'.[1]

As with the Elgin Marbles, it appears that a chance juxta-
position of events finally elicited official interest in a national
gallery. The Austrian payment occurred just when it seemed that
a distinguished private collection—indeed one of the finest in
England—might leave the country, and it enabled the Govern-
ment to purchase the paintings for the nation. Furthermore, it is
clear from Robinson's speech that the ministry fully expected Sir
George Beaumont to bequeath his collection to the new gallery,
thus establishing 'a splendid Gallery of works of art, worthy of
the nation'.[2] Two excellent private collections for the price of one
was a bargain too attractive for the Government to decline. It
was a comparatively inexpensive way to alleviate the embarrass-
ment occasioned by the frequent comparisons with national art
collections on the continent. Apart from these considerations,
furthermore, some members of the Cabinet shared the enthusiasm
for art that made men like Beaumont avid collectors. Lord
Liverpool himself had already expressed interest in acquiring a
collection of paintings for the nation, particularly one, like
Angerstein's, that was broadly representative of old and modern
masters alike.[3] Peel, the Home Secretary, at this time was begin-
ning his famous collection of paintings by Dutch, Flemish, and
British artists, many of which hang in the National Gallery today.
Robinson, too, went out of his way on a later occasion to defend
public expenditure for the arts. In March 1824, during a discussion
of public works in London, he referred to the opposition raised
against the purchase of the Elgin Marbles several years earlier. 'It
was said,' he recalled, 'that the burthens of the people should be
relieved, before the public money should be employed to any such

[1] *Parliamentary Debates* (Commons), 2nd ser., 10 (23 February 1824): 315–
316.
[2] Ibid. In 1823, Beaumont had promised to give his paintings to the
nation, provided that a proper gallery be found to accommodate them.
[3] Martin, 'National Gallery, II', p. 24.

purposes,' and yet, 'that magnificent collection of the remains of ancient art . . . was now confessed to be one of the most splendid and valuable ornaments of the country. . . .'[1]

The Government's decision to purchase the Angerstein collection was also influenced by firm support for the measure in the House of Commons. A decade later, Thomas Spring Rice, Secretary to the Treasury in Lord Grey's administration, remarked that 'he never recollected a feeling so strongly expressed upon all sides as that which prevailed in favour of establishing a National Gallery'.[2] It was not just that a group of determined connoisseurs in Parliament, particularly Agar Ellis, Baring, and Long, had put pressure on the Government. The proposal found endorsement in all political camps. When the grant was debated on 2 April 1824, no M.P. opposed the resolution 'That £60,000 be granted, to defray the charge of purchasing, and the expenses incidental to the preservation and public exhibition of the Collection of Pictures which belonged to the late John Julius Angerstein, Esq. for the year 1824.' Even Hume warmly welcomed the chance to 'rescue the country from a disgrace which the want of such an establishment had long entailed upon it'. It was a rare occasion indeed when Hume found himself in complete accord with George IV, who also favoured obtaining the Angerstein paintings for the nation. Agar Ellis, delighted with the response of the House, confidently predicted 'that the present would form a new era in the history of the arts' in Great Britain. The British school of painting, he explained, would at last enhance the country's glory, for artists now had access to 'first-rate models' which could only improve their 'character and renown'.[3]

If Parliament was going to spend money on art, Old Masters were an appropriate object of public purchase and, like ancient statues, were expected to serve as example and inspiration for the artist and public alike. But, while the House of Commons was willing to make occasional allocations for the arts, it had no intention of involving itself heavily in an ongoing commitment to foster culture. Having decided to establish the National Gallery, the House proceeded to treat it like an unwanted stepchild. For fourteen years after its opening on 10 May 1824, the nation's

[1] *Parliamentary Debates* (Commons), 2nd ser., 10 (23 March 1824): 1382.
[2] *Parliamentary Debates* (Commons), 3rd ser., 22 (14 April 1834): 739.
[3] *Parliamentary Debates* (Commons), 2nd ser., 11 (2 April 1824): 101–3.

collection of paintings suffered from utterly inadequate housing. There was the possibility of serious damage to the pictures from dirt and heat in the small buildings in Pall Mall where they were first displayed. Yet a new museum, erected by parliamentary grant specifically for the purpose, was not ready until 1838.[1]

Nor did Parliament make sufficiently precise plans for the administration of the gallery which, from birth, was the object of jurisdictional disputes. Beaumont had promised his collection to the British Museum, whose building programme at that time was designed to provide a gallery for paintings. The trustees of the museum argued that the National Gallery belonged under their authority, while critics of the trustees' management of the British Museum sought to keep the nascent art gallery independent of their supervision. The opposition included some outspoken M.P.s, including Croker, and the Liverpool Government found it wise to avoid the issue at first. It established the national collection of paintings in Angerstein's former house in Pall Mall and placed it under the general control of the Treasury. A keeper was appointed, with the paltry annual salary of £200, and was charged with the immediate supervision of the collection. For several weeks, the question of jurisdiction over the National Gallery remained in abeyance, but the temporary arrangements could not suffice indefinitely. At the end of June 1824, the Government appointed a 'Committee of Gentlemen for the Superintendence of the National Gallery in Pall Mall'. All the distinguished members—Lords Liverpool and Aberdeen, Robinson, Long, Beaumont, and Lawrence, President of the Royal Academy—were trustees of the British Museum. If, in their new capacity, they kept no official records and held no regular meetings for three years, it was because supervision of the National Gallery effectively passed to the British Museum trustees, particularly to their Subcommittee for the Department of Paintings, Prints and

[1] 'The house in which these treasures of art are for the present deposited,' wrote Gustav Waagen, the German art historian, in the 1830s, 'is . . . by no means worthy of them. The four rooms have a dirty appearance; and, with great depth, so little light, that most of the pictures are but imperfectly seen. They are hung without any arrangement, as chance has decided. . . . This building, which is an ordinary private house, affords no security against fire. . . .' Gustav Friedrich Waagen, *Works of Art and Artists in England*, trans. Hannibal Evans Lloyd, 3 vols. (London: John Murray, 1838; reprint edition, London: Cornmarket Press, 1970), 1: 185.

Drawings. The Liverpool Government and the House of Commons had, after all, committed public funds to the British Museum's building plans, and they were reluctant to multiply the bodies responsible for the nation's art collections.

It was only in 1827 that the National Gallery began to enjoy independence from British Museum control, when Canning, Lord Liverpool's successor as Prime Minister, appointed Peel and Agar Ellis to the gallery's 'Committee of Gentlemen'. Neither was a trustee of the British Museum at the time. Their presence on the gallery's supervisory board meant that the Treasury could not continue to deal directly with the British Museum trustees while neglecting the National Gallery's own appointed board. Once the personnel of the two bodies was no longer interchangeable, the National Gallery committee could finally start to develop as a functioning board of trustees. The British Museum soon formally recognized the gallery as a separate institution, but jurisdictional problems nonetheless remained.[1] Tangled lines of authority continued to issue from the Treasury, the National Gallery's board, and its keeper, and a clear assignment of authority was not laid down by the Treasury until 1855. Thus for more than three decades, the gallery was allowed to flounder about, 'the plaything of great statesmen and distinguished amateurs, always well-intentioned and sometimes generous, but very seldom possessing any of the precise technical or historical knowledge, the catholicity of judgment or the clearness of aim which the infant institution required'.[2]

The interest which the House of Commons expressed in the foundation of the National Gallery and the half-hearted, miserly assistance subsequently afforded the museum reflected a deep ambivalence in official views concerning art's social function.[3] It seems that the legislators, at least the ones who gave any thought to artistic efforts, were motivated by conflicting convictions that reduced official cultural policy to a series of contradictions. On

[1] Holmes and Collins Baker, *National Gallery*, pp. 4–6; Martin, 'National Gallery, II', pp. 27–31, and IV, pp. 200–2.

[2] Holmes and Collins Baker, *National Gallery*, p. 30. A regular annual purchase fund was not provided for the gallery until 1855.

[3] They also reflect what seems to be a permanent problem of arts funding: the fact that governments are willing to allocate money for collections or buildings, but are far less interested in the routine tasks of daily maintenance.

the one hand, they sincerely subscribed to the ancient, and neo-classical, view of art as a moral influence in society. Croker expressed a common belief when he explained that 'works of art were especially calculated to civilize and humanize the public at large'.[1] In an age that relished cock fighting, bear baiting, and public executions, the arts stood for manners, grace, refinement, and humaneness—in short, for civilization. The humanizing mission of the arts was stressed repeatedly throughout the nineteenth century, and never more insistently than at the beginning. 'There can be no question but that refinement of manners has been, in general, the immediate and obvious consequence of the extended influence of the imitative arts,' asserted Henry James Pye, the Poet Laureate, in 1807, while Martin Archer Shee more elaborately praised the arts as 'those softeners of human life, those refiners of the rough and drossy ore of humanity', and 'the real benefactors of society, refining its pleasures from sensuality, its luxuries from grossness'.[2] A correspondent to the *Artist* in 1807 wrote:

> I have always ventured to express my opinion that the cultivation of the Arts . . . was highly favourable to the cause of religion and virtue, and that by softening the manners, cultivating the taste, and awakening the finest feelings of the heart, we promote the interests of the most benevolent of all Religions.[3]

In these decades of growing religious concern among Anglicans as well as Dissenters, when the Church Commissioners and Church Building Society, the Bible Society, the Clapham Saints, and countless others were all fighting for Christianity in Britain, the arts, too, could be enlisted in the service of virtue.

They could be enlisted even more conspicuously in the service of taste, probably the most overworked and ill-defined word in the English language during this period. Eighteenth-century writers had been very fond of formulating the precise rules that governed taste, and the preoccupation endured well into Victor-

[1] *Parliamentary Debates* (Commons), 2nd ser., 10 (29 March 1824): 1474.

[2] 'On the Influence of the Imitative Arts on Manners and Morals', *Artist*, no. 18 (11 July 1807), p. 12; Shee, *Rhymes on Art*, pp. xvii, xxxiv.

[3] Anonymous correspondent, 'Notes of various Correspondents on the Moral Powers of the Arts', *Artist*, no. 16 (27 June 1807), p. 11.

ian times. Not only did art critics and connoisseurs continue to explore the subject, but Members of Parliament liberally distributed the noun throughout debates on museum purchases and public works.[1] Parliamentary exchanges on matters of taste at times degenerated to downright silliness, but the occasional absurdities in a sense further underscored the lawmakers' deeper concern for the quality of life in England. The spreading ugliness of industrialization, the filth and poverty of the crowded towns, the veneration of business success and material prosperity—all were symptoms and causes of marked changes in traditional values and social patterns. Poets and social critics—men like Shelley, Coleridge, Southey, and the young Carlyle—sensed a general disorientation and confusion throughout society in these years. Labour agitation, political repression, and economic dislocation characterized the early decades of the nineteenth century, and questions of Catholic emancipation and electoral reform divided a nation already gripped by an abiding fear of social crisis.

Much of the preoccupation with taste reflected a profound anxiety about society's future. Men doubted whether the rapidly growing population, particularly in the new urban centres, could be absorbed within the old class framework and looked nostalgically to the life style of their fathers and grandfathers. It was this anxiety which made many of art's patrons and supporters hail the arts as agents of refinement. Through artistic culture, they claimed, the lower classes could be taught to share the values and aspirations of their social betters, to admire the great works of civilization embodying the universal principles of beauty and order. Just how the arts were to humanize the crowds that lived in an environment of habitual dirt, drink, violence, and crime was never satisfactorily explained. Still, it was an article of faith, or devout hope, for many people at this time, and for decades to come, that the arts, given sufficient encouragement, could accomplish even that. Among art's promoters, social concerns powerfully buttressed aesthetic interests.

[1] New courts of justice in Westminster, for example, were denounced as 'contrary to every principle of sound and legitimate taste', and 'a disgrace to national taste.' Croker asserted that Parliament had a responsibility to consider, not only the expense of any public work, but how 'it might reflect on the national taste'. *Parliamentary Debates* (Commons), 2nd ser., 10 (18 March 1824: 1284; 11 (21 May 1824): 814; 10 (1 March 1824): 626.

If Members of Parliament were swayed, perhaps only sub-consciously, by considerations such as these, there were, on the other hand, opposing arguments that could not help but influence the legislators as well. In the first place, art by no means met with universal approval. Much of the middle class expressed an explicit hostility towards the arts that had roots both in religious attitudes and in a preoccupation with industrial enterprise. The puritanical fear of worldly temptations and immortality, the businessman's contempt for time wasted on apparent frivolities, the emphasis which both placed on hard work and discipline, provided an atmosphere which discouraged cultural pursuits in many middle-class, and also some upper-class, homes.

Secondly, prevailing theories of state intervention and the very structure of the British Government at the time placed implicit restrictions on official subsidies to art. In the 1820s, the state's responsibilities were held to begin and end with administering justice, collecting taxes, and defending the country. Except for the Treasury, the courts, and the military departments, England's central administration could be characterized by a striking lack of personnel and powers.[1] There was nothing like an organized bureaucracy, and the Government operated—in G. M. Young's classic phrase—on very 'slight equipment' indeed. Parliament had conceded that it was worth spending money to preserve statues and paintings for the nation. It could not yet envision a more generous programme of art subsidies that might interfere with the work of individual patrons or artists. That the state had any responsibility for the living artist would have seemed ludicrous to most Englishmen, not only in the 1820s, but throughout much of the century. It was only persuaded to intervene in the terrible plight of factory workers and miners after long, bitter contro-versy. Government support of the arts in Great Britain could only expand as the administrative machinery of the state expanded and as government itself was seen to have an increasingly broad role in society.

[1] David Roberts, *Victorian Origins of the British Welfare State*, Yale Historical Publications (New Haven: Yale University Press, 1960), p. 13.

The 1830s

[i]

In the 1830s, the British Government began that growth in complexity and range of powers that ultimately affected the arts, together with all facets of national life. The decade opened with an intense agitation for political reform, such as England had not known since the seventeenth century. At its close, economic depression and the first wave of Chartist violence presaged the tensions and miseries of the 'Hungry Forties'. Against this dramatic background, theories of a passive, laissez-faire state demanded critical re-evaluation. While individualism remained the dominant principle of political economy, the conviction grew that the state held some responsibility for its people—not only to protect their bodies and property from assault, but also to foster their welfare. Political reform, in the first Reform Act of 1832 and the Municipal Corporations Act of 1835, was interspersed with legislation directed towards social reform. The House of Commons Select Committee on Factory Children's Labour led to the Factory Act of 1833, and the Poor Law Commissioners saw their efforts enacted into law the following year. The new Poor Law was deterrent, not humanitarian, in emphasis, and the jurisdiction of the Factory Act was severely restricted. Both seem paltry efforts beside Coleridge's or Southey's blueprints for a paternalist government. Yet with their systems of inspectors, reports, and, in the case of the Poor Law, educational facilities, both Acts helped prepare the country for the intrusive power of the state in the affairs of local government and the lives of private citizens.

At the base of all social theories and programmes lay the overwhelming problem of education, and the state's responsibility to provide a national system of education was vigorously debated throughout the decade. Aspects of that debate merit some examination here, for official views on state education were

closely related to official views on cultural subsidies, while government aid to education set the pattern for much of the public funding subsequently made available to the arts. The controversy over the financing of education involved bitter sectarian partisanship. Anglicans and Dissenters alike feared parliamentary encroachment on the authority exercised by their agencies of education—respectively the National Society and the British and Foreign School Society—since the early years of the century. The exclusive affiliation of the great universities with the Church of England helped to justify opposition from Dissenters, who largely held to the principle that education should be excluded from the Government's legitimate concerns. Others even then realized that no voluntary system could cope with the rapidly multiplying numbers of illiterate children, and they urged a comprehensive national scheme. The demand for education of the lower classes became increasingly insistent throughout the 1830s, as many members of the middle and upper classes began to recognize in education the only cure for society's unsettled condition. The threads of reasoning tended to become snarled as the debate proceeded. Religion and social stability figured almost as prominently as reading and writing. The fine arts, too, were inextricably drawn into the discussion.[1]

James Millingen, for example, developed his critique of the British educational system around the neglected needs of art and science. In *Some Remarks on the State of Learning and the Fine-Arts in Great Britain* (1831), the archaeologist and antiquarian blamed the Tory Governments of the last fifty years for the decline of British science and literature. Millingen rejected the opinion that the arts and sciences 'should be left, like any other commodity, to find their natural price at the market, according to the demand which may exist for them', and he observed that, while 'even such notoriously despotic and suspicious governments as those of Austria and Russia, promote Education and Learning among their subjects, it is singular that the British Government should remain totally passive'.[2] He applauded the encouragement

[1] The education question was not, of course, a new subject of public interest in the 1830s, but the controversy attracted increased attention, and passion, as the state began encroaching on other areas previously left to voluntary efforts.

[2] *Some Remarks on the State of Learning and the Fine-Arts in Great Britain, on*

afforded by the French Government, and offered traditional arguments for promoting national glory through culture. Of greater interest, however, in the context of the 1830s, is Millingen's assertion that French institutions of learning

> have had a very powerful effect on the national character, and by uniting different ranks in the same pursuits and pleasures, have given, even to the lower orders, a courteousness of manners which distinguishes them. Hence, too, crimes are much less frequent than in England, and under the most difficult circumstances, a great respect for property has been constantly found.[1]

Edward Bulwer-Lytton, the popular novelist and Radical Member of Parliament, devoted much of the first volume of *England and the English* (1833) to the question of popular education. He called for strong *'directive government'*, providing 'National Schools, on a wide and comprehensive plan'. The principle of state intervention was clear in his mind:

> If ever . . . the people of this country shall be convinced that a government . . . should be a providing government and not a yielding one . . . I apprehend that one of the first axioms we shall establish will be this: Whatever is meant for the benefit of the people shall not be left to chance operation, but shall be administered by the guardians of the nation.[2]

There were, however, limits which Bulwer-Lytton placed on the benefits to be derived from popular education. He expressed sympathy with the concern, often voiced in opposition to teaching the poor, that education would make the working classes disinclined to work, and he proposed, therefore, that 'the art and habit of an industrious calling make a *necessary* part of education'.[3] There was nothing egalitarian in Bulwer-Lytton's scheme; writing in the well-established vein of enlightened paternalism,

the Deficiency of Public Institutions, and the Necessity of a Better System for the Improvement of Knowledge and Taste (London: J. Rodwell, 1831), pp. i, 3.

[1] Ibid., p. 70. The incongruity of that assertion, just after the Revolution of 1830, did not evidently occur to the author. In any case, the principle enunciated was widely held.

[2] *England and the English*, 2nd ed., 2 vols. (London: Richard Bentley, 1833), 1: 220, 190, 274. The first edition appeared earlier in 1833.

[3] Ibid., 1: 365–6.

he painted a glowing picture of the benevolent state. 'I would wish,' he told his readers:

> that you should see the Government educating your children, and encouraging your science, and ameliorating the condition of your poor; I wish to warm while you utter its very name, with a grateful and reverent sense of enlightenment and protection; I wish you to behold all your great Public Blessings repose beneath its shadow. . . .[1]

William Ewart Gladstone offered an even loftier conception of the state. At the end of the decade, the young Member for Newark published *The State in its Relations with the Church*, a work which commingled questions of education, morality, political theory, religion, and the arts in sombre, weighty prose. Building on the works of Burke, Coleridge, Southey, and numerous theologians, and curiously foreshadowing Matthew Arnold, Gladstone called the state 'the safeguard of the best, purest, and truest portions of the common life', responsible for the 'cultivation and improvement' of its members. After dwelling at some length on the moral and religious nature of the state, Gladstone turned to combat 'the crude and novel dogma, that the State is appointed to be conversant with material ends alone'. What better means, he asked, to prove that the wise government concerns itself with the welfare of each subject 'as an immaterial and an immortal being' than to cite the demand for encouragement of the arts and popular education? Gladstone was on fairly sure ground with the latter example, for by 1839 there was a growing consensus 'that the Government has a legitimate concern in the education of the people', but he had difficulty making a case for the former. Alluding to the British Museum and National Gallery, he asserted that 'the State offers to its individual members those humanising influences which are derived from the contemplation of Beauty embodied in the works of the great masters of painting'. All the same, he had to concede that 'in this country . . . little has been done by national means for the fine arts . . .'. The most revealing part of the entire chapter comes with Gladstone's observation that 'the higher instruments of human cultivation are also ultimate guarantees of public order'.[2]

[1] Ibid., 2: 305–6

[2] *The State in its Relations with the Church*, 4th ed., rev. and enl., 2 vols.

As these few examples suggest, aesthetic, religious, and social considerations were constantly confused, no matter how hard serious thinkers tried to compartmentalize them. The debate on national education wandered off into diverse channels that somehow managed to end in proposals for parliamentary grants to the arts, defences of the Established Church, attacks on the same, or warnings against social upheaval. When the House of Commons discussed national education in the 1830s, the same entanglement of issues enlivened and complicated the debates.

Appropriately enough, it was Bulwer-Lytton who stressed the relationship between ignorance and crime during a debate in the Commons on 14 June 1832. He had moved the repeal of certain taxes on newspapers, 'taxes on knowledge', as they were called, and he associated their repeal with Parliament's 'duty . . . to diffuse cheap instruction amongst the people'. He addressed his arguments, however, more to the lawmakers' fears than to their sense of duty:

> When he looked round and saw the results of that ignorance which the laws he desired to abolish fostered and encouraged, breaking forth not only in wild and impracticable theories, but, as the experience of a few months since had taught them, in riot, and incendiarism, and crime—when he saw them written in the fires of Kent, and stamped in the brutal turbulence of Bristol, he felt, that in this Parliament, and at this period of the session, he did but fulfil his duty in pointing out the evils of the present system. . . .

Educated men, he explained, were not deluded 'by those superficial and dangerous notions of the injustice of the divisions of property, which men who are both poor and ignorant so naturally conceive, and so frequently act upon . . .'.[1]

Although Bulwer-Lytton's motion was not carried, his arguments survived in various forms. A year later, when John Arthur Roebuck, the Radical Member for Bath, proposed a resolution calling on the House 'to frame some plan for the universal education of the people', he stressed the social implications of education:

(London: John Murray, 1841), 1: 78, 81, 151, 154–7. The first edition appeared in 1839.

[1] *Parliamentary Debates* (Commons), 3rd ser., 13 (14 June 1832): 620–1.

It means the so framing the mind of the individual, that he may become a useful and virtuous member of society in the various relations of life. It means making him a good child, a good parent, a good neighbour, a good citizen, in short, a good man.[1]

Hume more bluntly averred that 'the more the people were instructed, the more were the means increased of keeping the people tranquil and their institutions stable'.[2] Evidently the reform agitation of the early 1830s had unsettled some Radical minds.

On 30 July 1833, all the standard arguments against state interference in education were aired in the course of the debate, both by members of the Whig Government and by the Opposition. Lord Althorp, Chancellor of the Exchequer in Earl Grey's Cabinet, expressed the view that governmental endeavour in the field of education would put an end to the considerable 'voluntary exertions of individuals', a result which he, for one, would deplore. Daniel O'Connell, the Radical Member for Dublin, reminded the House unnecessarily that 'this was a subject on which the interference of the Government was capable of provoking very strong feelings in a country like this', and he concluded that 'one of the best resolutions they could come to was to govern as little as they could'. Peel praised the many advantages which free countries enjoyed and expressed his belief that a state-controlled 'system of education appeared to him to trench upon religious toleration; for it must, almost of necessity, interfere with religious opinion'.[3] Early in the decade, distrust of state-sponsored education cut across party lines.

Roebuck withdrew his motion, and all that Parliament would concede for the purposes of national elementary education in 1833 was a grant of £20,000 to assist both the Anglican and Nonconformist societies in building schools. Hume called the grant a 'miserable pittance' which hardly met the need for a system of education undertaken nationally by parliamentary initiative. Henry Warburton, the Radical Member for Bridport, also called for 'a matured plan of national education', but these

[1] *Parliamentary Debates* (Commons), 3rd ser., 20 (30 July 1833): 140, 142.
[2] Ibid., 172. Both Roebuck and Hume were among a group of Radical Members, strongly influenced by Benthamite theories, who kept up a persistent demand for a system of public education.
[3] Ibid., 168, 169, 173.

protests were ineffective. So too was the tirade which William Cobbett, who had turned parliamentarian late in life, directed against education. True to the stand he took in his *Political Register* against middle-class domination of the working classes through charity, benevolent schemes, or any 'comforting system', Cobbett demanded to know what education had accomplished thus far. 'Nothing but to increase the number of schoolmasters and schoolmistresses—the new race of idlers,' he maintained. 'It was nothing but an attempt to force education—it was a French— it was a Doctrinaire—plan, and he should always be opposed to it.'[1]

For the rest of the decade, successive Governments followed the same inconclusive policy that satisfied neither Cobbett nor Hume. The grants to the school societies continued and, in 1839, were placed under the jurisdiction of a Committee of the Privy Council on Education, established only after fierce controversy. Its establishment meant that the British Government at last assumed some measure of official responsibility for public education. It meant that 'the passion for an educated people, which united all reformers',[2] was beginning to prevail against the opponents of strong, centralized government. Surveys of the state of elementary schooling in England during the 1830s had revealed the appalling numbers of children receiving little or no education, and proved conclusively that the voluntary principle could no longer serve as the single solution to the crisis. Nevertheless, while recognizing the need for state aid, Parliament refused to enact legislation leading towards a complete system of national education, and sought to evade the politically explosive issue for the next thirty years.

[ii]

The same hesitancy and uncertainty clouded the British Government's first effort in the field of art education. More daring here than in the boundless area of national elementary instruction, Parliament approved and financed the establishment of a School of Design in London, which opened in 1837. It is unlikely, however, that the legislature would have sanctioned the enterprise if

[1] *Parliamentary Debates* (Commons), 3rd ser., 20 (17 August 1833): 733-5.
[2] G. M. Young, *Victorian England, Portrait of an Age* (London: Oxford University Press, Galaxy Books, 1971), p. 59.

it had not already endorsed the principle of public aid to education through its grants to the school societies. Nor would art schools have been organized so rapidly, at least in comparison with parliamentary action on other educational matters, if commercial interests had not strongly supported the endeavour. But even in this undertaking, no consistency of purpose or programme prevailed. From the start, conflicting theories were allowed to interrupt the management of the school, and for fifteen years the experiment hovered on the verge of failure.

The School of Design grew out of the Select Committee on Arts and Manufactures which sat in 1835 and 1836. The committee, in turn, had a lengthy history behind it. The interrelationship between art, manufactures, and trade had long been appreciated, and for decades many artists and their patrons had insisted on the utility of the arts. The bylaws of the British Institution explicitly connected the encouragement of British artists with the improvement and extension of British manufactures, and, by its very name, the Society for the Encouragement of Arts, Manufactures, and Commerce announced its founders' recognition of the reciprocal influence of art and industry.[1] Voices were raised to urge the inclusion of art instruction for practical purposes in the school curriculum, and Hoare repeatedly asserted in *Epochs of the Arts* that the fine arts should be cultivated as 'a source of utility and revenue'.[2]

In part, the emphasis on art's utility represented a response to the demands of the time for 'useful knowledge'. From the mid-eighteenth century, science and technology had attracted increasing interest, and, with the advance of industrial production, they were clearly destined to play a far more significant role in national affairs than the arts could ever assume. All ranks of society developed a seemingly insatiable appetite for practical information, which private circulating libraries, book clubs, and local academies for discussions and lectures were founded to

[1] The bylaws of the British Institution are quoted in Pye, *Patronage*, pp. 302–3. The profits which Josiah Wedgwood made from imitating Greek vases in the Hamilton collection must have convinced any sceptic that art could be good business.

[2] P. xii. 'But what branch of manufacture,' Hoare asked, p. 108, 'does not feel the influence of Painting? Jewelry, dress, arms, furniture, carriages, houses, ships, coins—all feel the result of the existing state of Design.'

supply.[1] Voluminous encyclopaedias, penny publications for working men, and numerous successful reviews both served and profited from this interest, which made publishing a big business in the first decades of the nineteenth century. In the 1820s and thirties, new educational facilities arose, thanks to the energies of men like Henry Brougham, who played a leading role in the establishment of Mechanics' Institutes and the University of London. He was also instrumental in organizing the Society for the Diffusion of Useful Knowledge, whose title epitomized the purpose behind a broad range of activities in this period. Bentham's famous comparison of push-pin and poetry, expressed in his distinctive vocabulary, made much common sense.[2] Many people who did not enjoy art, or appreciate its social uses, saw little value in cultural refinements. The fact that art might have a significant bearing on commerce and industry, however, was an argument of critical importance to them.

The argument was not brought forward for the sole purpose of broadening art's appeal. The resumption of normal commerce with the continent after two decades of war suddenly accorded new prominence to the connection between art and trade. While Great Britain held a clear quantitative lead in industrial output, the quality of French fancy goods, such as ribbons, shawls, gloves, paper hangings, china, and ornamental metal work, was decidedly superior. British manufacturers not only found their fancy goods competing unfavourably in continental markets, but they also had to expend considerable sums on foreign designs in order to attract consumers at home. The French schools of industrial design, particularly the two in Paris and Lyons supported by state and municipal funds, were known in Britain, where there

[1] Of course, the humanities and fine arts were not excluded from these organizations, but the overwhelming emphasis was on the acquisition of scientific, commercial, or industrial knowledge.

[2] 'Prejudice apart, the game of push-pin is of equal value with the arts and sciences of music and poetry. If the game of push-pin furnish more pleasure, it is more valuable than either. Everybody can play at push-pin: poetry and music are relished only by a few.' *The Works of Jeremy Bentham*, ed. John Bowring (Edinburgh: William Tait, 1843), 2: 253.

Included in his 1831 platform of principles for parliamentary candidates, Bentham listed 'Useful Knowledge to all promised'. 'Parliamentary Candidate's Proposed Declaration of Principles', quoted in *The English Radical Tradition 1763–1914*, ed. Simon MacCoby (London: Nicholas Kaye, 1952), p. 110.

was nothing comparable. The more recent systems of public instruction in design for artisans, instituted by the Prussian and Bavarian governments, were also beginning to attract attention.

At home, Mechanics' Institutes throughout the country offered elementary instruction in drawing after numerous operatives had found that 'some practical skill in the arts of design is either absolutely needful, or would be eminently useful'.[1] These schools, however, were not equipped to offer any advanced teaching directed towards the particular requirements of specific industries, and the Royal Academy, Britain's bastion of high art, would certainly not allow its own facilities to be used for such purposes. The Scottish Board of Trustees for the Encouragement of Manufactures continued to run its school which offered artisans instruction in commercial design, and the British Government provided art instruction at the Royal Military Academy, Woolwich, and the Royal Military College, Sandhurst.[2] Clearly something more was required, if Great Britain expected to retain industrial leadership unimpaired. If the superior design and elegance of French manufactures were reason enough for the considerable French export trade, it was time that British artisans should apply themselves to the study of design.

The House of Commons appreciated the gravity of the situation. Here was not merely a matter of buying or housing statues and paintings, but rather a question of art applied to the vital processes of a commercial nation which the parliamentary spokesmen of industry and trade could well understand. Peel, whose family wealth derived from the calico-printing business, was quick to call his colleagues' attention to the problem. On 13 April 1832, during discussion of a new building for the National Gallery, he said that the interest of British manufacture

> was also involved in every encouragement being held out to the fine arts in this country. It was well known that our manu-

[1] 'Report from the Select Committee on Arts and Manufactures' (1835), p. 116. The evidence given by Charles Toplis, a vice-president of the London Mechanics' Institution, pp. 108–18, provides interesting information about the London organization. Appendix no. 3 of the report contains a list of the subjects studied there. Edwards, *Administrative Economy*, p. 16, mentions art instruction at Mechanics' Institutes in Glasgow, Manchester, and Coventry.

[2] Quentin Bell, *The Schools of Design* (London: Routledge & Kegan Paul, 1963), p. 48.

facturers were, in all matters connected with machinery, superior to all their foreign competitors; but, in the pictorial designs, which were so important in recommending the productions of industry to the taste of the consumer, they were unfortunately, not equally successful; and hence they had found themselves unequal to cope with their rivals. This deserved the serious consideration of the House in its patronage of the fine arts.

Warburton, the son of a timber merchant, agreed that encouragement of the fine arts 'would tend materially to an improvement in our manufactures', and 'thought that the expense incurred would be paid over and over again by the advantages derived by the country'. Hume informed the House that 'there was only one man at Coventry who was at all proficient in forming designs for silk', while 'at Lyons there was a School of Design, with numerous students, entirely for the purpose of improvement in patterns and articles of taste. Hence the superiority of the French in this respect to our manufacturers.'[1]

Beyond Westminster, Benjamin Robert Haydon was at work seeking to augment the Members' interest in art education. Haydon, an historical painter whose ambition exceeded his talent, imagined himself the national spokesman for high art and acted as Parliament's nagging conscience where art was concerned. After a falling out with the Royal Academy early in the century, he persistently urged the Government to foster the arts through commissions, competitions, and public works. In the 1820s and 1830s, he submitted to Parliament and to various ministers no fewer than ten petitions, plans, memoranda, and protests about official treatment of the arts.[2] As he was nearly always destitute, Haydon had strong reasons for urging state promotion of art, but his motives were not entirely personal. He believed that his mission was to elevate public appreciation of art, particularly historical painting, and he had a fanatic's perseverance and determination in the pursuit of his goal. While he may have done more immediate harm than good to the interests of art in Great

[1] *Parliamentary Debates* (Commons), 3rd ser., 12 (13 April 1832): 467–9.

[2] Benjamin Robert Haydon, *Correspondence and Table-Talk, with a memoir by his son, Frederic Wordsworth Haydon*, 2 vols. (Boston: Estes & Lauriat, 1877), 2: 218–21.

Britain, it was impossible to ignore him and the cause he championed.

From the very start of the 1830s, Haydon pressed the needs of British industrial design on the attention of ministers. On 14 October 1830, he wrote to remind the Duke of Wellington that:

> the public establishment and encouragement of High Art is essentially requisite to a manufacturing country. Taste in design can only be generated by excellence in elevated Art. Our Manchester cottons were refused in Italy at the conclusion of the war in 1816, because their design was tasteless . . . This is a fact, I can assure your Grace, and I submit that it goes far to prove the importance of design to a nation so far advanced as we are.

He suggested that the Government set aside one or two thousand pounds yearly for the arts. The Prime Minister's reply stated tersely: 'The Duke is convinced that Mr. Haydon's own good sense will point out to him the impossibility of doing what he suggests.'[1] With political reform preoccupying the nation, Wellington could not waste time or effort on designs for cotton textiles.

The reform crisis once settled, Haydon applied his energy to the Whig Government. In December 1832, he wrote to Lord Grey, urging him to 'establish Schools of Design in all the principal towns, with a system of instruction similar to that at Lyons'.[2] He had further occasion to talk to the Liberal Party leaders as he worked on the picture of the Reform Banquet which he was commissioned to paint. He could not only appeal to their sound business instincts, but, with the more radical members of the party, he could arouse their dislike of special privilege, as embodied in the Royal Academy.[3] The two elements merged to present a convincing case for the need to examine critically and thoroughly British art education. William Ewart, the Radical M.P. for Liverpool, shared many of Haydon's views on art. He

[1] Ibid., 2: 226–7. In any case, Wellington was notably unenthusiastic about promoting cultural programmes.

[2] Ibid., 2: 220.

[3] The Radical attack on the Royal Academy, under Hume's leadership, became intense in the 1830s, and regularly intruded into parliamentary debates about the arts.

was, moreover, a vigorous opponent of monopolies, as well as the son of one of Liverpool's most successful merchants.[1] His combined interests made him eager to encourage instruction in industrial design, and on 14 July 1835, he moved:

> That a Select Committee be appointed to inquire into the best means of extending a knowledge of the Fine Arts, and of the Principles of Design among the people—especially the manufacturing population of the country; and also, to inquire into the constitution of the Royal Academy, and the effects produced by it.

In the discussion that followed, no one denied the need for such an inquiry, although several Conservative Members defended English taste and celebrated the achievements of private patronage. Perhaps the most significant observation came from John Bowring, the Radical Member for the Clyde Burghs, when he said that 'Art was in France more popular, in England more aristocratical.'[2] Fundamentally, Ewart and those who supported his motion were trying to effect a complete re-orientation of British art. They wanted what had been for centuries the pastime of the rich to become a familiar aspect of the daily lives of the people. It would take more than the select committee, appointed that day, to accomplish this change, but an appropriate beginning had been made. It was fitting, even necessary, that the initial step in the process should be prompted by industrial, not aesthetic, interests, for the working classes of the 1830s knew far more about factories than museums.

The Select Committee on Arts and Manufactures, Parliament's first extensive inquiry into the state of the arts in Great Britain, sat during 1835 and 1836 for two successive sessions, heard dozens of witnesses, and published voluminous minutes of evidence, covering matters as diverse as Jacquard looms and the National Gallery. In 1835, the committee consisted of forty-nine members, including Ewart as chairman, Hume, Peel, O'Connell, Roebuck, Warburton, Bulwer-Lytton, and Lord John Russell. The Radicals

[1] Bell, *Schools of Design*, p. 45; and W. A. Munford, *William Ewart, M.P. 1798–1869: Portrait of a Radical* (London: Grafton & Co., 1960), pp. 18–19, 66, 77. In addition to the Royal Academy, Ewart challenged the privileged position of the Bank of England and the East India Company.

[2] *Parliamentary Debates* (Commons), 3rd ser., 29 (14 July 1835): 553–62.

were conspicuously well represented, and a number of the members were associated with commercial or industrial interests. The committee focused its inquiries on the lack of instruction in industrial design available to British artisans, the resulting impact on British manufactures, and the need for more effective legal protection of original designs, patterns, and inventions.[1]

The evidence quoted in the interim report, published in September 1835, unanimously supported one basic contention: British workers had to be trained in the principles of design if their manufactured goods were to compete successfully in international and domestic markets. The statements of James Morrison, a member of the select committee who spoke as the head of a large commercial house in London, were echoed by nearly every other witness, artist as well as manufacturer. Morrison found British manufactures 'greatly inferior in the art of design' to work produced on the continent, and he attributed the superiority of foreign goods 'to the fact that on the continent they have public schools for teaching the art of design; that it has been part of their system to educate men as professors of the art of design as applied to the manufactures, and also as teachers; whereas in this country we have neither the one nor the other'. Greater familiarity with design was obligatory among British artisans, Morrison believed, 'because some branches of our manufacture really languish from the want of encouragement in the art of design'.[2] Other spokesmen for art, industry, or commerce heartily concurred, pointing also to expressions of the workers' sincere desire for art instruction,[3] and recognizing that both the manufacturers themselves and the public at large needed education in the principles of elegant design and good taste. Rarely did a witness appear who was not questioned about the quality of British taste: was it improving? How did it compare to the French? Would art instruction elevate it?

The intensity and frequency of these questions suggest that the

[1] One outcome of the inquiry was increased interest in the copyright protection of such commercial property. The Design Registry Office was established in 1839, and a Select Committee on Copyright of Designs sat in 1840.

[2] 'Report from the Select Committee on Arts and Manufactures', pp. 13, 14.

[3] The inhabitants of Foleshill, a community near Coventry engaged primarily in ribbon manufacture, in fact petitioned Parliament to assist them in founding a school of design connected with that trade. Ibid., p. 35.

committee members were trying to ascertain, not only the com-
mercial well-being of the nation, but also, in a vaguer sense, its
moral health. Although this theme tended to remain submerged
beneath the industrial purposes of the inquiry, it surfaced on
several occasions. When questioned, George Foggo, a minor
historical painter, expressed his opinion that a system of local art
schools would 'tend to a general improvement of the morals of
the people as well as of their intellect'. Philip Barnes, a Norwich
architect, was asked whether the establishment of schools of design,
attached to art galleries, 'would have the effect not only of im-
proving manufactures, but the moral and social conditions of
people'. 'Unquestionably', he replied, explaining that 'the lower
orders of society . . . would be very much improved in a very
short period of time.'[1] Even in what could have remained a purely
commercial and industrial investigation, morality and social im-
provement slipped into the discussion on the coat-tails of taste
and the arts. Throughout most of the century, the themes
remained inextricably linked.

Early in 1836, a smaller committee began further hearings,
particularly concerned with the more advanced levels of art
education. It was before this committee that the Royal Academy
came under detailed and largely hostile examination, with Haydon
gladly serving as the key witness against the institution.[2] The
committee's final report, published in August 1836, criticized the
lack of encouragement which the arts, in all their manifestations,
had received in Great Britain. 'Yet, to us, a peculiarly manufac-
turing nation', the report continued:

> the connexion between art and manufactures is most important;
> —and for this merely economical reason (were there no higher
> motive), it equally imports us to encourage art in its loftier
> attributes; since it is admitted that cultivation of the more
> exalted branches of design tends to advance the humblest
> pursuits of industry, while the connexion of art with manufac-
> ture has often developed the genius of the greatest masters of
> design.

[1] Ibid., pp. 51, 97.
[2] For Haydon's performance on that occasion, as well as his running feud
with the Royal Academy, see Quentin Bell, 'Haydon versus Shee', *Journal of
the Warburg and Courtauld Institutes* 22 (1959): 347–58. Martin Archer Shee
had by then become President of the Royal Academy.

In recommending the establishment of art schools in England, including a school to train art teachers, the report proposed that local schools be specifically related to local manufactures. It also carefully set forth the role which the committee members pre-scribed for the Government: 'The interposition of the Govern-ment should not extend to interference; it should aim at the development and extension of art; but it should neither control its action, nor force its cultivation.'[1] The wariness which Parliament had shown towards state involvement in popular education found some expression in the committee's attitude towards art instruc-tion, and there were strong reasons for its caution. In artistic matters, no Government thus far had shown any promise of administrative expertise or sympathetic insight. Jobbery made all state-supported programmes suspect during the early nineteenth century, and the arts seemed a particularly fertile field for favour-itism and corruption. The select committee urged action, but circumspectly.

The Melbourne ministry, however, had already decided upon action. In July 1836, without waiting for the publication of the final report, the Board of Trade and the Treasury had agreed to include a vote of £1,500 on the estimates for the coming year, in order to undertake the experiment of a school of design in London.[2] The grant secured, a committee was appointed to organize and establish the school. It first met in December 1836 at the Board of Trade, and, for the next fifteen years, the Board retained a direct control over the enterprise. Presumably, had the Committee of the Privy Council on Education existed at the time, it would have assumed responsibility for the school, but that is only conjecture. The fact that the Board of Trade supervised Great Britain's first venture into a programme of state-aided art education leaves no question about the Melbourne Cabinet's priorities.[3] After all, support for the Whigs came traditionally from mercantile, not artistic, interests.

[1] *Parliamentary Papers* (Commons), 'Report from the Select Committee on Arts and Manufactures', 1836, 9: iii–v.

[2] Bell, *Schools of Design*, pp. 60–1; 'The School of Design', *London and Westminster Review* 27 (July 1837): 118.

[3] Not that Great Britain was egregious in this respect. Colbert's interest in the arts, for example, in seventeenth-century France, had reflected com-mercial considerations.

The implementation committee did not afford the school a smooth commencement. In flagrant disregard of the final report's criticism of the Royal Academy, Charles Poulett Thomson, President of the Board of Trade, named only Academicians to represent the artistic profession on the committee. The rest of the members were parliamentarians, manufacturers, and art patrons. Haydon, understandably, was incensed. In January 1837, he wrote to Lord Melbourne that 'it is quite in opposition to the principles of your Government to throw a School of Design, meaned to be independent for the good of Art, into the hands of men notoriously so inimical to High Art as they have been proved . . . Poulett Thompson [*sic*] has been made a complete tool of'.[1] The *Spectator* took up the assault in the same month, attacking the Government with radical glee:

> The Fine Arts, under Government auspices, are furnishing very pretty illustrations of the foul arts of jobbing and corruption. The proposed school for teaching the art of design bids fair to exhibit the proficiency of its managers in designing arts . . .
>
> The apprehensions expressed by Mr. Haydon . . . that the School of Design will be rendered subservient to the Academy, seem to be but too well-founded . . .
>
> The conduct of the Government in this business is disgraceful: it is of a piece with that scandalous job the Mock National Gallery.[2]

George Foggo, the historical painter who had appeared before the 1835 committee, developed this criticism further in a small pamphlet published two years later. Addressing himself to the Right Honourable C. Poulett Thomson, he excoriated the Government's policy for the school:

> Without waiting for the report of the Committee [of 1836], the Chancellor of the Exchequer obtained from Parliament a grant of fifteen hundred pounds for the creation of a central

[1] Haydon, *Correspondence and Table-Talk*, 2: 233. In the same letter, p. 234, he told the Prime Minister: 'As a proof that the public are feeling the thing, Hansard has sold more of the "Report", than on any other subject, however political.' If Haydon can be trusted, that is an interesting sidelight on the extent to which the 1835–6 inquiry called public attention to the arts.

[2] 'The "School of Design" Job', *Spectator* 10 (28 January 1837): 90–1.

School of Design, and although the report, which has since been printed and published, convicts the Royal Academy of every quality that should deprive it of the confidence of the country . . . influence over the new schools, the Parliamentary Schools of Design is given to that secret, self-elect society. Thus, whilst every important measure for the promotion of the arts and manufactures is neglected, that alone which is doubtful or dangerous is carried out under a liberal President of the Board of Trade, assisted by convicted monopolists. . . .

Foggo concluded his pamphlet with the prophecy 'that Government *interference* will perpetuate our faults, and blight our hopes'.[1]

Undeterred, the Board of Trade went forward with its plans for the London school, which opened in June 1837 in the Somerset House rooms recently vacated by the Royal Academy. With some additional members, the committee—which had been meeting since December—officially became the governing council of the school, under the direction of the President and Vice-President of the Board of Trade.[2] John Buonarotti Papworth, an undistinguished architect, was named director, responsible for the daily supervision of the school, with a staff of four assistants. Fees of four shillings per week were charged for full-time students, but by the end of the year these had been reduced to four shillings a month.[3] The hostile reception of the new institution by the men whom it had been established to instruct may have helped to lower the charges. The *Mechanics' Magazine* published a scornful account of the School of Design in the very week it opened,

[1] *Results of the Parliamentary Inquiry Relative to Arts and Manufactures* (London: T. & W. Boone, 1837), pp. 3–4, 15. The *London and Westminster Review* joined in the protest against control of the new school by the Royal Academy, in an article summarizing the 1835–6 inquiry and its results, 27 (July 1837): 116–39.

[2] None of the critics of the Royal Academy were included on the school's council.

[3] Frank P. Brown, *South Kensington and its Art Training*, with a Foreword by Walter Crane (London: Longmans, Green & Co., 1912), p. 3. There was no programme of scholarships to lighten the burden of the fees for needy students, although small monetary awards of £1 to £5 were distributed as prizes for excellence in various categories of design.

In fairness to the Royal Academy, its critics might at least have pointed out that the Academy art schools were free, being subsidized by other of its enterprises.

observing how little the needs of the working man seemed to have figured in its organization. The article pointed to the 'rather aristocratic representatives of the manufacturing interests' who sat on the school's council, and it found the weekly charge of four shillings highly inappropriate for an establishment proposing to dispense art education cheaply to the working classes. The hours of attendance, furthermore, effectively excluded artisans who could not spare their daytime hours for instruction in design. So long as classes were held only 'from ten o'clock to four daily' and cost the artisan 'nearly *ten* guineas per annum', 'the "School of Design" will be *open to the labouring classes* in name alone', the article concluded.[1]

Clearly there was some confusion of purpose among the founding fathers. At the outset, the council ruled that the study of the human figure would not be taught and that instruction would be strictly limited to ornamental design applicable to manufactures. It intended that the school should form those skilled artist-artisans whose absence had been lamented repeatedly in front of the select committee. Yet it did little at first to attract workers to the premises. In fact, a considerable proportion of the students were not connected with a craft or industry at all, but were aspiring artists, a number of whom hoped to proceed from Somerset House to the Royal Academy schools. With the establishment of evening classes at the School of Design in August 1837, more craft apprentices began to enrol, but many still found the fees prohibitive and continued to seek instruction at Mechanics' Institutes.[2]

Even as the number of artisans at the School of Design increased, they were not always satisfied with the art courses offered to them. For years, pupils, staff members, the council, Government officials, and art critics argued over the school's curriculum, some demanding studies from life, others contending that these only lured students from their practical studies and encouraged distracting dreams of high artistic endeavour. The council ruled now one way, now the other, and, in most cases, their decisions

[1] 'The New School of Design', *Mechanics' Magazine* 27 (3 June 1837): 131.
[2] Stuart Macdonald, *The History and Philosophy of Art Education* (London: University of London Press, 1970), pp. 73–4. In addition to Bell's detailed study, Macdonald provides extensive information about the select committee of 1835–6 and the School of Design.

made little difference. The great majority of students who entered the school had no preliminary art training whatsoever. Advanced drawing was out of the question for them. What they needed was instruction in the most rudimentary principles, and the School of Design became more a centre for elementary art lessons than a source of creativity in industrial design.

Management difficulties also plagued the school, with the director, council, and Board of Trade involved in jurisdictional disputes similar to those that beset the National Gallery in its first decades. Successive British Governments seemed incapable of devising an efficient plan for arts administration, or even of learning from past blunders. William Dyce, a painter who had provided vigorous leadership for the school while serving as director from 1838, resigned in 1843 after endless squabbles with the council.[1] His successor, Charles Heath Wilson, author, art teacher, and mediocre artist, became involved in a professional quarrel with one of the teachers and provoked a student revolt in 1845. The resulting publicity revealed the pervasive mismanagement of the London school. In the House of Commons in July 1845, William Williams, the Radical Member for Coventry who had sat on the select committee of 1835, called attention to the disgrace. A merchant, he showed keen interest in the progress of the school, and he moved for a select committee to inquire into the cause of the revolt, as well as the general condition of the school. His motion was defeated in a debate characterized by profound disagreement over the school's relative success or failure.[2]

While there was no agreement on the school's accomplishments, nearly everyone had an opinion to express on the subject. Some voices spoke more authoritatively than others. When Augustus Welby Northmore Pugin, the eminent Gothic revival architect, designer, and art critic, condemned the school's achievements, his views were cited with respect in parliamentary debate.[3] He found that the school had totally failed to produce artists for crafts or manufactures, turning out instead, he asserted, 'mere imitators of any style', imbued with no true sense of design. Although the school had existed for nearly ten years, Pugin was

[1] Bell, *Schools of Design*, pp. 90–113.
[2] *Parliamentary Debates* (Commons), 3rd ser., 82 (28 July 1845): 1149–60.
[3] Ibid., 1152, 1156.

still 'actually driven to seek efficient assistance from the Flemish and German operatives' for his various projects.[1] *Punch* lampooned 'The School of Bad Designs,' lamenting that Pugin had to cross the seas in search of skilled decorators, and saving some choice barbs for Wilson's incompetence as director.[2] In September 1847, the *Athenaeum* announced:' The School of Design has been turned into a school for scandal.' It accused the school's managers of leading the institution far from its original aim to improve 'ornamental art, with regard especially to the staple manufactures of the country'. The school's pupils, the article alleged, were subjected to an impossibly exalted curriculum which set 'the sons of labouring men, mechanics, and such like', to copying 'Ghiberti's gates, or the best of Giulio Romano's or of the Mediaeval ornaments'.[3]

The school had ended by doing just what the council had sworn ten years earlier that it would not do. It was filling its students' minds with dreams of high artistic endeavour. The School of Design seemed fated to revolve in endless theoretical cycles, until Henry Cole interested himself in its affairs at the end of the 1840s. The story of how he engineered a parliamentary inquiry in 1849 and three years later transformed the school into the Department of Practical Art must be reserved for a subsequent chapter. Suffice it to say here that, until 1852, the School of Design remained a case history of what state intervention could not effect. Characterized by an almost total lack of system or consistent policy, vacillating between the claims of trade and of art, it offered little encouragement for the advocates of national support for the arts.

Parliament had, however, made some efforts towards the wider diffusion of art throughout Great Britain which the 1835–6 committee had urged. Within a few years of the founding of the London school, the House of Commons voted funds 'in aid of

[1] 'Mr. Pugin on Christian Art', *Builder, An Illustrated Weekly Magazine for the Architect, Engineer, Operative, and Artist* 3 (2 August 1845): 367.

[2] 'The School of Bad Designs', *Punch, or the London Charivari* 9 (1845): 70.

[3] 'The Government School of Design', *Athenaeum, Journal of English and Foreign Literature, Science, and the Fine Arts*, no. 1037 (11 September 1847), pp. 961–2. The press was by no means unanimously critical of the school. After an initial period of doubt, the *Art-Union* argued that the school could exert an important, beneficial influence on British taste and artistic skill. See, for example, 'The School of Design', *Art-Union* 2 (February 1840): 24.

local subscriptions for the establishment of Schools of Design in large towns'.[1] Even before the publication of the 1836 report, some provincial associations had petitioned Parliament for funds to assist in the establishment of local schools of design, and others soon followed suit. At first, the Board of Trade was not willing to undertake the further responsibility. As late as the 1840s, it did so only on the principle of matching local contributions for the schools. Treasury money was not forthcoming until the school committee in a specific area had guaranteed an annual local subscription for at least three years. Annual grants from the central council of the School of Design to the local branches usually amounted to £150 or £250, depending on particular needs, and, although the grant may seem insignificant, the Board of Trade deemed it sufficient to justify control from London. While local committees, composed of the area's manufacturers, Members of Parliament, and wealthy art patrons, managed the branch schools, their subjects, courses, and modes of instruction were set at the central London school, which also dispatched casts, models, prints, and constant advice. Consonant with the age that saw the development of the official inspector as a familiar bureaucratic figure, a provincial inspector was appointed to check on the branch schools' orthodoxy.[2]

By the time that the Select Committee on the School of Design sat in 1849, the national School of Design consisted of the central establishment, plus a separate school for women in London, together with fourteen branch schools in England and Scotland. These were located primarily in major industrial communities, including Manchester, Birmingham, Glasgow, Sheffield, Coventry, and Leeds.[3] Their individual histories reflect varying degrees

[1] *Parliamentary Debates* (Commons), 3rd ser., 59 (20 September 1841): 667–668.

[2] *Parliamentary Papers*, vol. 31 (1844) (*Reports from Commissioners, Inspectors, and Others*), 'Third Report of the Council of the School of Design, for the Year 1843–4', p. 27; and Bell, *Schools of Design*, pp. 100–26. The branch schools had far fewer gentlemen-artists in attendance than the central London school, although ladies' classes figured prominently in the provinces. There the male students were predominantly working-class, and in several towns during the grim 1840s, it was difficult for them to pay the monthly fee of two shillings, the usual charge at the provincial schools.

[3] *Parliamentary Papers* (Commons), 'Report from the Select Committee on the School of Design', 1849, 18: xviii. Three schools were also proposed for Ireland at the time.

of success, near bankruptcies, much straying from original purposes, and often waning interest on the part of the local communities. Still, by 1849, parliamentary grants to the schools exceeded £55,000 and 15,000 to 16,000 students had received some instruction through their facilities.[1] Pupils, ranging in age from nine to over twenty, and pursuing a variety of occupations, had studied aspects of art and design in their classrooms.[2] Cole might have been justified in telling the 1849 committee:

> I apprehend that the assumption in starting these schools was, that the benefit should be strictly commercial. I do not think these schools were created for aesthetic purposes . . . I apprehend that the age is so essentially commercial, that it hardly looks to promoting anything of this kind except for commercial purposes.[3]

Art instruction, no matter how elementary, had nonetheless reached a wider segment of society than ever before in Great Britain. Art, aesthetic or commercial, was a little more popular and a little less aristocratic as a result.

[iii]

In recommending measures to disseminate an interest in art throughout the country, the select committee of 1835–6 had not limited its suggestions to drawing schools. It had also found a widespread desire for free public art galleries and museums, and it urged the establishment of these institutions wherever possible. Countless witnesses testified to the need for art collections, accessible without charge to the working classes, not only to furnish models for industrial design, but also to raise the quality

[1] Ibid., pp. 424, 52.

[2] The 'Third Report of the Council', p. 51, contains a copy of the head school's prospectus for 1843–4. Branches of instruction included 'Instruction in the History, Principles, and Practice of Ornamental Design', 'Elementary Colouring', 'Drawing from Casts', 'Modelling', 'Shading', and 'Outline Drawing'. On p. 25, a classification of the students at the branch school, Spitalfields, showed fifty weavers of silk, satin, and velvet attending classes, nineteen each of wood carvers and cabinet makers, and small groups of many other craftsmen, including stone masons, house painters, plasterers, iron founders, and book binders.

[3] 'Report from the Select Committee on the School of Design', p. 286.

of British art and national taste.[1] Many of those questioned assured the committee that artisans were eager for the opportunity to use museums and libraries, if only these would remain open in the evening, after workday hours. Indeed, attendance figures at the two free museums in London clearly testified to a growing public interest. Between 1830 and 1835, the number of yearly visitors to the National Gallery more than doubled, jumping from 60,321 to 127,268. This was an extraordinary increase when one considers the miserably cramped building where the collection was housed at this time. By 1840, with the opening of new quarters, the figure had risen to 503,011.[2] In 1835, when the public could attend on only three days each week, the British Museum attracted over 230,000 visitors, a far cry from the 15,197 recorded in 1809.[3] The 1840 Report of the Royal Institution of Liverpool waxed enthusiastic over the public response to its free exhibition of 1839. The management's 'faith in the good feeling of the public, and in the aptitude of all minds—even the lowest—to receive refined and elevating impressions, has not disappointed them', it stated. The museum 'has been crowded, monthly, by the thousands', and, the report continued smugly, 'in opening these opportunities to the labouring classes, this institution cannot but feel that it occupies the place of a public benefactor and instructor, awakening in uncultivated minds feelings and ideas calculated to soften the rudeness of manners, and to increase the happiness and virtue of life'.[4] Like so many optimistic men and women of the mid-nineteenth century, the managers of the Liverpool Royal Institution espoused the belief that popular improvement in taste and discernment implicitly resulted in moral progress.

[1] Foggo dubbed museums 'the permanent and all-important sources of taste', and George Rennie, the sculptor, believed 'the standard of public taste would very soon be raised, by opening a museum in every town'. 'Report from the Select Committee on Arts and Manufactures', 1835, pp. 49, 70. See the article in the *London and Westminster Review* (July 1837), p. 137, for similar views advocating 'the opening of the public museums to the whole of the British public, without impediment or exception'.

[2] *Parliamentary Papers* (Commons), 'Report from the Select Committee on National Monuments and Works of Art', 1841, 6: 180.

[3] *Parliamentary Papers* (Commons), 'Report from the Select Committee appointed to inquire into the Condition, Management and Affairs of the British Museum', 1836, 10: 103; and Pye, *Patronage*, p. 239.

[4] Report, quoted in Edwards, *Administrative Economy*, p. 373.

The responsibility for establishing and maintaining museums clearly could not be left to private initiative. As Charles Toplis, a vice-president of the London Mechanics' Institution told the 1835 Select Committee on Arts and Manufactures: 'With regard to the museums, they, of course, must, if formed, be formed entirely by the Government, because to be useful they must be open. . . .' They must, that is to say, be open regularly and freely to the public, and by the 1830s it was recognized that state aid would be necessary to maintain, or at least to subsidize, such institutions on a broad basis throughout the country.[1] Support for parliamentary grants to museums came from an especially illustrious source when William Howley, Archbishop of Canterbury and a trustee of the British Museum, told the 1836 Select Committee on the British Museum that 'an expenditure of money in that way will be rather approved by the people than otherwise'.[2]

Professor Hobsbawm has argued that the period from the late 1830s until the 1870s was an exceedingly bleak time for the working classes, in terms of popular culture as well as social conditions. The older patterns of artisan culture were crumbling in the face of increasing industrial and urban pressures, and as yet such new forms as the music- and dance-halls had not fully emerged.[3] Admittedly, evidence concerning this question is limited. The available museum attendance figures offer no precise sociological breakdown, and the sociological implications of the expanding cultural opportunities remain an elusive problem. To speak with certainty about the kinds of people visiting museums in the early Victorian period is impossible. It is unlikely that the lowest segments of society swelled the attendance figures. Contemporaries themselves, however, spoke of working-class visitors, and the evidence suggests that the more skilled and educated strata of the working classes had begun to treat museums and galleries as forms of entertainment, as well as places of instruction, by the 1840s.

[1] Report, p. 118. In 1840, Edwards, *Administrative Economy*, p. 107, wrote: 'That it is only from the government we can expect any adequate provision of National Galleries of Art, co-extensive with the wants of the people, is an opinion in which all who have displayed any interest in the subject seem now to be fully agreed.'

[2] Report, p. 457.

[3] E. J. Hobsbawm, *The Age of Revolution 1789–1848* (New York: The New American Library, Inc., Mentor Books, 1962), pp. 324–5.

The Whig Governments of the 1830s did not ignore the findings of select committees nor the opinion of the First Primate. During that decade, a new building was erected for the National Gallery, and work continued on the new structure for the British Museum in Bloomsbury. Between 1821 and 1840, over £750,000 was spent from public funds for the upkeep, collections, and expansion of the British Museum, while grants for the construction of the new National Gallery exceeded £86,000.[1] The figures by themselves, however, tell nothing, except what the comparatively meagre amount for the National Gallery may suggest. From 1826 to 1840, parliamentary grants for the purchase of paintings amounted to just under £40,000, a ridiculously small sum for the requirements of a developing public art museum.[2] Official policy towards the fine arts was still miserly, and the treatment of the National Gallery reveals how little the Liberal ministries were motivated by artistic considerations.[3]

The new National Gallery arose from the dust of Charing Cross after years of dispute and delay. The fate of the building project was interwoven with the ambitions of the Royal Academy, with public concern over Government spending, and with the reputation of John Nash. Nash, George IV's favourite architect, was busy rebuilding large sections of London during the 1820s and had turned his attention to the area recently cleared at Charing Cross. He drew up plans which included, on the north side of the site, a new building for the national collection of paintings,[4] but by 1830 Parliament was no longer inclined to support Nash's grandiose schemes. Not only was he personally in disgrace on account of alleged speculation in Crown leases, but his plans were utterly contrary to the insistence on retrenchment that guided the

[1] 'Report from the Select Committee on National Monuments and Works of Art', pp. 175, 179. Hume told the House of Commons that the new National Gallery cost the public £100,000. *Parliamentary Debates* (Commons), 3rd ser., 43 (6 July 1838): 1308.

[2] 'Report from the Select Committee on National Monuments and Works of Art', p. 178.

[3] The blame by no means lies solely with the Liberals. The trustees of the National Gallery had been protesting to the Wellington Government since 1828 that the building in Pall Mall was inadequate for the national collection of paintings, but the Tories ignored the problem. Holmes and Collins Baker, *National Gallery*, p. 50. Peel's public enthusiasm for the project blossomed after the Tories left office late in 1830.

[4] Martin, 'National Gallery, III', pp. 124–8.

economic policies of both the Wellington and Grey administrations. The days when funds were lavishly allocated to refurbish royal palaces and to redesign city squares, at the taxpayers' expense, were over. The House of Commons, supported by angry public opinion, scrutinized public works projects critically, and a picture gallery was not considered a matter of national urgency. In the estimates presented to the Commons in the spring of 1831, the Grey ministry did not include funds to erect a National Gallery. It seemed as if the project had fallen victim to Government scruples over public expenditure. Nor were hopes for the gallery's new home encouraged by Parliament's preoccupation with the unfolding reform crisis.

The building plans were resuscitated when another architect, William Wilkins, devised new arrangements for the northern side of what became Trafalgar Square. He designed a building that promised to be all things to all people—a structure to house not only the National Gallery, but also the Royal Academy which wanted new accommodation, and the Public Records which urgently needed permanent housing. His plan was economical and seemed to solve a number of problems simultaneously. The trustees of the National Gallery agreed to accept Wilkins' proposal in September 1831, and they presented it to Lord Grey who was impressed by its practical aspects.[1] His ministry, however, was reluctant to proceed with plans to commence building, and it took a strong expression of parliamentary support for the measure to guarantee the Government's cooperation.

Members and friends of the Royal Academy proved a powerful lobby in this endeavour, but even more influential arguments were brought forward to persuade the M.P.s. Work at length began on the new National Gallery primarily because the House of Commons was convinced that art could serve a commercial and social purpose. The arguments for art's commercial benefits, voiced on 13 April 1832, when Peel called on the Government to appropriate funds for a museum building, have already been discussed. They provided the major points raised during that debate. Lord Ashley, better known as the Earl of Shaftesbury, saw other potential advantages, which reflected his untiring efforts to improve the conditions of the working classes. 'He considered that the erection of a gallery would be extremely beneficial for artists

[1] Ibid., IV, pp. 203–6.

and mechanics to resort to, and he had reason for believing that
it would be frequented by the industrious classes, instead of
resorting to ale-houses as at present.'[1] The fact that art treasures
deserved adequate housing for their own sake was never men-
tioned and, perhaps, would not have occurred to anyone at the
time. Lord Althorp, Chancellor of the Exchequer, accurately
expressed the opinion of a Government fully sympathetic to the
persistent clamour for economy. 'It was right and fit', he said,
'that a place should be provided for the reception of the pictures,
which would be convenient to the public, but he was not pre-
pared to go to any architectural expense for that purpose.'[2]

The House of Commons was prepared, in this instance, to put
pressure on the Grey ministry. Three months later, Thomas
Spring Rice, Secretary to the Treasury, moved 'for a grant of
£15,000 as the first instalment towards the expense of building a
National Gallery', and Lord Althorp explained that 'the sense of
the House had been so strongly expressed upon the subject, that
he thought the Ministers would not have done their duty if they
did not apply for the grant'.[3] Once again, parliamentary enthusi-
asm had influenced Government policy concerning the National
Gallery, and some of the thinking behind that enthusiasm may be
glimpsed in Peel's brief, but telling, speech on the occasion of
the Government's *volte-face*:

> In the present times of political excitement, the exacerbation of
> angry and unsocial feelings might be much softened by the
> effects which the fine arts had ever produced upon the minds of
> men. Of all expenditure, that like the present, was the most
> adequate to confer advantage on those classes which had but
> little leisure to enjoy the most refined species of pleasure. The
> rich might have their own pictures, but those who had to

[1] *Parliamentary Debates* (Commons), 3rd ser., 12 (13 April 1832): 469.

[2] Ibid., 468. Lady Elizabeth Eastlake, 'Memoir of Sir Charles Lock
Eastlake', in Sir Charles Lock Eastlake, *Contributions to the Literature of the
Fine Arts*, 2nd ser. (London: John Murray, 1870), p. 153, quoted a letter
written by her husband in the 1830s: 'Lord Althorp . . . sets his face against
the arts altogether, and said once that if he had his way he would sell the
National Gallery, and have nothing of the kind.' Eastlake, a painter, succeeded
Shee as President of the Royal Academy in 1850. After serving as keeper of
the National Gallery in the 1840s, he was named director in 1855. Lady
Eastlake was a noted art historian in her own right.

[3] *Parliamentary Debates* (Commons), 3rd ser., 14 (23 July 1832): 644, 646.

obtain their bread by their labour, could not hope for such an enjoyment . . . He therefore, trusted that the erection of the edifice would not only contribute to the cultivation of the arts, but also to the cementing of those bonds of union between the richer and the poorer orders of the State, which no man was more anxious to see joined in mutual intercourse and good understanding than he was.[1]

Following two years of political agitation for parliamentary reform, Peel's opinions doubtless found wide sympathy in the House, and the vote was approved. The outcome of the debate should not suggest that Parliament played the role of Maecenas, while the Grey ministry guarded the Treasury with a miserly eye. Parliament's treatment of art was miserly all too often, and Grey himself actually favoured Wilkins' plan. But his hand needed to be strengthened by a mandate from the House of Commons, and he took no action until that mandate was clear. The debate of 13 April 1832 revealed support from all parties for funds to build a new National Gallery, and the Government responded accordingly. Advocates of Wilkins' design were overjoyed. It did not matter to them that concerns far removed from the realm of art had, on this occasion, thrown the decision in their favour.

Work on the building did not go smoothly after July 1832, for Wilkins' plans did not please the parishioners of St. Martin's, where the new edifice was to be located. Protests were raised about interference with the view of the church, a parish meeting was organized, and the Government hastily looked around for an alternative site, or an existing building which could function as the national picture gallery.[2] Fortunately, contingency plans proved unnecessary. Despite several months of press debate over the inadequacies of Wilkins' design, the House of Commons stood behind it, and a majority of M.P.s. continued to urge the construction of the new National Gallery at Charing Cross. A few, however, were disappointed when the project was renewed

[1] Ibid., 645. The Government may have been all the more willing to pay some attention to the arts since the Reform Bill had finally passed through the House of Lords early in June, thereby averting the threatened constitutional crisis.

[2] *Parliamentary Debates* (Commons), 3rd ser., 20 (12 August 1833): 534; Edwards, *Administrative Economy*, pp. 122-3; and Martin, 'National Gallery, V', pp. 275-9.

in late August 1833. Cobbett, for one, 'objected to the whole population of the country being taxed to pay for the erection of metropolitan buildings'[1]—a criticism that would recur throughout the next century during debates on art. The following year, during discussion of a National Gallery vote in April, Edward Ruthven, the Liberal Member for Dublin, opposed the grant, stating that 'when their constituents were complaining of distress, it was not a time for such a lavish expenditure on works of art, however excellent they might be'.[2] The 'can't afford it now' attitude similarly found spokesmen whenever Parliament debated expenditure on the arts, and influenced the legislators' decisions, even as they voted funds to continue construction of the new museum.

The National Gallery in Trafalgar Square was opened to the public in April 1838 and at once proved a disappointment. The fact that the Government had allotted an entire wing of the building to the Royal Academy was the chief cause of criticism. The division of space not only seriously curtailed the gallery's room for growth, but also gave indisputable proof of the Academy's quasi-official status, a particularly sore point with its critics.[3] Thus, from the start, the new gallery was hampered by inadequate areas for expansion. 'The promised land . . . which comprised five rooms in a line . . . soon proved an illusion . . . Before three months were out complaints were received by Sir Robert Peel concerning the heat and foul atmosphere of the rooms.'[4]

Nor was the exterior of the building more impressive than the interior. Shortly after its opening, Thackeray described the

[1] *Parliamentary Debates* (Commons), 3rd ser., 20 (23 August 1833): 868.

[2] *Parliamentary Debates* (Commons), 3rd ser., 22 (14 April 1834): 745–6.

[3] Throughout the period of construction, and after, Members of Parliament, particularly Radicals, expressed concern over the decision to house the Academy in the National Gallery building. They asked why the Academy, as a result of its public accommodation, should not be more subject to parliamentary control, and why its exhibitions should not be open freely to the public one or two days a week. The admission fee to the Academy exhibition was one shilling, and the catalogue cost another. The Government always came to the Academy's defence, but promised that it would have to move from its new quarters should the National Gallery require those apartments.

[4] Holmes and Collins Baker, *National Gallery*, p. 53.

gallery as 'a little building like a gin-shop',[1] and W. B. Sarsfield Taylor, writing in 1841, regretted that the National Gallery should discredit British architectural skill, 'for want of a small share of liberal feeling in those who held the purse-strings of the nation'.[2] Ruthven had had his way, as it turned out, and no great expenditure had been lavished on the new building. As Peel subsequently explained: 'When the grant for the present National Gallery was made, there were so many claims on the public purse, that Parliament was not disposed to vote a large sum for the purpose.'[3] As for planning and internal organization, critics could find evidence of neither. There was no apparent effort to arrange the pictures in any semblance of historical order, or even to furnish an adequate catalogue.[4] Once again, the British Government had proved incompetent in administering the arts, and the *Spectator*'s scornful epithet, 'Mock National Gallery', seemed all too justified.[5]

Indifferent, perhaps, would be a more accurate word than incompetent to describe official Liberal policy towards the National Gallery. For the most part, the leading ministers did not see a pressing need for the state to support the fine arts. They were responsible for the shocking fact that the Government failed to purchase for the National Gallery Sir Thomas Lawrence's famous collection of drawings by Old Masters,[6] at the very moment that a parliamentary committee was recommending ways to extend 'a

[1] William Makepeace Thackeray, 'Strictures on Pictures', in *Critical Papers in Art* (London: Macmillan & Co., 1904), p. 4. The article first appeared in *Fraser's*, June 1838, under one of Thackeray's regular pseudonyms, Michael Angelo Titmarsh.

[2] *Present Condition of the Arts*, 2: 197.

[3] *Parliamentary Debates* (Commons), 3rd ser., 81 (27 June 1845): 1338.

[4] Edwards, *Administrative Economy*, pp. 120-1, 131; and Dyce, *National Gallery*, pp. 2, 14-15, 58-60.

[5] See above, p. 45, where the *Spectator* article, dated 28 January 1837, is quoted in the discussion of the London School of Design.

[6] Lawrence, who died in 1830, had provided in his will that they be offered first to the Government at a moderate price, but the Government was not interested. The Royal Academy tried to raise sufficient funds for the purchase and failed. After years of indecision, the Treasury offered to buy certain drawings at half their estimated price. The proprietors had no choice but to sell the drawings thereafter, gradually in small lots. Sir Robert Peel was one of the purchasers. Lady Eastlake, 'Memoir', pp. 151-6; Holmes and Collins Baker, *National Gallery*, pp. 9-10; and Taylor, *Present Condition of the Arts*, 2: 375-7.

knowledge of the Fine Arts, and of the Principles of Design among the people'. If art for the sake of commercial wealth merited Treasury support, art for any other purpose, as men like Melbourne and Althorp strongly believed, should still rely on private patronage. 'In this country', Coleridge wrote in 1831, 'there is no general reverence for the fine arts; and the sordid spirit of a money-amassing philosophy would meet any proposition for the fostering of art, in a genial and extended sense, with the commercial maxim—*Laissez faire*.'[1]

In his description of general British attitudes towards art, Coleridge was probably correct, although by the 1830s there would have been notable exceptions to the rule. For the statesman who said, 'God help the minister that meddles with art,' Coleridge's indictment was certainly applicable. According to Haydon, Lord Melbourne expressed his memorable opinion in a conversation with the painter on 24 September 1835, when Haydon, yet again, had urged a yearly grant of £2,000 'for the public encouragement of high art'. He told Haydon on several occasions that private patronage sufficed and that state interference in such matters as art was contrary to national tradition and policy.[2] Melbourne enjoyed teasing Haydon, bantering with him and often adopting attitudes designed to shock the zealous suppliant. Nevertheless, Melbourne's opposition to Government involvement in support of art was firmly rooted in his Whig allegiance to the principles of laissez faire. He was 'against the State taking on any task that was not a necessity; he did not look on historical painting as a necessity'.[3] Lord Althorp expressed similar suspicions of Government aid to the arts, and told Haydon bluntly that the 'Government did nothing for painting because it was not the practice'.[4] The record of Haydon's conversations may be

[1] *The Complete Works of Samuel Taylor Coleridge*, ed. W. G. T. Shedd, vol. 6: *Specimens of the Table Talk of the Late Samuel Taylor Coleridge* (New York: Harper & Bros., 1853), p. 358.

[2] Haydon, *Correspondence and Table-Talk*, 2: 357, 388–9.

[3] David Cecil, *Lord M. or the Later Life of Lord Melbourne* (London: Constable, 1954), p. 89. As a matter of practical policy, furthermore, Melbourne wanted no part of the professional rivalries that raged among artists, and his Government's consistent support of the Royal Academy meant perhaps nothing more than a desire to take the line of least resistance.

[4] Haydon, *Correspondence and Table-Talk*, 2: 384, conversation dated 25 November 1832. Althorp's own tastes inclined towards racing, hunt-

coloured by personal disappointments and professional frustrations, but, in any case, there can be no doubt that these were not the men to foster a sympathetic state policy for the fine arts in the 1830s.

Apart from the Grey and Melbourne ministries, however, there was a perceptibly broadening enthusiasm for art, not merely as the handmaiden of trade, nor as the appropriate content of galleries and museums, but as a valuable component of daily life. By the late 1830s, industrialists, financiers, and commercial magnates were replacing noble connoisseurs as the country's major art collectors, and the middle class was beginning to establish its own tastes and whimsies in matters of art. 'The patronage which had been almost exclusively the privilege of the nobility and higher gentry', Lady Eastlake wrote, 'was now shared (to be subsequently almost engrossed) by a wealthy and intelligent class, chiefly enriched by commerce and trade. . . .'[1]

But it was not only the wealthy middle class that showed increased appreciation of art and patronized the work of living artists.[2] In the late 1830s, art unions began to be established on the model of the German *Kunst-Vereine*, which brought art into the homes of a wider public than ever before. Operating on small contributions from members, these organizations were able to purchase paintings and sculpture priced from a few to a few hundred pounds, which were subsequently distributed to subscribers according to various means of selection. Although the different unions followed diverse schemes of management, their effect was the same: the British art-buying public, while still comparatively small, for the first time included people of limited means. The Art Union of London was established in 1837, with similar undertakings in cities throughout Great Britain.[3] Further proof of growing public interest in the arts came in 1839, with the launching of the *Art-Union*, the first major British periodical devoted entirely to the arts, which dominated the field of art

ing, prize-fighting, and farming, according to the *Dictionary of National Biography*.

[1] 'Memoir', p. 147.

[2] Many new collectors preferred not to compete with art dealers and cognoscenti in buying Old Masters. In any case, collections of Old Masters were growing increasingly more expensive to acquire.

[3] Edwards, a founder of the London Art Union, described the development of British art unions in *Administrative Economy*, pp. 243–8.

journals for the rest of the century.[1] Perhaps no figure speaks more eloquently of the spreading enjoyment of art than an item in the appendix of the interim report of the Select Committee on Arts and Manufactures: in a survey of classes offered at the London Mechanics' Institution, it was noted that 'there is also a class for the study and practice of Music, the Teachers of which are paid by the Class – – – No. of Members, 90'.[2]

If some people were implicitly beginning to esteem art as a necessary part of their social surroundings, at least one man in the 1830s determined to make explicit the relationship between art and society. In a welter of books, articles, designs, and drawings, A. W. N. Pugin hammered out his message to the British public: art, particularly architecture, is the measure of the society that creates it. In the Gothic architecture of the Middle Ages, he saw the inspirational reflection of a truly Christian people, and, with the zeal of a convert to Catholicism, he discovered the spirit of Protestantism in the mediocre productions of modern British architecture. Loss of faith meant loss of beauty; the people who had repudiated their old religion could only produce architectural monstrosities. Much in Pugin's writings savours of religious propaganda, but his fundamental conviction, that the moral state of society finds expression in its works of art, was addressed to a public regardless of creed. In *Contrasts*, published in 1836, Pugin used a series of detailed drawings, comparing mediaeval and modern buildings, to illustrate the theme of his text: the lack of veneration felt at present for both religion and art was mirrored in contemporary architecture and decoration.

Pugin's work found a receptive public. The Oxford Movement had brought religious values into the forefront of discussion. The Gothic revival in architecture made many readers familiar with his vocabulary, and ecclesiology was in the air. The burning of the old Houses of Parliament in 1834, and the competitions for designing and decorating the new buildings, aroused national controversy over the style of art appropriate for a great public

[1] Helene E. Roberts, 'British Art Periodicals of the Eighteenth and Nineteenth Centuries', *Victorian Periodicals Newsletter*, no. 9 (July 1970), p. 3. The *Art-Union* had no formal connection with the London Art Union, but shared its desire to stimulate popular enthusiasm for art. In 1849, its name was changed to the *Art-Journal*.

[2] Report, 1835, p. 140.

structure. Pugin connected art and society in a living bond of reciprocal influence. He sought to demonstrate that art was not a refinement to be imposed on the surface of society, but a manifestation of the very spirit of that society. These theories, blending ethical, social, and artistic themes, spoke persuasively to Pugin's times.

Elements of Pugin's gospel were already familiar. Belief in the social benefits of religion had spurred Parliament in 1818 to grant a million pounds for building churches as bulwarks against godless Jacobinism. Hope for the social utility of art had helped convince Parliament to build a new National Gallery. The interrelationship between art and religion had been recognized from the dawn of civilization. But Pugin was saying more than all this. He was arguing for a sophisticated integration of ethics and aesthetics, and was working out a theory of art criticism that inextricably linked both concerns together as instruments of social renovation. His teachings, later embodied in the more famous, wide-ranging work of John Ruskin and William Morris, coloured the British view of art for the rest of the century. His work turned art from a matter of 'dead decorative forms to that of underlying principles of social order'.[1] For at least several decades, it helped to cement art to morality.

[1] Kenneth Clark, *The Gothic Revival: An Essay in the History of Taste* (London: Constable, 1928), p. 288. Among the many writers on these themes, see Raymond Williams, *Culture and Society*, chapter VII, 'Art and Society', about Pugin, Ruskin, and Morris.

The Royal Commission and the Radical Offensive

[i]

The concerns and anxieties of the 1830s intensified in the following decade, when economic conditions exacerbated social and political tensions. Chartist disturbances and threats of insurrection, mass public gatherings and angry torchlit meetings convinced many observers that Britain would explode in revolution before the end of the decade. Parliament responded to the atmosphere of crisis with varied measures. It is ironic that the decade that finally witnessed the repeal of the Corn Laws, an act hailed as the triumph of laissez faire, also marked the extension of state interference. In Lord Ashley's mines and factory legislation, the Minute of 1846 expanding the powers of the Committee on Education, the Public Health Act of 1848, and numerous other acts concerning sewers, gasworks, cemeteries, and police, Parliament broadened its sphere of jurisdiction. In 1843, it turned once again to religion in the hope of relieving social unrest, and passed Peel's measure to create ecclesiastical districts in densely populated areas. At such a time, the interest which the ruling classes had previously shown in art as an instrument of education and moral improvement for the people was bound to increase.

The major artistic project with which successive ministries were concerned in this decade arose initially out of necessity. The Old Palace of Westminster was destroyed by fire in October 1834, and both Houses of Parliament needed new quarters. What was extraordinary, however, was the amount of time and effort taken to plan the interior decoration of the new structure. This was no routine public works project, or monetary grant for art stored away in museums. From the Gothic pinnacles down to the ornamental pavement of the corridors, the Government, through the Royal Commission on the Fine Arts, committed itself to an ex-

tensive programme of public patronage for artists in nearly every branch of the decorative arts. Nothing comparable had ever occurred, nor has Britain seen anything quite like it since. The Commissioners conscientiously sought to use the opportunity that accident afforded to raise the quality of British art, and, even more conscientiously, to uplift public taste. They hoped, in the grandiose scheme of decoration for the Houses of Parliament, to apply art to the betterment of the British people. Art assumed a place in the forefront of public discussion, as competitions, exhibitions, numerous reports, and the ongoing, but slow, progress of the building helped to make art a prominent news item for more than two decades. At first, the vast project was hailed as the dawn of a new age for British art. It ended, like most of the British Government's previous activities on behalf of the arts, in frustration and disarray.

The decision to build the New Palace at Westminster in the Gothic style, and the selection of Charles Barry's design for the structure, provided the initial arena for controversy in the 1830s. The dispute, however, remained essentially architectural until the time came to consider the building's interior decoration. This task fell first to the Select Committee on Fine Arts, appointed by the House of Commons in 1841 to serve as a clearing house for the ideas and suggestions proffered during the preceding six years. As early as July 1835, when he appeared as witness before the Select Committee on Arts and Manufactures, Dr. Gustav Waagen, director of the Royal Gallery at Berlin, had said that 'the construction of the new Houses of Parliament would afford an honourable opportunity' for employing painters on public works, and, consequently, for promoting historical painting in England. He even suggested that frescoes might be attempted in the project.[1] Earlier, in March 1835, Haydon had presented his inevitable petition to the Building Committee of the new Houses of Parliament, 'praying that spaces be left in the new building for the decoration of the Houses by painting, and urging the Committee to consider the vast benefits that may accrue to the arts and manufactures of this country if the opportunity be seized for the public encouragement of historical painting'.[2] The appeal was echoed in various journals and reviews, including the newly

[1] 'Report from the Select Committee on Arts and Manufactures', 1835, p. 9.
[2] Haydon, *Correspondence and Table-Talk*, 2: 220.

founded *Art-Union* which lost no chance to criticize official 'coldness' towards the arts and to recommend employment of historical painters in decorating the Houses of Parliament.[1] In May 1840, Ewart took advantage of a vote on supply for the new Houses to express his hope that the money 'would not be expended upon the exterior architecture only, but would be partially expended in works of sculpture and painting for the interior of the building also'.[2]

By 1841, the Melbourne ministry recognized that the building had progressed far enough to necessitate plans for its interior decoration. In February, Henry Labouchere, President of the Board of Trade, requested a small grant for experiments in fresco painting.[3] The House of Commons responded by appointing a select committee 'to take into consideration the Promotion of the Fine Arts of this Country, in connexion with the Rebuilding of the New Houses of Parliament'.[4] Over half of the fifteen members, including Benjamin Hawes, the Radical chairman, and Ewart, Hume, Peel, and Thomas Wyse, the Radical Member for Waterford City,[5] were veterans of the Select Committee on Arts and Manufactures. Labouchere was also a member, as was Henry Thomas Hope, the Conservative M.P. for Gloucester, to whom Disraeli dedicated *Coningsby*.[6] It is clear, not only from the committee's membership, but also from the many references in its report to the Schools of Design and the impact of art on industry, that the committee was an outgrowth of the 1830s. The interest which art had aroused among expanding circles of society in that decade, and the awareness of its increasing importance in national

[1] See, for example, 'Encouragement of Art', *Art-Union* 2 (August and October 1840): 123, 156.

[2] *Parliamentary Debates* (Commons), 3rd ser., 53 (4 May 1840): 1187.

[3] Lady Eastlake, 'Memoir', p. 166. Evidently, the Board of Trade, with its control of the Schools of Design, had a monopoly on artistic initiative in the Government.

[4] *Parliamentary Papers* (Commons), 'Report from the Select Committee on Fine Arts', 1841, 6: ii.

[5] Thomas Wyse was an Irish Catholic of learning and culture. Until agitation for Catholic emancipation opened a possible political career for him, Wyse travelled in Italy and the Near East, settling in Italy in 1821, where he married the daughter of Prince Lucien Bonaparte, Napoleon's brother. He returned to Ireland in 1825, and was first returned to Parliament in 1830. *Dictionary of National Biography*.

[6] Hope was the son of Thomas Hope, the noted art collector.

culture as well as commerce, created a favourable atmosphere for the deliberations of the Select Committee on Fine Arts.

The committee's report, published in June 1841, reflected the preoccupations of the previous decade. But it equally stressed the needs of the present and future. To one witness after another, the committee members posed the questions: 'Do you expect that the arts would be very much improved in this country, if the new Houses of Parliament were to be decorated by painting and sculpture?' and 'Do you think that the introduction of fresco painting would have a beneficial effect on the character of national art?'[1] The witnesses, such as Sir Martin Archer Shee, Charles Barry, Charles Eastlake, William Dyce, and Bellenden Ker, the well-known art patron, all answered affirmatively. The opportunity had to be seized to foster the high arts, languishing from public and private neglect. Towards the conclusion of the report, the committee approvingly quoted Sir Martin Archer Shee's estimate of the situation: ' "It is the only opportunity that has occurred for many years, and if it be suffered to pass unheeded, I should say that there is no hope in this country for Artists in the higher departments of the Arts." ' As Barry observed, nothing was so calculated to direct public attention to the arts as adorning great public buildings with paintings and sculpture.[2]

The select committee's recommendations laid the basis for the subsequent development of the interior decoration of the Houses of Parliament. It proposed the appointment of a Royal Commission to assist the Government in formulating a plan, and asserted that all branches of art—not just the higher—merited encouragement in 'so eminently national a building'. In particular, it recommended the use of fresco as especially suited to the decoration of public buildings, and it selected British history as the most appropriate subject for representation, by painting or sculpture, in the new Houses of Parliament.[3]

In the 1840s, historical painting was still widely considered the loftiest form of painting, and in their desire to promote that barely existing school of British art, the select committee members were at one with their times, an age 'obsessed by the ambition for

[1] See pp. 25, 26, 29, 30, 38, 47, 50 of the report, for examples of these questions, with only slightly varied phrasing.

[2] Ibid., pp. x, 7, 9, 20.

[3] Ibid., pp. iii–iv, x.

High Art'.[1] Fresco, recently revived in Germany by the Nazarene painters, recalled all the glories of Renaissance art, and the select committee was not unduly concerned by the fact that hardly an artist in Great Britain was familiar with the technique. A little practice, they were certain, could remedy that defect, and further-more Thomas Wyse assured them that Peter von Cornelius, the famous Nazarene painter, with whom Wyse had talked in Ger-many in 1839, possessed full confidence in the skill of British artists. According to Wyse, Cornelius described the new Houses of Parliament as the invaluable occasion for 'founding a school of fresco painting, which would emulate if not surpass that of any other in Europe'.[2] Nor did the incongruity of neo-Raphaelesque frescoes decorating a Gothic structure seem to cause the com-mittee any anxiety.[3] Its members were called upon to promote the fine arts, and none were so important to promote as the loftiest forms, not only for the sake of artists, but also, they believed, for the sake of 'the People' on whose character art supposedly exerted a beneficial, elevating, and moral influence.[4] Sir Martin Archer Shee expressed the thinking implicit in their conviction when he testified

> that the object of the Committee is, not so much to forward the arts themselves, as through their influence to advance the great end, towards which the promotion of the fine arts can be con-sidered but as a means, the civilization of our people; to give to their minds a direction which may tend to withdraw them from habits of gross and sensual indulgence; to secure and sustain the intellectual supremacy of our country, not only with respect to the present age, but with reference to posterity. . . .[5]

[1] A. Paul Oppé, 'Art', in *Early Victorian England*, 2: 154. There are in-numerable books dealing with Victorian taste. Among others, see Ames, *Prince Albert*; Nikolaus Pevsner, *High Victorian Design, A Study of the Exhi-bits of 1851* (London: Architectural Press, 1951); and John Steegman, *Victorian Taste: A Study of the Arts and Architecture from 1830 to 1870*, with a Foreword by Sir Nikolaus Pevsner (London: Thomas Nelson, 1970). This book was first published in 1950 as *Consort of Taste 1830–1870*.

[2] Report, pp. iv, 67. Cornelius himself inspected plans for the new Houses of Parliament during a brief stay in London, November 1841, and provided information about fresco painting.

[3] Steegman, *Victorian Taste*, p. 133. [4] Report, pp. v–vi.

[5] Ibid., p. 18. Edwards more explicitly linked art to the social and political anxiety of the time, in *Administrative Economy*, pp. 187, 193. 'At the very

The general election of July 1841 brought the Conservatives back to power. As Prime Minister, Peel appointed the Royal Commission on the Fine Arts which the select committee of 1841 had recommended to preside over the decoration of the Houses of Parliament. The Commission was formally nominated in November, with Prince Albert assuming the post of chairman. Whether Peel nominated the young prince consort in order to divert him from more weighty matters, or whether Peel already had reason to value his industry and abilities, is less important than the fact that for the rest of his life Prince Albert devoted great time and attention to the Commission, and by his presidency lent a grandeur and dignity to its proceedings. In Albert, the German tradition of princely patronage and artistic enterprise came to Great Britain, where he had to learn to adapt it to the parliamentary system, to a watchful and often critical press, and to the cumbersome machinery of Royal Commissions.[1] Charles Eastlake, recognized by then as a leading authority on art history, was named secretary to the Commission, the sole professional artist connected with that body. The Commissioners represented a mixture of illustrious lords and interested M.P.s of varied political affiliations, trustees of the British Museum and National Gallery, art collectors, and members of the council of the School of Design. Several names from the Select Committee on Fine Arts reappeared, including those of Peel, Sir Robert Inglis, Lord Francis Egerton, Benjamin Hawes, and Thomas Wyse. Lords Melbourne and Palmerston were appointed, as were Lord Lansdowne, Lord John Russell, the Duke of Sutherland, Lord Lyndhurst, and Sir James Graham, the Home Secretary in Peel's Cabinet. Together they formed an impressive phalanx of private art patrons, connoisseurs, and enthusiasts. It remained to be seen whether they could transfer their interest to the very different demands of public patronage.[2]

time when the sad forebodings of a renewed combination between discontent and ignorance are already rife in our land,' he argued, 'the highest *political* interest of England demands the employment of the arts for public and national purposes. . . .' He called the arts 'direct and efficient co-agents in attaining the worthiest objects of good government—RELIGION—CIVILIZATION—SOCIAL ORDER. . . .'

[1] Albert's activities with the Society of Arts in the 1840s will be discussed in the following chapter, as they led directly to his work for the Great Exhibition of 1851.

[2] Charles Barry was not included among the Commissioners, an omission

Despite its sweeping title, the Royal Commission on the Fine Arts had only one specific charge: 'to inquire into the mode in which, by means of the interior decoration of . . . said Palace at Westminster, the Fine Arts of this country can be most effectually encouraged'.[1] By the time the Commissioners issued their first report in April 1842, they had decided that fresco painting was indeed the mode best calculated to encourage the fine arts, and they had determined on a competition of fresco cartoons, as the first step in preparing British artists for work in that medium. In announcing the competition, the Commissioners stipulated that the cartoon subjects be drawn either from British history, or from the works of Spenser, Shakespeare, or Milton. Eleven premiums, altogether amounting to £2,000, would be distributed as prizes to the most promising competitors. The competition was confined to British artists, or foreign artists who had lived in Great Britain for at least ten years. This was, after all, an enterprise to encourage British art.

In addition to inaugurating the system of competitions, in their first report the Commissioners indulged in abstract observations on 'the connexion between the arts and national culture and character'. With echoes of Pugin, they asserted that 'the formative arts must always express the manners, the general taste, and, to a certain extent, the intellectual habits of the nation in which they are cultivated. . . .' They insisted that the demand for high, moral art existed in Britain, but could find little expression while state patronage was withheld. Private support could not alone suffice: 'the service of religion or the protection of the state [was] indispensable, at the outset at least, for the full practical development of the highest style of painting'. Thus state aid was necessary to give expression to the 'national taste' for the higher branches of art.[2] The existence of such a taste was, most likely, a figment of the Commissioners' collective imagination, inspired by their zeal to elevate the quality of national culture. What matters most is that an official document in 1842 devoted nine pages to these

that caused no slight coolness between them and the architect. Macaulay was added to the Commission in 1844.

[1] *Parliamentary Papers*, vol. 25 (1842) (*Reports from Commissioners, Inspectors, and Others*), 'Report of the Commissioners on the Fine Arts', p. 4.

[2] 'Report of the Commissioners', pp. 7–8, 48, 10–11.

considerations, totally apart from commercial or industrial interests.[1]

The fresco cartoons were submitted in competition by the beginning of June 1843, judged, and opened to public exhibition in Westminster Hall during the first week of July. Public interest had been growing during the year since the competition was announced, and people were eager to view the first fruits of the unprecedented project. Months earlier, in December 1842, *Blackwood's* had reported that 'there never has been a period in this country when the arts have excited such general interest. Everywhere, in every society, they are a topic of conversation'.[2] Some of the excitement shared by artists and their friends, as well as the general public, found expression in Thomas Wyse's speech to a meeting of artists, held in the same month at the Freemasons' Tavern in London:

> The decoration of the Houses of Parliament . . . will do more, I am thoroughly convinced, to effect the two great improvements we all have at heart, to elevate and diffuse art, than any scheme yet attempted in this country. Let the feeling and love of art which such a work is calculated to produce once penetrate the mind of the country, and we shall not want places and opportunities for its amplest display. Other buildings will follow the Houses, other public bodies will not be less liberal than the legislature. It is thus art gets . . . into the eyes and hearts of a people. I trust the time is fast approaching when, instead of being a luxury, it will be considered a necessary, the enjoyment of which will be as natural to man as his breathing; as essential to the full sustainment of his intellectual and moral health as wholesome bodily food to his physical.[3]

Public response to the exhibition of the cartoons was enormous. Thousands of visitors viewed the life-size drawings daily during

[1] The observations are contained in the second appendix to the report, 'The General Object of the Commission Considered in Relation to the State and Prospects of the English School of Painting', pp. 9–17.

[2] 'Sir Joshua Reynolds's Discourses. With Notes by John Burnet, F.R.S.', *Blackwood's Edinburgh Magazine* 52 (December 1842): 767. *The Wellesley Index to Victorian Periodicals*, vol. 1, attributes the article to John Eagles, artist, author, and frequent contributor to *Blackwood's*.

[3] Quoted in Pye, *Patronage*, p. 183.

the two months that they were on display.[1] For the first two weeks, an admission fee of one shilling was charged, but thereafter the public was admitted gratis, except on Saturdays when the shilling charge was reinstated.[2] A sixpenny catalogue was prepared, which Eastlake abridged 'to a penny size for the million'. Yet the million had other ideas. ' "Many of the most wretchedly dressed people prefer the sixpenny one with the quotations, and it is a very gratifying sight to witness the attention and earnestness with which they follow the subjects with the books in their hands." '[3] Over 140 cartoons were entered in the competition, from which eleven were initially selected for awards, three premiums of £300 each, three of £200, and five of £100.[4] The judges were Peel, Lord Lansdowne, art patron and Whig leader, and Samuel Rogers, poet and art connoisseur, in addition to three British artists. They awarded prizes to artists whose historical scenes bore such unprepossessing titles as 'Caractacus led in Triumph through the Streets of Rome', 'First Trial by Jury', and 'The Cardinal Bourchier urging the Dowager Queen of Edward IV. to give up from Sanctuary the Duke of York'.[5] *Punch*, as one might expect, delighted in mocking these pomposities. As late as 1847, it commemorated yet another exhibition in Westminster Hall with its own splendid version of 'Charles II in the Oak'.[6]

The competitions did, indeed, drag on for years. Fearing to reach a decision prematurely, the Royal Commission hesitated to commit itself to any scheme of decoration, or any group of artists to execute it. In their second report, the Commissioners invited

[1] Lady Eastlake, 'Memoir', p. 174.

[2] *Parliamentary Papers*, vol. 29 (1843) (*Reports from Commissioners, Inspectors, and Others*), 'Second Report of the Commissioners on the Fine Arts', p. 67.

[3] Lady Eastlake, 'Memoir', p. 173. Lady Eastlake quoted from a letter written by her husband, on 22 July 1843, to an unspecified correspondent. The 'quotations' mentioned refer to citations from Milton, Shakespeare, or Spenser, appropriate to the various cartoons. Ames, *Prince Albert*, p. 52, describes this catalogue as 'an early appearance of the skill at popularization' which characterized Prince Albert's efforts for the arts.

[4] After door receipts proved highly profitable during the first fortnight, the Commissioners, with the approval of the Lords of the Treasury, decided to award ten more prizes of £100 each to meritorious artists in the competition. Second Report, p. 67.

[5] Ibid., p. 66.

[6] 'High Art in Westminster Hall', *Punch* 12 (1847): 267.

artists to submit portable specimens of actual fresco painting, to be exhibited in 1844. Sculptors in bronze and marble were also invited to compete, as were artists in wood carving, glass staining, arabesque painting, heraldic decoration, and ornamental metal-work and pavements. Having viewed the results of these competi-tions, the Commissioners ventured in their third report to nomi-nate six artists, including William Dyce and Daniel Maclise, from whom they proposed to solicit further designs, coloured sketches, and specimens of fresco paintings, as tests of their ability to execute works for the House of Lords. But, even in taking this step, the Commissioners proceeded with extreme caution, ex-plicitly declaring themselves in no way obligated to employ these artists ultimately, if their official choice fell elsewhere.[1]

All the premiums awarded in the past few years meant nothing in terms of eventual employment. There was no process of elimination, no narrowing of the field of candidates. Even while they announced the names of the chosen six, the Commissioners offered subjects 'for general competition, to give other artists the chance to offer specimens in cartoon-drawing and fresco-painting'. They seemed to have made little progress in three years, and the whole endeavour began to look like an interminable exercise in futility. Similarly with sculptors and other decorative artists, the Commissioners would merely name individuals or firms whose work they thought merited commendation. They hastened to explain that their selection in no way implied the exclusion of other contenders for patronage.[2] Whether the Commissioners were afraid to arouse enmities among artists and to offend any competitors by a final choice, or whether they were not yet fully satisfied with the skill exhibited by the artists, they scarcely helped the profession they sought to promote. Artists wasted valuable time, and often went to considerable expense to produce works for competition, only to learn that the Commissioners wanted further proofs of excellence before reaching conclusive decisions. Exhibition succeeded exhibition—of fresco samples, cartoons, sketches, sculpture, various examples of decorative art, and finally oil painting.

If the Royal Commission knew what it was looking for, few

[1] *Parliamentary Papers*, vol. 31 (1844) (*Reports from Commissioners, Inspectors, and Others*), 'Third Report of the Commissioners on the Fine Arts', pp. 7, 9.
[2] Ibid., pp. 7, 11, 19–20.

others did. Pugin's famous remark that, unlike Barry, he could not have developed the overall plan of the new building, for 'the Fine Arts Commission would have been too much for [him]', has been widely quoted.[1] Many other artists must have shared his sentiments. Henry Hallam, the historian and Royal Commissioner, unwittingly suggested one source of the Commission's difficulties when he wrote in an appendix to the third report:

> I must confess that by the encouragement of the fine arts, as expressed in the terms of our Commission, I never understood the giving employment to particular individuals, but the elevation of the national character by the development of powers which, in ordinary circumstances, could not be adequately displayed.[2]

In setting their sights so high above particular individuals, the Commissioners overlooked the essential human ingredient in any programme to encourage the arts. Eastlake, too, had some theoretical observations to make in a subsequent appendix dealing with the question of suitable topics for pictorial or sculptural representation in the Houses of Parliament:

> The history of the Fine Arts employed as in this case, shows that it has always been considered desirable to connect a patriotic or moral object with that of mere decoration. The condition of a pleasing effect on the eye is to be considered indispensable, but the artist has, in the most approved examples, combined this with a higher gratification . . . Excellence is supposed to be required, and the perfection of painting consists in more than a momentary appeal to the eye.[3]

The Royal Commissioners were nothing if not earnest in their efforts to raise the national character through art. But they set themselves incapacitatingly vast and vague aims, and whether British art profited from their noble purpose is open to question.

[1] See, for example, A. E. Richardson, 'Architecture', in *Early Victorian England*, 2: 215. Pugin's official role in connection with the new Houses of Parliament was to superintend the wood carving, but the position fails to suggest the tremendous extent of Pugin's influence on the decoration of the building. He seems to have had a far greater role in designing both its interior and exterior than Barry liked fully to acknowledge.

[2] Third Report, p. 29.

[3] Ibid., p. 35.

Meanwhile, certain peers of the realm did not appreciate the Commission's long labours and were growing impatient in their temporary quarters. While room had been made for the Commons in the old House of Lords, the Lords were meeting in the Painted Chamber. Lord Brougham, in particular, objected to this arrangement, and, in May 1844, he exploded angrily at the entire building scheme. He called the Gothic design 'an eye-sore to everybody of taste', and had even harsher words for the planned fresco decorations. He defied the Commissioners 'suddenly to call into existence such a number of paintings, without getting trash of the most hideous description. To cause men to paint by the square acre [was] not the way to encourage the arts. He greatly doubted whether fresco paintings were adapted to our climate at all. . . .' Finally, he accused Barry of endless procrastination in readying the new House of Lords for occupancy.[1] In August, Lord Campbell urged the Lords to take steps 'in order to prevent their being longer condemned to the hole in which they at present transacted their business', and Lord Monteagle blamed the elaborate decorative scheme for the delay:

He was strongly opposed to all lavish decoration, especially if such decoration would interfere with the erection of the building itself. Now, there were schemes on foot, he understood, for applying to all parts of the new Houses of Parliament all sorts of heraldic ornaments, frescoes, and gildings. Even the Committee-rooms were to be decorated in this way; and he must say that anything in worse taste or less suited to the simple habits of the English, he could scarcely conceive possible. If they misapplied ornament, they must also misapply time and money, and he protested against going to such expense in works of this sort.

Lord Wharncliffe observed that he 'hoped they would not be obliged to wait until British artists were taught to paint frescoes. If they were, he feared they would have to wait some time.'[2]

Brougham renewed his complaints and criticisms the following

[1] *Parliamentary Debates* (Lords), 3rd ser., 74 (17 May 1844): 1247–8.

[2] *Parliamentary Debates* (Lords), 3rd ser., 76 (9 August 1844): 1954–5. Thomas Spring Rice was created Baron Monteagle in 1839. As a trustee of the National Gallery and a firm supporter of the London Art Union, his participation in the discussion is surprising.

year, furious that 'their Lordships were to be detained until the new Houses could be adorned', and the Marquess of Clanricarde concurred that 'the Fine Arts ought to be made subservient to their Lordships, instead of their accommodation being made subservient to the Fine Arts'.[1] There spoke a representative of the old-fashioned view of patronage if ever there was one. Brougham's exasperation prompted *Punch* to hint darkly that 'the building now in course of erection, ostensibly for the accommodation of the Lords and Commons', was, in fact, designated to become a picture gallery—solely for portraits of Prince Albert.[2]

Barry's new House of Lords was finally ready for occupation in 1847. The House of Commons took an additional five years, reaching completion nearly two decades after the Old Palace was destroyed. Yet still the interior decoration remained unfinished. The Royal Commission at last named several artists to begin work on frescoes in the new buildings, among them Charles West Cope, William Dyce, and Daniel Maclise, but as late as 1860, Dyce still had not completed his frescoes for the Queen's Robing Room.[3] More serious was the fact that a number of the completed frescoes soon began to show unmistakable signs of decay—mildew and blistering, followed in some cases by disintegration. Whether fresco was indeed unsuited to the London climate, as Lord Brougham asserted, or whether the technique of fresco painting had been incorrectly applied, the medium had to be abandoned. Some of the most famous paintings in the Houses of Parliament were executed in water-glass, a method combining watercolour with a silica surface. Maclise's *Meeting of Wellington and Blücher after Waterloo* and *Death of Nelson*, both in the Royal Gallery, were painted in water-glass, and were only completed in the 1860s, after Prince Albert had died and the labours of the Royal Commissioners had come to an end. Their high purpose had resulted in confusion, waste, and considerable failure. While the competitions and exhibitions attracted widespread attention to

[1] *Parliamentary Debates* (Lords), 3rd ser., 81 (9 June 1845): 206, 208.

[2] 'The Houseless Lords', *Punch* 9 (1845): 11.

[3] *Parliamentary Debates* (Commons), 3rd ser., 160 (3 August 1860): 676–7. Dyce complained that the Arthurian subjects he was depicting had 'a great quantity of chain mail' which required much time and effort to paint. T. S. R. Boase, 'The Decoration of the New Palace of Westminster, 1841–1863', *Journal of the Warburg and Courtauld Institutes* 17 (1954): 351. Boase's article deals in great detail with the history of the Royal Commission.

the arts, the long delays and conspicuous blunders had done nothing to improve the image of official programmes for the arts. If the rebuilding of the Houses of Parliament provided a focus for the expanding public awareness of the importance of the fine arts in national life, the experience was short-lived. The Great Exhibition of 1851 soon captured public interest, and appreciation of the arts once again became entangled in industrial and commercial displays. High art, which the Royal Commissioners had sought to nurture, found no comfortable resting place in the Crystal Palace.

[ii]

While the Commissioners pondered, examined, and hesitated, others worked to extend the audience for the arts in less dramatic, but ultimately more effective ways. Throughout the 1840s, several Members of Parliament persistently introduced or supported petitions, motions, and bills aimed to bring the arts more readily to diverse social groups. Three men were particularly active in this endeavour: the Radicals Joseph Hume, William Ewart, and Thomas Wyse, who accomplished far more on the floor of the House of Commons than in the deliberations of the Royal Commission. All served on the 1841 Select Committee on Fine Arts and, together or separately, on numerous other committees related to the arts during the rest of the decade. Ewart and Wyse were deeply committed to the extension of popular education through state support, and their efforts on behalf of art belong in the context of the broader Radical campaigns against privilege and for national education.

During the 1840s, the art unions, founded in the previous decade, were highly successful in arousing enthusiasm for the arts among a broad sector of society. When their existence was threatened by Act of Parliament in 1844, Ewart and Wyse led the effort in the House of Commons to ensure their continued legal operation. By that time, the London Art Union had become something of an institution, with a membership of nearly 14,000 and subscriptions amounting to £15,000.[1] Its first president was

[1] Anthony King, 'George Godwin and the Art Union of London 1837–1911', *Victorian Studies* 8 (December 1964): 108. The annual subscription rate was one guinea, in return for which members were eligible for prizes

the Duke of Cambridge, Queen Victoria's uncle, and its governing committee included Charles Barry, Herbert Minton of the famous Staffordshire ceramic works, Sir Richard Westmacott, the sculptor and Academician, and Samuel Smiles. Among the M.P.s on the committee were Benjamin Hawes, Henry Thomas Hope, Ewart, and Wyse. Charles Dickens and Baron de Rothschild were initial subscribers. As part of its efforts to encourage an appreciation of art throughout society, the London Art Union each year gave a free exhibition of the pictures selected by prize winners. During the two weeks that the show was open in August 1843, over 147,000 visitors attended the gallery, lent by the Society of British Artists for the occasion.[1] Between the fresco cartoons and the Art Union, 1843 was a good summer for free art exhibits in London.[2]

The committee of the London Art Union had more in common with the Royal Commissioners on the Fine Arts than the popularity of their exhibitions. They shared grandiose visions of art's role in society and the same fervent desire to elevate human character through art. In April 1840, at the fourth annual general meeting of the London Art Union, George Godwin, the Honorary Secretary, prefaced the drawing for prizes with a characteristic address:

> The influence of the fine arts in humanising and refining—in purifying the thoughts and raising the sources of gratification in man—is so universally felt and admitted, that it is hardly

won by lottery. The winners were allowed to choose their own prizes, according to the price on the winning ticket, from one of the five major art exhibits in London: the Royal Academy, the British Institution, the Old and New Societies of Painters in Water Colours, and the Society of British Artists. The governing committee of the Art Union determined what proportion of the subscription fees would be allocated for prizes, and also the value assigned to the various prizes. In some other art unions, the governing committees actually selected the works of art to be awarded as prizes to the lottery winners. In 1840, the London Art Union Committee allotted £1,400 for prizes. There were forty-two winning tickets, enabling one winner to purchase a work of art valued at £200, another at £150, and on down the price scale to ten tickets worth £10 each. 'The Art-Union of London', *Art-Union* 2 (May 1840): 67.

[1] King, 'Godwin', pp. 103, 105, 107, 111.

[2] Perhaps the publicity attending the decoration of the Houses of Parliament helped to spur the growth of the London Art Union.

necessary now to urge it. By abstracting him from the gratifi-
cation of the senses, teaching him to appreciate physical beauty,
and to find delight in the contemplation of the admirable
accordances of nature, the mind is carried forward to higher
aims, and becomes insensibly opened to a conviction of the
force of moral worth and the harmony of virtue. By assisting,
then, to implant a taste for works of fine art, and to afford means
for the universal enjoyment of it, all may rest assured that they
are forwarding the best interests of humanity, and entitling
themselves eminently to the applause of the high-minded.[1]

Probably the most popular way in which the London Art
Union created opportunities for the enjoyment of art was its
annual distribution of an engraving to each of its subscribers.
Every year, the governing committee commissioned an engraver
to execute prints of a painting which the committee thought
worthy to hang in homes throughout the country. Over the years,
the Art Union engraved works by the most prominent British
artists—Turner, Frith, Landseer, Mulready, Maclise, to name only
a few—and made their art known at home and around the world.[2]
It was this activity, however, which almost caused the suppression
of art unions. Print-sellers and art dealers, anxious for their own
businesses, feared that the London Art Union would eventually
monopolize the market for engravings, and that the production of
engravings in large numbers would destroy their value. Taking
advantage of the new process of electrotyping, which rendered
steel engraving less expensive and longer lasting, the Art Union
was able to distribute its selected engravings in greater quantity
and at lower cost than was ever before possible.[3] If the walls of
the Houses of Parliament largely failed to popularize art, en-
gravings succeeded beyond a doubt. Professional art dealers
wanted to make certain that they profited from that success.

The fact that art unions operated as a form of lottery enabled
the dealers and print-sellers to obtain a ruling against them in

[1] Quoted in 'The Art-Union of London', *Art-Union* 2 (May 1840): 67.

[2] By the 1860s, there were about 750 honorary secretaries of the London
Art Union around the world, representing distant clusters of members. Over
20,000 prints of both of Maclise's famous paintings in the Houses of Parlia-
ment were distributed by the London Art Union. King, 'Godwin', pp. 121,
102.

[3] Ibid., pp. 113–14; and Oppé, 'Art', p. 123.

April 1844. They were, in fact, violating various lottery acts which dated back to the reigns of George II and George III, and the Solicitor to the Treasury warned Godwin to suspend all further activities of the London Art Union or expose its members to the threat of prosecution.[1] Fortunately for the thousands of members who had already subscribed their guinea for 1844, the Art Union had friends in Parliament. In July, Lord Monteagle introduced a Bill in the House of Lords to legalize the unions temporarily.[2] In moving the second reading two days later, he pointed out that the London Art Union contributed more for the purchase of works of art than 'was appropriated to the purpose by the munificence of Parliament'. The various unions throughout the United Kingdom, in London, Dublin, Edinburgh, Manchester, Birmingham, Liverpool, and in other large towns, according to Monteagle, had altogether spent £30,000 on art in the past year, while artists were coming to look on art unions as their best customers.[3] The following day, the Duke of Cambridge praised the work of the art unions, and melodramatically begged their Lordships to act speedily on the measure before them, as he was 'liable to be imprisoned' for his affiliation with the London union.[4]

The Lords and Commons obligingly expedited the measure, and, on 5 September, the Art Unions Bill received the Royal Assent. The Act, legalizing the art unions' transactions, required them in future to obtain charters of incorporation or to submit their rules and regulations for the approval of the Board of Trade.[5] Lord Monteagle had explained on 18 July that 'he was desirous to place Art Unions under the direction of the Board of Trade, because at present all the schools of design in the country were under the control of that department'. Despite the fact that the Board of Trade had kept the Schools of Design in a state of confusion for seven years, Parliament could find no other convenient pigeon-hole for the arts.

[1] King, 'Godwin', p. 114. Under the existing law, each member would have been liable to a £20 fine.

[2] *Parliamentary Debates* (Lords), 3rd ser., 76 (16 July 1844): 875. Monteagle subsequently became president of the London Art Union.

[3] *Parliamentary Debates* (Lords), 3rd ser., 76 (18 July 1844): 997–9.

[4] *Parliamentary Debates* (Lords), 3rd ser., 76 (19 July 1844): 1068.

[5] *Parliamentary Papers*, vol. 1 (1844) (*Bills: Public*), 'A Bill, intituled An Act for legalizing Art Unions'.

As the authority of the 1844 act extended only until 31 July 1845, Ewart and Wyse prepared a Bill in 1845 to continue the protection afforded art unions for another year.[1] Temporary legislation could not suffice indefinitely, however, and in 1844–5 a select committee of the House of Commons considered the permanent status of art unions. With Wyse as chairman, the committee's members included Ewart, Lord Palmerston, Thomas Duncombe, the Radical Member for Finsbury, and Sir Frederic Thesiger, the Solicitor General. At least five of the members were, or had been, subscribers to the London Art Union,[2] and the committee's basically favourable attitude towards art unions was suggested by the very terms of its appointment:

> to consider the objects, results, and present position of Art Unions, how far they are affected by existing Laws, and what are the most expedient and practicable means to place them on a safe and permanent basis, and to render them most subservient to the improvement and diffusion of Art through the different classes of the Community. . . .[3]

The report, published in August 1845, not surprisingly endorsed the art unions. Proceeding from a general description of the major associations in the United Kingdom, their methods of operation, and the sums of money spent on works of art, the report focused on the objections raised by opponents of the art union movement. The principal complaints were that the unions fostered the production of inferior works by inferior artists, that they neglected and injured high art both by interfering with ordinary patronage and by distributing quantities of inferior engravings, that they ignored other branches of art, especially sculpture, and that they 'connected with Art a spirit and practice of gambling and jobbing'. The committee found no validity in the first two charges, and urged art unions to encourage other forms of art where the expense was not prohibitive. As for the last and at the time the most serious charge against the unions,

[1] *Parliamentary Papers,* vol. 1 (1845) (*Bills: Public*), 'Bill for Legalizing Art Unions'.

[2] King, 'Godwin', pp. 105, 107, lists the Members of Parliament affiliated with the union in its early years.

[3] *Parliamentary Papers* (Commons), 'Report from the Select Committee on Art Unions', 1845, 7: ii.

the report declared that examples of abuse were rare and that, in most cases, art unions functioned for the promotion of art, not for the profit of their managers. Any defects, the committee believed, could be remedied in the future by stricter regulation.[1]

The Select Committee on Art Unions, like every other official body concerned with the arts in the 1840s, gave special consideration to the higher arts. Yet a refreshing note of pragmatism leavens the heavy theorizing of its report. 'Art unions', the committee conceded,

> must meet, to a great degree, the recognised predilections of the public, such as they are; and though they may lead and regulate, they cannot persist in altogether counteracting them. It is obvious too much ought not to be expected from the present working of these institutions in reference to High Art.[2]

The committee members were well aware that art would never be widely welcome in British homes if it were viewed as something imposed from above. 'Unless the public at large sympathise in Art, and feel it to be an enjoyment, we shall never attain anything national in Art, or have a public to appeal to.'

The report not only showed an unusually sensible approach to the problems of elevating public taste, but it also revealed a sensitivity to the needs of diverse communities rarely found in official pronouncements on art at this time. In praising the London Art Union's distribution of engravings, the report observed that 'to many a small town these Art Union engravings are treasures; they are perhaps the only ones, in the way of Art, they possess'. It commented favourably on the diversity found among the various unions:

> In Birmingham and Manchester they will take the special character depending on the special wants of the places. Edinburgh will have its '*genius loci*' as well as Dublin . . . This is no matter of regret; on the contrary, it is one of the most significant evidences of the utility of the system. From the free working of these several bodies results the vitality of the whole.[3]

[1] Ibid., pp. xviii, xxv.
[2] Ibid., pp. xxx, xxxii. Even 'the more homely scenes of common life', the report continued, p. xxxiii, '. . . provided they be combined with moral influences', can be useful, 'as they are oftentimes the only intelligible mode in which Art can speak to a large portion of the community'.
[3] Ibid., pp. xxvi, xxxvi–xxxvii.

In order to preserve this vitality, the select committee recommended that jurisdiction over art unions should not be vested in the Board of Trade, which could not possibly devote sufficient time or care to them. Instead, the committee sought to place the unions 'under a department specifically charged with the interests of Art (such as exists in almost every country in Europe)', and proposed that a Committee of the Privy Council be appointed for the purpose, along the lines of the Board of Trade and the Committee on Education.[1] At least a few members of the legislature finally recognized the special needs and demands of art.

In March 1846, Wyse, Ewart, and Colonel Rawdon, the Liberal Member for Armagh City, introduced a Bill, embodying the committee's main proposals. It met some difficulty on 29 July, when Henry Goulburn, the Conservative Member for Cambridge University, asserted that the Bill's promoters were 'trying to avail themselves of one of the vicious propensities of our nature to engage in games of chance',[2] and Peel concurred. Disappointed by Peel's attitude, Wyse could not refrain from observing that:

> taste for art could only be created by diffusing among the population a love of art; this again could only be done by means of engravings; for it was not every man who could procure pictures of the highest excellence, unless he had the large fortune as well as the excellent taste of the right hon. Baronet.

The public had proved willing to subscribe £40,000 annually, in sums of one guinea, to various art unions that 'had been the means of expending £100,000 in objects of art'. Wyse trusted that Parliament would not be responsible for stopping this source of patronage.[3]

The Bill passed through the House of Commons and speedily through the Lords, receiving the Royal Assent on 13 August 1846. It legalized art unions without reference to any time limit, provided that the procedures first set down in the Act of 1844

[1] Ibid., p. xxix.

[2] *Parliamentary Debates* (Commons), 3rd ser., 88 (29 July 1846): 188.

[3] Ibid., 191, 193. Sir Robert Harry Inglis, the staunchly Tory Member for Oxford University, used the occasion of the debate to voice his minority view that art by no means promoted morality. This was his repeated contention, and it must, at least, have provided variety in the discussions of the Royal Commission on the Fine Arts and the 1841 Select Committee on Fine Arts, on both of which he served.

were observed. The Act of 1846, however, did not specify the Board of Trade as the supervisory authority, and, vaguely in keeping with the select committee's recommendations, only mentioned 'any Committee of Her Majesty's Privy Council, to whom the consideration of Art-Unions shall be referred by Her Majesty'.[1] The legislation was too imprecise to effect a change in the official manner of administering the arts in the 1840s, and, before the end of 1847, the Board of Trade was supervising the affairs of art unions. Yet so little thought was given to the matter that for twenty years jurisdiction over the unions was confusingly divided between two Government departments: exemption from the lottery laws in favour of art unions rested with the Board of Trade, while violations of those laws came under the authority of the Home Office. Parliament not only relegated the arts to the Board of Trade, a department of state never intended for their promotion, but the legislators made little effort to ensure that the Board could fulfil its cultural responsibilities in a systematic fashion. The reputation of art unions gradually declined as countless violations and abuses in their management went unpunished for lack of effective regulation.[2]

In the 1840s, however, the unions were at the height of their popularity. There is no question that their proliferation throughout the country attested to public interest in, and eagerness to possess, works of art. In September 1845, the *Builder* marked the closing of the London Art Union's yearly picture exhibition with the assertion: 'If the Art-Union of London did nothing more than provide this annual enjoyment for all classes of the community, it would be entitled to our gratitude.'[3] While the *Builder*'s praise may have been somewhat prejudiced, as George Godwin had become its editor in 1844, strong words of commendation came

[1] *Parliamentary Papers*, vol. 1 (1846) (*Bills: Public*), 'Bill for Legalizing Art Unions', p. 2.

[2] *Parliamentary Papers* (Commons), 'Report from the Select Committee on Art Union Laws', 1866, 7: v. The 1866 committee, which lies outside the scope of this chapter, found the quality of most art unions greatly deteriorated since the first inquiry. The average value of prizes was too small to purchase art of any quality in the 1860s, and shilling art unions had multiplied which were parodies of the original idea—mere lotteries barely connected with the arts. In Ireland, one 'art union' awarded pigs, sheep, horses, carriages, harnesses, crinolines, and feathers, in addition to pictures. Ibid., p. 24.

[3] 'Art-Union of London', *Builder* 3 (13 September 1845): 440.

from no less a critic than Michael Angelo Titmarsh, Esq., alias William Thackeray. In the *Pictorial Times*, April 1843, when criticism of the art unions as modes of gambling was already mounting, Thackeray vigorously defended their efforts to awaken a popular love of art. 'I am sure', he maintained, that:

> the people of England are likely to be better patrons of art than the English aristocracy ever were, and that the aristocracy have been tried and *didn't* patronise it . . . No, no; *they* are not the friends of genius. That day is over; its friends lie elsewhere; rude and uncultivated as yet, but hearty, generous, and eager . . .
>
> There are a thousand men read and think to-day, for one who read on this same day of April, 1743. The poet and artist is called upon to appeal to the few no longer. His profit and fame are with the many . . .
>
> The pit, it is my firm belief, knows just as much about the matter in question as the boxes know; and now you have made Art one of the wants of the public, you will find the providers of the commodity and its purchasers grow more refined in their tastes alike. . . .[1]

The significant achievement of the art unions was to bring art, even if not a very exalted kind, into the lives of people socially below the prosperous middle and upper-middle classes. In statements to the 1866 Select Committee on Art Union Laws, Henry Cole described the membership of the London Art Union as primarily 'of the lower middle class, in country towns'. Out of ten thousand subscribers, he could find only 'a bishop, a few peers, two Members of Parliament, seven baronets, and only 21 persons whose names were at all known'.[2] Cole presented his evidence as proof of the Union's decline; Ewart and Wyse would have been pleased to know that so many thousands of people outside the metropolis, despite their restricted means, cared enough about art to contribute their guinea.

[iii]

Art unions were not the only means by which the Radicals and their supporters sought to open the world of art to the people.

[1] 'Letters on the Fine Arts. No. 2.—The Objections Against Art Unions', *Pictorial Times*, 1 and 8 April 1843, in Thackeray's *Critical Papers in Art*, pp. 192–4. [2] Report, 1866, p. 24.

Repeatedly, they pressed the House of Commons to provide free public admission to art exhibitions wherever possible. Nor was their effort confined to museums alone. Hume continued the Radical attack on the privileged status of the Royal Academy, demanding that certain times be set aside for the public to view its yearly exhibition free of charge. With equal persistence, he worked to secure free admission to all national monuments containing works of art, and presided over a 'Society for Obtaining Free Admission to Public Monuments'.[1] His particular targets in this case were Westminster Abbey, St. Paul's, and other cathedrals throughout the country whose governing bodies charged fees for displaying the interiors of the buildings. He argued that 'for the sake of public morals and public refinement, it was expedient that Cathedrals should be thrown open, and that, under proper regulations, it might be done with the utmost safety to the monuments and the buildings'.[2]

Both Wyse and Ewart supported Hume's contention on numerous occasions, and Peel confessed that 'as regarded public, political, and social results . . . he contemplated with great satisfaction the admission of the humblest classes of society to view these monuments'.[3] The issue, however, involved parliamentary encroachment on the jealously guarded preserves of the Church of England, and thus Hume inevitably failed to obtain legislation to support his views. But he did find some sympathy in the press. An article in *Blackwood's*, for example, appearing in April 1842, was severely critical of the many fees exacted at St. Paul's, and described the free opening of national monuments as 'the opportunity of diffusing popular education in . . . the cheapest, simplest, and least objectionable way'.[4] Wyse also specifically linked education and the arts in his speech at the Freemasons' Tavern in December 1842. The artist and legislator alike, he maintained, had a responsibility to further public education, 'by multiplying our schools, and improving our modes of teaching . . . by admission

[1] 'Chit Chat', *Art-Union* 2 (August 1840): 128.

[2] *Parliamentary Debates* (Commons), 3rd ser., 74 (16 April 1844): 34.

[3] Ibid., 43. Another example of a similar discussion can be found in *Parliamentary Debates* (Commons), 3rd ser., 82 (4 August 1845): 1374–6.

[4] 'The World of London. Part XI', *Blackwood's* 51 (April 1842): 422–3. *The Wellesley Index to Victorian Periodicals*, vol. 1, attributes the article to John Fisher Murray, Irish humourist and essayist.

to public monuments, museums, and galleries, combined with a higher character of art amongst artists themselves. . . '.[1]

The House of Commons Select Committee on National Monuments and Works of Art had already espoused similar views in 1841. This was scarcely unexpected, as Hume chaired the committee and its members included Ewart, Henry Thomas Hope, and other friends of the arts.[2] In its report, presented in June 1841, the committee expressed its confidence in the uplifting influence that free admission to religious edifices would have on the mind of the spectator, and its certainty that the public would respectfully treat works of art in churches and cathedrals.[3] The report of this select committee is less interesting for its findings on cathedrals and public monuments, however, than for its evidence concerning the popularity of museums and art galleries. In this respect, the 1841 Select Committee on National Monuments and Works of Art represented a significant step towards the important Museums Act of 1845.

During the 1830s, growing public interest in museums had already attracted notice, and their utility as a means of imparting upper-class culture and values to the lower classes had been recognized.[4] The point was repeatedly emphasized in the 1840s. The *Art-Union* rejoiced that the National Gallery had 'become the resort of the many-aproned sons of industry, not only on

[1] Quoted in Pye, *Patronage*, pp. 180–1.

[2] As far as the arts were concerned, 1841 was a busy year for Hume, Ewart, and Hope, as well as a few other members who served both on this committee and the Select Committee on Fine Arts which preceded the Royal Commission. Later in the decade, Hume was also a member of the House of Commons Select Committee on Works of Art (1848) and the Royal Commission for inquiring into the Constitution and Government of the British Museum (1847–8). The former committee investigated the shortage of space at the National Gallery and recommended enlarging and improving the Trafalgar Square site. *Parliamentary Papers* (Commons), 'Report from the Select Committee on Works of Art', 1847–8, 16: 3–4.

[3] *Parliamentary Papers* (Commons), 'Report from the Select Committee on National Monuments and Works of Art', 1841, 6: vi–viii.

[4] The Select Committee on National Monuments and Works of Art was appointed in 1841 'to inquire into the present state of the National Monuments and Works of Art in . . . Public Edifices; to consider the best means for their protection and for affording facilities to the Public for their inspection, *as a means of moral and intellectual improvement for the People*'. Ibid., p. ii. (Author's italics.)

holidays, but on those Mondays dedicated of old to tippling and riot . . . If the example of the Government were followed by other proprietors of picture galleries', the journal claimed, 'true taste would be more generally diffused in the land, and the populace would look at public statues without desiring to throw stones at them'.[1] W. B. S. Taylor vividly explained the assumed connection between art and social order, in a passage dealing with the important moral influence of picture galleries on human character:

> when art is thus enthroned in a nation, we have a decisive guarantee that the state of society is sound and wholesome . . . But sad is the prognostic, when the arts lose their hold on the affections of a people . . . At such a time, it is evident that the frame of society has been much shaken, and that order is about to be submerged by anarchy.[2]

The report of the Select Committee on National Monuments and Works of Art offered detailed proof that art was increasing its hold on the affections of the British people. Numerous museum officials told the same story. William Seguier, keeper of the National Gallery, and George Thwaites, assistant keeper, calculated that there had been over ten thousand visitors to the gallery on certain holidays, when no extra police assistance was necessary to preserve order. A gallery attendant testified to the interest shown by workers: 'I notice mechanics that come, and they appear to come in order to see the pictures, and not to see the company.' 'Do you think that the interest in the pictures is increasing on the part of the visitors?' Hume asked him. 'I think it is increasing every day. . . .'[3] Sir Henry Ellis, Principal Librarian at the British Museum, reported that 32,000 people visited the museum on one Whit-Monday, causing museum officials no difficulty in maintaining order.[4] Hampton Court, open to the public free of charge since November 1838, also attracted numbers of visitors, although a trip to the palace required transport from

[1] 'Public Statues and Monuments', *Art-Union* 2 (June 1840): 90.

[2] *Present Condition of the Arts*, 2: 368.

[3] Report, pp. 131, 133, 137.

[4] Ibid., p. 151. The title of Principal Librarian signified the superintendence of the entire museum, not only the book and manuscript collections. The trustees of the British Museum had only decided in the late 1830s to open the museum to the public during the Easter and Whitsuntide holidays.

London. 'On Whit-Monday we average 3,000,' the caretaker of
the Hampton Court apartments and pictures informed the com-
mittee. He described the majority of the visitors as 'lower class',
coming from London in vans—'sometimes we have 60, 70, and
80 vans in a day, each van containing nearly 30 persons'—and
occasioning no 'difficulty in maintaining order, and protecting the
things'.[1] Allan Cunningham, a writer on art and artists, offered
the most telling endorsement of museums and picture galleries
when he discussed popular response to the National Gallery:
'You see a great number of poor mechanics there, sitting wonder-
ing and marvelling over those fine works, and having no other
feeling but that of pleasure or astonishment; they have no notion
of destroying them. . . .' The committee asked him to specify
the class of people he referred to. 'Men who are usually called
"mob"; but they cease to become mob when they get a taste.'[2]

That must have been good news at a time when the mob loomed
so large in the national consciousness. Unemployment was wide-
spread as the cotton industry struggled through a prolonged

[1] Ibid., pp. 122, 124, 126. Admittedly, it was not only the art, including
Raphael's famous cartoons, that drew crowds from London to Hampton
Court. After viewing the pictures, they would spend the rest of the day in
the palace park, 'very often, with music, dancing and enjoying themselves'.
Ibid., p. 125. The obvious use which the working class made of museums on
holidays had already led Hume in 1840 to urge the House of Commons to
take steps to open the British Museum and the National Gallery on Sundays,
'after divine service'. He made an eloquent case for Parliament's duty to
provide means of 'rational instruction and amusement' for the public, but
the House of Commons would not permit that infringement of the strict
Sabbath observance until 1896. *Parliamentary Debates* (Commons), 3rd ser.,
55 (14 July 1840): 720–2. Illogically, Hampton Court was already open to
the public on Sunday in 1840, not to mention 'the houses of licensed victu-
allers, of sellers of beer, and of keepers of gin shops . . . now legally open to
the public' on the Lord's Day. Ibid.

[2] Report, p. 91. J. F. Murray phrased the same sentiment more delicately
in 'The World of London. Part XI,' *Blackwood's* 51 (April 1842): 421. The
British Museum 'is a school of mind and manners,' he wrote, 'and it is only
by contemplating the faces of those who are engaged in recreating here, that
you can form an adequate idea of its beneficial effects upon society at large'.
See note 4, p. 86. By 1846, attendance figures at London's free public
museums had mushroomed. A total of 825,901 people visited the British
Museum, including the Reading Room, in that year, and 608,140 went to the
National Gallery. *Parliamentary Papers*, vol. 34 (1847) (*Accounts and Papers*),
'Accounts, &c. of British Museum and National Gallery'. Again, precise
sociological analysis of these figures is impossible.

depression. The potato crop failed in Ireland, and famine drove thousands of Irish poor into the crowded, miserable urban slums of England and Scotland. It was a decade characterized by protest, sometimes violent, against steam-driven machines in Lancashire and turnpike companies in Wales, against Corn Laws that kept up the price of grain, and against a Parliament that had rejected the People's Charter. There were attacks on private property, threats against factory owners, and an abortive Irish uprising. Everywhere, 'the condition-of-England question'[1] demanded Parliament's attention, and Britain's legislators were eager to encourage almost any potential palliative, including public museums.

The benefits of free public museums, however, were largely limited to the metropolis. While many cities had art academies and institutions which might occasionally allow free public admission to their exhibitions, the municipal museum or art gallery was as yet scarcely known. As Edwards observed in 1840: 'It is needless to add, that of public collections of works of Art in our great manufacturing towns, fitted to elevate the taste and to develop the capabilities of our artisans, we are wholly and absolutely destitute.'[2] It was to correct this situation that Ewart, Wyse, and Joseph Brotherton, the Radical Member for Salford, introduced a Bill in 1845 to enable town councils in corporate towns to establish museums of art.

While Ewart, who introduced the Bill, and Wyse, who seconded it, spoke principally of completing the work of the Schools of Design by making specimens of art available to artisans throughout the country, social considerations also figured prominently in the debate. Hume contended, not quite accurately, that experience in London had shown that 'the labouring classes . . . had deserted the public houses, preferring to visit places where they could improve their minds. . . '. Lord John Manners praised the 'decorous conduct of the people on every occasion when they were admitted to witness objects of art and curiosity', and he argued that 'the more facilities that were given to the people in large towns, and throughout the country, to observe works of

[1] The expression was originally Carlyle's in *Chartism* (1840). Like Disraeli's term, 'the two nations', it became a catch phrase to summarize the manifold problems besetting the country.

[2] *Administrative Economy*, p. 109.

art, the more would be done to work out the true civilisation of the country'. Brotherton said that 'it was much better to cultivate a taste for the arts at the public expense than to raise a large amount of taxation for the prevention and punishment of crime'. Montague Gore, the Member for Barnstable, commended the Bill because 'it was a wise and sound policy to promote such objects as those which had been suggested; they were calculated to improve the social system, and to render the artisan and the labourer sober and industrious, cheerful and intellectual'. He believed that the measure 'would tend not only to raise science to a loftier eminence, but at the same time, while improving the morals and purifying the spirits of the people, to extend the basis on which rested the foundation of peace, security and national prosperity'.[1]

While the notion of art museums as a deterrent to crime may seem quaint in the twentieth century, it was a matter of conviction for many in the mid-nineteenth. But Peel, who had certainly upheld the belief in the 1830s, maintained in 1845 that more pressing matters claimed Parliament's consideration. He objected to the Bill's provision allowing town councils to levy a rate for the purpose of establishing museums. 'It will be necessary for us,' he warned his colleagues:

> during the present Session, to call upon the House to confer powers of local taxation for the purposes of ventilation, and improving the salubrity of the dwellings of the population. What I would advise is, not to increase to too great an extent the demand on the inhabitants of towns for the purposes of these local improvements. We ought to take care not to raise a prejudice against them by increasing too much the burdens of local taxation.

He believed that the most desirable course was 'to endeavour in the first instance to raise as much as possible by private subscription'.[2] As private patron and leader of the Opposition, he could afford to adopt lofty attitudes concerning art's function in society. As Prime Minister in a period of economic distress, he could not

[1] *Parliamentary Debates* (Commons), 3rd ser., 78 (6 March 1845): 381–4, 387, 390–1.

[2] Ibid., 388–9. He did not oppose the permanent maintenance of such museums by local taxation, once the cost of construction had been met by private subscription.

allow the arts a high position on the Government's list of budgetary priorities. Salubrity of dwellings was more essential than public museums, he reasoned with justification. It was a frequent cause of frustration to artists in the nineteenth century that interest expressed by Opposition spokesmen seldom materialized as legislation when they came to power. From the perspective of office, the arts did not yet command enough significant political support to ensure their place in the legislative programme of successive Governments.

On certain occasions, however, Parliament was ready to disregard the Government's position, as it had in the case of the new National Gallery building. In 1845, it decided that Britain beyond the metropolis ought not to be deprived of the many useful benefits which art allegedly could furnish. Ewart's Bill passed through both Houses, received the Royal Assent on 21 July 1845, and became the first Act by which Parliament gave local authorities the power to provide cultural facilities.[1] Applying only to towns with a population exceeding ten thousand, it enabled the councils of municipal boroughs to erect and maintain buildings for museums of art and science. The rate levied for the purpose was not to exceed one halfpenny in the pound, and admission fees charged at municipal museums were not to exceed one penny per person.[2] Thus arose the municipal museum, an

[1] S. K. Ruck, *Municipal Entertainment and the Arts in Greater London*, with a Foreword by W. A. Robson (London: George Allen & Unwin Ltd., 1965), p. 56.

[2] *Parliamentary Papers*, vol. 4 (1845) (*Bills: Public*), 'A Bill to enable Town Councils to establish Museums of Art in Corporate Towns, as amended by Committee'. In 1850, Ewart and Brotherton introduced a measure which repealed the Act of 1845 and replaced it by the Public Libraries Act. The latter enabled town councils to levy a rate for the purpose of founding and maintaining public libraries, as well as museums of art and science. The population figure and the limit on the rate were retained from the earlier Act, but the Act of 1850 further required an approving vote of two-thirds of the local ratepayers before the Act could be adopted in any given town. It also eliminated admission charges at municipal libraries and museums. *Parliamentary Papers*, vol. 7 (1850) (*Bills: Public*), 'A Bill for Enabling Town Councils to establish Public Libraries and Museums, as amended by the Committee, on re-commitment'. In 1847, Wyse lost his seat in Parliament and soon afterwards embarked on a diplomatic career in Athens. Otherwise, no doubt, he would have actively supported the 1850 measure together with Ewart. In 1843, he had sponsored the Act which exempted from local rates

institution which has been called a symbol of 'Victorian prosperity in one of its most imposing forms'.[1] Few eligible towns rushed to take immediate advantage of the opportunities which the Act afforded, but gradually over the second half of the century, a number of towns established their own public museum and art gallery. More important than the speed with which the Act was implemented was the precedent which it set. In 1845, the Radicals and their supporters won for the arts an official place among the rapidly growing concerns of local government.

It is interesting that, at the same time that the Museums Act of 1845 was passing through Parliament, the Peel ministry was shepherding its own Museums Bill through the Lords and Commons. The Government Bill, prepared and brought in by the Solicitor General and Sir James Graham, the Home Secretary, was entitled 'A Bill for the Protection of Property contained in Public Museums, Galleries, Cabinets, Libraries, and other Public Repositories, from Malicious Injuries'. It reflected the Government's horrified reaction to the recent damage to the Portland Vase, in the British Museum's collection of antiquities,[2] and it was entirely disciplinary in intent. There were no references here to the 'instruction and amusement' of the people, as in the other Museums Bill of 1845, only talk of punishment. So severe was the measure that the Lords balked at it. Lord Lyndhurst, the Lord Chancellor, complained that 'a person laying his finger upon a plaster-cast in a shop window would come within the provisions of the Bill, and might be liable to two years' imprisonment, hard labour, and private whipping'. Lord Brougham claimed that 'the punishment was the same as inflicted for felonies of the highest character', and 'he was perfectly astonished at such a Bill coming

all land and buildings occupied by societies established exclusively for scientific, literary, or artistic purposes.
[1] B. Ifor Evans and Mary Glasgow, *The Arts in England* (London: The Falcon Press, 1949), p. 62.
[2] *Parliamentary Debates* (Commons), 3rd ser., 78 (13 March 1845): 783. On 7 February, a young man, William Lloyd, had smashed the vase to pieces, for no ostensible reason. When brought before the Bow Street magistrate, it was discovered that no existing law covered such acts of destruction as he had committed. The vase was ultimately repaired with great skill, but the incident raised serious questions about the safety of the public art collections. Miller, *Noble Cabinet*, pp. 207–8.

from the Commons'.[1] The Lords reduced the maximum penalty from two years to six months, but retained hard labour or private whipping as alternative modes of suggested punishment.[2] The Bill, which also received the Royal Assent on 21 July 1845, stands in startling juxtaposition to the endless praise of art's humanizing and ennobling influence. It reveals, furthermore, how firmly the old view of art, as objects to be collected for display, was entrenched in the attitudes of the ruling class. It was all very well for the Radicals to preach about bringing art to the people, but art was also property, and in the 1840s, every man had to look out for property, whether his own or the nation's.

When the last great threat to property in the 1840s had been overcome, and the Chartists gathering in London in April 1848 had been dispersed in confusion, Charles Kingsley looked to museums to help reunite 'the two nations'. In a series of articles for F. D. Maurice's short-lived Christian Socialist weekly, *Politics for the People*, Kingsley described to his working-class audience the treasures to be found in museums. He spoke of the inspiring influence which paintings had always exercised on him, and hailed picture galleries as 'the townsman's paradise of refreshment'.[3] In the British Museum and National Gallery, he explained, all Englishmen meet as equals, with equal right to 'glory in these noble halls', for 'English commerce, the joint enterprise and industry of the poor sailor as well as the rich merchant, brought home these treasures from foreign lands . . . The British Museum is a truly equalizing place, in the deepest and most spiritual sense. . . .'[4]

Perhaps this was only fantasy on the part of the author of

[1] *Parliamentary Debates* (Lords), 3rd ser., 81 (1 July 1845): 1396.

[2] *Parliamentary Papers*, vol. 4 (1845) (*Bills: Public*), 'A Bill for the better Protection of Works of Art, and Scientific and Literary Collections, as amended by the Committee', and 'Amendments made by the Lords'. Another Act introduced by Graham as Home Secretary was the Theatres Regulation Act of 1843. This Act, which ended the monopoly on legitimate drama enjoyed by the patent theatres, consolidated and extended the Lord Chamberlain's censorship powers over the drama.

[3] 'The National Gallery.—No. 1,' in *Politics for the People* (London, 1848; reprint ed., New York: Augustus M. Kelley, Reprints of Economic Classics, 1971), pp. 5–6. The article appeared in the first issue, 6 May 1848, under Kingsley's pseudonym, 'Parson Lot'. *Politics for the People* sold for one penny.

[4] 'The British Museum', in ibid., p. 183. This article appeared on 1 July 1848.

Yeast and *Alton Locke*, a country clergyman who was delighted to learn that the South London Chartists perused his volume of *Twenty-five Village Sermons* (1849).[1] Many of the theories about art's ethical value and benefit to society, voiced so fervently in the 1840s, represented little more than wishful thinking. But, as always, the belief itself counted more than its accuracy, and it was symptomatic of the tenacity with which the Victorians clung to their faith in man's power of self-improvement through education. In the decade that opened with the Great Exhibition, that faith seemed gloriously justified.

[1] Amy Cruse, *The Victorians and Their Reading* (Boston and New York: Houghton Mifflin Co., 1935), p. 118.

Cole and Company

[i]

The Great Exhibition of the Works of Industry of all Nations ushered in the second half of the nineteenth century with pomp, splendour, and reassuring evidence of British industrial vigour. To many observers, it symbolized the prosperity and domestic tranquillity that followed the turbulent 1840s. It became part of the national consciousness in the mid-Victorian decades, and served as a model for subsequent expositions at home and abroad. For the arts, it provided the stimulus behind the British Government's most extensive enterprise in the field of art education to date.

Beginning in the 1850s, a new Department of Practical Art, subsequently incorporated into the Department of Science and Art, initiated a system of state-aided art schools which, for once, was administered with efficiency and consistent goals. In part, the Department's achievements were due to the expanding national exchequer that permitted ever larger expenditure for its activities, but equally responsible were the limits which its officers placed on departmental concerns. No beguiling dreams of high art distracted them from their daily tasks.[1] They were practical men, working to include art in the national elementary school curriculum and to educate the taste of artisans and consumers alike in the interests of British industry and trade. They were imbued with deep faith in the principles of individual initiative and self-help, which Samuel Smiles celebrated in 1859, and they believed that, in the process of self-betterment through education, art had a significant role to play.

The origin of the Great Exhibition, and of many later efforts to enlist national interest in the arts, may be traced back to the mid-

[1] This chapter will deal only with that part of the Department concerned with the arts.

eighteenth century and the Society for the Encouragement of Arts, Manufactures, and Commerce. The Society of Arts, as it was generally called, had continued its efforts to promote the practical application of fine art to industry for nearly a century, and in 1844-5 had sponsored two small exhibitions of British manufactures. Both efforts failed to attract much notice,[1] and by the 1840s, the society's energies were clearly flagging. With the assumption of the presidency by Prince Albert, however, it gained new stature, became incorporated in 1847, and began to promote the developments that led to the Crystal Palace.

Prince Albert took his presidency of the society seriously. His interest in art was not assumed for titular honours, but showed itself in numerous unofficial ways. He gave much thought to the reorganization of the National Gallery's collections and the planning of the Manchester Art Treasures Exhibition of 1857. He helped to compile a corpus of Raphael's works which proved valuable to art scholarship, and his collection of early German and Italian paintings contributed to growing public interest in the 'Primitives'.[2] He was also an amateur composer; in short a prince 'gilded by the gracious gleam / Of letters, dear to Science, dear to Art . . '.[3] But Albert was no dilettante. His enthusiasm for art was integrally associated with his concern for 'the Progress and Improvement of the Public'. He gave to societies for bettering the conditions of the poor the same thought and attention that he brought to the arts.[4] He believed that art served a high national purpose, that it was essentially linked both to the country's industrial growth and to its moral progress. In these convictions, he was completely in accord with Henry Cole.

[1] Henry Cole, *Fifty Years of Public Work of Sir Henry Cole, K.C.B. Accounted for in his Deeds, Speeches and Writings*, 2 vols. (London: George Bell & Sons, 1884), 1: 119. All the material in these volumes dealing with events after the Great Exhibition was compiled by Cole's children after his death.

[2] Ames, *Prince Albert*, pp. 145, 149–51, 166, 174; Oppé, 'Art', p. 112; and Steegman, *Victorian Taste*, pp. 60–1, and chapter 10 on 'The 1850's: The New Connoisseurship'.

[3] Tennyson's Dedication to the *Idylls of the King*. Although the first four Idylls were published in 1859, the dedication was written after the Prince's death.

[4] 'The Late Prince Consort', *Quarterly Review* 111 (January 1862): 182, 198. *The Wellesley Index to Victorian Periodicals*, vol. 1, attributes the article to Lady Eastlake.

Cole was the other major influence in reviving the Society of Arts. He joined the society in 1846, after his successful efforts to promote the introduction of penny postage and to bring order to the Public Record Office, where he remained officially employed until 1852. Like the Prince, he was a born reformer, and he shared Albert's interest in applying art to industrial production. Under the pen name Felix Summerly, he had compiled several guides to the contents of national monuments and collections, and he had published a series of children's books with illustrations by leading artists.[1] He had had firsthand experience with applied art in 1845, when the Society of Arts offered prizes for producing beer jugs and tea services for everyday use. Working at the British Museum to consult 'Greek earthenware for authority for handles', Cole designed a tea service and persuaded Herbert Minton to manufacture it.[2] Not only did Cole's tea service win the society's silver medal in 1846, but Minton found great public demand for 'Felix Summerly's service'. Encouraged, Cole became convinced that 'an alliance between fine art and manufactures would promote public taste, and conduce to the interest of all concerned in the production of art manufactures'. Accordingly, in 1847, he organized a group of artists, designers, and manufacturers to produce a series of items entitled Summerly's Art Manufactures.[3]

With the combined talents of Cole and Prince Albert, the Society of Arts launched a series of industrial exhibitions in 1847 through 1849, that drew increasingly large crowds. When 100,000 people visited the exhibit of British manufactures in 1849, Cole and the Prince realized that the time had come to expand their horizons.[4] They began to lay the groundwork for a great ex-

[1] For his various encounters with what he called the 'Technical Arts', see Cole, *Fifty Years*, 1: 98–103. Some of Summerly's guides are preserved in *Miscellanies by Henry Cole, C.B.*, vol. 7, in the library of the Victoria and Albert Museum.

[2] Cole, *Fifty Years*, 1: 104–5.

[3] Ibid., 1: 106–9. The Prince fully supported the endeavour. In his 1846 presidential address to the Society of Arts, he had already spoken of the pressing need to foster 'most efficiently the application of the Fine Arts to our manufactures'. Speech quoted in Pevsner, *High Victorian Design*, pp. 13–14.

[4] Cole, *Fifty Years*, 1: 379–80, 2: 211; C. H. Gibbs-Smith, comp., *The Great Exhibition of 1851: A Commemorative Album* (London: Victoria and Albert Museum, HMSO, 1950), pp. 5–6; and *The Crystal Palace Exhibition Illustrated Catalogue* (London: George Virtue for the *Art-Journal*, 1851; re-

position of national industrial production, such as the French Government had sponsored periodically since the end of the eighteenth century. In the course of the planning, the project became international in scope and grew to fill Joseph Paxton's Crystal Palace in Hyde Park. The Royal Commission, appointed early in 1850 to supervise the arrangements for the Exhibition, consisted of distinguished artists, engineers, leading members of both political parties, and the Prince Consort as president. Cole was a member of the executive committee on which the principal responsibilities fell.

The Great Exhibition offers such a wealth of information—statistical, anecdotal, social, political, and psychological—about mid-nineteenth-century England that it fully merits the vast assortment of books that have been devoted to various facets of the subject. Only three aspects, however, are significant here: the Exhibition's financial backing, the place of the arts in the Crystal Palace, and the influence that the spectacle ultimately exerted on British art education.

From the start, the advocates of the 1851 Exhibition knew that the British Government would not follow the French example of subsidizing such an endeavour. Furthermore, they did not want it to. A national enterprise, they believed, should be supported by voluntary contributions from across the country, in order to mirror the spirit of individual initiative that had raised British industry to international predominance. On 17 October 1849, in a speech at the Mansion House, Cole sought to arouse public support for the project and professed the conviction

> that no public works are ever executed by any foreign government which can vie for magnificence, completeness, and perfection, with those that our countrymen execute for themselves . . . The feeling of the Society of Arts and of Prince Albert is, that it would be far nobler for the English people to do the thing well for themselves, as far as they can, rather than ask the Government for assistance. (Hear, and cheers.)[1]

print ed. of *Art-Journal* Special Issue, with an Introduction by John Gloag, Dover Publications, 1970), p. xiii. The *Journal of Design and Manufactures* 1 (April 1849): 59–62, described the third of the society's exhibits.

[1] Cole, *Fifty Years*, 1: 141–2, quoted from the report of the speech that appeared in *The Times* the following day.

His experience with postal reform and the public records had no doubt shown Cole what to expect from official assistance in the form of delays, vacillation, and jobbery.

After a slow beginning, private guarantees and cash subscriptions started to accumulate, and the plan seemed sufficiently promising for the Bank of England to make the necessary financial advances.[1] Parliament certainly had no intention of appropriating funds. Throughout 1850 and 1851, whenever the matter was discussed, both Houses expressed apprehension that the Russell Government would seek public funds to assist the enterprise,[2] and, in the end, official aid was minimal. The Government assisted in corresponding with foreign countries, arranging for the use of Hyde Park, and organizing the police, but wherever such help 'entailed expense, the cost of it [was] defrayed from the funds of the Exhibition'.[3] The Commissioners, however, proved to be canny businessmen, and the Exhibition was a resounding financial success. Over six million visitors paid entrance fees ranging from one shilling to three pounds, and Exhibition receipts surpassed the half million mark. When all expenses were paid, the Commissioners were left with a handsome surplus of £186,000.[4]

Even before the final financial statement gave the ultimate stamp of approval to the Commissioners' efforts, the *Art-Journal* had drawn its own moral from the Exhibition. In its *Illustrated Catalogue*, the editors observed, 'The success which has attended the experiment may, in a great measure, be referred to the freedom of action which this dissociation from the timid councils of the government secured for its projectors.'[5] Henry Cole, who had

[1] Ibid., 1: 168–70, and *Illustrated Catalogue*, p. xvi.

[2] See, for example, *Parliamentary Debates* (Lords), 3rd ser., 112 (4 July 1850): 866–90; (Commons), 3rd ser., 112 (4 July 1850): 901–35; 115 (3 April 1851): 1020–9. Lord John Russell, as a member of the Royal Commission for the Exhibition of 1851, as well as head of the Government, defended the Commission's plans against the onslaught of its critics. Concern for property bordering on the Hyde Park site, fear that hordes of foreign vagrants would descend on London, along with thousands of native visitors, the spectre of red republicanism, and the inviolability of the public parks—all figured in the opposition to the Exhibition, led by the xenophobic Colonel Sibthorp, a Tory extremist.

[3] Cole, *Fifty Years*, 2: 211.

[4] Gibbs-Smith, *Commemorative Album*, pp. 32–4, offers detailed facts and figures.

[5] *Illustrated Catalogue*, p. xiii.

already learned that lesson, found his opinion confirmed by the Great Exhibition. When he became a departmental official shortly afterwards, he applied his faith in the value of voluntary endeavour to a nation-wide programme of art education.

Among the thousands of exhibits of machinery, raw materials, and manufactured goods inside the Crystal Palace, little room was found for the fine arts. They did not belong in an Exhibition of the Works of Industry of all Nations, and the Commissioners decided to admit art as a fourth category of exhibit only under very restricted conditions. The *Official Descriptive and Illustrated Catalogue of the Great Exhibition* explained, in the introduction to the fine arts section, that the Exhibition had 'relations far more extensive with the industrial occupations and products of mankind than with the Fine Arts. . . '. The fine arts themselves were not relevant to the Exhibition's purposes, but, as illustrations of mechanical processes, they could claim a legitimate place. 'Paintings, as works of art, are excluded', the *Official Catalogue* pointed out; 'but, as exhibiting any improvements in colours, they become admissible. When admitted, they are to be regarded not so much as examples of the skill of the artist, as of that of the preparer of the colours.'[1] Thus the Fine Arts Court was filled with oddly assorted enamels, mosaics, paintings, chromolithographs, ivory and wood carvings, all illustrating technical improvements. The Commissioners also included statuary, since mechanical techniques were applied to the actual carving and casting, and sculpture of all sizes and subjects decorated the Crystal Palace.[2]

It was unfortunate that the Commissioners did not exclude art altogether. The Great Exhibition was, essentially, a trade fair, grander in scope than any previous one, heralded with proclamations of international peace and friendship, but aimed primarily to stimulate international commerce for the sake of the British economy. It was a sort of paean to the promised bounties of free trade between nations, and the arts could only suffer from display among the exhibits. There was a real danger that art and technology would become increasingly confused in a society agog over technical innovations, and in which even the most educated

[1] *Official Catalogue*, quoted in Pevsner, *High Victorian Design*, pp. 120–1.
[2] Ames, *Prince Albert*, p. 82; Christopher Hobhouse, *1851 and the Crystal Palace* (New York: E. P. Dutton & Co., 1937) p. 114; and Steegman, *Victorian Taste*, pp. 221–2.

were likely to succumb to the confusion. In a lecture delivered to the Society of Arts in November 1851, Dr. William Whewell, Master of Trinity College, Cambridge, praised the 'machine with its million fingers work[ing] for millions of purchasers'. While in more primitive nations, 'Art labours for the rich alone,' he asserted that 'here she works for the poor no less'.[1] Clearly, the art which he described emerged from the factory, not the studio. The Great Exhibition gave considerable support to the attitude that demanded of art some profitable purpose or instructive lesson. The subordination of art to commercial ends, which first received official endorsement in the 1830s, became part of a widely shared public sentiment in the 1850s and 1860s.

While the Great Exhibition was an unqualified financial success and displayed British technology to advantage, it posed some unflattering questions about that elusive commodity, public taste. Fourteen years of effort by the Schools of Design had not raised British industrial design to the quality of French production. 'I freely admit,' Cole told the Society of Arts in December 1852, 'that in the execution of art applied to industry, the French are, upon an average, better educated and better workmen than ourselves.'[2] Ralph N. Wornum made a more sweeping criticism of English craftsmanship. In his essay, 'The Exhibition as a Lesson in Taste', which won the *Art-Journal*'s prize of one hundred guineas for an essay on the Exhibition, Wornum deplored the decorative style lavishly displayed in the Crystal Palace. He found the designs overly ornate, and inappropriate to the purposes of the objects they adorned. While European manufactures in general suffered from such excess, English work especially betrayed its inferiority.[3] The *British Quarterly Review* observed: 'We have learnt from the Great Exhibition that there are numer-

[1] 'Dr. Whewell on the General Bearing of the Great Exhibition', *Lectures on the Progress of Arts and Science, Resulting from the Great Exhibition in London* (New York: A. S. Barnes & Co., 1854), pp. 14–15. The English edition of the volume was published in 1852 under the title *Lectures on the Results of the Great Exhibition of 1851*. Whewell's lecture was the first of this series, delivered before the Society of Arts on the suggestion of Prince Albert.

[2] Cole, 'The International Results of the Great Exhibition', quoted in *Fifty Years*, 2: 251.

[3] Wornum was an art critic, lecturer at the School of Design, and subsequently keeper of the National Gallery. The essay appeared at the end of the *Art-Journal*'s *Illustrated Catalogue* and ran for 22 unnumbered pages.

ous points in which we are inferior to the foreigner, and in some, as in the principles of design, and the science of coloured harmony, we are lamentably ignorant.'[1] The taste shown by consumers was as much to blame as that of the producers. Most of the Exhibition's visitors came to gape and admire. Few, like the young William Morris, fled in disgust and dismay. Obviously, the programme to train artist-artisans, undertaken by the Schools of Design, had neither produced skilled designers, nor taught the public to demand higher standards of excellence. The quality of industrial design and the nature of public demand were interdependent, and any future scheme of art education would have to take both factors into account.

[ii]

The Great Exhibition had demonstrated how far the Schools of Design had fallen short of their original purpose. To Cole, it came as no revelation. Since 1848, he had been campaigning for total reform of the national Schools of Design. He was certain that he could accomplish the reorganization needed to put the schools on an effective basis, and for two years he preached that message, through various means, to the Board of Trade.

Cole's official connection with the Board had begun in 1848 when the creator of Summerly's Art Manufactures was invited to report on possible improvements in the Schools of Design. In typical fashion, Cole wrote no fewer than three reports, in the last of which he advocated nothing 'short of a complete change of system'.[2] Fearing to lose the matter in the shuffle of departmental papers, Cole used his influence with Thomas Milner Gibson, the Liberal M.P. for Manchester and a former vice-president of the Board of Trade, to obtain a select committee in March 1849 'to inquire into the Constitution and Management of the Government School of Design'.[3] Cole, when called before the

[1] Art. V, *British Quarterly Review* 16 (August 1852): 144. The article repeatedly stressed 'the growing feeling that English industry must be properly sustained by industrial instruction' (p. 144).

[2] Cole, *Fifty Years*, 1: 114.

[3] Ames, *Prince Albert*, p. 83; Bell, *Schools of Design*, p. 222; and *Parliamentary Papers* (Commons), 'Report from the Select Committee on the School of Design', p. ii. The term 'Government School of Design' referred to the central London school and all its branches.

committee, argued for more strictly commercial and industrial studies at the schools, both in London and at the branch locations. While expressing the opinion that 'the Government should not attempt to do those things which the public can do for itself', he conceded that 'there being at the present time no public demonstration that the public itself can look after design, it is a proper thing for Government to do, if they can do it and will do it, and will learn how to do it properly'.[1] Implicit was the assertion that, as yet, the Government had not learned to do it properly. Cole was disappointed that the committee's final report was far less critical of the school than the draft report which he had had a hand in composing. Nevertheless, the committee had been useful in collecting information that showed the increased cost of the branch schools, declining local interest in them, and failure to develop a consistent teaching programme or to produce significant numbers of ornamental designers.[2] It was precisely the sort of information Cole wanted.

The most effective weapon which Cole aimed against the Somerset House system of art instruction was a new periodical which he launched in March 1849. The monthly *Journal of Design and Manufactures* was devoted exclusively to the cause of industrial design. With numerous illustrations and an innovative use of actual sample textiles and wallpapers, the *Journal* stressed its main principles that design and purpose must be in harmony, that beauty of form must coexist with utility. Among the men affiliated with Cole in this venture were two artists with long and frustrating experience in the affairs of the Schools of Design, William Dyce and Richard Redgrave, as well as Matthew Digby Wyatt, and Owen Jones, the architect and ornamental designer.[3] Cole was gathering around himself a corps of men who shared his views and participated in various enterprises on behalf of industrial art. Redgrave and Dyce were associated with Summerly's Art Manufactures; Digby Wyatt served as secretary to the Executive Committee of the 1851 Royal Commission; and Jones was largely responsible for the interior decoration of the Crystal

[1] Report, pp. 286, 188–9.

[2] See the draft report which the committee chairman, Milner Gibson, proposed, in the Report, pp. xiii, xvi, xxvi. Bell, *Schools of Design*, pp. 234–8, describes the committee's struggle over its report.

[3] Pevsner, *High Victorian Design*, pp. 139–40.

Palace. Together they waged an unceasing campaign against the Schools of Design.[1]

From the first issue, the *Journal of Design and Manufactures* spared the schools no criticism. In March 1849, it published a 'History of the Constitution of the "Government" School of Design and its Proceedings', in which the author declared the school to be a 'complete failure'. In April, the *Journal* gloated at the appointment of the Select Committee on the School of Design and trusted that the committee would 'not leave this vexed question until the schools are wholly reformed and taken clean out of the charge of all *dilettanti* half-informed bunglars. . .'. It doubted the existence 'out of all last year's manufactures, [of] any ONE single useful article of *first-rate* quality which is the unassisted design of a pupil who has been *wholly* educated in these schools'.[2] The barrage continued month after month, until February 1852, when Cole finally obtained what he wanted. Thereafter, the *Journal* ceased publication.

The School of Design did not, however, lack defenders who viewed it as something more than a factory annex. Wornum, for one, challenged Cole's view that instruction in the schools should be dictated by industrial considerations. In two articles in the *Art-Journal*, he argued 'that there is a distinct study of design or Ornamental Art wholly independent of its application'. Factory operatives, he claimed, received sufficient industrial training on the job. What they needed, and wanted, was 'cultivation of their taste', and 'aid in the principles and general capabilities of ornamental Art'. With the technological processes of manufacture changing rapidly, the Schools of Design could not possibly provide adequate instruction in the latest methods, using the most modern machines. Furthermore, conditions at different factories within any one trade varied widely. The schools' true business, therefore, was 'to offer instruction of the highest description to all who desire to obtain a knowledge of ornamental Art, and to

[1] Cole, *Fifty Years*, 1: 108. The *Journal* accomplished more than the embarrassment of the schools' managers, however. It also advocated improved copyright laws for designs, and helped to promote passage of the Designs Act, 1850, which was extended in 1851 to afford better protection to exhibitors at the Crystal Palace.

[2] *Journal of Design and Manufactures* 1 (March 1849): 24–6; (April 1849): 63–4.

supply a complete and systematic course of education in relation to every kind of decorative work'.[1]

Wornum's defence appeared too late to affect the fate of the schools. In January 1852, the Board of Trade asked Cole to assume their management. Both Henry Labouchere, the President of the Board, and Earl Granville, the Vice-President, had served on the Royal Commission of 1851 and had had ample opportunity to witness Cole's expertise in handling the administrative details of the Exhibition. Once international competition in the Crystal Palace had shown the continued inadequacy of British industrial design, they decided to entrust him with the schools' reform.

Cole immediately wrote to Labouchere, stipulating what he regarded as the prerequisites for successful reorganization. He wanted the Government School of Design to become a separate department of the Board of Trade, with its own secretary to deal directly with the President or Vice-President of the Board. He sought to eliminate the divided responsibility and authority of managerial committees and to bypass the petty tyranny of the Board's permanent subordinate officials. He suggested that the new division be called the Department of Practical Art.[2] By the end of the month, Labouchere informed Cole that 'the Chancellor of the Exchequer and he had agreed to enlarge the School of Design and change its name'. On 31 January, the Treasury formally sanctioned the arrangement by which the new Department of Practical Art was placed under the control of a general supervisory manager, devoting his full time to the Department, at an annual salary of £1,000. A professional artist was to assist and advise him, on a part-time basis, for £300 a year.[3] Cole became the Superintendent of General Management and Redgrave the art adviser.

The two men immediately threw themselves into the work at hand. In March, they submitted departmental estimates for the

[1] R. N. Wornum, 'The Government Schools of Design', *Art-Journal*, n.s., 4 (January 1852): 16 and (February 1852): 38–9.

[2] Cole, *Fifty Years*, 1: 295–6.

[3] Ibid., 1: 296–7. Cole 'rather objected' to sharing authority with a second director, but Labouchere said 'this ought to be at [the] beginning, and changes might be made afterwards'. See the correspondence between the Treasury and the Board of Trade, in an appendix to the 'First Report of the Department of Practical Art', in *Parliamentary Papers*, vol. 54 (1852/53) (*Reports from Commissioners, Inspectors, and Others*), pp. 297–8.

coming year to Joseph W. Henley, Labouchere's successor in the Earl of Derby's short-lived Government. Parliament voted the funds, and with a budget of £10,050, plus an additional £7,870 for the branch schools, the Department of Practical Art began its existence.[1] In his first annual report to the Board of Trade, Cole outlined the three main objects for which the Department worked during its first year:

> 1st, General Elementary Instruction in Art, as a branch of national education among all classes of the community, with the view of laying the foundation for correct judgment, both in the consumer and the producer of manufactures; 2d, Advanced Instruction in Art, with the view to its special cultivation; and lastly, the Application of the Principles of Technical Art to the improvement of manufactures, together with the establishment of Museums, by which all classes might be induced to investigate those common principles of taste, which may be traced in the works of excellence of all ages.[2]

In Cole's statement of the Department's goals, his apparent concessions to the demand for general art education, voiced by Wornum and others, represented no real retreat from the views which he had reiterated from the late 1840s. Like Wornum, Cole recognized a pressing need to educate public taste, and his advocacy of elementary art instruction was motivated by that need. But his interest in the quality of public taste remained rooted in his concern for the quality of British industrial production, and even in designing a general art education programme for the Department of Practical Art, the functional aspects of such training remained uppermost in Cole's mind. At the start of his career as a departmental administrator, he never lost sight of the commercial purpose behind the new system of art schools which he and his colleagues at the Department were busily preparing in 1852.

The first departmental aim, to spread art 'among all classes of the community', was the most important aspect of the Department's activities, and inspired its pioneering endeavours in the

[1] *Parliamentary Papers*, vol. 54 (1852/53) (*Reports from Commissioners, Inspectors, and Others*), 'Second Report of the Commissioners for the Exhibition of 1851', p. 71.

[2] 'First Report of the Department of Practical Art' (January 1853), p. 2.

establishment and development of local museums and art exhibits. Cole had recognized in the Great Exhibition the general indictment of public taste which Wornum issued in his prize essay, and he realized that any increased effectiveness of state-aided art instruction had to be predicated on widespread education in the principles of good design. It was this belief that prompted the first national effort to introduce art into elementary education in the United Kingdom.

With the approval of the Committee of the Privy Council on Education, the Department of Practical Art undertook not only to teach elementary art in primary schools throughout the country, but also to train school-teachers to carry on the work themselves, with models and examples prepared by Cole and Redgrave.[1] The Department established a class for these teachers, which met on Saturdays in London, 'for the purpose of learning the course of elementary instruction recommended by the Department', and arranged for a trained master to impart instruction to school-teachers too far from the metropolis to attend the Saturday class. The Committee on Education considered requiring art instruction at the teacher training schools under its inspection, or at least demanding 'a certain proficiency in drawing . . . by each student on account of whose examination the Training School receives a grant'. In principle, the Committee recognized 'that the power of accurately delineating the forms of objects, ought no longer to be regarded as an accomplishment only, or as the result of some rare natural aptitude, but as an essential part of education'.[2] Art at last had lost its official status as a polite, aristocratic skill and received significant acknowledgement of its importance in general education. With this endorsement, Cole and Redgrave could pursue their programme vigorously.

Their major responsibility, and the reason for their appointment, was to reform the Schools of Design, whose costs had risen considerably since the early 1840s. The branch schools led a pre-

[1] The training of these teachers actually began in 1851, with the cooperation of the Board of Trade and the Education Committee, but was extended and regularized by the Department of Practical Art. 'First Report of the Department of Practical Art', p. 3. This form of teacher training should not be confused with the preparation of masters for local art schools which, as another of the Department's programmes, will be discussed below.

[2] Ibid., pp. 4–7.

carious existence, managed by local committees with no knowl-
edge of art or design, and demanding more and more aid from
Somerset House as local voluntary subscriptions dwindled away.
The public had expected tangible and immediate results from
these first state-aided ventures in art education, and lost interest
when the schools turned to teach what the artisan-students
needed most—elementary instruction in drawing.[1] Cole believed
that solid local support could provide the only secure foundation
for art schools, and the experience of the Schools of Design had
proved to him 'that the more the Government aided, the less the
locality did for itself'. 'It therefore became necessary,' he explained
in the first report,

> to change the system, unless art was to be taught only as a
> charity; and the Board of Trade resolved, not indeed to dis-
> courage any local desires for art education, but to measure the
> expression of them by the local acts, to take performances
> rather than promises as the grounds for rendering assistance,
> and to endeavour to establish a self-acting system.[2]

Art education, in other words, would be based on the principles
of self-help and voluntary initiative.

The Department of Practical Art therefore announced a new
set of requirements for financial aid in establishing local art
schools. As part of the plan to further general art education, the
Department stipulated that no school of art[3] could be founded
unless:

> *three* existing local public schools [were] willing that the whole
> of their scholars (both boys and girls) should receive at least
> one lesson in drawing during the week, and each school must
> pay to the master attending not less than £5 a year for such
> instruction. Each of these schools must provide at half the
> prime cost, copies and models, etc. according to their means.

[1] See the discussion of the decline of the Schools of Design in W[illiam]
B[ell] Scott, 'Ornamental Art in England', *Fortnightly Review*, n.s., 8 (October
1870): 402–3. Scott, a painter, poet, and writer, was affiliated with branch
schools of art under both the old and new dispensations.

[2] 'First Report of the Department of Practical Art', p. 8.

[3] No longer called a School of Design.

These arrangements *ensure* that considerable numbers will be taught drawing in return for Government aid.[1]

The locality had the further responsibility of providing and maintaining the premises for the district's art school, and the central Department agreed to supply the school with 'casts, models, and one set of examples at half the prime cost, which is about £35 for a distinct school of art'.[2] The local committee of management also had to undertake to offer midday classes at the art school for a moderate fee, as well as evening classes at a lower rate. The latter provisions were intended to make art instruction available to adults, particularly workers whom Cole was eager to attract to the new schools. Half of the fees were paid to the art master, whom the Board of Trade guaranteed an income of £70 for the first year, should the fees prove inadequate. Thus the Department of Practical Art and the Board of Trade, while controlling to a large extent the course of art instruction throughout the country, had little to do with the management or expenses of the new local art schools, which were designed to form a 'more self-supporting system'.[3]

For a while, therefore, two sets of art schools existed simultaneously in the United Kingdom: the old Schools of Design, which were gradually altered to meet the Department's regulations, and the new local schools. The first of the latter was established at Waterford, Ireland, in October 1852. A school subsequently founded at Chester was already self-supporting by the time that Cole wrote the Department's first report, and applications for art masters and state assistance had been received from

[1] 'First Report of the Department of Practical Art', pp. 8–9. These provisions mark a major distinction between the old and new systems. The old Schools of Design had no responsibility to extend the teaching of elementary art outside the art school itself. In the Department's reports, the term 'public school' should be understood in the American rather than the British sense.

[2] Ibid., p. 9. Under the former system, local Schools of Design received examples gratuitously.

[3] Ibid. There were good reasons for believing that manufacturers would be willing to contribute towards local art education in the 1850s. Not only had the Great Exhibition helped to form a public attitude favourable to industrial education in general, but the prosperity which British industrialists enjoyed in this decade tended to stimulate their interest in supporting educational schemes with potentially profitable applications.

140 localities.[1] In succeeding years, the Department broadened its
efforts to introduce elementary art education into the curriculum
of primary or parish schools. By 1863, 71,423 children 'attending
parochial schools [were] receiving one or two drawing lessons a
week from the master of the neighbouring School of Art, or from
some of his assistants, or from their own schoolmaster in case he
held a certificate of competency from the Department'.[2]

In London, the central School of Design underwent similar
reorganization in the interests of efficiency and economy. In
keeping with Cole's conviction that the school's real business was
to teach design for manufactures, special technical classes were
established in practical construction, wood engraving, painting
on porcelain, 'and Decorative Art in all kinds of Woven Fabrics
and Paper Staining, and in Metals, Furniture, and Jewellery'.[3]
This was the advanced instruction in art, which Cole had listed
at the opening of the first report as one of the Department's
principal objectives, and the technical classes received his particu-
lar interest.

Higher instruction in art and design, which had been available,
in theory at least, at the branch Schools of Design, became con-
centrated at the London school, while the new local art schools
served primarily to provide basic elementary preparation in
drawing. A system of scholarships was created to enable promis-
ing pupils at local schools to attend classes in London, but so
limited was the art instruction in local schools prior to 1852, that
outside the metropolis only five students were found with the
necessary qualifications.[4] Gradually the central school in London
became a teacher-training school to prepare masters for the
country's branch schools. In 1853, when the Department moved
the school from Somerset House to Marlborough House, it was
renamed the 'Normal Training School of Art', and by 1856,
the Department reported that its central London school was
'chiefly a training-school for teachers, although the public, on
the payment of fees, [were] enabled to take advantage of

[1] Ibid., pp. 9–10.
[2] *Parliamentary Papers* (Commons), 'Report from the Select Committee on
Schools of Art', 1864, 12: v.
[3] 'First Report of the Department of Practical Art', pp. 16–17, 19–22, and
Macdonald, *Art Education*, p. 169.
[4] 'First Report of the Department of Practical Art', pp. 38–9.

the high instruction furnished for the masters of provincial schools'.[1]

The third departmental goal which Cole specified in his first report was the establishment of museums in connection with 'the Application of the Principles of Technical Art to the improvement of manufactures'. From the very start of its existence, a principal part of the Department's efforts and funds were expended on its museum, known over the years as the Museum of Manufactures, the Museum of Ornamental Art, the South Kensington Museum, and finally the Victoria and Albert. So successful was the Department in assembling a distinguished collection of applied art and other objects that, in the public mind, the Department came to figure as little more than its museum. The educational purpose that underlay the museum's development was clearly stated in the Department's first report:

> Indeed, a Museum presents probably the only effectual means of educating the adult, who cannot be expected to go to school like the youth, and the necessity for teaching the grown man is quite as great as that of training the child. By proper arrangements a Museum may be made in the highest degree instructional. If it be connected with lectures, and means are taken to point out its uses and applications, it becomes elevated from being a mere unintelligible lounge for idlers into an impressive schoolroom for every one.[2]

[1] Cole, *Fifty Years*, 1: 299; *Parliamentary Papers*, vol. 28 (1854) (*Reports from Commissioners, Inspectors, and Others*), 'First Report of the Department of Science and Art', pp. xli–xlii; and *Parliamentary Papers*, vol. 24 (1856) (*Reports from Commissioners, Inspectors, and Others*), 'Third Report of the Department of Science and Art', p. xii. Macdonald, *Art Education*, pp. 172–4, describes the general fee-paying students, in both the central and branch schools. In the latter, by the 1860s, they outnumbered the prospective teachers and artisans for whom the schools were meant to exist. Most of the general students were aspiring artists 'in this age of Leighton, Watts, Millais, and Landseer, when more paintings were being sold than in any other half-century'.

[2] 'First Report of the Department of Practical Art', p. 30. Ames, in *Prince Albert*, pp. 118–19, discusses the novelty of the art museum as an instrument of general education, which Prince Albert, Cole, and their associates 'created . . . in less than a decade'. While the educational value of museums was widely recognized long before 1852, the Department's museum was the first national collection in the United Kingdom explicitly founded as an agent of instruction.

This conviction guided the growth of the institution during its formative years.

Under the old regime at Somerset House, some weak attempts had been made to establish a museum of applied art, but the Great Exhibition prompted the first serious effort to build a collection, and furnished the objects that formed its core. At the close of the Exhibition in October 1851, Parliament sanctioned the expenditure of £5,000 to purchase exhibits that might serve as models of design in a national museum of art manufactures. The Board of Trade appointed Cole, Redgrave, Pugin, and Owen Jones as a committee to make the selection, which embraced both European and Oriental work. Subsequently, these objects were moved to Marlborough House, which became the Department's London headquarters.[1]

Gifts and loans rapidly enriched London's newest museum. In 1853, the Department organized a loan exhibition of valuable furniture and cabinet work, including pieces from Windsor and Buckingham Palace, together with contributions from the Earls Granville and Amherst, the Duke of Devonshire, Baron de Rothschild, and numerous other noted collectors.[2] A small portion of the Marlborough House museum, and one which aroused much public interest, was devoted to displaying alleged errors in taste. All variety of manufactures—glass, pottery, carpets, anything that deviated from the principles of design approved by the Department—were exhibited as a warning to producers and consumers.[3] The venture was short-lived, for victimized manufacturers complained loudly; yet it left no doubt of the dogmatic certainty with which the Department set about its business. Taste was not a

[1] 'First Report of the Department of Practical Art', pp. 30–1, and Ames, *Prince Albert*, pp. 97–8. The accommodation at Marlborough House was granted by royal permission when the General Registrar of Births, Deaths and Marriages required the Somerset House apartments. In *Fifty Years*, 1 : 283, Mr. Herbert, R.A., a veteran instructor and administrator at the London School of Design, is also mentioned as a member of the museum's first selection committee.

[2] 'First Report of the Department of Practical Art', p. 32; and 'First Report of the Department of Science and Art', pp. liii–liv, 299. This was the first of many loan exhibits organized by the Department.

[3] Dickens publicized this 'House Full of Horrors', in *Household Words*, 4 December 1852. Also see Cole, *Fifty Years*, 1 : 285–6, and 'First Report of the Department of Practical Art', p. 33.

matter of opinion for Cole and his colleagues, but a question of fixed principles.

The Department tried to make the museum's collections as widely accessible to the public as possible. Admission was free two days of the week, while three days were set aside to allow the Department's pupils peace and quiet for purposes of study. Anyone willing to pay 6d. on those days, however, was considered a student, and duly admitted.[1] The Board of Trade sanctioned arrangements to allow local art schools to borrow articles from the museum for two months during the summer and to purchase duplicate items at half their cost to the Department. By 1855, a circulating museum had been formed, 'consisting of about 400 specimens and representing each section of the central Museum'. Its purpose was 'to bring home the specimens of the London Museum to the provincial towns, with the view of improving the state of art-manufactures in them', and by early 1856, over 55,000 persons had seen the exhibit in Birmingham, Nottingham, Macclesfield, Norwich, and Leeds.[2] In 1853, 125,000 people visited the Marlborough House museum, with over five thousand crowding the rooms 'most inconveniently' on certain holidays.

Cole watched proudly as the Department's collections expanded with varied acquisitions. At the end of 1853, he could boast that 'within its moderate compass, there is probably no European collection of ceramics more complete or comprehensive'.[3] Two collections particularly enhanced the museum's reputation during the 1850s, and indicate the nature of the Department's working relations with the Treasury. In 1854, Prince Albert and Cole became interested in the Bernal collection, an extraordinary array of objects representing assorted art manufactures from the Byzantine period to the eighteenth century, which had been brought together by the late Ralph Bernal, a Whig M.P. His executor first offered the collection to the nation, but the price was higher than the Government was willing to spend. After much negotiating, the Treasury agreed to permit the Department to pay no more than £12,000 for portions of the collection. The Society of Arts

[1] 'First Report of the Department of Practical Art', p. 33.

[2] 'Third Report of the Department of Science and Art', pp. xiv, 73.

[3] 'First Report of the Department of Science and Art', pp. liii, liv. By then, the Department had purchased the extensive Bandinel collection of porcelain and earthenware.

unsuccessfully petitioned the House of Commons to purchase the entire collection, reminding the legislators of past losses, such as the Lawrence drawings, whenever considerations of short-term economy had been allowed to prevail. Gladstone, then Chancellor of the Exchequer,

> imposed the condition that the Department was to price every object and not to exceed the price named; and if there was any balance on the purchases, it was to be paid back, and not to be used in securing desirable objects which fetched more than the price named. The result was that a few of the very finest objects were lost.

Out of the nearly 4,300 lots, the Department purchased 725 in a sale that lasted thirty-two days during March and April 1855, and realized over £62,600. Among the items acquired for the Museum of Ornamental Art were numerous kinds of porcelain, faience, miniatures, mediaeval metalwork, jewellery, ivories, silver, armour and arms, stained and Venetian glass, cutlery, keys, clocks, watches, and furniture. Much of the general public could not understand Government expenditure on such things. *Punch*'s mock description of a sale of teacups and umbrellas belonging to the 'Aarons Collection' doubtless amused many of its readers, but in no way inhibited the Department's collecting zeal.[1] Redgrave wrote enthusiastically to Cole the following September: 'What we want now are remarkable pieces of whatever we buy—some truly unique and grand specimens. . . .'[2]

The Government raised even greater difficulties over the purchase of the Soulages collection of mediaeval Italian majolica, wood carving, and bronzes. Cole learned of the collection, belonging to Jules Soulages of Toulouse, from Herbert Minton, and in 1855 travelled to France to examine it. He determined to purchase the entire collection for his Department's museum as 'it

[1] Bernal was of Jewish extraction, a fact which heightened *Punch*'s delight in parody. See Steegman, *Victorian Taste*, pp. 253–4, for a description of the sale and *Punch*'s reaction; also Ames, *Prince Albert*, pp. 121–2; Cole, *Fifty Years*, 1: 289–90; 'Third Report of the Department of Science and Art', pp. xiii–xiv; and *Parliamentary Papers*, vol. 24 (1856) (*Reports from Commissioners, Inspectors, and Others*), 'Third Report of the Commissioners for the Exhibition of 1851', pp. 40–1.

[2] Victoria and Albert Museum, *Cole Correspondence*, box 14, letter dated 21 September 1855.

would be of great use to manufactures'. Temporarily avoiding the issue of Treasury funding, Cole tried to arrange for private guarantees to ensure acquisition. There was little interest, however, until Prince Albert guaranteed £1,000, and the Department was finally able to effect the purchase at a total cost of £13,500, thanks entirely to private support. The objects were transported to England, catalogued, and opened to public display at Marlborough House in December 1856. Lord Palmerston inspected the collection, accompanied by an anxious Cole, and pronounced his verdict. As the Battle of Styles over the design for new government offices subsequently confirmed, Palmerston had no sympathy with the mediaeval style. His tastes were classical, and, at his advanced age, he was not prepared to change his mind. Looking at the majolica, he asked Cole, 'What is the use of such rubbish to our manufacturers?' He certainly had no intention of recommending the purchase of the collection for the nation, and, according to the financial arrangements which Cole had concluded, it had to be sold. The Soulages collection was purchased by the executive committee of the Manchester Art Treasures Exhibition of 1857, and very gradually the Department of Science and Art bought it back piecemeal, under the restrictions imposed by its annual parliamentary grant.[1]

The incident underscores the extent to which a purely commercial point of view dominated both the Department's and the Government's attitude towards the museum; invariably, the foremost consideration involved potential benefit to manufacturers. In 1863, Cole prepared a memorandum, outlining the principles to be followed in enlarging the museum's collections. He confined purchases 'to objects wherein fine art is applied to some purpose of utility',[2] and, so long as Cole was in charge, this was always the rule. The fate of the Soulages collection also illustrates the obstacles that blocked any attempt to establish long-range goals for the arts in Great Britain at this time. When state support depended on the predilections of opinionated ministers, chances for effective planning were slight. Nevertheless, the museum thrived on gifts, bequests, and purchases until Marlborough House no longer had room for its contents, and the collections had to be moved to more spacious quarters. By the end of the

[1] Cole, *Fifty Years*, 1: 290–4.
[2] Ibid., 1: 345.

1860s, the museum was comfortably ensconced at South Kensington amid numerous buildings devoted to science and art.

[iii]

The history of the museum has outpaced the history of the Department itself, and it is necessary to return to 1852 and to the Queen's address that opened Parliament in November. In his diary, Cole recorded that 'Lord Derby introduced science and art into the Queen's speech',[1] topics no doubt advanced by Prince Albert who was keenly interested in extending scientific, as well as artistic, education throughout the country. Her Majesty informed Parliament that:

> the advancement of the Fine Arts and of Practical Science will be readily recognized by you as worthy of the Attention of a great and enlightened Nation. I have directed that a comprehensive Scheme shall be laid before you, having in view the Promotion of these Objects, towards which I invite your Aid and Co-operation.[2]

The Queen, in effect, was asking Parliament to establish an agency that would accomplish for science what Cole's Department was accomplishing for art. In response to her speech, a new organization, the Department of Science and Art, was founded that included among its responsibilities the more limited tasks of the Department of Practical Art.

The Department of Science and Art originated with a request from the Prime Minister to the Board of Trade concerning ways to implement the royal directive. In March 1853, the Board addressed a long letter to the Treasury, urging the establishment of a 'United Department of Science and Art', to operate on the same self-supporting principles that had guided the Department of Practical Art. It recommended that two secretaries, one for

[1] Ibid., 1: 305.

[2] *Parliamentary Debates* (Lords), 3rd ser., 123 (11 November 1852): 19. The Queen then proceeded to congratulate Parliament 'on the generally improved Condition of the Country, and especially of the Industrious Classes'. In the comparatively tranquil years between 1848 and the Crimean War, the British Government had the time to consider comprehensive schemes for art and science, and a healthy enough economy to make such schemes practicable.

each branch of the new department, be placed in control. The Lords of the Treasury informed the Board:

> that they entirely concur in the proposed arrangement, which will unite in one department, under the Board of Trade, with the Departments of Practical Art and Science, the kindred and analogous institutions of the Government School of Mines and Science, the Museum of Practical Geology, the Geological Survey, the Museum of Irish Industry, and the Royal Dublin Society, all of which are in part supported by Parliamentary Grants; and my Lords have given directions that the Estimates for all these institutions shall be brought together under the general head of 'Board of Trade Department of Science and Art'.[1]

Thus the Department of Practical Art, with its museums and a growing number of local art schools, joined several scientific establishments to form a single department responsible to Parliament. Cole continued in office as secretary for art, and Dr. Lyon Playfair was appointed secretary for the Department's scientific affairs.[2] They proceeded to plan a network of science and art schools connected with metropolitan establishments, which provided models and illustrations, advanced instruction, and teacher training to serve the needs of the whole country.[3]

For Cole, the groundwork was already well laid by the Department of Practical Art, and the new Department represented only a continuation of former responsibilities. The programmes and projects, planned since early 1852, progressed satisfactorily, as he wrote in the first report of the Department of Science and Art. In 1853, the Committee of Council on Education included drawing in the examination given to applicants for certification at the teacher-training schools under its inspection. Since October 1852,

[1] The correspondence between the Board of Trade and the Treasury appears in the appendix to the 'First Report of the Department of Science and Art', pp. 1–10. The Edinburgh Museum of Science and Art subsequently became affiliated with the Department.

[2] Playfair, a professor of chemistry, had served on numerous Royal Commissions, including that of 1851, when he was Special Commissioner in charge of the Juries at the Great Exhibition. In the new department's title, science significantly took precedence over art.

[3] 'First Report of the Department of Science and Art', pp. ix–x; and 'Third Report of the Commissioners for the Exhibition of 1851', pp. 19–21.

sixteen self-supporting local art schools had been established, bringing instruction in elementary drawing to forty-seven public schools in their vicinities, as well as to seventeen private schools. Many of the new art schools were so successful that the Department did not need to augment the masters' salary for the first year.[1] In London, the Normal School at Marlborough House offered classes in elementary drawing to public school teachers and more advanced art training to future masters of the local schools of art. 'Prize studentship' awards at branch art schools and scholarships to the London school encouraged the more able students to continue their studies. In all the machinery of instruction, inspection, and examinations, the new joint secretaries did not lose sight of the Department's major goal. The final sentence of their first report asserted its primary purpose: 'By these several means above stated . . . it may be hoped that the Department will continue to be instrumental in raising the character of our manufactures, as well as the intellectual appreciation of those who have to produce and consume them.'[2]

In the next decade, several significant changes affected the working of the Department. In 1855, Dr. Playfair was named sole secretary, the dual division of duties having proved inconvenient and cumbersome in practice.[3] The following year, an Order in Council finally transferred responsibility for the Department from the Board of Trade to the Committee of Council on Education, where it belonged in the first place.[4] Even more important was the adoption in the early 1860s of a system of payment on results for art instruction throughout the country. The method of basing financial aid on the results of examinations given to pupils at various levels of art training was similar to the system of funding already established by Parliament for general primary

[1] 'First Report of the Department of Science and Art', pp. xxi, xxiv–xxviii. By 1856, there were sixty-four branch art schools. 'Third Report of the Department of Science and Art', p. xxii. See note 1, p. 110, for the Department's use of the term 'public schools'.

[2] 'First Report of the Department of Science and Art', pp. xlvii–xlix, lvii–lviii, lx–lxi, lxviii–lxix.

[3] 'Third Report of the Commissioners for the Exhibition of 1851', p. 21. Cole became Inspector General.

[4] *Parliamentary Papers*, vol. 46 (1856) (*Accounts and Papers*, February 1856), 'Order in Council for Placing the Department of Science and Art under the Education Department, and for other Purposes'.

education. Despite Matthew Arnold's protests, this mechanical, inflexible approach dominated British education for several decades.[1]

Furthermore, by the mid-1860s, Cole and his associates had largely abandoned the industrial emphasis that characterized the Department's work in its early years. The vocational classes in specific ornamental skills for industry were discontinued, and the course of instruction at departmental art schools was reorganized to emphasize principles of drawing.[2] Years of experience had taught Cole 'that State interference in any special technical teaching, founded upon the assumption of trade requirements, does not succeed'.[3] In the fighting days of the *Journal of Design and Manufactures*, he had held diametrically opposed views. In practice, however, he had come to realize that a Government department could neither mould nor meet the constantly changing supply-and-demand conditions of industry and commerce. Better to concentrate on general skill in drawing, Cole decided, and to try to ensure that at least the basic elements of pictorial art were as widely understood as possible. By the 1880s, applied art found scarcely any place in the curriculum of the departmental schools, and the central school in London was 'run solely for providing drawing, painting, and modelling teachers'.[4]

Outside the Department, the passage of the Public Libraries Act of 1855 authorized the levying of local rates to establish schools of art and science, a measure in accord with the Department's efforts to encourage self-supporting institutions of this nature.[5] The Department was also eager to further the establishment of municipal museums, as provided by legislation in 1850.

[1] 'Report from the Select Committee on Schools of Art', 1864, pp. v–vi, x–xi, xiv; and Cole, *Fifty Years*, 1: 303–4.

[2] Arnold S. Levine, 'The Politics of Taste: The Science and Art Department of Great Britain, 1852–1873', Ph.D. dissertation, University of Wisconsin, 1972 (Ann Arbor, Michigan: University Microfilms, 1972), pp. 374–5; and Macdonald, *Art Education*, p. 171.

[3] Cole, *Fifty Years*, 2: 289.

[4] Macdonald, *Art Education*, p. 294. The Arts and Crafts Movement of the 1890s helped restore craft classes to their proper place in the departmental schools, as well as earning them a prominent place in schools under the jurisdiction of the London County Council. Ibid., pp. 294–9.

[5] The opportunities for technical education provided by the Act were, however, largely ignored. Munford, *Ewart*, pp. 140–1. Ewart was once again active in steering the Act through the Commons.

It sent objects on loan to local museums, sold duplicate items from its own collections at moderate prices, and was always ready to impart advice, rules, and principles.[1] This was not the least of the ways in which the 'South Kensington system' spread its influence throughout the country.

[iv]

Before we can talk of the South Kensington system, however, some further explanations are required. The development of the complex of buildings devoted to art and science was by no means the Department's work alone. The initiative in the effort was taken by the Commissioners for the Exhibition of 1851 who had a sizeable surplus fund to put to use. Plans for the expenditure of the surplus were under discussion from the summer of 1851, when the likelihood of profit had already become a certainty. Suggestions poured into the Royal Commission from individuals and associations across the country. Numerous mechanics' institutes urged that the money be spent to establish similar institutes and art schools. Other groups called for the founding of a Central College of Arts and Manufactures, connected with provincial schools. Miscellaneous suggestions included the transformation of the Crystal Palace into a winter garden and the creation of an 'Albert Park' near London.

The overwhelming majority of the proposals, however, were educational in purpose, either recommending the establishment of schools and scholarships, or advocating the formation of national collections related to the industrial arts and sciences.[2] There was general agreement that the money should be applied to some

[1] By 1896, '33,960 objects were on loan [from the South Kensington Museum] to 55 Provincial Museums, 22 Temporary Exhibitions, 251 Schools of Art, 8 Art Classes, and 59 Science Schools'. *Parliamentary Papers* (Commons), 'Second Report from the Select Committee on Museums of the Science and Art Department', 1898, 11: xv.

Major provincial museums were established during the second half of the nineteenth century at Birmingham (1867), Liverpool (1877), Leicester (1885), Leeds (1888), and many other towns where they were supported by municipal funds, private gifts and subscriptions, or, most frequently, a combination of both.

[2] 'Second Report of the Commissioners for the Exhibition of 1851', pp. 45–55.

useful end. As the *British Quarterly Review* justly observed: 'Never was the desire for intellectual advancement more strongly expressed than it is at the present time: the expression, however, indicates but one line of direction, and that is, the useful applications of science.'[1] The Commissioners were agreed that any plan which they might adopt should continue the work of the Great Exhibition and 'serve to increase the means of Industrial Education, and extend the influence of Science and Art upon Productive Industry'.[2] They therefore dismissed all proposals to turn the Crystal Palace and its site into a pleasure garden or amusement park, and kept their serious objective firmly in mind.[3]

Conscious that Great Britain was 'the only country which has neither supplied (in any practical or systematic shape) scientific nor artistic instruction to its industrial population, nor provided, for men of Science and Art, a centre of action, and of exchange of the results of their labours', the Commissioners sought to remedy that deficiency.[4] They concluded that one large educational institution was needed, 'adequate for the extended wants of industry, and in connexion with similar institutions in the provinces'. Rather than dissipate the surplus fund among several local institutions, thereby reducing the chance to render significant assistance to any, the Commissioners proposed to establish a central institution in the metropolis, affiliated with local establishments throughout the nation and empire by scholarships and other means. The Commissioners did not, however, see themselves as the direct agents in developing this global network. They believed that they could most effectively use their funds

[1] Art. V, 16 (August 1852): 134.

[2] 'Second Report of the Commissioners', p. 9. The original terms of their charter did not empower the Commissioners to undertake further activities of this sort, and they were consequently granted a supplemental charter in December 1851, which enabled them to do so.

[3] In any case, the Commissioners were bound to remove the Crystal Palace from Hyde Park, according to the terms of the warrant that allowed them to take possession of the site. The Crystal Palace Company was formed to purchase the building, and subsequently found a permanent home for it at Sydenham, 'as a place of exhibition and amusement, to form a remunerative speculation to the shareholders'. 'Third Report of the Commissioners', pp. 13–15. The Crystal Palace continued to serve the metropolis in numerous ill-assorted capacities until it burned down in November 1936.

[4] 'Second Report of the Commissioners', p. 40.

by carefully preparing the basis and framework of a large and comprehensive plan and securing facilities for its execution, leaving it to the various interests concerned to give substance to it, whilst the perfect development of the system must be left to the progressive action of time. . . .

Without further elaborating the details of such a plan, the Commissioners concluded their second report by invoking Divine Providence and requesting the assistance of Parliament.[1]

The Commissioners especially needed parliamentary aid, because what they proposed was an extensive and immediate programme of land purchases. Recognizing the poor economy of piecemeal acquisition, in light of the spiralling costs of London real estate, they determined to obtain at least seventy acres of land across Kensington Road from the Gardens, nearly opposite the site of the Crystal Palace. They asserted that 'the present is the last opportunity of finding an unoccupied space in a desirable situation, within the limits of the Metropolis', and recommended purchasing a total of 150 acres in South Kensington 'for the development of great national objects'. The opportunity, once lost, '[could] not possibly recur'. The Commissioners resolved, therefore, to spend £150,000 of their surplus fund to acquire the site, 'upon the condition that Her Majesty's Government would engage to recommend to Parliament the contribution of a sum of like amount towards the purchases contemplated'.[2] Here was one occasion when the Commissioners did not scorn state involvement. Their own funds simply could not provide an adequate basis for future development.

Both the Government and Parliament proved responsive to the appeal. Whether moved by the spirit of the Great Exhibition to further the objects which the Commissioners urged, by wide public support for the project, or simply, as Cole suggested, by Prince Albert's persuasiveness,[3] Lord Derby's ministry cooperated with the Commissioners. Just before the Government left office in December 1852, Benjamin Disraeli, Chancellor of the Exchequer at the time, secured parliamentary approval for a £150,000 grant towards the purchases of land which the Commissioners desired.

[1] Ibid., pp. 11, 20, 41.
[2] Ibid., pp. 36–9.
[3] Cole, *Fifty Years*, 1: 319.

With £300,000 at their disposal, the Commissioners bought some eighty-six acres at South Kensington. In September 1853, when further purchases became necessary and feasible, the Aberdeen ministry requested and received from Parliament an additional grant of £25,000. By April 1856, the Commissioners reported that a total of £342,500 had been spent on South Kensington land, £177,500 of which derived from Parliament's generosity, and £165,000 from the Commissioners' fund.[1] In working out the partnership between the Commissioners and the Treasury, it was agreed that the Commissioners

> should hold the whole of the purchase (already made and to be made thereafter), subject to such directions of appropriation as should from time to time be issued by the Treasury in respect to such part, not exceeding one moiety, as should by agreement between that Board and the Royal Commissioners be set apart for such institutions connected with Science and Art as are more immediately dependent upon and supported by the Government from funds voted by Parliament. . . .[2]

A place was clearly being prepared for the Department of Science and Art in the Commissioners' 'large and comprehensive plan'.

The South Kensington estate developed rapidly. In 1854, an Act of Parliament authorized the Commissioners to make roads on the estate, and Cromwell Road, Prince Albert's Road, and Exhibition Road consequently appeared on the map of London, nearly enclosing the Commissioners' property. As the time approached to plan buildings, the Commissioners considered the numerous artistic, industrial, and scientific collections in London that suffered acutely from lack of space. Most pressing were the needs of the Department of Science and Art which, together with its museum, was scheduled soon to lose its offices, whenever the Prince of Wales should require Marlborough House. After comparing various building plans, the Commissioners opted for an iron structure, which was indestructible, easily dismantled and transported elsewhere, and moderate in cost.[3] These considerations, and the obvious need for room to exhibit the national

[1] 'Third Report of the Commissioners', pp. 9–11.

[2] For the various legal arrangements between the Treasury and the Commissioners, see Ibid., pp. 16–18; and Cole, *Fifty Years*, 1: 324.

[3] 'Third Report of the Commissioners', pp. 28, 59.

collections, persuaded Palmerston's Government to request
£15,000 for the building. The House of Commons complied in
August 1855.

The iron galleries, popularly known as the 'Brompton Boilers',
were opened to the public in June 1857. By then, a parliamentary
grant of £10,000 had enabled the Department of Science and Art
to move its offices, art school, and Museum of Ornamental Art
to South Kensington. It must have been gratifying to Cole to
have all the projects in which he took such great interest, and for
which he had provided untiring labour and initiative, finally
assembled under his watchful eye. Although he was dissatisfied
with the 'Boilers', considering them ugly and impractical,[1] they
nonetheless represented the beginning of the great complex of
institutions devoted to art and science towards which he had been
working, directly and indirectly, for a decade. The new museum,
officially known as the South Kensington Museum, housed more
than ornamental art from Marlborough House and a collection of
models and exhibits from the Crystal Palace, which the Commis-
sioners had been storing temporarily in Kensington Palace. It also
served as home for a distinguished collection of fine art, begun in
1857, when John Sheepshanks, a Yorkshire industrialist, gave
over two hundred modern British paintings to the nation. The
conditions of the gift necessitated the construction of a separate
fireproof gallery, which was opened at the same time as the
'Boilers'.[2] In 1858–9, further galleries were added to accommodate
the Vernon collection of British paintings, presented to the nation
in 1847, and the Turner bequest, both of which had been kept at
Marlborough House.[3] Cole was named director of the museum,

[1] Cole, *Fifty Years*, 1: 324.

[2] Ibid., 1: 325–6. Sheepshanks stipulated that the pictures be kept either
in a suitable building in the immediate Kensington vicinity, or else at Cam-
bridge. As there was no suitable space available in the iron building, a
special gallery was built. Also see *Parliamentary Papers* (Commons), 'Report
from the Select Committee on the South Kensington Museum', 1860, 16: v.
Sheepshanks is a good example of the many wealthy provincial collectors
who became the major patrons of contemporary British art by the 1840s.

[3] Correspondence between the Treasury and the Department of Science
and Art, 1865–6, in *Parliamentary Papers*, vol. 40 (1866) (*Accounts and Papers*),
'South Kensington Museum (New Buildings)', p. 1. While the Turner be-
quest was at Marlborough House, Ruskin worked there, cataloguing and
organizing the thousands of watercolours and drawings. The National
Gallery had no room for the Vernon and Turner collections at the time.

and, following Playfair's resignation, became sole secretary of the
Department of Science and Art. It is no wonder that he was
sometimes called, and not altogether affectionately, King Cole.[1]

As with numerous other projects dependent on parliamentary
grants, building at South Kensington proceeded largely on a con-
tingency basis for several years. By 1860, 'before any general plan
had been matured, the sum of £40,698 had been expended on
buildings so far partaking of a temporary character that they were
not designed as part of any general scheme'. Between 1860 and
December 1865, the Department of Science and Art undertook
an extensive building programme, which added to South Ken-
sington's architectural cluster two large closed courts, five picture
galleries, two art training schools, four official residences, new
workshops, barracks, stores, and offices. At the end of 1865, the
Department requested further grants from the Treasury and
finally received approval for the 'expenditure of a sum not ex-
ceeding £195,000' over several years.[2] Gradually the South Ken-
sington Museum became a rich hodge-podge of artistic, scientific,
and mechanical objects; architectural models, patented inventions,
trade and education collections, applied art from the twelfth to
the nineteenth centuries, watercolours, prints, and oil paintings
offered an overwhelming choice of exhibits for the curious and
studious alike.[3] Cole, ever aware of his responsibilities to the
greater public, made sure that working people could profit from
the assembled displays. The museum was the first to remain open
regularly on several evenings a week, setting an example for other
public institutions.

The Department's activities and influence increased over the
years. By 1873, shortly before his retirement from official life,
Cole could announce that:

> since the year 1852, I have witnessed the conversion of twenty
> limp Schools of Design into one hundred and twenty flourish-

[1] Cole, *Fifty Years*, 1: 310, 354.

[2] 'South Kensington Museum (New Buildings)', pp. 1–2, 4.

[3] 'Report from the Select Committee on the South Kensington Museum',
1860, pp. iii, v–vi, gives some idea of the variety of the museum's collections,
which served as model, not only for numerous smaller museums of applied
and industrial art throughout Great Britain, but also for several institutions
on the continent and in the United States. Levine, 'Politics of Taste', pp.
346–7.

ing Schools of Art in all parts of the United Kingdom . . . Five hundred night classes for drawing have been established for artisans. One hundred and eighty thousand boys and girls are now learning elementary drawing . . . The South Kensington Museum has been securely founded as a National Centre for consulting the best works of Science and Art, as a Storehouse for circulating objects of Science and Art throughout the Kingdom. Whilst this Museum itself has been visited by more than twelve millions of visitors, it has circulated objects to one hundred and ninety-five localities holding exhibitions, to which more than four millions of local visitors have contributed about ninety-three thousand pounds.[1]

When people spoke of South Kensington in the 1860s, they meant the Department of Science and Art, with its vast collections, National Art Training School,[2] and energetic involvement in diverse aspects of national life.

The Department was not, however, the whole of South Kensington. Over the years, the estate filled with buildings. The Royal Horticultural Society opened its gardens there; Royal Albert Hall was built, and a National Training School for Music was established in 1876, supported by private contributions and independent of Government control.[3] The National Portrait Gallery was temporarily housed at South Kensington, until it

[1] Cole's speech at the distribution of prizes to students at the Nottingham School of Art, 15 January 1873, quoted in *Fifty Years*, 2: 347.

[2] As the Department's head school in London was renamed in 1863. After 1896, it enjoyed the more prestigious title of Royal College of Art. A reorganization of the college's instructional divisions was undertaken in 1901, and finally, in 1967, England's leading art institution achieved independent university status, with the authority to grant degrees. Macdonald, *Art Education*, p. 357.

[3] The school's prospectus of management, drawn up in 1874, noted that the Committee of Council on Education had recently 'recognized the importance of Music in Elementary Education, by making a grant of one shilling on behalf of every child taught singing' in a public school. Some slight official recognition of music as an art worth supporting had come in 1868, when the Treasury began to make a regular annual grant of £500 to the Royal Academy of Music. British Information Services, *Entertainment and the Arts in Great Britain: The Story of Government Encouragement* (New York: British Information Services, 1950), p. 16; Cole, *Fifty Years*, 1: 365–77; and Henry Cope Colles, *The Royal College of Music, A Jubilee Record 1883–1933* (London: Macmillan & Co., 1933), pp. 1–4.

moved next door to the National Gallery, and after endless dis-
cussion the natural history collections of the British Museum were
transferred there.[1] Numerous other museums, teaching establish-
ments, and societies devoted to art and science settled at South
Kensington in later decades. The Royal Commission for the
Exhibition of 1851, as a permanent body legally affiliated with
the South Kensington property, came to embody the aims of the
Great Exhibition in forms less glamorous, but more substantial,
than Paxton's glass house.

[v]

The South Kensington complex did not develop quite as
smoothly as the preceding narrative suggests. From the first,
hostility was expressed towards the idea of centralizing institu-
tions of art and science in what was then considered a remote
corner of London. There were also objections to granting a
Government department sole authority over nation-wide pro-
grammes of artistic and scientific instruction. In its first report,
the Department of Science and Art sought to allay suspicions
regarding its intentions:

> this Metropolitan Establishment . . . was not to be regarded as
> an attempt on the part of the State to impose its own views of
> Science and Art, but as a healthy and perpetually progressive
> exhibition of the state of advancing knowledge; not as an
> institution for the benefit only of the residents in the metropolis,
> but as a centre of union whence students from all parts of the
> United Kingdom might derive knowledge, and carry the same
> back to their own localities.[2]

Nevertheless, when the House of Commons debated the grant of
£15,000 to construct the 'Boilers', opposition to the entire scheme
was vehement.

Three particular objections figured in the debate over grants to
South Kensington, both in 1855 and subsequently. Several M.P.s
led by Richard Spooner, the Conservative Member for North

[1] These collections joined the Department's various scientific institutions
already located at South Kensington. The National Portrait Gallery was
established in 1856, for historical, rather than aesthetic, reasons.

[2] 'First Report of the Department of Science and Art', p. xi.

Warwickshire, suspected that £15,000 would be but the first of many instalments required for the estate. They protested that no detailed plan had been laid before them, and demanded to know what would be the ultimate cost of the project before they approved any expenditure. Furthermore, many complained of the new museum's location. William Williams, a Radical, asserted that the site was 'at too great a distance from the metropolis for the people to make a proper use of it'.[1] Most significant was the animosity which no less a figure than John Bright displayed towards Cole and his associates. 'They were told that what was wanted was a temporary building,' he said:

> Well, but after it had been erected, half a dozen gentlemen, a small clique connected with Marlborough House and the Society of Arts, would pull the strings again, and the House would be told that the building was wholly insufficient ... They were all aware that there were a number of very shrewd and clever Gentlemen, who, ostensibly studying the public good ... found themselves comfortably settled with salaries of £1,000 or £2,000 a-year. His own opinion was, that it was only the beginning of a huge job.

Although the grant was voted by a majority of fifty-two, the opposition had transcended party lines and raised issues that could not be ignored.[2]

Similar opposition was expressed the following year, when the House of Commons debated a grant of £10,000 to help the Department of Science and Art move to South Kensington. Sir Henry Willoughby, the Conservative Member for Evesham, went so far as to assert 'that the best thing they could do would be to sell' the property, since it 'was too remote from the metropolis' for any useful purpose. It was left to Disraeli, a Royal Commissioner and Chancellor of the Exchequer when the land was first purchased, to defend the Commission and its relations with the

[1] As if the Great Exhibition had not proved that the western section of London was perfectly accessible to millions of people.

[2] *Parliamentary Debates* (Commons), 3rd ser., 139 (2 August 1855): 1683–1691. It is interesting that the opposition did not use the costs of the Crimean War as a principal excuse for curtailing expenditure on the South Kensington estate. Spooner mentioned 'the burdens imposed upon the country', but the opposition was motivated by considerations other than national priorities in wartime.

Government. He concluded, in phrases which must have cheered Cole, that 'it was of the first necessity to a country like England that it should cultivate the taste of its people, and bring to bear upon the productions of its manufacturing skill all the inspirations and refinements of art'. Once again, the opposition was defeated and the vote approved.[1]

For the rest of the decade, the unabated expansion of the South Kensington estate kept its critics in a constant state of irritation. Serious talk of moving the National Gallery there further exacerbated their annoyance. The Department of Science and Art seemed to them intent on devouring all independent institutions and branding them with the South Kensington stamp.[2] William Coningham, the Liberal Member for Brighton who entered the House in 1857, replaced Spooner as the leading critic of the Department, and through repeated accusations and complaints, he persuaded the House of Commons in June 1860 to appoint a select committee to investigate the South Kensington Museum. The committee, however, was anything but hostile. Neither Coningham, Spooner, nor Williams were members, and the chairman was Robert Lowe, Vice-President of the Committee of Council on Education, the body officially responsible for the Department of Science and Art.[3] The committee's report, issued on 1 August, found none of the shocking jobbery which Coningham had alleged. To the contrary, the committee members praised the South Kensington Museum for its economical purchases, its

[1] *Parliamentary Debates* (Commons), 3rd ser., 142 (6 June 1856): 1124–33.

[2] All public funds available for museum purposes were not devoted to South Kensington in these years, despite the accusations of the museum's critics. In 1869, the Royal Academy finally moved out of the National Gallery building to Burlington House, and a new wing was commenced at the gallery which opened in 1876. Some small stop-gap alterations had already been made in 1860. Furthermore, in 1855, the Treasury conceded the gallery's need for an assured annual purchase grant, and a special Exchequer grant was provided in 1871 to meet the high cost of acquiring numerous works from the Peel collection. Holmes and Collins Baker, *National Gallery*, pp. 31–2, 42, 56–9.

Parliament also recognized Scotland's need for a national gallery and authorized the allocation of £30,000 towards the construction of a building. The National Gallery of Scotland in Edinburgh was opened to the public in 1859. Harris, *Government Patronage*, p. 288.

[3] Coningham, understandably, was furious at his exclusion. See *Parliamentary Debates* (Commons), 3rd ser., 160 (14 August 1860): 1310, 1312.

clear system of arranging and labelling exhibits, the success of its circulating museum, and the popularity of its experiment in evening openings.[1] The museum was resoundingly acquitted at its first public trial.

Four years later, the Department's entire art education programme came under more probing and critical scrutiny. The Select Committee on Schools of Art, appointed in March 1864, was chaired by Sir Stafford Northcote, and included Lowe, Ewart, and Edmund Potter, a prominent Manchester industrialist who had written a pamphlet against the Department's schools in 1854. Partly prompted by the dissatisfaction which branch art school masters expressed towards the new system of payment on results, the committee conducted a balanced inquiry and published its report in July. It recognized the waste and mismanagement that had hindered the working of the old Schools of Design, and praised the improvements which the Department of Science and Art had accomplished. It seriously questioned, however, the expediency of payment on results as a system of financing art education. In a meaningful paragraph, it described the diverse ways in which the public viewed the role of art schools: while some people considered that the schools were intended primarily to aid manufactures, others saw them as part of a general education; while some called for more technical instruction in industrial processes, others desired training in the principles of high art.

Since it was clear that the Department could not always please everyone, the committee suggested that the Department should adopt an attitude of flexibility and sensitivity to local needs. The committee found payment on results inappropriate to art education because the system imposed an officially prescribed course of studies. Sir Charles Eastlake told the committee that 'a strictly defined course of instruction . . . if too rigorously insisted on . . . cramps the energies of the master, and destroys the interest of the student', and Charles Heath Wilson gave evidence to the same effect. Wilson, who had served as headmaster of the Glasgow School of Design after his experience at Somerset House, told the committee: 'I am anxious that we should not have a mere

[1] 'Report from the Select Committee on the South Kensington Museum', pp. iv, vii. Perhaps Cole helped to secure this endorsement of his work. Cole's *Miscellanies*, vol. 10, pp. 161–5, contains a draft report on the South Kensington Museum, 'as prepared by H.C. for Mr. Lowe, 25 July 1860'.

system of routine and mannerism generated by one authority operating upon the minds of the whole of the people throughout the country.' The committee members agreed. Strict regulation, they maintained, would tend 'to render the schools unpopular, and to diminish the chance of local support'. They found that the Department had already lost potential cooperation by supervising the schools without sufficient attention to the wants of the immediate localities.[1]

Without invective or hyperbole, the 1864 committee issued a just indictment of the South Kensington system of art education. Theirs were the criticisms which Cole repeatedly, but ineffectively, tried to refute. As early as November 1857, when the broad lines of the critique were already emerging, Cole insisted that the Government had 'endeavoured to obtain and preserve as much local co-operation as possible' in its educational efforts.[2] In 1873, he was still explaining that any successful attempt to spread an interest in art throughout the country required the voluntary cooperation of individuals, joined to municipal and state encouragement.[3] Cole was literally correct. The Department had always sought voluntary local cooperation, but in the form of money, not ideas. Even after the publication of the 1864 report, few significant changes were made in the operation of the Department's art schools, and payment on results was not eliminated from state-sponsored art education until 1902.

It would be misleading to suggest that parliamentary opinion veered away from the Department and ceased to appropriate the necessary funds. On the contrary, the House of Commons continued to approve large sums for the Department's expenses and building plans. Many M.P.s, both Conservative and Liberal, warmly supported the Department's work and attested to widespread appreciation of its programmes throughout the country.[4] Complaints, of course, were still raised that the South Kensington Museum 'like a sponge . . . was gradually sucking up everything

[1] 'Report from the Select Committee on Schools of Art', pp. iv–v, vii–xi, xiv–xviii, 148.

[2] Speech at South Kensington, quoted in Cole, *Fifty Years*, 2: 290.

[3] Speech at the Nottingham School of Art, quoted in Ibid., 2: 348. See note 1, p. 127.

[4] See, for example, *Parliamentary Debates* (Commons), 3rd ser., 189 (9 August 1867): 1229, 1233.

in the metropolis', and one M.P. observed that never 'in the history of the world [had] any people . . . ever acquired a taste for science and art through a Government grant'.[1] But most Members recognized that the Department was doing its job as efficiently and economically as possible.

In evaluating the broader public response to the Department of Science and Art, it is important to remember that the traditional British antagonism towards active, interfering government was still strong in the 1850s and 1860s. Much of the hostility expressed against Cole and his Department was part of a general hostility towards all efforts to establish centralized administrative control in any sphere of activity. It is significant that two of the most glowing contemporary accounts of the Department's work were written by Frenchmen.[2] Foreigners were accustomed to, and admired, effective and vigorous centralized government, especially with regard to education. The same was not yet, if ever, true of the British. For the most part, they approached such undertakings suspiciously. Edmund Potter expressed a general viewpoint in his 1854 pamphlet, 'Trade Schools', when he extolled self-reliance and independence. He saw no need whatsoever for state involvement in art education, and considered it contrary to natural economic laws. 'Only fancy a dictator on Taste!' he scoffed. 'A Pugin stamping his opinion, his Taste, on all manufactures, reversing demand and forcing supply for a period. . . .'[3]

Dickens included a trenchant parody of the Department's pedagogic methods and aesthetic attitudes in the first two chapters of *Hard Times* (1854), where an unidentified gentleman delivers a lecture to schoolchildren on how not to decorate carpets, crockery, and wallpaper. Described as a 'mighty man at cutting and drying . . . a government officer . . . always with a system to force down the general throat like a bolus', he was surely a veiled portrait of

[1] Ibid., 1238, 1234. This M.P., oddly enough, was Ralph Bernal Osborne, the Liberal Member for Nottingham, and son of the Ralph Bernal whose collection of *objets d'art* was one of the first great additions to the museum.

[2] Prosper Mérimée, 'Les Beaux-Arts en Angleterre', *Revue des deux mondes* 11 (15 October 1857): 866–80; and Paul Allard, 'L'Art-Department et l'enseignement du dessin dans les écoles anglaises', *Gazette des Beaux-Arts* 23 (1 November 1867): 393–418.

[3] 'Trade Schools', p. 21, in Edmund Potter, *Pamphlets Published at Various Periods from 1831 to 1855* (Manchester: Johnson & Rawson, 1855). The several pamphlets are paginated separately.

Cole.[1] The *Saturday Review* objected to the Department for reasons of economy, believing that Government was growing altogether too expensive, even in its peripheral agencies:

> If it were possible to speak seriously on a subject which everybody treats as a standing joke, we should say that this jest of science and art is a most expensive one . . . we spent last year £125,000 on science and art, of which moderate sum the South Kensington sponge sucked up more than £96,000 . . . What we are going to spend this year we do not trust ourselves to say.[2]

The Department's most distinguished critic was John Ruskin. Throughout his life, he struggled against the values of a society which he found ugly, tasteless, and mean. In countless lectures, articles, books, and letters to the press, he expounded a theory of aesthetic criticism that was linked inseparably to his social commentary. It was from him, far more than from Pugin, that the public learned to consider art as an index of society's moral health. The scope of his vision, and the intimate relation which he sought between art and all social functions, made him strenuously oppose the system of art instruction advocated by the Department of Science and Art. He abhorred the notion that design should be considered an adjunct to industrial enterprise. England would produce quality designs for manufacture, he argued, not by forcing art to worship the 'Goddess of Getting-on', but by educating people as artists, in the spirit of art rather than commerce.[3] Even after the Department had changed the emphasis of

[1] *Hard Times*, chapter 2. K. J. Fielding, 'Charles Dickens and the Department of Practical Art', *Modern Language Review* 48 (July 1953): 270–7, presents convincing evidence that Cole was Dickens' model for this caricature. Later in the second chapter of *Hard Times*, Dickens portrayed the schoolmaster, M'Choakumchild, as one of many teachers 'lately turned at the same time, in the same factory, on the same principles, like so many piano-forte legs'. One of his acquired skills was 'drawing from models'.

[2] 'Science and Art in Parliament', *Saturday Review* 24 (17 August 1867): 215. The *Art-Journal*, in contrast, had by 1860 become one of Cole's and the Department's staunchest defenders in the press. See, for example, 'The Department of Science and Art: What It Has Done, Is Doing, and May Do', *Art-Journal*, n.s. 6 (August 1860): 225–8.

[3] See Lectures I and III of *The Two Paths*, published in 1859, for examples of Ruskin's critique of the Department's approach to industrial design. Lecture III is better known under the title 'Modern Manufacture and Design'.

its instruction from industrial application to elementary drawing, Ruskin suspected its motives. As late as 1877, he wrote:

the suddenly luminous idea that Art might possibly be a lucrative occupation, secured the submission of England to such instruction as, with that object, she could procure: and the Professorship of Sir Henry Cole at Kensington has corrupted the system of art-teaching all over England into a state of abortion and falsehood from which it will take twenty years to recover.[1]

Perhaps it was the sheer volume of Ruskin's work and the range of his interests that reduced his influence on the art curriculum taught under departmental supervision. From amidst his warnings, exhortations, and curses, there emerged no clear programme of action with which to challenge the South Kensington approach to art education. While he was up against master systematizers in the Department of Science and Art, his own theories on the subject were not neatly systematized. But that Ruskin was a major force behind the increasing public awareness of and interest in art instruction cannot be doubted. When Felix Slade, the philanthropist and collector, died in 1868 and left £35,000 to establish professorships of fine art at Oxford, Cambridge, and University College, London,[2] Ruskin was asked to become the first holder of the Oxford chair. The Slade professorships brought the fine arts into the curriculum of the country's most prestigious universities and represented a major step in the institutionalization of art in England.

The Department of Science and Art, the chief agent in that institutionalization, was bound to arouse opposition. It not only intensified, to a considerable extent, state involvement in national education, but it also offered a startling new concept of the public museum. At South Kensington, the museum was an integral part of the Department's educational programme and offered a wide

[1] 'Fors Clavigera, Letters to the Workmen and Labourers of Great Britain', Letter 79 (18 June 1877), in *The Works of John Ruskin*, ed. E. T. Cook and Alexander Wedderburn, 39 vols. (London: George Allen, 1902–1912), 29: 154.

[2] The Slade School of Fine Art, a branch of University College, opened in 1871. Contributions from the College, together with Slade's gift and additional money for scholarships, made its foundation possible.

variety of extension services that stretched its influence far beyond West London. There was much in the Department's programme that was innovative and forward-looking, and it was unfortunate that this vital part was frequently eclipsed by the dogmatic theorizing of department officials. Cole and other spokesmen for the Department shared the academic conviction that artistic models existed to be imitated. They were certain that the Department could dispense the knowledge, examples, and advice which alone made drawing a useful skill and led to the production of correct, tasteful designs. They were busy men, with little time to consider alternative methods. Besides, they thought that they already had rules and principles enough for the entire country. Cole liked to speak about the 'application of the laws which regulate beauty', and the Department's teaching materials were oppressively didactic.[1] With its emphasis on learning the rules and producing work for inspection and competition, the Department effectively reduced art to a joyless exercise for thousands of children.[2] Through centralized examinations and certificates of competency in drawing, it ensured departmental control over the preparation of teachers, both for art and primary schools, and thus perpetuated the mechanical, imitative system of art instruction.[3] The fears expressed by the 1864 Select Committee on Art Schools were valid, and it is sad that so many children were first

[1] See Cole's speech at South Kensington, November 1857, quoted in *Fifty Years*, 2: 289. The Department, however, had no monopoly on this lifeless approach to art. In 1851, David Ramsay Hay founded the Aesthetic Society in Edinburgh to ascertain the objective laws and principles of beauty, and no less a personage than Prince Albert declared that 'the Fine Arts . . . rest on the application of the laws of form and colour, and what may be called the science of the beautiful'. Speech at the Birmingham Town Hall, 22 November 1855, quoted in Lady Eastlake, 'The Late Prince Consort', p. 191. Walter Houghton, in *The Victorian Frame of Mind* (New Haven: Yale University Press, 1971), p. 145, observes that 'the Victorian mind in general was committed to the concept of absolute law. Politics, morals, history, economics, art, education—all were governed, it was thought, by universal laws or principles true for all times and places. . . .'

[2] By 1887, over 875,000 students in primary day schools received instruction in drawing through departmental auspices. Marius Vachon, *Rapport sur les Musées et les Écoles d'Art Industriel en Angleterre* (Paris: Ministère de l'Instruction Publique et des Beaux-Arts, Imprimerie Nationale, 1890), p. 35.

[3] A system which 'did not receive its *coup de grâce* until the nineteen-thirties'. Macdonald, *Art Education*, p. 169.

introduced to art in so harsh and unappealing a form. It was regrettable, too, that the British Government's first long-term and extensive commitment to art helped to strengthen opposition to state intervention nearly as effectively as to promote it.

During the 1850s and 1860s, British society and national culture were subjected to searching criticism, in which art's role in contemporary society and the state's responsibility to art figured prominently. The controversies were not relegated to weighty journals, but filled the columns of the periodical press, helping to mould public opinion about aesthetics and ethics alike. The fact that men like Ruskin, Matthew Arnold, Spencer, and J. S. Mill contributed to the debate ensured a large and attentive audience. These were hardly years of unmitigated complacency. Scientific inquiry, and the work of Darwin in particular, had raised some profoundly unsettling questions. Events overseas—the Crimean War, the rise of Napoleon III, the unification of Italy, the American Civil War—prompted a serious re-evaluation of Great Britain's duty and position as a great power. Political events at home, especially the growing likelihood of further franchise extension in the 1860s, also stimulated social criticism and analysis. The governing classes wondered what the potential new voters thought, what values they honoured, and particularly how well were they educated. Education was more than ever a subject of inquiry, and the discussion, as always, merged in the fiercer collision of views concerning the state's role in society. For purposes of public health, social reform, education, and law enforcement, the British Government was acquiring significantly enlarged powers in these years, but most people did not realize the full implication of this gradual development. While centralization and uniform administration from London slowly, but securely, established themselves throughout the country, Englishmen never paid more reverent homage to self-help and individual enterprise.

Changing Perspectives

[i]

By the turn of the century, the heyday of laissez-faire economic and social theories had unmistakably passed, and in the decades preceding the First World War, the British public could not fail to recognize the rapidly increasing extent of state intervention into numerous spheres of national life. From the Education Act of 1870 to the National Insurance Act of 1911, unprecedented legislation laid the foundation of the welfare state. The spread of socialist doctrine in a variety of guises, the emergence of the Labour Party, the impact of the new unionism, and the growing imperialist mentality—all created an atmosphere in which people looked to the state to take an active and directing role in handling the nation's complex problems. The prolonged depression of the 1870s through the 1890s further discredited laissez-faire as an effective approach either to the national or the international economy. There was still, of course, bitter opposition to state encroachment on individual liberties. Herbert Spencer continued his earlier diatribes against centralization in a work aptly entitled *The Man versus the State* (1884), and others, like Fitzjames Stephen, William Lecky, and Lord Hugh Cecil, contributed to the critique of interventionist government.[1] But theirs was clearly a rearguard struggle. The end of the nineteenth century saw Conservatives and Liberals alike promoting legislation that aimed to impose parliamentary authority over matters previously left to the efforts of private philanthropy or self-improvement.

The Liberals, in fact, gave state interference on behalf of social amelioration a prominent place in their official party creed. While T. H. Green had earlier offered a philosophical justification for

[1] Individualists such as these found unexpected, and probably unwanted, allies among distributivists, syndicalists, and guild socialists who opposed the overwhelming concentration of authority in the hands of the state.

the abandonment of laissez-faire, the Campbell-Bannerman and Asquith ministries after 1906 transformed theory into old age pensions, labour exchanges, health and unemployment insurance, and tax reform. In speeches and essays, Liberals loudly touted their new official outlook. Asquith praised 'the governing impulse in the later developments of Liberalism in the direction of education, temperance, better dwellings, an improved social and industrial environment; everything, in short, that tends to national, communal, and personal efficiency'. Herbert Samuel asserted as the party's first principle 'that it is the duty of the State to secure to all its members . . . the fullest possible opportunity to lead the best life'.[1] H. W. Massingham announced the state's responsibility to 'raise the average of character, or *morale*, in its citizens', and L. T. Hobhouse, regarding the state as a form 'of human association for the maintenance and improvement of life', stressed this view as a major departure from the 'older Liberalism'.[2] While their modes of expression varied, all would have agreed with the observation, made as early as 1885 in Joseph Chamberlain's Radical Programme, 'that the tendency of modern legislation is to give Government more rather than less to do'.[3]

One of the areas in which successive Governments found more to do was the provision of recreational facilities. Associated with official concern for national health, Parliament expressed growing interest in the way British citizens spent their leisure time.[4] The line between recreation, amusements, and culture was difficult to draw, and the arts proved to be the unlikely beneficiaries of several public health enactments extending the power of local

[1] H. H. Asquith, Introduction to *Liberalism, an Attempt to State the Principles and Proposals of Contemporary Liberalism in England*, by Herbert Samuel (London: Grant Richards, 1902), p. x; and Samuel, Ibid., p. 4.

[2] Massingham, Introduction to *Liberalism and the Social Problem*, by Winston Spencer Churchill, 2nd ed. (London: Hodder & Stoughton, 1909), p. xix; and Hobhouse, *Liberalism*, with an Introduction by Alan P. Grimes (New York: Oxford University Press, Galaxy Books, 1964), p. 71. The book was first published in 1911.

[3] Joseph Chamberlain and others, *The Radical Programme with 'The Future of the Radical Party' by T. H. S. Escott*, ed. with an Introduction by D. S. Hamer (Brighton: The Harvester Press, 1971), p. 222.

[4] The fact that so many of them were voting after the Third Reform Act of 1884 may have stimulated the legislators' interest.

government over recreation and entertainment. Together with cricket and football grounds, gymnasiums and public walks, Parliament enabled local authorities to provide band music in public parks and to enlarge their jurisdiction over music halls and museums.[1] Several private bills had already established these powers in a few localities, particularly at resorts and spas where such amenities were considered good business. In the Public Health Acts, Parliament over the decades granted similar benefits to local authorities throughout the country. The accepted doctrine of British government that restricted the use of rates by local governing bodies to those purposes authorized by 'charter, statute, or other enabling instrument by means of which a council can acquire power', necessitated this slow and cumbersome procedure for the enrichment of life in local communities.[2] Nevertheless, a start was made at the end of the nineteenth century, and, while local authorities remained restricted in their ability to furnish cultural facilities, the opportunities for enjoying art in provincial towns gradually increased in the following decades. Among the other legislation which broadened local responsibility in this area were Local Government and Public Libraries Acts, while the Public Entertainments Act of 1875 proved a boon to London's theatres. Lifting the eighteenth-century ban against public entertainment prior to 5 p.m. 'in the cities of London and Westminster', it opened a world of matinee performances to the suburban housewife.[3] Parliament was learning that 'pleasure . . . needs legislating for and organising at least as much as work'.[4]

[1] See the Public Health Acts of 1875, 1890, 1899, and 1907. The Museums and Gymnasiums Act, 1891, enabled urban authorities to levy a $\frac{1}{2}$d. rate for museum purposes. In a related field, the local art schools of the Department of Science and Art came under the jurisdiction of local education committees, according to the provisions of the 1902 Education Act. By the Board of Education Act, 1899, the Department had already been absorbed into the new Board of Education.

[2] See William A. Robson, *The Development of Local Government*, 3rd ed., rev. (London: George Allen & Unwin, 1954), pp. 261–5, 304–7, for the effects of the doctrine of *ultra vires* on municipal government.

[3] *Parliamentary Papers*, vol. 5 (1875) (*Bills: Public*), 'A Bill intituled An Act for amending the Law relating to Houses of Public Dancing, Music, or other Public Entertainment of the like kind, in the Cities of London and Westminster'.

[4] Lady Violet Greville, 'Social Reforms for the London Poor. Part 1—

The arts, however, were only peripheral items in the public health legislation. 'Public opinion and legislation in the nineteenth century were more intent on securing open space . . . as a contribution towards public health than as a medium for providing entertainment or even aesthetic enjoyment.'[1] The physical effects of the industrial revolution on the British people were becoming a matter of some concern,[2] and physical fitness appeared to many observers far more important than browsing through museums and galleries. Fortunately, at least one of the arts could be combined with fresh air recreation, and band concerts in public parks became a highly popular form of entertainment. In 1902, the London County Council spent over £12,000 on nearly 1,200 performances in metropolitan parks and gardens during the summer. In addition to the Council's own band of over one hundred players, fifty additional bands were pressed into service for the summer music programme. An estimated 1,100,000 people heard the performances in the metropolis, a crowd which one Tory M.P. was convinced 'might have been occupied in a much worse way had the music not been provided'.[3] Other municipalities similarly entertained their citizens, and brass band concerts helped introduce music to a section of the public whose enthusiasm might never have been aroused by opera or classical music.

How the public used its leisure time was not only an object of interest to Parliament and local authorities. In the late Victorian and Edwardian period, philanthropists, artists, entrepreneurs, and social critics increasingly asked what sort of amusements entertained the average British citizen. Theirs was not just a general anxiety over the quality of national life, such as found expression throughout the century. They were specifically interested in the quality of British entertainment, and the decades before the First

The Need of Recreation', *Fortnightly Review*, n.s. 35 (January 1884): 21. Lady Greville explained: 'By pleasure I mean recreation'.

[1] Ruck, *Municipal Entertainment*, p. 44.

[2] See Samuel Hynes' discussion of the Inter-Departmental Committee on Physical Deterioration, which reported in August 1904, in *The Edwardian Turn of Mind* (Princeton: Princeton University Press, 1968), pp. 22–4.

[3] *Parliamentary Debates* (Commons), 4th ser., 120 (7 April 1903): 1337. William Johnson Galloway, M.P. for Manchester, made the observation. Another major alternative to the pub, according to opponents of strict Sabbath observance, became available in 1896 when the national museums and galleries were finally allowed to open on Sunday.

World War saw diverse efforts to raise the calibre of the perform-
ing arts. With the overwhelming popularity of music hall variety
shows, lovers of music and drama sought to lure some of the
large vaudeville audiences to the concert hall and to the legitimate
theatre. The initiative and financial support for their numerous
endeavours came almost exclusively from private enthusiasm and
generosity, for wherever culture could not be combined with
physical recreation, public support of art was offered reluctantly,
if at all.

The most celebrated campaign for the performing arts in the
early twentieth century was the drive to establish a national
theatre. With eminent playwrights, drama critics, theatre man-
agers, actors, and society figures all espousing the cause, it never
lacked publicity. The idea can be traced as far back as 1769, when
David Garrick organized a festival to honour Shakespeare at
Stratford. Since that time the national theatre movement was
always associated with plans to commemorate the nation's greatest
dramatist, and Shakespeare proved invaluable in lending prestige
to the British drama's struggle for national recognition. A sub-
stantial step towards a national theatre was taken in 1879, when
the Stratford Memorial Theatre was opened, thanks to the zeal
and fund-raising abilities of a Stratford resident, Charles Edward
Flower. Its establishment heightened the demand in the 1880s and
1890s for a theatre of national status in London.[1] Looking at the
excellent performances of the Comédie Française, and the
deteriorated condition of the English stage, 'given up mostly now
to the exhibition of ballets or burlesques', Lady Juliet Pollock
had concluded in 1871 that Government assistance was needed to
save British drama.[2] At the same time, Richard Henry Horne,
poet and prolific writer on many subjects, argued for a national
theatre in terms by then familiar to advocates of state support for
art:

> A regular, a systematic stage influence upon national character
> of the kind we advocate, must eventually exercise its due, its

[1] See Geoffrey Whitworth, *The Making of a National Theatre* (London:
Faber & Faber, 1951), pp. 24–31, for developments up until the 1870s; and
Allardyce Nicoll, *A History of English Drama 1660–1900*, 6 vols. (Cambridge:
Cambridge University Press, 1952–9), 5: 66–7.

[2] Juliet Pollock, 'The Comédie Francaise', *Contemporary Review* 18 (August
1871): 45, 55.

inevitable power of softening, purifying, and elevating, and thus render the aid of a National Theatre well worthy the consideration of a wise and economic Government, were it only from the saving it would effect in the cost of the various departments of our penal legislature and reformatory institutions. . . .[1]

No less a critic of British culture than Matthew Arnold concurred that the theatre exerted a profound impact on national life and manners. For that reason, he urged the establishment of an English theatre company on the French model, subsidized by the Government and presenting a repertory of Shakespeare and modern British drama. There would always be a demand for theatrical entertainment, he argued, and national character could only suffer from the habitual dose of undignified, purposeless, and poorly acted performances that currently passed for drama on the English stage. The favourite British doctrine 'of the mischief of State interference' had once again done its damage, Arnold observed. 'We left the English theatre to take its chance. Its present impotence is the result.'[2]

Arnold's warning was consistent with his earlier essays and his continued assault on Philistinism. Throughout his writing, whether as Professor of Poetry at Oxford, school inspector, or social commentator, he sought to persuade his compatriots of the need for central organization, for some definite and nationally recognized standards of quality to uphold in the face of commercial, quantitative measurements. That his writing was elitist in tone and implication is not in dispute. Still, he saw the real threat of mass-produced culture and groped for immutable centres where the finest products of human thought and art could be preserved, and from which they could be disseminated. His anxious perception of the lack of such centres had given deep seriousness to the apparent fussiness of *Friendship's Garland* and *Culture and Anarchy*, and it prompted his appeal for a national theatre. He wanted a national company to cherish the best of British drama, to perform these plays as works of art, and to

[1] R. H. Horne, 'The Burlesque and the Beautiful', *Contemporary Review* 18 (October 1871): 406.
[2] Matthew Arnold, 'The French Play in London', in *Irish Essays and Others* (London: Smith, Elder & Co., 1882), pp. 235, 240–1.

bring them, not only to London's West End audiences, but to the East End and provincial towns as well. He hoped that a national institution in London would serve as a model for similar local endeavours, supported by municipal subsidies. His repeated message, often echoed by later advocates of a national theatre, was: 'The theatre is irresistible; *organise the theatre.*'[1]

What precisely the term 'national theatre' meant was open to interpretation. To some it meant simply one pre-eminent commercial theatre, such as Henry Irving made the Lyceum, which set a brilliant example and redounded to the credit of the whole dramatic profession. Others, like Arnold, clearly envisioned a theatre managed for artistic, not commercial, purposes and supported by Treasury grants. Between these views fell a third, which held it

> sufficient that a theatre should be owned by the nation, and placed, by some form of endowment, above the necessity of constant and immediate profit-making. It mattered not at all from what funds the theatre was erected, and the endowment supplied.[2]

This was the approach which the leaders of the national theatre movement adopted in the early decades of the twentieth century. They had few expectations of official interest in their plans, and they relied on private munificence to provide the funds needed to found a theatre worthy of national ownership.

The Shakespeare Memorial National Theatre General Committee, which for several decades directed the efforts towards a national theatre, began its work in 1909, with the active participation of the Earl of Lytton, George Bernard Shaw, Sir Herbert Beerbohm Tree, many other leaders of the theatrical world, and a few Members of Parliament. Looking towards the approaching tercentenary of Shakespeare's death in 1916, the committee's immediate purpose was to raise money, and they accordingly launched an appeal for contributions to the national theatre drive. The gift of £70,000 from Sir Carl Meyer, a wealthy, German-born financier, started the campaign auspiciously, and Shaw, with characteristic energy, promoted the cause in letters to the press,

[1] Ibid., pp. 241, 237.
[2] 'The Proposed Shakespeare Memorial National Theatre. An Illustrated Handbook, 1909', quoted in Whitworth, *National Theatre*, pp. 82–3.

prefaces to his plays, and even in a one-act drama specially written to popularize the national theatre movement. *The Dark Lady of the Sonnets*, first presented at the Haymarket Theatre in November 1910, featured Master Shakespear in a midnight encounter with Queen Elizabeth. The dramatist appealed to the Queen to 'endow a great playhouse, or . . . to coin a scholarly name for it, a National Theatre, for the better instruction and gracing of your Majesty's subjects'. The Queen's promise to 'speak of this matter to the Lord Treasurer' brought a groan of despair from Shakespear, 'for there was never yet a Lord Treasurer that could find a penny for anything over and above the necessary expenses of your government, save for a war or a salary for his own nephew'.[1] Among the other playwrights and dramatic critics who argued vigorously for a national theatre were William Archer, Harley Granville-Barker, and Henry Arthur Jones, whose numerous speeches and essays on the subject were published in 1913 as *The Foundations of a National Drama*.[2] The press followed the discussion closely, and columns of print were devoted to letters which hotly debated the issue.

Despite Shaw's eloquence, the near extinction of provincial theatrical companies, and the mounting costs of theatrical productions, the idea of a publicly endowed national theatre lacked broad support. As always, the habitual British fear of state control provided opponents of the plan with powerful ammunition. Even Henry Irving, who was sympathetic to the idea of a national theatre, had unequivocally stated in 1878 that:

> it was not at the time advisable to touch upon the subject of State subsidy with reference to the British stage. The institutions of this country are so absolutely free that it would be

[1] George Bernard Shaw, *The Dark Lady of the Sonnets*, in *Selected Plays of Bernard Shaw*, 4 vols. (New York: Dodd, Mead & Co., 1948–57), 3: 872–3. In the same volume, see the preface to *Plays Pleasant*, pp. 115–16, for other Shavian comments on the importance of a national theatre. In a letter to *The Times*, 10 May 1909, p. 12, Shaw asked, 'Why will they build an uncommercial cathedral to accommodate 50 churchgoers when 500,000 playgoers are left without an uncommercial theatre?' 'The theatre,' he continued, 'is literally making the minds of our urban populations to-day.'

[2] *A National Theatre, Scheme & Estimates* (London: Duckworth & Co., 1907), by Archer and Barker, was first privately printed in 1904 and represented the earliest concrete blueprint for a national theatre in England.

dangerous—if not destructive—to a certain form of liberty to meddle with them.[1]

More vehemently, Sir Charles Wyndham wrote to the *Daily Telegraph* in March 1908:

A National Theatre, if it is to be in fact what is indicated by the name, would be a type of institution alien to the spirit of our nation and of our age, which has always believed in, and relied on, individual effort and personal competition as a healthier stimulus than the motherly or grand-motherly fostering of a State nurse.[2]

These objections, stated in various forms over the years, provided a formidable obstacle to the national theatre effort. Perhaps, too, some lingering puritanism made potential contributors withhold gifts to the General Committee's funds. Many people still considered the theatre a far less respectable object of patronage than, say, the National Gallery. Nor could the theatre appeal to a businessman's sense of sound investment. Stage productions, unlike museum collections, were ephemeral forms of art. They were not property, in the sense of something solid and enduring, but were complicated endeavours that depended for success on numerous variable factors, including public taste. With the exception of a few distinguished and generous patrons, private support for noncommercial drama was insufficient to found a national theatre by the tercentenary of Shakespeare's death in 1916.[3]

Having secured only about one-fifth of the funds needed to establish and endow a national theatre, the SMNT Committee began seriously to consider state support. To gauge parliamentary opinion, one of its members, Halford John Mackinder, the

[1] Paper read to the Social Science Congress, October 1878, quoted in Whitworth, *National Theatre*, p. 32.

[2] Quoted in Whitworth, *National Theatre*, p. 92.

[3] Among the most prominent exceptions were Barry Jackson (knighted in 1925) and Annie Horniman. Before the First World War, Jackson founded the Pilgrim Players and the Birmingham Repertory Theatre, and afterwards provided annual summer productions at the Malvern Theatre Festivals. Miss Horniman, from a wealthy family of tea merchants, underwrote a large part of the expenses of the Abbey Theatre, Dublin, and in 1908 launched a repertory theatre, the Gaiety, in Manchester. She also financed productions of some of Shaw's early plays.

Unionist M.P. for Glasgow, introduced a motion in the House of Commons on 23 April 1913. He moved the resolution, 'That, in the opinion of this House, there should be established in London a National Theatre, to be vested in trustees and assisted by the State, for the performance of plays by Shakespeare and other dramas of recognised merit.' Mackinder explained why state endorsement had proven essential and described the contemplated theatre as an agency of popular education of the first importance. He saw no reason to fear official competition with private theatrical enterprise. After all, he told his colleagues, 'You already build some of your battleships in Government dockyards, and a greater number in private dockyards. You exchange even your constructors between the national dockyards and private dockyards. And so it might be with your actors.' Arthur Ponsonby, the Liberal Member for Stirling Burghs and the son of Queen Victoria's private secretary, went even further than Mackinder in his support of a national theatre:

> The day is passed, I think, when the arts are merely looked upon as trivial and frivolous adjuncts of our ordinary life. The arts have come to be part and parcel of our lives, and nobody's education is complete without the arts. It is time in this country that we should have a Minister of Fine Arts who should be responsible for pictorial art, for music, and for the drama . . . I do not see why all these three sister arts should not be encouraged and supported by the State in order that the leisure of the people—and we want to see they have more leisure—should be looked after so that they can get a high class of entertainment which in itself is an education. . . .[1]

Ponsonby's vision was too radical even for the reforming Liberal ministry.[2] E. J. Griffith, the Under-Secretary to the Home Department, asked whether 'the functions of government extend, as far as the theatre is concerned, to the extent of saying that it is the duty of the State to take part in recognising and endowing a National Theatre?' He was inclined to think not. He saw the Government's responsibility in terms of crowning, not initiating, a project of this nature:

[1] *Parliamentary Debates* (Commons), 5th ser., 52 (23 April 1913): 454, 491.
[2] In fact, he joined the Labour Party a few years later.

The time for crowning has not come. The hon. Member admits that only £100,000 out of £500,000 has been subscribed voluntarily. I think the hon. Member, on consideration, would agree that until, at any rate, by far the greater part of the £500,000 has been subscribed voluntarily, the time for crowning has not arrived. That is the view which I take.

In a conclusion worthy of Dr. Johnson's remark on the belated assistance offered to struggling artists by their alleged patrons, Griffith suggested that the appropriate time for state aid would come once the theatre had been erected, equipped, and reasonably endowed. Other speakers raised familiar objections. Arthur Lynch, the Nationalist Member for West Clare, warned of efforts to 'Prussianise our institutions'. Frederick Booth, the Liberal Member for Pontefract, resented money allotted to 'pamper the intellectuals', while pressing problems of social reform demanded public funds, and Sir Frederick Banbury, the Unionist Member for the City of London, argued for retrenchment.[1] With no party backing, the SMNT resolution failed to win adequate parliamentary endorsement.[2] While enough public interest had been evident since the 1840s to warrant gradually increasing state support of museums, no such broadly based interest called on the country's legislators to subsidize the performing arts.

Hopes for a national opera received even less encouragement

[1] Debate, 23 April 1913, 481, 484, 471, 493–4, 488.

[2] It is interesting that J. R. Clynes and Will Crooks, both Labour Members, were among the supporters of the motion. Robert Blatchford, the socialist author of *Merrie England*, considered art among life's necessities. C. F. G. Masterman, Liberal author of *The Condition of England*, ranked it among 'life's lesser goods'. Blatchford, *Merrie England* (New York: Monthly Review Press, 1966), p. 219 (first published 1894); and Masterman, *The Condition of England* (London: Methuen & Co., 1909), p. 27.

Many advocates of a national theatre believed that an acting school should form an essential part of any such institution, and there were several proposals, and unsuccessful attempts, to found acting academies in the latter half of the nineteenth century. Finally in 1904, Sir Herbert Beerbohm Tree, the famous actor-manager, founded an acting school in his own theatre, His Majesty's. After some financially lean years and a move to Bloomsbury, the Academy of Dramatic Art established its reputation and received a Royal Charter in 1920. In its early growth, the academy depended entirely on private interest and financial support. See Kenneth R. Barnes, *Welcome, Good Friends. The Autobiography of Kenneth R. Barnes*, ed. Phyllis Hartnoll (London: Peter Davies, 1958), pp. 67–82. Barnes was the principal of the academy, 1909–56.

in the early twentieth century. The opera had never been considered an indigenous art, except in the ballad form used so successfully by John Gay in *The Beggar's Opera* (1728). Italian and German opera reigned at Covent Garden, and opera in English had to struggle to assert its legitimacy, although the efforts of impresarios like Carl Rosa and Charles Manners, who formed touring companies to present opera in English, helped to improve the status of native opera. The subject claimed Parliament's attention in 1903, when W. J. Galloway, an ardent musical amateur and author of *The Operatic Problem* (1902), moved 'That, in the opinion of this House . . . it is desirable that National Opera Houses under public control should be established in the principal cities of the United Kingdom.' He cited the popularity of band concerts and performances in Queen's Hall, as well as the financial success of music festivals, to prove that the public was eager to hear music.[1] He deplored the commercial point of view that dominated the treatment of music in England and that, he said, had made opera at Covent Garden a fashionable, but not an artistic, event. He offered no apology for raising the issue

> because, after all, the House existed for the purpose of effecting the greatest good of the greatest number, and if by encouraging art they could do something to improve the social conditions of the people, and to remove evils which they all deplored, surely they could not regard the time spent in considering the subject wasted.[2]

Claude Hay, the Conservative Member for Shoreditch, insisted on 'the great educational and human side of music', and further emphasized the social benefits to be anticipated from Treasury support of the art. The working classes, he assured the House, would 'give up their spare time to music rather than a public house', and he therefore urged the Government to establish a permanent institution for the public enjoyment of music. Replying for the Balfour Government, Sir William Anson, Parliamentary

[1] In 1895, Henry Wood, the conductor, inaugurated the Promenade Concerts at Queen's Hall. The price of admission was low enough to make the concerts accessible to working-class audiences who were treated to classical as well as contemporary music.

[2] *Parliamentary Debates* (Commons), 4th ser., 120 (7 April 1903): 1343, 1337–9, 1341.

Secretary to the Board of Education, would only assure 'his hon. friends . . . that the Government were alive to the importance of the question'.[1]

Whether or not the Government acknowledged the importance of the question, it had no intention of proposing grants in aid of a national opera. 'We pay thousands of pounds every year for more or less useless public libraries,' John F. Runciman, the sharp-tongued music critic, wrote in the *Saturday Review*, in December 1903:

> We keep up a National Gallery; we have a British Museum and a Victoria and Albert . . . but I do not believe that any Government, for many years at any rate, will dare to hand out money for a national opera . . . if ever Mr. Balfour seriously considered the matter the idea was doubtless driven out of his head by the cheerful though somewhat costly picnic called the Boer War.[2]

Opera was far too limited in its public appeal to justify Exchequer subsidies, especially after an expensive war, when the Opposition was clamouring for retrenchment. Like the theatre, it would have to wait until the 1940s before receiving any significant financial support from the state.

Private efforts, however, were undaunted by lack of official endorsement. With limited funds, but a strong sense of mission, the Old Vic brought operatic entertainment to the working-class population of Lambeth from the late 1880s. Originating in 1880 as the Royal Victoria Coffee Music Hall in the redecorated Royal Victoria Theatre, the venture at first bore no resemblance to the Old Vic that later became renowned for its Shakespeare repertory. Its founder, Emma Cons, developed the enterprise in order to provide decent amusement for the Lambeth poor, and it represented an outgrowth of her work for housing and temperance reform.[3] With the support of such artists as Arthur Sullivan and Carl Rosa, and the generosity of Samuel Morley, the wealthy textile manufacturer and M.P., she was able to raise funds to

[1] Ibid., 1342–4. With less than forty Members present, the House was then adjourned.

[2] Runciman, 'The Idea of Mr. Manners', *Saturday Review* 96 (19 December 1903): 759.

[3] She was a managing director of the South London Dwellings Company, and a member of the London County Council.

maintain the theatre as a place of decorous family entertainment, where alcoholic drinks and gambling were prohibited.

From the start, a weekly concert formed part of the entertainment, and gradually it came to include operatic excerpts, presented in tableaux. The music hall licence, under which the theatre operated, forbade the presentation of an entire scene from any opera, and thus the Lambeth audience learned to follow opera in a somewhat episodic form. But their enjoyment remained unimpaired. By 1906, when the active management of the theatre had passed to Lilian Baylis, the niece of Emma Cons, the average attendance at the operatic tableaux varied between 1,600 and 2,000. At the same time, variety shows at Victoria Hall attracted only an average audience of 1,200. Other entertainment offered at the Old Vic included ballad concerts, symphony concerts, lectures, and sometimes oratorios, but opera was the most popular item on the programme, with one exception. During the few years that the Vic offered animated pictures, they drew crowds of 2,000 to each show. Lilian Baylis realized the tremendous popular appeal of the infant cinematograph, but her theatre was not technically equipped to compete with commercial picture palaces, and she soon eliminated films from the Vic's repertory.[1]

The Old Vic management pursued its purpose to provide inexpensive but good entertainment, despite a chronic shortage of funds. As a charitable trust under the authority of the Charity Commissioners, the theatre enjoyed tax exempt status, while the City Parochial Fund gave the Vic a grant to help provide fine musical entertainment at low prices. Other forms of assistance, however, both official and private, were scant in the years immediately before the First World War, and an appeal for £5,000 early in 1914 produced only a few hundred.[2] Nonetheless, Miss Baylis and the Vic governors somehow managed to provide opera to wartime audiences and over the years helped to create an enthusiastic following for opera in English. In addition,

[1] Edward J. Dent, *A Theatre for Everybody: The Story of the Old Vic and Sadler's Wells* (London and New York: T. V. Boardman & Co., 1945), pp. 21–33; Cicely Hamilton and Lilian Baylis, *The Old Vic* (London: Jonathan Cape, 1926), pp. 177–200; and Sybil and Russell Thorndike, *Lilian Baylis* (London: Chapman & Hall, 1938), pp. 13–17.

[2] Dent, *Theatre for Everybody*, pp. 36, 70; and Hamilton and Baylis, *Old Vic*, pp. 197, 279–80.

Shakespeare and classical drama were added to the agenda of entertainment in 1914, laying the foundations of the distinguished reputation which the Old Vic came to enjoy in the British theatre and around the world.

The Royal College of Music, opened at nearly the same time as the Royal Victoria Coffee Music Hall, also owed its existence to private initiative. In 1882, the college inherited the building and assets of the National Training School for Music, which closed after six years of precarious existence at South Kensington. Although the college had not yet been founded in 1882, efforts were already under way to raise a capital fund sufficient to endow numerous scholarships for advanced study in music. The Prince of Wales and other members of the royal family participated in the campaign and enlisted the support of mayors throughout the country to promote local interest in the new institution. When the college opened in 1883, private contributions had provided fifty permanent scholarships, for which over 1,500 candidates competed.

As the number of scholarships and paying students increased, the college outgrew its accommodations in the old National Training School, and the Commissioners for the Exhibition of 1851 offered a new site at South Kensington. The cost of the building was substantially met by Samson Fox of Leeds, a mechanical inventor and enthusiastic music lover, and in May 1894, with much fanfare and pageantry, the Prince of Wales opened the college's new home. Fox was not the only generous benefactor. In 1903, Sir Ernest (later Lord) Palmer, of the Reading firm of Huntley & Palmer, Biscuit Manufacturers, gave £20,000 to start the Royal College of Music Patron's Fund, which over the years helped British-born musicians further their studies and skills in numerous ways, while other gifts augmented the college's library and collection of musical instruments.[1] The college, like the Royal Academy of Music, received a small grant from the Treasury, but its operating costs were met by students' fees. Since it was largely independent of the Education Department's supervision, as well as support, it continued to depend heavily on private generosity for the expansion and quality of its programmes.

[1] Colles, *Royal College of Music*, pp. 4–8, 38–9.

On the elementary level of music instruction, the Education Department continued to subsidize the teaching of singing in schools under its inspection. According to the 1890 Code of Regulations, a grant of 1s. was provided for each student 'satisfactorily taught to sing *by note* . . . or (ii) 6d. if they are satisfactorily taught to sing *by ear*'.[1] But music appreciation in any broad sense formed no part of the curriculum, and the same rigid, mechanical attitude dominated the Education Department's approach to national music instruction as guided its efforts in drawing classes. The results were predictable. A correspondent to the *Academy* reported in 1908: 'I live opposite to a school where music is carefully and constantly taught; the children have acquired the difficult art of dropping a semitone per minute.' Another correspondent described the noise proceeding from a country school during the singing class as 'a volume of annotated roaring'.[2] Runciman asserted that British children were 'not merely not learning to sing well: they [were] absolutely being taught to sing badly'. Why were teachers and pupils compelled to devote several hours each week to these exercises in futility, he asked:

> The answer is simple as simple can be. The admired legislators of this country determined in their wisdom that music should be one of the 'subjects' on which youngsters should be examined and sums of money paid in grants in proportion to results . . . I deny most emphatically that anything beyond these grants can be gained. An acquaintance, even an intimate acquaintance, with the tonic sol-fa system does not constitute a knowledge of music.[3]

So long as the Education Department condoned and promoted the methods used to introduce children to music, the performing arts in Great Britain were almost better off without official recognition.

[1] *Parliamentary Papers*, vol. 55 (1890) (*Accounts and Papers*, March 1890), 'Minute of 10th March 1890, Establishing a New Code of Regulations, by the Right Honourable The Lords of the Committee of the Privy Council on Education', p. 14.

[2] 'Life and Letters', *Academy* 74 (18 and 25 April 1908), pp. 680, 704.

[3] Runciman, 'Music and the Schoolmaster', *Saturday Review* 96 (17 October 1903): 489.

[ii]

Throughout the nineteenth century, and up until the Second World War, the lion's share of public funds for the arts went to the maintenance, exhibition, and expansion of the national art collections. Although particular purchases for the National Gallery occasionally provoked bitter controversy, by and large public and parliamentary opinion came to accept museum expenditure as a legitimate means of increasing national wealth, both materially and intangibly. While substantial state aid to music and drama would have seemed a flagrant waste of public money on ephemera, as well as a dangerous interference with artistic freedom, Englishmen by the turn of the century were generally proud of their country's art collections. They considered that museums, national and municipal, contributed significantly to the dignity and stature of civic life.[1] Yet even in this aspect of art patronage, the Government often dragged its feet and seemed to begrudge museums the funds needed for their upkeep and growth. In the 1890s, it proved so slow to respond to Henry Tate's offer of his collection of British paintings that the country nearly lost the chance to acquire what later became the National Gallery of British and Modern Foreign Art.

British artists and admirers of British painting had long resented the subordinate status allotted to the native school of art in the national collections. While Turner's paintings were stored away, largely inaccessible to the public, the National Gallery prominently displayed its collection of Italian, Flemish, and Dutch masters which far surpassed the incomplete holdings of British work. During the course of the nineteenth century, many of the earlier prejudices against British art had disappeared. Not only had Old Masters become increasingly rare on the market, largely beyond the purchasing power of private British collectors, but

[1] The large number of local museums founded between 1880 and 1920, both by private and municipal efforts, attests to public enthusiasm for these institutions. Relatively few of these were art galleries, and the majority contained mixed collections of natural history, archaeology, local antiquities, and objects of applied art. Henry Miers, *A Report on the Public Museums of the British Isles (other than the National Museums) to the Carnegie United Kingdom Trustees* (Edinburgh: Carnegie United Kingdom Trust, 1928), pp. 10, 23. It is interesting that readily forthcoming private resources were not, in most cases, available for the establishment and support of local repertory theatres.

even experienced museum curators were troubled by the possibility of forgeries. The popularity of contemporary painters—Frith, Millais, Landseer, to name only a few—the publicity that greeted the work of the Pre-Raphaelites, and the display of British paintings at the South Kensington Museum, all helped to raise the British school in the public estimate and to promote the demand for an extensive, systematic gallery of British art.

When James Orrock, landscape painter, watercolourist, art collector, and lecturer, read a paper to the Society of Arts in March 1890, concerning the neglect of the British school in the national collections, *The Times* devoted a leader to the subject. It called for 'the creation of a great British Gallery which should contain within itself the works of our national painters in oil and water-colour, of our national sculptors, of our national miniaturists, and of our national engravers. . . . Why', *The Times* asked, 'cannot we have in London, started partly by voluntary effort and afterwards subsidized and directed by the Government, a gallery that shall do for English art what the Luxembourg does for French?' Citing the rising market value of English pictures, it urged the National Gallery to fill the gaps in its British collections before the prices soared out of reach.[1] The same leader reported that Henry Tate had offered the National Gallery his large and important collection of paintings, which included works by many modern British artists of high repute.[2]

Tate's proposal set off two years of dilatory negotiations between the Treasury, National Gallery, South Kensington Museum, London City Corporation, and Henry Tate. At first, the donor imposed the condition that his collection of pictures be hung together at the National Gallery—a condition that raised numerous difficulties for the trustees of the overcrowded museum. Although the press was largely in favour of accepting the offer,[3]

[1] *The Times*, 13 March 1890, p. 9. Despite the fact that Orrock was an indifferent artist and a haphazard collector, his lecture to the Society of Arts, as reported by *The Times*, helped to focus public attention on this serious deficiency in Great Britain's national collections.

[2] Tate had made his fortune in sugar refining.

[3] *Punch*, however, criticized Tate's demand for a special Tate room at the National Gallery and could not resist a typical pun: 'The King of the National Picture Donors is henceforth "the Potent Tate".' 22 March 1890. The article is included in a bound volume entitled *Press Cuttings March 1890–August 1902*, p. 10, in the Tate Gallery Archives, London.

the gallery had to decline Tate's gift for lack of space, and because his stipulations 'would have violated the historical and educational system on which the works in the National Gallery [were] arranged, and would have set a precedent for breaking the gallery into a series of smaller and independent collections'.[1] Other accommodations were suggested, such as Kensington Palace or the South Kensington Museum, where Tate found the proposed galleries ugly and unacceptable. Finally, in March 1891, he offered 'to build a gallery himself at a cost of £80,000 if the Government would give him a site of his own choosing'.[2] Tate chose a site at South Kensington that had already been purchased to accommodate scientific collections, and the Gallery of British Art received yet another official rebuff. It was then proposed that the Corporation of London contribute a plot of land on the Embankment, but the businessmen of the Corporation placed so high a price on the property that that scheme also had to be abandoned.[3] At length, early in 1892, official indecision and indifference having blunted Tate's zeal, he withdrew his offer. As the *Liverpool Echo* observed: 'The capacity for bungling possessed by our public departments has seldom been displayed in more undisguised fashion than in regard to the proposed National Gallery of British Art.'[4]

With a change of Government in the summer of 1892, Tate renewed his dealings with the Treasury, and an agreement was at last concluded with Sir William Harcourt, the Liberal Chancellor of the Exchequer. In exchange for Tate's art collection and the funds to build a gallery, the Government provided the site of Jeremy Bentham's model penitentiary at Millbank. At its opening in July 1897, the works displayed in the new museum included paintings and sculpture from Tate's collection, most of the Vernon collection, and other examples of nineteenth-century British art from the National Gallery and South Kensington. Tate, who became a baronet in 1898, subsequently increased his original gift of paintings and bore the cost of structural additions to the gallery that doubled the amount of exhibition room. After

[1] Letter from W. L. Jackson, Financial Secretary to the Treasury, to Tate, 26 June 1890, quoted the following day in *The Times*. *Press Cuttings*, p. 15.
[2] *Pall Mall Gazette*, 21 March 1891, in *Press Cuttings*, p. 49.
[3] *Press Cuttings*, pp. 49–61.
[4] Ibid., 9 February 1892, p. 63.

his death, Joseph Duveen, the elder, became the gallery's major benefactor, and the famous art dealer financed a further extension that opened in 1910. Until the First World War, the Gallery of Modern British Art, as it was officially called, remained little more than an annex of the National Gallery. The Treasury did not authorize the appointment of a separate director and trustees until 1917, and, apart from maintenance costs, little public money was spent.[1]

The munificence of private donors only seemed to persuade successive Governments that museums were in no desperate need of state assistance. With the exception of an £800,000 grant to build the Victoria and Albert Museum,[2] which was after all an important part of a Government department, Treasury aid to museums was neither lavish nor prompt.[3] For years after 1876, the National Gallery trustees met with delay and frustration in their efforts to obtain a site for further expansion. A few more exhibition rooms were opened to the public in 1887, but the additional space obtained was insufficient. Even after military barracks, on property immediately contingent to the gallery, were removed, the Treasury was slow to recognize the gallery's claim to the area. Negotiations between the trustees, the War Office, the Treasury, and the Office of Works dragged on until 1907, when building began at last for new additions which were opened to the public in March 1911.

[1] Blunt and Whinney, *Nation's Pictures*, pp. 67–77; Holmes and Collins Baker, *National Gallery*, pp. 79–82; John Rothenstein and Mary Chamot, *The Tate Gallery, A Brief History and Guide* (London: The Tate Gallery, 1951), pp. 3–7; and *The Tate Gallery*, with an Introduction by Norman Reid (London: The Tate Gallery, 1969), pp. 5–6. The Tate remained affiliated with the National Gallery at Trafalgar Square until the Act of 1954 which finally effected the official separation of the two collections and gave the Tate trustees sole responsibility for the Millbank gallery.

The new permanent building for the National Portrait Gallery, next to the National Gallery, opened in 1896—forty years after the Portrait Gallery was founded—and was also largely financed by private generosity. *Parliamentary Papers*, vol. 8 (1928/29) (*Reports from Commissioners, Inspectors, and Others*), 'Interim Report of the Royal Commission on National Museums and Galleries', p. 19. In 1897, the Wallace collection was bequeathed to the nation, on the condition that the Government house and maintain it.

[2] 'Interim Report of the Royal Commission on National Museums and Galleries', p. 17. The present building was completed in 1909.

[3] Although it still amounted to far more than any other artistic enterprise received.

As critical as the gallery's shortage of space was its pressing shortage of purchase money. The annual picture purchase grant of £5,000 was entirely inadequate in the current art market, when there was as yet no legal machinery for controlling the export of works of art from Great Britain, and when the prices which American millionaires were willing to pay for Old Masters made it difficult even for museums to compete with them. In 1885, the Treasury enabled the gallery to purchase two highly prized works from the Duke of Marlborough's collection—Raphael's altarpiece, '*The Ansidei Madonna*', and Van Dyck's famous portrait of Charles I on horseback. But the Raphael cost £70,000 and the Van Dyck £17,500, and after this expenditure, considered extraordinary at the time, the Treasury withheld the gallery's grant-in-aid for two years. In 1890, just when its grant had finally been restored in full, the gallery faced another emergency. Three important portraits from the Earl of Radnor's collection at Longford Castle came on the market, and once again a special parliamentary grant was needed to supplement private gifts, in order to ensure acquisition for the National Gallery.[1] Parliament could not be expected to perform such rescue operations repeatedly, and by the turn of the century, it seemed inevitable that the best works in private British collections would eventually find their way overseas.

Hoping to forestall that disaster, a group of patriotic art lovers organized the National Art-Collections Fund in 1903, with the express purpose of keeping great works of art in the country. Lord Balcarres (later the Earl of Crawford and Balcarres), the Unionist M.P. for North Lancashire who enjoyed extensive interests in art and architecture, served as chairman of the provisional committee, and, by 1906, the fund was sufficiently well organized to save Velazquez' 'Rokeby' Venus for the nation. Using all their powers of persuasion, the fund's organizers raised the £45,000 needed for purchase.[2] This supremely lovely female

[1] Philip Hendy, *The National Gallery*, London, 4th ed. rev. (London: Thames & Hudson, 1971), pp. 59–60. The three paintings were Holbein's *Jean de Dinteville and Georges de Selve* ('*The Ambassadors*'), Moroni's *A Nobleman*, and *Don Adrian Pulido Pareja*, mistakenly ascribed to Velazquez. Lord Rothschild, Charles Cotes, and Sir Edward Guinness (subsequently Lord Iveagh) each contributed £10,000, and the remaining £25,000 was provided by the special grant.

[2] See *Art Treasures for the Nation, Fifty Years of the National Art-Collections*

nude is said to have caught the eye of Edward VII, whose vigorous endorsement of the fund's campaign may have helped secure the money from private donors. As D. S. MacColl, the outspoken art critic and a founding member of the fund, observed in an article highly critical of the National Gallery's system of management:

> In the present distress there is a better prospect of our reproach being taken away by voluntary effort, than by a change of policy on the part of a Government harrassed with other things. No one is likely to divide a cabinet on the question of protection for the diminishing treasures of art in the country. . . .[1]

Even more dramatic was the last-minute rescue of Holbein's *Christina of Denmark, Duchess of Milan* in 1909. When the Duke of Norfolk decided to sell the painting for £72,000, he gave the National Gallery one month to raise the sum, or lose the work to the United States. Reluctantly, the Treasury agreed to supply £10,000, but the end of the month found £40,000 still outstanding, despite all the efforts of the National Art-Collections Fund. As the period of grace expired, the fund received word from an English lady living abroad that she would furnish the remaining amount.[2] Such windfalls were not likely to occur in every emergency. What was needed, the *Saturday Review* maintained, was a

Fund, with an Introduction by the Earl of Crawford and Balcarres (London: Thames & Hudson, 1953), pp. 5–8, for the formation of the fund and its difficult campaign to save the 'Rokeby' Venus. On this occasion, the Treasury refused a special grant.

[1] Dugald Sutherland MacColl, 'A National Art Collections Fund', *Saturday Review* 96 (26 September 1903): 394. MacColl also used the *Saturday Review* during 1903 to pursue his campaign against the Royal Academy's administration of the Chantrey Trust. As a result, a House of Lords select committee was appointed in 1904 to inquire into the situation, but nothing came of its suggested reforms. MacColl served as keeper of the Tate Gallery from 1906 to 1911, and of the Wallace collection from 1911 to 1924.

The Contemporary Art Society, another private effort, which secured works by contemporary artists for national and municipal galleries, was founded in 1910.

[2] *Art Treasures for the Nation*, p. 8. The anonymity of the donor was a condition of the gift. Also see the interesting record, compiled by Cecil Gould—*Failure and Success: 150 Years of the National Gallery 1824–1974* (London: The National Gallery, 1974)—that gives brief accounts of twenty pictures that were lost to the gallery and twenty that were saved. It is Gould, p. 82, who points out Edward VII's attraction for the 'Rokeby' Venus.

large contingency fund, authorized by Act of Parliament, to which the Government could turn in a crisis. 'The State must be prepared to purchase with State funds if the tendency of our works of art to emigrate to other countries is to be checked.'[1] The tendency was not checked. Between 1913 and 1952, 45 Rembrandts, 40 Rubens, 12 Holbeins, 28 Gainsboroughs, and 10 Velazquez were exported from Great Britain,[2] and the drain has continued down to the present. The British Government was willing enough to adopt ad hoc measures when occasion demanded, but it refused to be bound to any general principles or programme of action. Successive ministries would not undertake the planning, nor allocate the money, needed to offer real safeguards for the retention of art treasures on British soil.

[iii]

Thus in a period when legislation gave the Government 'more rather than less to do', the Government did far less than was necessary to encourage the arts throughout Great Britain. Not only were the performing arts ignored, but even the national museums suffered from insufficient Treasury support. Admittedly, statesmen in the period preceding the First World War had little time to worry about art. Problems of great urgency demanded their attention and claimed ever larger shares of the national budget. The maintenance of an overseas empire, the cost of social reform at home, and the naval race with Germany placed heavy strains on the Exchequer, and it is no wonder that few legislators were inclined to increase the country's financial burdens by assisting the arts. It was enough, they believed, if local rates were made available for some cultural purposes, and if the Treasury intervened to help acquire a few highly publicized paintings. More could not reasonably be expected of Governments preoccupied with the country's international security and national well-being.

Yet there never was a time during the nineteenth century when Governments could not have cited national and international anxieties to withhold money from the arts. From the 1820s through the 1860s, nonetheless, some progress had been made in

[1] 'How Shall We Save Our Pictures?' *Saturday Review* 108 (9 October 1909): 434.

[2] *National Trust Guide*, p. 47.

the development of an official policy towards art. A Government department had been established to spread the knowledge of elementary art and design throughout the country, while a complex of buildings in the west of London was devoted to fine and applied art. Whether or not one was in sympathy with the aims of the Department at South Kensington, it clearly represented official recognition of art's utility to the nation at large and reflected the mid-nineteenth century faith in education, artistic or scientific, as a social panacea. By the turn of the century, however, and in the decade before the First World War, there was little official interest in further developing the national facilities for art enjoyment and instruction. Existing institutions, of course, continued to receive funds, and existing programmes were administered. But no efforts were made by any Government in this period to initiate new programmes or to apply public funds for artistic purposes in any innovative way.

Reasons of practical finance in part shaped official attitudes, but other, less tangible, considerations may also have been involved. Profound changes in the way people viewed art, and its social functions, may have undermined the theoretical basis for state support. New movements in art and aesthetic theory may have prompted statesmen to question the benefits to be derived from subsidizing cultural enterprises, and, in this context, public support of art may have seemed less justifiable than ever. The relationship between artistic trends and Treasury funding cannot be documented, but that such a relationship existed is offered here as a possible explanation for the hiatus in the development of official cultural policies at the turn of the century.

To underscore the deeply unsettling nature of the changing attitudes towards art, it is useful to turn back briefly to the mid-Victorian years. During the 1850s and 1860s, public opinion had been very certain of the role art should serve in society. In those decades, the British people viewed art more dogmatically and didactically than ever before. Art was expected to conform to the Christian and domestic virtues which society revered, and the association of beauty and morality loomed large in the mid-Victorian mentality. Art was required to foster elevated sentiments and to extol the devoted family life to which the middle classes were strongly attached. 'The aim of high art is the seeking and interpreting the beautiful of God's works and a working with

His truth,' wrote the Reverend William Barnes in 1861.[1] Innumerable other writers shared his sentiments, for there did, in fact, exist something like a 'community of taste' in those decades. It is not just a convenient cliché used to describe the imagined serenity of the mid-Victorian years by writers no longer working within a clear consensus of opinion. In the 1850s and 1860s, the public knew what it liked in fiction, painting, poetry, and sculpture, and it also knew which emotions were the proper ones for art to express.

For this reason, society did not hesitate to rule tyranically over the realm of art. Militant morality was on the march and nearly smothered the arts in its incessant appeal to propriety. Good taste was more than ever invoked as a standard of conduct, and because taste was so closely linked with notions of class, gentility, and education, people joined the clamour against alleged obscenity all the more vigorously to secure a place in the ranks of the righteous. Artistic expression had to be examined carefully, the watchdogs of public morality claimed, to protect the unsuspecting from anything low or suggestive that might lurk beneath the guise of high art.[2] It was this mentality that prompted Lord Chief Justice Campbell to introduce, and Parliament to pass, the Obscene Publications Act of 1857, 'for more effectually preventing the Sale of Obscene Books, Pictures, Prints, and other Articles'.[3]

Society's moral guardians were gratified by the passage of the Act, which created a new statutory weapon with which to go crusading against the filth of Holywell Street. But their most insidious enemy did not emerge from the centre of London's pornography trade. The greatest danger seemed to infiltrate British art, drawing much of its inspiration from France, in the writing of men like Gautier, Baudelaire, and Flaubert, and the doctrine of *l'art pour l'art*. People in England became aware in the 1850s and 1860s that all modern British poetry did not produce Tennyson's lofty impact or even echo Martin Tupper's comforting platitudes. In the verses of William Morris, D. G. Rossetti, Swinburne, and their admirers, readers were being introduced to strange, provocative worlds of colour and passion, where lan-

[1] 'Thoughts on Beauty and Art', *Macmillan's Magazine* 4 (June 1861): 135.

[2] While people claimed that art should have a morally elevating impact, they were deathly afraid, it seems, that it might not.

[3] *Parliamentary Papers*, vol. 4 (1857, sess. 2) (*Bills: Public*).

guage and form mattered as much as, or more than, the subject. Even reputedly open-minded critics took alarm. John Morley, reviewing Swinburne's *Poems and Ballads* in the *Saturday Review*, found the volume 'crammed with pieces which many a professional vendor of filthy prints might blush to sell', oozing 'unspeakable foulnesses'.[1] The public furore over the book terrified its publisher, Moxon, who withdrew it from sale.[2]

Several years later, in 1871, Robert Buchanan, a mediocre poet, launched his famous attack on 'the Fleshly School of Poetry', in an article combining the worst elements of panic and prudery that characterized the preceding decades.[3] Rossetti was the chief victim of this assault, although Swinburne received his share of blows as well, and Baudelaire was, inevitably, blamed for many of the sins of 'the modern Fleshly School'. Buchanan saw 'Sensualism, which from time immemorial has been the cancer of all society . . . shooting its ulcerous roots deeper and deeper' into the fabric of British life, and he accused the 'Fleshly Poets' of furiously abetting the process. He criticized Swinburne, Rossetti, and similarly disposed poets, for wishing 'to create form for its own sake' and claimed 'that all the gross and vulgar conceptions of life which are formulated into certain products of art, literature, and criticism', emanated from 'a sort of demi-monde' in London, composed of 'men and women of indolent habits and aesthetic tastes'.[4]

By 1872, the guardians of national virtue already recognized 'aesthetic tastes' as a distinct menace. If, in 1838, the English scarcely knew the meaning of the word 'aesthetical', thirty years later, it had for many people acquired a pejorative connotation.[5] It represented a radically new approach to art and art appreciation, subordinating content to treatment and sweeping aside all the

[1] 'Mr. Swinburne's New Poems', *Saturday Review* 22 (4 August 1866): 145.

[2] Moxon had already been found guilty of blasphemous libel for publishing *Queen Mab* in 1841.

[3] The article first appeared in October 1871, in the *Contemporary Review*, and then, in an expanded form, as a slim book in 1872. Quotations here are from the book, *The Fleshly School of Poetry and Other Phenomena of the Day* (London: Strahan & Co., 1872).

[4] *Fleshly School*, pp. 21, 1, 83–4, 37, 52, 5–6. The significance of this silly book lies less in Buchanan's frantic critique of Swinburne's and Rossetti's poetry than in his identification of 'form for its own sake' as a threat to existing canons of art criticism.

[5] 'Plato, Bacon, and Bentham', *Quarterly Review* 61 (April 1838): 463.

moral and intellectual standards of criticism that had provided solid criteria for judging art in the preceding decades. Gradually, morality's grip on art was being loosened, and the celebrated conclusion of Pater's *Studies in the History of the Renaissance*—the determination to savour 'not the fruit of experience, but experience itself', 'to burn always with this hard, gemlike flame'— seemed to provide an eloquent endorsement of the iconoclasts' work.

Pater did not catch the world totally unawares in 1873. By the mid-1860s, a few critics and writers were arguing for different modes of response to art and beauty, unrelated to moral impulses engendered in man's mind and heart. Eneas Sweetland Dallas, for one, assigned to art 'the world beyond consciousness', and described the impact of art in such terms as 'electric', 'shock', and 'thrill of pleasure'.[1] With unusual perception for the period, Philip Gilbert Hamerton recognized in the 'Principle of Art for Art' 'more influence than any other consideration in determining the rank which an artist's name must ultimately hold in the catalogue of masters'.[2] The *Westminster Review* contributed its dignified voice to the discussion and concluded that the artist's 'one business . . . is to gladden and gratify us without an afterthought'. Unable in any way 'either to make or to mar in the momentous work of moral instruction and moral achievement', art must be 'allowed to go her natural way in the unswerving search for beauty'.[3] This was by no means rampant hedonism. Even in succeeding decades, the aesthetic approach to art never entirely ousted the ethical. But the point of view was definitely beginning to shift by the end of the 1860s. The certainty with which art had been turned into moral and socially useful channels, and the assumptions that supported the efforts to make art applicable to trade and industry, were no longer unchallenged.

From the 1880s until the First World War, art seemed to bolt right out of the grasp of that middle-class audience which had

[1] *The Gay Science*, 2 vols. (London: Chapman & Hall, 1866), 1: 312–13, 316.

[2] *Thoughts About Art*, rev. ed. (Boston: Roberts Brothers, 1871), p. 381. The essay, 'The Artistic Spirit', in which this observation appeared, was included in the earlier 1865 edition.

[3] 'Art and Morality', *Westminster and Foreign Quarterly Review*, n.s., 35 (January 1869): 179, 184.

finally settled down to feel comfortable in its presence. It was no longer the tame, familiar commodity that had been raffled off in art union lotteries, linked to butter knives and brooches at public exhibitions, and marshalled under the authority of a Government department. It seemed to delight in shocking the public, and attitudes, only emerging in the 1860s and 1870s, became full-fledged theories which outraged some people and sorely baffled others. The moral-didactic view of art was assailed on all sides. Whistler's libel suit against Ruskin in 1878 concisely summed up the clash of old and new, for Whistler's paintings, like his manifestos, proclaimed art's independence from morality, from social responsibility, and even from human content.[1] His canvases were carefully arranged studies of colour, form, and harmonic effect. They were as incomprehensible to a public that applauded Millais' later commercial efforts, as the Post-Impressionist exhibition of 1910–11 was to an audience that acclaimed Alma-Tadema's academic epics. Roger Fry, who organized the Post-Impressionist show, expounded an aesthetic theory that repudiated anecdotal and representational art. To many viewers and critics, the show was a repudiation of art itself.

What were people to think of the self-conscious aesthetes, whose very style of life appeared nothing more than endless attitudinizing? If there was more to Oscar Wilde than met the eye, he was best known, at least prior to his trial, for his witticisms, his costumes, and his reputedly exotic tastes. He and his many imitators encouraged the growing suspicion that the artist existed apart from society, that he cared nothing for the moral impact of his work, and, impervious to any audience, studied only his own visions and emotions. '*A true artist takes no notice whatever of the public,*' Wilde wrote, hyperbolically denying the whole tradition of British culture. '*The public are to him nonexistent.*'[2]

The decadents were even harder to understand than the aesthetes. How should one respond to their 'over-subtilizing

[1] Whistler sued Ruskin after Ruskin referred to one of Whistler's *Nocturnes* as a pot of paint flung in the public's face.

[2] *The Soul of Man under Socialism and Other Essays,* with an Introduction by Philip Rieff (New York: Harper & Row, Harper Colophon Books, 1970), p. 260. 'The Soul of Man under Socialism', where this assertion appears, was first published in the *Fortnightly Review,* February 1891.

refinement upon refinement', their 'spiritual and moral perversity', and fascination with disease?[1] What could people make of the *Yellow Book* or the *Savoy*, whose elegant and wicked drawings by Aubrey Beardsley were such a far cry from the staid and sober *Art-Journal*?[2] There were, indeed, other notes struck in the cultural life of Great Britain during the 1890s. Hardy, Kipling, Shaw, Pinero, Wells, Conrad, Maugham, Elgar, Morris, Sargent, and the New English Art Club—the list of artists active in this single decade is dazzling. For the most part, they rejected the idea of an elite minority culture, and their art reflected the social environment in which they worked. The Pugin-Ruskin tradition of art criticism found a prolific spokesman in William Morris who preached of art inextricably joined to the life and labour of the English people, and whose own example provided a powerful impetus behind the Arts and Crafts Movement of this period. For him, the quality of craftsmanship and the condition of society were nearly identical problems.

Yet the dissident voices were not drowned out. The suspicion that art might be amoral had been spread abroad, a feeling that the artist could turn his back on society and still pursue his proper function. The shared culture of the mid-Victorian era was destroyed irrevocably. Then the enjoyment of art was accessible alike to the Royal Academician and to Kingsley's labourer wandering through the National Gallery—or, perhaps more important, people were certain it was. But by the end of the nineteenth century, cognoscenti appeared to be arguing that the aesthetic experience belonged to the specially initiated. For decades, statesmen had been persuaded to subsidize cultural undertakings because of their conviction that art was not only an instrument of national glory and honour, but an effective means of humanizing and civilizing the 'industrious' classes. Now, in reply to the claims of the cognoscenti, the nation's legislators could well have asked: if art serves no purpose beyond itself, if it neither refines nor educates the people, promoting neither morality nor religion, why devote public money to its aid? Although few, if any, Cabinet ministers and M.P.s would have

[1] Arthur Symons, 'The Decadent Movement in Literature', *Harper's New Monthly Magazine* 87 (November 1893): 858-9.

[2] The public made so little of the *Savoy* that it scarcely survived one year, while the *Art-Journal* sold for decades.

articulated their feelings specifically in these terms, there was nonetheless a definite sense in these years that art was making a bad name for itself, and successive Governments were always sensitive to popular opinion. They were certainly not eager to associate themselves with anything which the public deemed immoral or irreligious, and they accordingly betrayed a definite wariness where art was concerned.

[iv]

The widely publicized controversy over dramatic censorship unequivocally revealed the Liberal Government's decision to play safe. For decades, the Lord Chamberlain's powers over free expression in the British theatre had been discussed and criticized. Select committees had heard evidence on the subject in 1832, 1853, 1866, and 1892, and during the first decade of the twentieth century the debate became impassioned. The legislation of 1737, which first gave the Lord Chamberlain authority to censor plays, had originated for political reasons, but, by the mid-nineteenth century, the purpose of the censorship had become unabashedly moral. Religion and sex were strictly taboo, and playwrights quickly learned the limits of the permissible. Restrictions that were tolerable in the 1850s, however, were intolerable to dramatists in the freer artistic atmosphere of the early 1900s.

Writers like Pinero, Jones, Granville-Barker, Edward Garnett, and, of course, the irrepressible Shaw sought to make modern British drama a forum for the serious and open discussion of critical social problems. It infuriated them that the Examiner of Plays, an official on the Lord Chamberlain's staff, should refuse to license their plays, as well as such important foreign works as Ibsen's *Ghosts*, while authorizing the production of foolish, and often lewd, French farces. They maintained that the obligation to submit to the Lord Chamberlain for a licence every play produced in the commercial theatre was a galling form of supervision, reserved for drama alone among all forms of artistic expression in England. They complained that the Examiner's rulings were arbitrary, based on personal preference rather than general principles. They likened his despotism to that of the Star Chamber, for there was no possible appeal from his decisions, and he was free to withhold the reasons for them. It did not help matters that,

throughout the decade, the Examiner was George Alexander Redford, a former bank manager, with no appreciation of the theatre as a form of art.[1]

While the number of prohibited plays was always infinitesimal compared with those authorized for production, the rejection of even one play was an outrage to opponents of the censorship. In 1907, Redford granted 536 licences, and refused to sanction only four plays.[2] One of the four, however, was Granville-Barker's *Waste*; another was *The Breaking Point*, by Edward Garnett, which proved appropriately titled. Its rejection helped to rally the literary world in united protest. On 29 October 1907, over seventy of the country's leading writers, including Meredith, Conrad, Hardy, Swinburne, and Henry James, published a letter in *The Times* protesting against the Examiner's authority. They claimed that the censorship had done nothing to promote morality, but rather had 'tended to lower the dramatic tone by appearing to relieve the public of the duty of moral judgment'. They announced that the Prime Minister had consented to receive a deputation of dramatic authors to discuss the whole subject.

The confrontation with Campbell-Bannerman never occurred, but Herbert Gladstone, the Home Secretary, received the aggrieved writers in February 1908. After listening to their case, he observed that dramatic censorship did not directly concern his department. In fact, he continued, the whole problem 'seemed not to belong to any distinct Department of State', but he would report the discussion to the Prime Minister.[3] Campbell-Bannerman, who was slowly dying, was surely not very interested, and the matter would probably have remained in limbo but for the exertions of a few Members of Parliament. In 1908 and 1909, Robert Harcourt, the younger son of the late Liberal Chancellor of the Exchequer, and author of several comedies, introduced Bills to 'abolish the powers of the Lord Chamberlain in respect of stage plays'.[4] He was supported by Arthur Ponsonby, Ramsay Mac-

[1] Among the literature on dramatic censorship in Great Britain, see Frank Fowell and Frank Palmer, *Censorship in England* (London: Frank Palmer, 1913); G.M.G., *The Stage Censor, An Historical Sketch: 1544–1907* (London: Sampson Low, Marston & Co., 1908); and Hynes' chapter, 'The Theatre and the Lord Chamberlain', in *Edwardian Turn of Mind*.

[2] Fowell and Palmer, *Censorship*, p. 353.

[3] *The Times*, 26 February 1908, p. 18.

[4] *Parliamentary Papers*, vol. 5 (1908) and vol. 5 (1909) (*Bills: Public*).

Donald, Sir Gilbert Parker, the Unionist Member for Gravesend who wrote plays, and Thomas Power O'Connor, another parliamentary author, who also took an active interest in the national theatre movement.[1] Their continued efforts kept the question before the House of Commons until the Asquith ministry finally appointed a joint select committee of investigation in July 1909.[2]

The Joint Select Committee of the House of Lords and the House of Commons, chaired by Herbert Samuel, Chancellor of the Duchy of Lancaster, heard evidence for four months from authors, theatre managers, Redford, and other appropriate witnesses. After sifting through reams of conflicting opinion, the committee concluded 'that the public interest requires that theatrical performances should be regulated by special laws'. Accordingly, it recommended that the Lord Chamberlain retain the power to license plays. Hedging somewhat on the question of performing unlicensed plays, the committee suggested that 'it should be optional to submit a play for license, and legal to perform an unlicensed play, whether it has been submitted or not'. But with the Director of Public Prosecutions waiting in the wings to press charges against both author and theatre manager, should any unlicensed play offend public decency, no manager would risk producing an unlicensed play.

The report, in other words, left matters largely where they were. The committee members had proven more sympathetic to the managers, who wanted the security that accompanied the Lord Chamberlain's license to perform, than to the writers who wanted complete freedom of expression.[3] More important, they ranged themselves with what they gauged to be public opinion. 'It is clear,' the report observed 'that the retention of the Censorship is desired also by a large body of public opinion . . . on the ground that its abolition would involve serious risk of a gradual demoralisation of the stage.'[4] If the English stage was not already

[1] Whitworth, *National Theatre*, p. 66.

[2] Redford made the supreme tactical error of refusing to license two short plays by Bernard Shaw in 1909, *Press Cuttings* and *The Shewing-up of Blanco Posnet*. For months, Shaw seized every opportunity to point out the absurdities of the censorship, and his campaign may have helped persuade the Liberal Government to take action, if only to win some peace and quiet.

[3] Although the licence was not a legal protection against prosecution, the system in effect worked that way.

[4] *Parliamentary Papers* (Commons), 'Report from the Joint Select Committee

demoralized by the predominance of vaudeville and imported farces, it is hard to see how much serious damage Shaw and his colleagues could have inflicted.

'Things will be in statu quo—a consummation which is, of course, the aim of the report in all its ramifications,' Max Beerbohm commented after the publication of the report,[1] and that was precisely where things remained. The Government made no move to implement even the weak attempt at compromise embodied in the suggestion of an optional licence, and the Lord Chamberlain's authority was in no way impaired as a result of the committee's findings.[2] The new Liberalism turned out to be very old-fashioned where the new 'drama of ideas' was concerned. There was, after all, little purpose to be served in championing an idea whose time had not yet come.[3]

The old attitudes towards art would not fade unobtrusively from the scene. The more they were challenged by the new aesthetics, the more tenaciously their advocates clung to morality and virtue, and sought to uproot whatever seemed demoralizing and debilitating in the national culture.[4] The protectors of the nation's moral tone pressed into service the Obscene Publications Act of 1857 and subsequent legislation to suppress the publication or circulation of works by Zola, Walt Whitman, Edward Carpenter, Joyce, and Lawrence, to name only a handful. They

of the House of Lords and the House of Commons on the Stage Plays (Censorship)', 1909, 8: viii–xi.

[1] 'The Censorship Report', *Saturday Review* 108 (20 November 1909): 626.

[2] It remained intact until 1968, when the Theatres Act finally eliminated dramatic censorship.

[3] At just this time, the Cinematograph Act of 1909 indirectly gave rise to a means of film censorship. While the Act's main purpose was to give local authorities the power to license cinemas as a way of enforcing safety regulations, local authorities soon found that they could use their licensing power to control the kind of films being shown. In 1913, the film industry organized its own British Board of Film Censors which rapidly gained semi-official status. Thereafter, local authorities generally refused to permit the exhibition of any film not approved by the board. It is interesting that the film censorship combined all the qualities criticized in the dramatic censorship: it was arbitrary, inconsistent, and not responsible to the representatives of the people. Yet its function must have met a public demand or the film trade would not have voluntarily muzzled itself.

[4] See the fascinating debate on 'Corrupt Literature' in the House of Commons, *Parliamentary Debates*, 3rd ser., 325 (8 May 1888): 1707–25.

believed, as their fathers had believed, that public morality was a legitimate concern of the state, and they used the law unstintingly in their battle for national purity. For people fearful of new ideas, both in the pictorial and the literary arts, the very stability of society seemed at stake. They derided Post-Impressionism, not only because it was incomprehensible to them, but because they saw it as a source of contamination to civilization itself. The pleasant genre scenes so beloved of the Victorians had celebrated the solid, secure society of family and hearth. To many of its critics, the new art reflected nothing but the rejection of old values and the adoption of anarchic, anti-social creeds. Labour strikes, Ireland, and women's suffrage were not the only issues dividing England in 1914. The First World War broke upon a country also experiencing an intellectual crisis that questioned the very function of a national culture.

CHAPTER SIX

Between the Wars

[i]

Four years of war did not resolve the intellectual crisis. Although the wartime experience helped to lay the groundwork for future public interest in the arts, the basic question concerning the artist's role in society remained deeply controversial. In the inter-war years, in fact, the debate was widened by the emergence of mass entertainment as a principal component of British culture. Cinema, gramophone, and wireless, together with the popular press, provided unprecedented opportunities for disseminating ideas and attitudes, for broadening outlooks, and, not least of all, for confirming prejudices. Under the impact of technology, the chasm between mass civilization and minority culture, to use F. R. Leavis' phrase, continued to expand, and the urgent need to re-establish a common culture, a shared set of values, figured prominently in the thought and discussion of the period. R. H. Tawney, writing in 1929, stressed that the English, 'more than any other nation, need a common culture',[1] and many critics found fault with expressionist or abstract art for promoting an elite form of artistic expression inaccessible to the general public.[2] International affairs, too, prompted concern for Britain's cultural development. The emergence of fascist governments, on the one hand, and the consolidation of the Bolshevik regime, on the other, forced advocates of democracy carefully to examine what centuries of parliamentary rule had accomplished for the physical and spiritual welfare of the private citizen.[3] As in the past, art's

[1] *Equality* (London: George Allen & Unwin, 1931), p. 30. Tawney first presented the work as the Halley Stewart Lectures, 1929.

[2] See, for example, Reginald Blomfield, *Modernismus* (London: Macmillan & Co., 1934); and Roger Hinks, 'Patronage in Art Today', in *Art in England*, ed. R. S. Lambert (Harmondsworth: Penguin Books [1938]), pp. 73–7.

[3] It was certainly no coincidence that the British Council was founded in 1934 to promote appreciation of British culture abroad. Financial support

function in society was debated within the larger question of the Government's social responsibilities, and the great attraction which Marxism and communism exerted for numbers of British intellectuals during the 1930s guaranteed that the controversy featured the most perceptive and probing thinkers of the decade.

The debate was not, however, the exclusive concern of intellectuals. From the time of the First World War until the outbreak of the Second, there was a concerted effort to introduce the arts more widely throughout society than ever before. Partly associated with experiments in education, including adult extension classes, the efforts resulted from private, municipal, and, to a lesser extent, parliamentary initiative. The advent of Labour as a governing party in the 1920s introduced a new element into the issue of national art subsidies, and the Labour Governments, for the most part, showed a more active interest in, and commitment to, the arts than either the Conservatives or Liberals had previously shown. If the Depression had not occurred, the story of Great Britain's official arts policy might have been accelerated by twenty years, but the economic catastrophe effectively destroyed all chances of significant support for art between the wars. Throughout the 1930s, successive Governments pursued the traditional approach to art in Great Britain: sympathetic statements, occasional ad hoc legislation and isolated Treasury grants, but no coherent or systematic plan of encouragement.

At times, official policy even seemed tantamount to discouragement. Lack of state aid to the performing arts became particularly critical when a heavy entertainments duty, imposed during the First World War and retained throughout the inter-war period, made both live entertainment and the cinema considerably more expensive to attend. A form of literary censorship continued through the machinery of Home Office, Post Office, and Customs surveillance, while pictorial art, too, came under a degree of official control. In 1929, police raided an exhibition of pictures by D. H. Lawrence, seizing several and ordering the destruction of numerous reproductions. Customs authorities contributed to the problems of organizing an International Surrealist Exhibition in 1936, and barred two paintings from entering the country.[1]

comes largely from parliamentary grants on the Foreign Office, Colonial, and Commonwealth votes.

[1] Alec Craig, *The Banned Books of England*, with a Foreword by E. M. Forster

The House of Commons, furthermore, was not altogether certain how to define art, although it had been discussing the subject, at irregular intervals, for over a century. During debate on exemptions from the Import Duties Act of 1932, Parliament's general confusion became embarrassingly evident. E. L. Burgin, Parliamentary Secretary to the Board of Trade, in attempting to explain why only some kinds of art would be added to the free list by the new measures under consideration, came perilously close to telling the House that 'a coloured cartoon is a work of art and an uncoloured cartoon is not a work of art'. Sculpture was excluded from the list 'because there has not been any possibility of defining where granite stops and art begins', and paintings were exempt from duty 'partly because they are media of culture, but also because we have a very valuable re-export trade in works of art'.[1] A Government unable to distinguish art from granite, and preoccupied with its re-export value, was not likely to forward a constructive policy.

Confusion of purpose also hindered the work of the Royal Fine Art Commission, a permanent body established in 1924, under the chairmanship of the Earl of Crawford and Balcarres.[2] According to its warrant of appointment, the Commission's purpose was 'to enquire into such questions of public amenity or of artistic importance as may be referred to them from time to time by any of Our Departments of State, and to report thereon to such Department; and furthermore, to give advice on similar questions when so requested by public or quasi-public bodies. . . '.[3] The Commissioners' role was purely advisory at first; it was not until 1933 that an additional Royal Warrant authorized them 'to call the attention of any of Our Departments of State, or of the

(London: George Allen & Unwin, 1937), pp. 32–4. See the series of articles, by Havelock Ellis, E. M. Forster, Virginia Woolf, and others, on 'The "Censorship" of Books', in *Nineteenth Century and After* 105 (April 1929): 433–50; and Viscount Brentford (William Joynson-Hicks), *Do We Need a Censor?* (London: Faber & Faber, 1929).

[1] *Parliamentary Debates* (Commons), 5th ser., 287 (19 March 1934): 961, 965, 958.

[2] Over the years, its eminent membership included Lord Curzon, Edwin Lutyens, D. S. MacColl, and William Rothenstein, among others.

[3] *Parliamentary Papers*, vol. 9 (1924) (*Reports from Commissioners, Inspectors, and Others*), 'Report of the Royal Fine Art Commission on the Proposed St. Paul's Bridge', pp. 2–3.

appropriate public or quasi-public bodies, to any project or development which in the opinion of the said Commission may appear to affect amenities of a national or public character'.[1]

But what constituted questions of public amenity or artistic importance? During its first thirteen years, the Commission offered suggestions for the placement of statues and public memorials, the layout of public buildings and municipal improvement projects in London and other cities, the preservation of historic buildings, the Tate Gallery's staircase, and the reading room of the British Museum. It advised the Postmaster-General on designs for telephone kiosks and postage stamps, and the Minister of Transport on pedestrian traffic signs.[2] In consulting with the London County Council about new helmets for the London fire brigade, the Commission was perhaps displaying an admirably broad understanding of the term 'fine art', but its interest in more traditional art forms was notably scant. It seems curious that, while the Commissioners' reports are filled with problems of an architectural nature, there is little mention of painting or sculpture, except in connection with monuments and public buildings. Ballet, opera, and drama are ignored in the reports; there is not even any discussion of designs for theatres or concert halls. Evidently the performing arts were not yet considered urgent matters of public amenity.

As in previous decades, museums were the one area of artistic endeavour that enjoyed moderate official attention consistently throughout this period. While the Labour ministries expressed concern for the financial plight of drama and opera, Parliament passed no measures to alleviate their difficulties. Several pieces of legislation, however, proved beneficial to museums, beginning with the Education Act of 1918, which empowered local education authorities to make grants to museums. The Public Libraries Act of 1919 finally removed the limit on funds that could be spent from the rates for museum purposes,[3] and in 1921 an

[1] *Parliamentary Papers*, vol. 12 (1933/34) (*Reports from Commissioners, Inspectors, and Others*), 'Fifth Report of the Royal Fine Art Commission', p. 2.

[2] See the Commission's six reports in this period, 1924–37, in *Parliamentary Papers* (*Reports from Commissioners, Inspectors, and Others*): second, vol. 10 (1926); third, vol. 6 (1928/29); fourth, vol. 13 (1930/31); sixth, vol. 10 (1937/38).

[3] The amount had previously been restricted to 1d. in the pound.

amendment to the Finance Act exempted from death duties objects of art sold to public collections or to the National Art-Collections Fund.[1] Advocates of state subsidies to art were amazed and delighted when, in March 1918, at a critical moment in the war effort, the Government sanctioned a special grant for purchases at the Paris Degas sale, which brought to the British national collections works by Ingres, Delacroix and Manet.[2] In 1922, Sir Robert Horne, Chancellor of the Exchequer in Lloyd George's post-war coalition, offered further evidence of governmental interest in the country's art possessions. Sir Philip Sassoon, the Conservative Member for Hythe and a trustee of the National Gallery, asked for reassurance that the Treasury would assist the gallery's efforts to stem the flow of invaluable art treasures from Great Britain. He asked whether the Treasury would be prepared to grant the extra sums needed to acquire masterpieces when private collections came on the market, and the Chancellor replied sympathetically:

> . . . we certainly ought not to allow such pictures to go out of the country if they can be kept here at a price which is reasonable . . . I cannot, of course, bind my successors in office, nor succeeding Governments, but I think it is only reasonable that we should be ready to vote in Parliament reasonable sums of money to preserve such masterpieces, if they do upon occasion happen to become the subject of prospective sale which would have the effect of taking them away.[3]

[1] In a matter closely related to the nation's art collections, the National Trust Act of 1937 enabled the National Trust to hold land and investments for the purpose of maintaining estates when their owners were no longer able to do so. In effect, the Act created the necessary conditions for the inauguration of the 'Country House Scheme', which allows owners of historic homes to transfer them to the Trust. Both the former owners and their heirs can continue to live in them, provided that certain conditions are observed and that the houses are regularly opened to the public. The National Trust was first registered in 1895 as a private company, 'The National Trust for Places of Historic Interest or Natural Beauty'. *National Trust Guide*, pp. 11, 13–14. Although the country house is probably Great Britain's most individual contribution to the visual and decorative arts, and although the tourist value of stately homes is inestimable, the National Trust has always suffered from inadequate financial support.

[2] Hendy, *National Gallery*, pp. 69–70; and Holmes and Collins Baker, *National Gallery*, p. 75.

[3] *Parliamentary Debates* (Commons), 5th ser., 157 (3 August 1922): 1865.

Local authorities, too, showed considerable interest in museums after the First World War, and, in the 1920s, municipal governments began to figure frequently as patrons of museums and art galleries. In 1929, the Liverpool Corporation made its first annual grant from the rates to help the Walker Art Gallery purchase works of art, while earlier in the decade, the Leeds Corporation bought from Lord Halifax the great Tudor-Jacobean mansion, Temple Newsam, which ultimately housed a local museum of decorative art. From the opening of the Usher Art Gallery in 1927, the Lincoln City Corporation allocated funds from the rates for its upkeep and growth.

There were, of course, significant exceptions to this promising state of provincial development. The Birmingham Corporation, for example, gave the City Art Gallery no public funds for acquisitions until after the Second World War,[1] and, far more important, there were large areas of the country that had no museum services available to local inhabitants. A study of the public museums of the British Isles, excluding the national institutions, which Sir Henry Miers undertook for the Carnegie United Kingdom Trust in 1927–8, revealed a strikingly haphazard distribution of museums. He found more than one hundred boroughs of over 20,000 population without a public museum, including Croydon with nearly 200,000 inhabitants. He also found inadequate funding to be the rule for municipal museums, crowded miscellaneous collections, and totally insufficient housing and storage space.[2] Nevertheless, Miers had to survey 267 municipal museums, directly supported by grants from the rates, a figure which at least indicated widespread, if poorly directed, local interest in providing museum facilities. By 1938, when S. F. Markham undertook a second survey for the Carnegie United Kingdom Trust, his report covered no less than 400 museums financed and administered by local authorities.[3]

Kenneth Clark describes Sassoon's own exotic tastes in art, worthy of Haroun al Raschid, in *Another Part of the Wood, A Self-Portrait* (New York: Harper & Row, 1974), pp. 220–1.

[1] Harris, *Government Patronage*, p. 293; Blunt and Whinney, *Nation's Pictures*, pp. 160, 193, 201.

[2] Miers, *Report on the Public Museums of the British Isles*, pp. 14–15, 17–19, 23–5, and appendix II.

[3] Sydney Frank Markham, *A Report on the Museums and Art Galleries of the British Isles (other than the National Museums) to the Carnegie United Kingdom*

The inter-war years saw museums, both national and municipal, assuming a more publicly oriented role in response to a growing awareness of their potential services to the community. In 1919, the third interim report of the Adult Education Committee of the Ministry of Reconstruction urged close cooperation between local museums and education authorities.[1] The Board of Education in 1931 published a pamphlet, *Museums and Schools*, which advocated greater use of museums for educational purposes. In 1927, a Royal Commission was established 'to enquire into and report on the legal position, organisation, administration, accommodation, the structural condition of the buildings, and general cost of the institutions containing the National collections situate in London and Edinburgh. . . '. Its interim report, issued in September 1928, stressed the essentially educational function of the national museums and galleries. 'Without them,' the Commissioners observed, 'the educational fabric of the State would be quite incomplete,' while scholars, artists, industrialists, schoolchildren, and the general public alike would be deprived of an incomparable source of information, inspiration, and edification.[2] The arguments of the Royal Commissioners would have sounded

Trust (Dunfermline: Carnegie United Kingdom Trust, 1938), p. 22. Out of the nearly 800 museums in Great Britain at that time, only about 80 were devoted purely to art. Ibid., p. 52. Markham, who assisted Miers in the earlier study, was National Labour M.P. for Nottingham.

[1] Miers, *Report*, p. 8, and Markham, *Report*, p. 24.

[2] 'Interim Report of the Royal Commission on National Museums and Galleries', pp. 3–5, 27–9. Viscount D'Abernon, a trustee of the National Gallery, was chairman of the Commission, whose members included Sir Henry Miers. The Commissioners issued their final report in two parts, in 1929 and 1930. Among their major recommendations was the establishment of a standing commission on the national museums and galleries to provide some measure of central coordination for the work of these institutions, and to oversee their relations with provincial museums. The Standing Commission on Museums and Galleries was duly created by Treasury minute in February 1931, and Lord D'Abernon served as chairman until 1937. The Commission issued two reports in the 1930s and does not seem to have exerted much influence. In 1938, Markham, *Report*, p. 170, reported that the nation's museums were developing without 'direction or authoritative oversight'.

Another advisory committee organized in this period was the Council for Art and Industry, established by the Board of Trade in 1934. It represented the continuation of a century of interest, on the Board's part, in the problems of industrial design.

exceedingly familiar even to the early Victorians. Although by the 1920s, many critics doubted whether art could confer any social benefits at all, the advocates of public funding for cultural facilities voiced opinions essentially similar to those put forward in the 1830s and 1840s. In the 1920s, when people assigned a positive value to the arts and urged Parliament to promote them, they still, in most cases, believed that art was a principal agent of education and, by implication, of moral improvement.

In this period, a number of educational authorities and museums —in Manchester, Leicester, Norwich, Leeds, and Salford, for example—began to organize schemes to employ teachers, curators, and guides for school visits and to use space in local museums as extended classrooms. The London County Council in 1935 inaugurated a vigorous programme to utilize museums in the school curriculum, which aimed to make London's wealth of museum facilities familiar to schoolteachers and pupils alike.[1] After decades of solemn pronouncements about the edifying influence of museums, efforts were finally being made throughout the country to apply the grandiose theories to practical programmes. The impetus for experimentation may have come from a number of sources. National dependence on a mass army for the first time during the war, and the advent of full adult suffrage afterwards, no doubt heightened official concern for the quality of education in Great Britain. Increased ease and rapidity of transport helped to facilitate museum visits by school parties, even from considerable distances. Innovative educational theories, which attracted growing interest after the war, emphasized the learning that occurs beyond the rigid structure of classroom and school. In the inter-war years, the nation's museums were subjected to intense scrutiny—by official commissions, private foundations, the Board of Education, and municipal authorities—in an effort to establish an overall policy to guide their growth along fruitful, mutually beneficial lines.

The attempt might have been more successful had there been some measure of agreement concerning the Government's role in the development of museums across the country. While there was general agreement that the state should participate more actively in the enterprise, views differed widely over the extent of

[1] Miers, *Report*, pp. 31–3, and Markham, *Report*, pp. 114–23.

participation. Markham, for example, suggested the creation of a new Government department with responsibility for local cultural services, or, alternatively, the placing of all museums and art galleries under the direct supervision of the Board of Education. The Royal Commission on National Museums and Galleries, however, had earlier rejected the idea of centralizing the national institutions under a single department of state. That was a continental practice, the Commissioners maintained, 'alien to the traditions under which the English Institutions have developed'.[1]

Museums in Great Britain would also have profited from more generous allocation of funds, both from parliamentary and municipal sources. For all the discussion of museums and their public services, surprisingly small amounts were available to them in these years. Expenditure on the leading national institutions in London, Edinburgh, and Cardiff never rose much beyond £1 million per year, and provincial museums received a total of about £450,000 annually. What this meant for the individual museum varied widely, but Markham counted 530 provincial museums with an annual income of less than £500.[2] No aid of any significance was forthcoming from national sources to aid the hard-pressed provincial institutions, and support from local authorities in most cases was inadequate. From his study of museums financed by local corporations, Miers concluded that no museum received more than a 3/4d. rate for its total upkeep, while the average cost of municipal museums to the ratepayer was less than ½d. in the pound per year.[3] Education authorities, even when they professed interest in closer cooperation between local schools and museums, were not interested in footing the bill. With very few exceptions, Markham found that 'not a penny piece comes from the education authorities to museums,

[1] *Parliamentary Papers*, vol. 16 (1929/30) (*Reports from Commissioners, Inspectors, and Others*), 'Final Report of the Royal Commission on National Museums and Galleries', pt. 1, pp. 12, 14–15.

[2] 'Interim Report of the Royal Commission on National Museums and Galleries', p. 28 and appendix III; Miers, *Report*, p. 36; and Markham, *Report*, pp. 17–18, 21.

[3] Miers, *Report*, pp. 17, 19. This was nearly ten years after the removal of the limits on museum expenditure from the rates. At the same time, Miers reported that libraries received grants ranging from a fraction of a penny to over 4d. in the pound.

who are expected to find the funds for this additional work from budgets that are already too low'.[1]

Under the economic conditions that prevailed after the war and during the Depression, large allocations of funds for museums could hardly be expected. Unemployment, hunger, and housing for people were more urgent concerns than accommodating stuffed birds and paintings, and successive Governments had no choice but to observe priorities. Nevertheless, official stinginess towards the nation's art collections and museums appears particularly dismal and unimaginative at this time. If the country could not afford to initiate projects, or to offer the subsidies to drama, music, literature, and the visual arts that one found in the United States under the WPA, British Governments might at least have remembered the lesson that art could be a sound national investment. But their basic approach to museum financing was to spend as little as possible.

One of the reasons, in fact, for establishing the Royal Commission on National Museums and Galleries was explicitly 'to consider in what way, if any, expenditure may be limited without crippling the educational and general usefulness of the Institutions. . . '.[2] That the National Gallery was not crippled by its minimal annual purchase grant—which twice in the 1930s the Treasury 'cut off . . . altogether'[3]—was only thanks to the generosity of rich private patrons and rare grants-in-aid from the Exchequer for special acquisitions. The Tate Gallery, which after the war became the home of British art from the sixteenth century and of modern foreign art, received no regular income from the Treasury until 1946.[4] The Royal Commissioners, however, were not in sympathy with a policy of public cultural austerity, and they issued a timely warning:

> . . . we believe that it would be disastrous, both from the standpoint of the educational needs of the country and of the national prestige, if the Collections, the splendour of which we have emphasised, were not adequately maintained. In our judgment

[1] Markham, *Report*, p. 125.

[2] 'Interim Report', p. 4.

[3] Clark, *Another Part of the Wood*, p. 232.

[4] Reid, Introduction to *Tate Gallery*, p. 5; and Rothenstein and Chamot, *Tate Gallery*, p. 7.

economy has already been pushed beyond the point of prudent administration.[1]

In their final report, they accurately summarized official treatment of the national museums over the previous century:

> In general it is true to say that the State has not initiated. The Collections, whether artistic, literary, or scientific, once formed by the zeal of individuals, and thereafter bestowed on or acquired by the State, have been maintained out of the public revenues at the lowest possible cost. The attitude of the State to the National Museums and Galleries has for the most part been a passive and mainly receptive attitude. Development has been spasmodic.[2]

Without generous private support, there would have been no development at all. While Treasury funds provided maintenance, and sometimes barely that, private donors saw to it that the great national collections continued to grow during the lean inter-war years. The Standing Commission on Museums and Galleries estimated that Joseph Duveen, the younger, spent £250,000 on public museums between 1930 and 1938, and the results of his munificence included a new gallery for the Elgin Marbles at the British Museum and sculpture galleries at the Tate.[3] It was Lord Duveen, too, who financed additional galleries at the Tate for modern foreign art, when the bequest of Sir Hugh Lane—thirty-nine modern pictures, mostly French—first raised the possibility of housing foreign collections there.[4] These collections were substantially enriched in 1923, when Samuel Courtauld, chairman of Courtaulds, Ltd., and active patron of the arts, gave £50,000 to the Tate trustees to purchase modern French paintings. The gift brought incomparable Impressionist and Post-Impressionist works to the Tate. Until after the Second World War, it was no exaggeration to say that the Tate was 'built entirely by private

[1] 'Interim Report', p. 29.

[2] 'Final Report', pt. 1, p. 10.

[3] Standing Commission on Museums and Galleries, *Second Report* (London: HMSO, 1938), pp. 6–8, 13. In 1933, Duveen the younger was raised to the peerage with the appropriate title of Baron Duveen of Millbank.

[4] Sir Hugh Lane, art dealer, collector, and critic, was drowned on the *Lusitania* in 1915.

benefaction'.[1] Outside London, too, private generosity gave rise to numerous provincial institutions which municipal funding might never have created.

At the end of his report, Markham paid tribute to 'the man in the street', as a patron of art, and urged museum curators and trustees to aim above all at enlightening 'the average wage-earner and his family'.[2] Influential work of this nature also proceeded outside museums, in classes of the Workers' Educational Association and University Extra Mural Departments, and in the tours of 'Art for the People'.[3] The British Institute of Adult Education, a voluntary organization founded in 1921, inaugurated 'Art for the People' in 1935. The scheme, operating on the simple principle that art should go to people who cannot go to art, was largely a private enterprise. The truckloads of pictures, displayed in small towns and rural areas lacking public collections, were on loan almost exclusively from private owners. The costs of the undertaking were met by the Carnegie United Kingdom Trust, the Pilgrim Trust, and private supporters, with a few pounds contributed by local authorities.[4] In each location where the pictures were displayed, the exhibition lasted about a month and admission was free. The British Institute of Adult Education brought in experts to talk about the art, to answer questions, and to encourage lively discussion among the viewers. In many cases, people came into contact with art for the first time, and discovered that they had opinions and ideas to articulate about the subject. The experiment proved extremely successful. The exhibitions attracted large audiences and stimulated the establishment of numerous local art clubs. They proved that enthusiasm for art

[1] Reid, Introduction to *Tate Gallery*, p. 5. After his wife's death in 1931, Courtauld gave to London University the leasehold of his home in Portman Square and a capital sum to provide the endowment for what became the Courtauld Institute of Art.

[2] Markham, *Report*, p. 173.

[3] See Robert Lyon, 'An Experiment in Art Appreciation', in *Art in England*, ed. R. S. Lambert, pp. 118–23. Lyon describes his work with a WEA class in the colliery town of Ashington, near Newcastle, in 1936. The Arts Council's report, *The First Ten Years* (London: The Arts Council of Great Britain, [1955/56]), p. 5, discusses the growing interest in music, drama, and literature in WEA and University Extra Mural classes during the 1930s.

[4] *First Ten Years*, pp. 5–6; and W. E. Williams, 'Art for the People', in *Art in England*, ed. R. S. Lambert, pp. 114–18. Williams, secretary of the BIAE at the time, conceived the plan.

abounded among hitherto untapped sections of the population in remote areas throughout the country. The lesson proved critically important during the Second World War for the subsequent growth of public art subsidies.

[ii]

As with the pictorial arts, the performing arts established roots throughout England during the inter-war years, thanks mainly to private endeavours. The Depression put an end to the interest which MacDonald's Labour Government had shown in assisting drama and opera, and, in any case, advocates of national and municipal subsidies to the performing arts had powerful vested interests to overcome, as revealed by the history of the 1925 Public Health Act. The Act expanded the powers of local authorities to spend the product of a penny rate on the provision of entertainment and recreational facilities in public parks and buildings. As the Bill left the House of Commons, the entertainment which it enabled local authorities to furnish included 'bands, concerts, performances, lectures, shows, exhibitions, competitions and other amusements'—a range of possibilities that had hitherto remained outside the jurisdiction of local authorities, except under limited circumstances or with the aid of private legislation. After the House of Lords had finished amending the Bill, however, stage plays, variety entertainment, and films ('other than a film illustrative of questions relating to health or disease') were explicitly withdrawn from the authority of local governments.[1] In making these changes, the Lords were responding to a furious campaign waged by the president of the Society of West End Theatre Managers and chairman of the Entertainments Protection Association. The irate lobbyist warned that municipal sponsorship of entertainment would be ruinous to the interests which he represented. Those interests controlled a great deal of money, and the final version of the Bill contained the amended clause.[2] Thus municipal authorities lost the opportunity to contribute to the widespread local interest in drama that developed after the First World War.

[1] *Parliamentary Papers*, vol. 3 (1924/25) (*Bills: Public*), 'Public Health Bill', as amended by Standing Committee C, pp. 29–30, 39, and Lords Amendments, p. 5.

[2] Robson, *Local Government*, p. 295.

At the national level of government, however, the Labour ministries of the 1920s appear to have been in basic sympathy with efforts to establish the performing arts on a secure financial basis. Labour Party statements throughout the period called for the extension of public educational, cultural, and recreational facilities to all citizens. They urged

> the greatly increased public provision . . . for scientific inves-
> tigation and original research, in every branch of knowledge,
> not to say also for the promotion of music, literature, and fine
> art, which have been under Capitalism so greatly neglected,
> and upon which, so the Labour Party holds, any real develop-
> ment of civilisation fundamentally depends. Society, like the
> individual, does not live by bread alone—does not exist only
> for perpetual wealth production.[1]

Beneath the partisan rhetoric of these pronouncements, a genuine eagerness to spread the bounties of civilization is evident. The Labour Party was not primarily an association of intellectuals. Its working-class supporters did not want theoretical harangues, but the decencies and comforts of life, including such amenities as music, literature, and fine art. From the early days of the Mechanics' Institutes, education and culture had held a prominent place in working-class aspirations, and during the nineteenth century enthusiasm for the arts had grown steadily.

In its vision of a new social order, the Labour Party wanted to secure a more honourable place for the arts than either the Conservative or Liberal Parties, whose members took culture largely for granted.[2] The country's first Labour Government took office in January 1924 with a programme that, among other proposals, called for the abolition of the entertainment tax. The Shakespeare Memorial National Theatre Executive Committee had high hopes for the Government, but its position in the House of Commons was precarious from the start, and it fell from office

[1] *Labour and the New Social Order. A Report on Reconstruction* (London: Labour Party, 1918), p. 21. See subsequent Party statements, such as *Labour and the Nation* (1928) and *What Socialism Will Really Mean to You* (1935).

[2] In a nice example of historical consistency, one of the first actions taken by Harold Wilson's new Labour Government, in March 1974, was to abolish the museums and art galleries admission fee of 10p., imposed by the Conservative Government at the start of the year.

before achieving any substantive measures on behalf of the theatre. An appeal to the Conservative ministry that succeeded it proved fruitless. With £100,000 available to begin building a national theatre, if the Government would provide an adequate site, the committee was informed by Lord Peel, the First Commissioner of Works, that 'the Government . . . find themselves unable to place a site at your disposal'.[1] The situation improved with Labour's return to office in June 1929. A month later, Ramsay MacDonald, again Prime Minister, expressed interest in the national theatre scheme, and invited its many advocates to cooperate in formulating one proposal to submit for official consideration.[2] The groups involved in the effort were not able to organize a conference until the end of November. By then, the international economic situation rendered insignificant, at least for the time being, the question of a national theatre.

But before the national theatre project 'went into winter quarters',[3] one last effort was made on behalf of British drama. On 26 November 1929, John Beckett, the Labour Member for Camberwell, introduced a Bill authorizing 'local authorities to spend an amount up to a penny rate annually on the establishment of municipal theatres'. In the ensuing debate, there was little opposition to the measure. Sir Charles Oman, the eminent historian and Conservative Member for Oxford University, reminded the House that the decadent Roman Empire collapsed once free shows were added to the free dole, and Colonel Albert Lambert Ward, another Conservative, opposed further burdens on the rates at a time of severe financial strain. Nevertheless, the Bill easily passed its first reading by 248 votes to 138. Support came from members of all parties, with Labour ministers, including the Prime Minister, among the 'Ayes'. Although Parliament's agenda was too crowded to admit further readings of the Bill, the broad support which its introduction received

[1] Peel's letter, dated 27 April 1925, quoted in Whitworth, *National Theatre*, p. 133. Also see pp. 125, 132.

[2] *Parliamentary Debates* (Commons), 5th ser., 230 (22 July 1929): 904. While the SMNT Committee was the most prominent of the groups working for a national theatre, there were numerous organizations interested in the movement and advocating diverse plans.

[3] Geoffrey Whitworth, *The Theatre of My Heart*, new ed. (London: Victor Gollancz, 1938), p. 67. Whitworth became honorary secretary of the SMNT Executive Committee in 1930.

gave some indication that attitudes towards public aid to the performing arts were beginning to change.[1]

Even in opposing the Bill, Lambert Ward expressed his appreciation of 'the educational influence which the drama has had in this country for so many years'.[2] A few years earlier, the Board of Education had issued a *Report on Drama in Adult Education*, which hailed the theatre as 'a most potent influence of moral, intellectual, and artistic progress'.[3] In 1930, the Royal Academy of Dramatic Art won a ten-year legal struggle to include drama among the fine arts exempted from the rates by the Scientific and Literary Societies Act of 1843. 'In our view', said Sir Robert Wallace in pronouncing judgment in the case, 'Dramatic Art is a Fine Art. I should have thought there could not have been the slightest doubt about it.'[4] But there had been a great deal of doubt about it, and in the very recent past. The disreputable aura that clung to the theatre disappeared slowly in the homeland of the Puritans, and drama was still considered the only form of art that required institutionalized censorship. Yet, by the mid-1920s, influential opinion could be heard proclaiming drama's exalted purpose and beneficial influence. Clearly, to win such praise from the usually cautious officialdom, the theatre must have gained a persuasive new ally. It had indeed—public opinion.

The theatre has always been one of London's major attractions, and the city's position as the leading theatrical centre of the country has never been challenged. With the decline of local stock companies in the provinces, however, it seemed by the early twentieth century that London might become England's only theatrical centre. Touring companies from London played several of the larger towns yearly, and visitors from the provinces, with time and money to spare, made a point of attending the theatre in London. With few exceptions, local dramatic enterprise was nearly non-existent. Without the First World War, the decline of local drama might have continued unchecked, but

[1] *Parliamentary Debates* (Commons), 5th ser., 232 (26 November 1929): 1213–20. It would be interesting to know if theatre managers would have succeeded in weakening or defeating the measure in subsequent stages of its passage through Parliament.

[2] Ibid., 1215.

[3] Report, quoted in Whitworth, *National Theatre*, p. 159.

[4] Barnes, *Welcome, Good Friends*, p. 122. For the full legal battle, see pp. 119–22.

the war introduced vast new audiences to the fascination of the theatre. Some of England's leading actresses entertained British soldiers serving abroad and performed plays of high quality, including Shakespeare and Shaw.[1] They received so favourable a reception that the military authorities added amateur theatricals to the social and educational activities designed to fill the soldiers' leisure time. Even at home, the new Army Education Scheme, which aimed to offer every serviceman thorough training in educational and vocational subjects, included drama in its course of studies. The War Office School of Education at Bedford made extensive use of theatrical productions as recreational activity, and, through these various programmes, many soldiers became familiar with serious drama for the first time.[2]

The war also prompted the establishment of the British Drama League, which actively contributed to the revivification of local drama. Geoffrey Whitworth, a publisher by profession, had seen the enthusiasm with which war workers responded to even the simplest theatrical productions, and he was determined to establish an association to foster community interest in the theatre.[3] The British Drama League was privately founded at the end of the war, through the efforts of Whitworth, Granville-Barker, and other staunch supporters of the British theatre. At its first annual conference in August 1919, it adopted two resolutions that guided its subsequent activities throughout the inter-war years. It pledged first to promote in all possible ways 'collective and individual efforts for the development of the art of acting, the drama, and of the Theatre as forces in the life of the nation', and, secondly, it urged the importance of 'a National Theatre policy adequate to the needs of the people'.[4] Throughout the next two decades, the League participated vigorously in the National Theatre movement. More important, it was a federation of theatrical organizations, both amateur and professional, 'scattered through the length and breadth of England, and ranging from small village acting societies to such important bodies as ... the Royal Academy

[1] For an account of one actress's experiences, see Lena Ashwell, *Modern Troubadours: A Record of the Concerts at the Front* (London: Gyldendal, 1922).

[2] Basil Dean, *The Theatre at War* (London: George G. Harrap & Co., 1956), pp. 22–9; and Whitworth, *National Theatre*, pp. 144–7.

[3] Whitworth, *Theatre of My Heart*, pp. 8–14.

[4] Resolutions, quoted in Ibid., p. 20.

of Dramatic Art. . . '.[1] It served as a central agency for all these groups, opened channels of communication among them, encouraged their activities, and promoted their interests nationally. In 1923, the League had three hundred affiliated associations, and by 1930 the number had reached 1,600, representing over 100,000 actors and playgoers.[2] By the late 1930s, over three thousand societies were associated with the League. 'Even villages were taking up amateur acting . . . The Churches had tacitly withdrawn their objections to the stage, and in many parishes the vicar himself organized amateur theatricals.'[3]

The British Drama League represented a huge constituency which politicians, like Churchmen, could not afford to ignore. In October 1929, prior to the League's tenth annual conference, the Home Secretary told Whitworth that Government support for the theatre was more than a question of finance. 'I hope,' wrote J. R. Clynes, 'your Conference will do something to create the National support which is necessary for your purpose.'[4] During the interwar period, parliamentary and municipal lawmakers alike began to recognize the extent of national interest in the drama. Although there would always remain legislators who shared the views of Oman or Lambert Ward, the greater part were aware that public opinion no longer squarely opposed state support for the theatre. Despite vested interests that continued to denounce official involvement in the performing arts, Government officials had begun to approach the question of state funding with greater favour than ever before.

However welcome the unprecedented official expressions of sympathy and endorsement may have been, they were not enough to run a theatre or found a national institution. During this difficult period, there was scarcely any public money available to support the professional theatre.[5] Throughout the 1930s, the

[1] Whitworth, *National Theatre*, p. 169.

[2] Whitworth, *Theatre of My Heart*, p. 34.

[3] Robert Graves and Alan Hodge, *The Long Week-End: A Social History of Great Britain 1918–1939*, 2nd ed. (New York: W. W. Norton & Co., The Norton Library, 1963), p. 348.

[4] Letter from Clynes to Whitworth, quoted in *National Theatre*, p. 172.

[5] The Treasury gave RADA an annual grant-in-aid of £500, after the academy received a Royal Charter in 1920, but the money to build new premises for RADA in the 1920s came from private donors, including Shaw who gave £5,000. Barnes, *Welcome, Good Friends*, pp. 118–19, 126–7.

SMNT Committee carried on its work without state aid, and, when in 1937 it was able to purchase a site in South Kensington for the projected national theatre, the £150,000 at its disposal was entirely the fruit of private generosity, compound interest, and capital appreciation.[1] The Old Vic also achieved national and international status in the inter-war years without any help from the Treasury. Private support was forthcoming early in the 1920s, when the LCC demanded considerable reconstruction of the theatre for safety purposes, and again later in the decade, when Lilian Baylis and the Vic governors decided to purchase the dilapidated Sadler's Wells Theatre as a means of extending their activities and audience.[2] For many of the Vic's ardent supporters, independence from state aid seemed a precious advantage. 'If the State-run, academic theatre were a natural development of the English stage,' it was argued, 'the English stage would have produced it long ere this; and if we set to work to make one—late in time and on the foreign model—the result would probably be rigid as well as expensive.'[3] Once again, traditional British suspicion of the state's regulating hand served to justify official neglect of the theatre, but the Old Vic's freedom was costly: it ended its 1938-9 season with substantial losses.[4]

Ballet, the art that put Sadler's Wells on the cultural map of the world, also went without Exchequer support. After decades of subservience to Italian opera or relegation to the music hall, the ballet in England was brought back to life by the visits of Diaghilev's Russian company just before the First World War. Suddenly, ballet belonged in the vanguard of the contemporary arts, appealing to a small circle of dedicated enthusiasts. The vogue for ballet did not extend, however, to English performers. Throughout the 1920s, ballet in England was dominated by foreign, especially Russian, dancers.

The Vic-Wells Ballet Company, as it was known, effectively

[1] Whitworth, *Theatre of My Heart*, p. 68. The Second World War interrupted plans to start building on the site.

[2] Hamilton and Baylis, *Old Vic*, p. 237. In addition to the Carnegie Trust, several metropolitan organizations did contribute to the costs of rebuilding the Sadler's Wells Theatre, including the City Parochial Foundation, the Finsbury Borough Council, and the City Corporation. 'Sadler's Wells Theatre', *The Times*, 20 June 1928, p. 18.

[3] Hamilton and Baylis, *Old Vic*, p. 224.

[4] Dent, *Theatre for Everybody*, p. 85.

eliminated the prejudice against English dancers, choreographers, composers for ballet, and even English set designers. Within the space of a decade, the company grew from a group of seven ill-paid members, performing once a fortnight in 1931, to the major representatives of English ballet. In 1937, the British Council sent the Vic-Wells Company to perform at the Paris Exhibition. In 1939, it gave a command performance at Covent Garden to honour the President of the French Republic. As the Old Vic became an unofficial national theatre company between the wars, its affiliated company, the Vic-Wells Ballet, became England's approximation of a national ballet. Its achievement was extra-ordinary in so short a time, all the more so because the company relied solely upon the generosity of devoted balletomanes, among them Lady Ottoline and Philip Morrell, on whose initiative the Sadler's Wells Circle was founded to fill the theatre's more expensive seats and to help finance new productions.[1] The only assistance which the Vic-Wells Ballet received from the state during the 1930s was an exemption from the entertainments duty, as a non-profit concern whose work was at least partly educational.[2]

If large sections of the British population were scarcely acquainted with the world of the theatre before the First World War, far greater numbers had no knowledge of the ballet. Even in the metropolis, where ballet companies abounded in comparison with the rest of the country, the pre-war audience was largely an intellectual and affluent group. From its opening in 1931, the

[1] Mary Clarke, *Sadler's Wells Ballet*, p. 86. Among the many other books about the company, see Cyril W. Beaumont, *The Vic-Wells Ballet* (London: C. W. Beaumont, 1935); Arnold L. Haskell, *The National Ballet; a History and a Manifesto. With an Overture by Ninette de Valois* (London: Adam & Charles Black, 1943); Phyllis W. Manchester, *Vic-Wells: A Ballet Progress* (London: Victor Gollancz, 1942); and Kate Neatby, *Ninette de Valois and the Vic-Wells Ballet*, 2nd ed., edited by Edwin Evans, with a Preface by Lilian Baylis (London: British-Continental Press, 1936).

Ninette de Valois, an Irish ballerina who trained with Diaghilev among other masters, arranged small dances for Old Vic operas and plays in the late 1920s. When the Old Vic managers acquired the Sadler's Wells Theatre in north London, she persuaded Lilian Baylis to permit dancers from her Academy of Choreographic Art to perform an evening of ballet every two weeks. Subsequently, a ballet training school was established at Sadler's Wells.

[2] Clarke, *Sadler's Wells Ballet*, pp. 109–10. Both the Old Vic and Sadler's Wells were granted this exemption.

Vic-Wells Ballet helped to expand that audience. At the Sadler's Wells Theatre, ballet could be enjoyed at lower prices than were ever available for the brief ballet seasons at Covent Garden. Although its prices gradually rose during the 1930s, the Vic-Wells management tried to keep them as low as possible, at least for the gallery. Furthermore, ballet was performed regularly at Sadler's Wells, throughout the better part of the year. Gradually, a new audience for ballet developed in the metropolis, and, by the end of the 1935-6 season, there were no longer empty seats at Sadler's Wells ballet performances. Before the outbreak of the Second World War, ballet had become one of the most popular forms of entertainment in London,[1] while in the mid-1930s, the Vic-Wells Company also began to make provincial tours. The Vic-Wells Ballet was not alone responsible for the fact that in the thirties the ballet 'rapidly extended its popularity from highbrows downwards'.[2] The yearly seasons of de Basil's company at Covent Garden kept alive the splendours of the Russian ballet after Diaghilev's death, and, on a humbler level, a revival of interest in folk dancing at this time helped to stimulate curiosity about its sister art. It was the work of the Vic-Wells Company, however, that raised English ballet to a position of esteem and gave English audiences a rich array of native talent to applaud. If ballet had not yet reached lower-class or rural audiences by the start of the Second World War, it was at least winning a place for itself as an important element in the national culture.

Opera had a far more difficult time of it. The expenses involved in the production of grand opera vastly exceeded those needed for ballet. Promoters often went bankrupt for their efforts, and three different syndicates tried to manage the Covent Garden Opera House in the 1930s alone. With tremendous financial risks involved in a single season of opera, producers preferred to rely on the safe, assured successes of German and Italian opera, performed during short opera seasons by foreign companies of known reputation. Operas by English composers, as well as foreign operas sung by English vocalists, had little appeal to managers with an eye on their balance sheets.[3] Even Sir Thomas

[1] British Information Services, *Entertainment and the Arts in Wartime Britain* (New York: BIS, 1944), p. 13; and Manchester, *Vic-Wells*, p. 32.

[2] Graves and Hodge, *Long Week-End*, p. 348.

[3] While nurturing native ballet, the Sadler's Wells Theatre before the

Beecham's English opera company, backed as it was by the Beecham family fortune, could not financially survive a season at Covent Garden. From the end of 1919 until the summer of 1920, it gave over a hundred performances of opera in English. It was an admirable attempt, fully in keeping with Beecham's ceaseless efforts since 1909 to improve the quality of English operatic entertainment. But his losses on the opera company continued to mount, surpassing £100,000 by late 1919, and in September 1920 he was declared bankrupt.[1]

Members of his company, however, were instrumental in forming what they ambitiously called the British National Opera Company in 1921. Until 1924, the BNOC provided brief seasons of opera in English at Covent Garden, although the theatre's management had little sympathy with its aspirations. The BNOC had none of the glamorous associations, none of the great names and traditions that brought audiences to hear the famous continental opera companies. Its artistic achievements, furthermore, were not always equal to its aim, and the Grand Opera Syndicate, which managed Covent Garden during the 1920s, did not intend to lose money by sponsoring the infant troupe. The drawing power of foreign companies mattered far more to businessmen than any responsibilities to national culture. With such prejudices towards British opera to contend with, it is surprising that the BNOC lasted until 1929, when financial troubles finally drove it into liquidation. From 1924 until the outbreak of the Second World War, German and Italian opera dominated the Covent Garden repertory, and foreign performers monopolized the limelight.[2]

Second World War also fostered native opera. When more commercially concerned houses would not consider them, the opera company at Sadler's Wells performed a number of works by British composers, from Purcell to Vaughan Williams, which were sung by British artists. In August 1974, the Sadler's Wells Opera, now performing at the London Coliseum, changed its name to the English National Opera.

[1] Harold Rosenthal, *Opera at Covent Garden: A Short History* (London: Victor Gollancz, 1967), pp. 101–4; and Desmond Shawe-Taylor, *Covent Garden* (London: Max Parrish & Co., 1948), pp. 57–8.

[2] 'It is really childish', wrote one critic in 1932, 'to attempt to pretend that there is to-day any British company capable of giving operatic performances on the level of those of the international season.' W. J. Turner, 'Opera and the BBC', *New Statesman and Nation*, n.s., 3 (30 January 1932): 120.

One of the principal developments on the British opera scene in this period

While the management of Covent Garden made no effort to encourage native talent in the inter-war years, its reliance on traditional programmes and policies did nothing to dampen public appreciation of musical entertainment, already widely noted before the First World War. After the war, it flourished even more vigorously with the aid of radio and recordings. With the mechanization of music, the historian of the Royal College of Music observed, the college's concern was not to persuade an indifferent world to care about music, 'but to direct into profitable channels an exuberant but uninstructed popular enthusiasm'.[1] Sir Henry Wood's Promenade Concerts continued to offer frequent opportunities for popular enjoyment of music, and, throughout the country, local clubs and societies were formed to enhance public participation in creating and understanding music. During the 1930s, Rural Music Schools spread to numerous regions, fostering amateur musical activity in villages and small towns. The National Federation of Music Societies was active, and municipally sponsored concerts increased in number. Birmingham finally acquired a symphony orchestra in 1920, which received regular subsidies from the city council, while London in this period gained two additional orchestras.[2]

The spate of musical activity undertaken both by municipal and private sponsorship did not go unnoticed at Whitehall. As in the case of the theatre, the Labour Government of 1929 tried to encourage opera, at least until the Depression temporarily discouraged further attempts at state patronage. Perhaps stimulated by the demise of the BNOC, MacDonald's ministry took an extraordinary step in 1930, when Philip Snowden, Chancellor of the Exchequer, agreed to Treasury support of opera at Covent Garden. In this endeavour, he departed sharply from the attitude expressed by Winston Churchill, his Conservative predecessor as

was the inauguration of the Glyndebourne Festival of Opera. Established in 1934 by John Christie, a wealthy manufacturer of organs, the festival offers a summer season of excellent opera on Christie's beautiful estate. The cost of transport to Glyndebourne, and the high price of the tickets, however, restrict the audience able to enjoy the festival.

[1] Colles, *Royal College of Music*, p. 46.

[2] To the London Symphony Orchestra, founded by musicians in 1904, was added the British Symphony Orchestra, also established by orchestral players, shortly after the First World War. In 1932, Beecham founded the London Philharmonic Orchestra.

Chancellor of the Exchequer, shortly before the defeat of the Baldwin Government. When asked, in January 1929, whether the Government was prepared to give financial assistance to opera in England, Churchill expressed his Government's 'sympathy' with operatic associations in the country, but added: 'I fear I cannot undertake financial assistance at the cost of the Exchequer to such associations.'[1] The Conservative position on this issue had not altered since the days of the Balfour Government.

Snowden and his Labour colleagues, however, were willing to undertake financial assistance to opera, through a complicated arrangement involving the British Broadcasting Corporation and a new Covent Garden Opera Syndicate. Essentially, the plan involved an increase in Post Office grants to the BBC, which, in turn, subsidized productions by the opera syndicate.[2] The BBC gained the right to broadcast these productions, and the intention was that popular prices would be available for certain performances. According to an agreement worked out between the BBC and the syndicate, the BBC pledged £25,000 a year—£7,500 out of its normal income, and £17,500 by means of the special supplement from the Post Office—for five years beginning in 1931. The purpose, as H. B. Lees-Smith, the Postmaster-General, told the House of Commons, was 'to put grand opera on a secure and not a precarious basis'.[3]

Although the House approved the supplemental agreement between the Post Office and the BBC in June 1931, there was widespread pressure on the Government to abandon the subsidy, even from within the Labour Party. Frederick Seymour Cocks, the Labour Member for Nottinghamshire, lost no opportunity to question ministers about the subsidy, which he considered a 'public scandal' at a time of grave economic crisis. He wanted the money transferred to the Ministry of Agriculture 'to provide

[1] *Parliamentary Debates* (Commons), 5th ser., 224 (22 January 1929): 16–17.

[2] The relationship between the Post Office and the BBC is discussed later in this chapter.

[3] *Parliamentary Debates* (Commons), 5th ser., 246 (15 December 1930): 826. Also see 245 (20 November 1930): 617–19; (27 November 1930): 1486; (1 December 1930): 1792–4; and *Parliamentary Papers*, vol. 25 (1930/31) (*Accounts and Papers*), 'Supplemental Agreement between H.M. Postmaster-General and the British Broadcasting Corporation'. Asa Briggs, *The History of Broadcasting in the United Kingdom*, vol. 2: *The Golden Age of Wireless* (London: Oxford University Press, 1965), pp. 179–80, explains the arrangements.

allotments for the unemployed'. Lieutenant-Colonel G. J. Acland Troyte, the Conservative Member for Tiverton, warned the Government that there was 'very great opposition' to the subsidy throughout the country,[1] and other M.P.s joined in the campaign to terminate the arrangement. They were soon successful. By the end of 1932, the new National Government had decided not to renew the supplemental grant to the BBC. Neville Chamberlain, Chancellor of the Exchequer, and Sir Kingsley Wood, Postmaster-General, both Conservatives, felt no binding commitment to an arrangement that had aroused much press, as well as parliamentary, criticism.[2] The early 1930s was not a time to experiment with state subsidies to art. With scarcely enough money to provide adequate social relief measures, the British Government's first attempt to render ongoing aid to the performing arts inevitably proved short-lived. The timing was unfortunate, but a major precedent had nonetheless been established.

[iii]

The greatest cultural challenge to the British Government between the wars did not come from the long familiar art forms—the theatre, ballet, and opera—but from the creations of modern technology. The cinema and wireless raised questions and difficulties which no previous Government had had to face. There were no precedents to follow, no traditional attitudes of cautious support, benign neglect, or outright indifference. The ways in which successive Governments approached films and broadcasting during the 1920s and 1930s tested what, if anything, had been learned during the previous century.

Governmental policy towards the cinema suggested that the official mind had learned very slowly. For three decades after the first moving-picture show was presented in London in 1896, the cinema in Great Britain was left to flourish as best it might under commercial promoters and the vigilance of the Board of Film Censors. It was entirely characteristic of the bureaucratic response to art in early twentieth-century England that films were regarded first as a potential source of corruption, to be policed like the

¹ *Parliamentary Debates* (Commons), 5th ser., 266 (9 June 1932): 2110; and 245 (25 November 1930): 1091.
² Briggs, *Broadcasting in UK*, 2: 180–1.

theatre, and, occasionally, the picture galleries. Some critics even questioned whether the cinema deserved to be classified as an art form. One writer in the *Nineteenth Century* dismissed it scornfully as 'mechanised entertainment'. It was, he asserted, 'only an artifice and not an art'.[1] Regardless of categories, however, no one questioned whether the new industry might need official encouragement or protection, for its extraordinary popularity assured its financial success. No other form of entertainment could compete in terms of audience. The picture palaces were crowded, and the public avidly followed press reports of the antics of their favourite movie stars.

Neither British industry nor artistry, however, reaped much benefit from this situation. The First World War interrupted the development of the infant industry in England, and, by the early 1920s, Hollywood had conquered British movie houses. American producers, adopting the policy of block booking that required European exhibitors to purchase numerous films in order to secure one particularly desirable one, were able to flood the British market. Comparatively few British pictures were issued each year, and these were crowded out of the theatres by American productions. American film companies, furthermore, began to acquire their own movie houses in England, thus increasing the difficulties which British producers confronted when trying to exhibit their films. Doubtless, cinema was a highly profitable form of mass entertainment, but, like the opera, native talent received little recognition.[2]

While the Hollywood invasion was acknowledged as a menace, Parliament took no significant action until 1927. Successive Governments ignored the example of Germany, where a large and flourishing industry, protected from Hollywood, had been founded during the war. Protection was a subject of heated debate in Great Britain throughout the century, but it was not until 1932, as the full impact of the Depression drove unemployment figures

[1] Bertram Clayton, 'Talking Pictures', *Nineteenth Century and After* 105 (June 1929): 821.

[2] Graves and Hodge, *Long Week-End*, pp. 133–42, describe developments in the British cinema from the turn of the century through to the 1920s. Also see F. D. Klingender and Stuart Legg, *Money Behind the Screen. A Report prepared on behalf of the Film Council*, with a Preface by John Grierson (London: Lawrence & Wishart, 1937).

ever higher, that tariffs were imposed. Laissez-faire was so in-
grained a doctrine of British commerce that only an economic
catastrophe could challenge it. As a matter of cultural policy,
protection was even more alien to official attitudes, and the decline
of the British film industry seemed destined to proceed apace. As
Glenvil Hall, the Labour Member for Colne Valley, informed the
House of Commons in 1942:

> At the end of the last war the British film industry was
> practically dead. It was because of the short-sighted policy of
> the Government at that time that Hollywood became the house-
> hold word it is to-day, and that American films found their way
> into almost every corner of the world.[1]

Economic considerations finally drove the Government to
action. In 1925, the Baldwin ministry rejected a request from the
House of Lords for the appointment of a departmental committee
to examine the causes of the film industry's depressed condition.
But two years later, it introduced a Bill to stimulate the production
and exhibition of British films.[2] Not only was the British film
industry itself an object of concern; the pervasive influence of the
cinema on public taste, and the economic implications of that
influence, had attracted the attention of businessmen and econ-
omic planners. At home and throughout the empire, films
affected consumption. Even in New Zealand, it was discovered,

> with its staunch British tradition, one finds evidence that cus-
> toms and the demand for goods are being largely influenced by
> changes in ideas and fashions other than those associated with
> British habits and tastes. Such preferences are, without com-
> ment, accepted as desirable and there seems little doubt that
> American films have played a part in moulding public tastes in
> many directions.[3]

The Cinematograph Films Act of 1927, passed only after
prolonged debate, established regulations for the booking and
registration of films, under the authority of the Board of Trade.

[1] *Parliamentary Debates* (Commons), 5th ser., 381 (7 July 1942): 699.
[2] *Parliamentary Papers*, vol. 9 (1936/37) (*Reports from Commissioners, In-
spectors, and Others*), 'Cinematograph Films Act, 1927: Report of a Committee
appointed by the Board of Trade', pp. 5–8.
[3] Ibid., p. 5.

More important, it imposed quotas on both renters and exhibitors, intended to ensure that, by 1936, a fifth of the films shown in Great Britain would be British-made.[1] The quotas applied to both short and long films of over 3,000 feet, and various conditions, covering screenwriters, producers, cameramen, technicians, actors, and the use of studios, had to be met. Only a few types of film were exempt from the Act, including newsreels, commercial advertisements, and instructional or scientific films. Administration of the Act was entrusted to the Board of Trade, whose proven unsuitability in administering the arts never seemed to impress Parliament.

A decade later, as the 1927 Act approached expiration, the Board of Trade appointed a committee, under Lord Moyne, to review the condition of the British film industry. The situation, the committee reported in November 1936, was still critical. The domestic market available to American film producers was at least three times greater than the market open to producers in Great Britain, and, if only for this reason, the number of films made in the United States could vastly surpass British production.[2] Furthermore, the Act of 1927, with its emphasis on quantity, 'had only encouraged the production of cheap and worthless second features which discredited the native cinema'.[3] The committee had no alternative but to recommend the continuation of the system of quotas for a further ten years. To safeguard the quality of British films, however, it urged that the quotas for any year be 'related to the production of British films of a good standard of quality during the previous year', and suggested that

[1] The extremely small percentage required for the first year of the Act's operation—7½ per cent for renters and 5 per cent for exhibitors—is telling proof of the miserable condition of the British film industry in 1927. See Part III of the 'Cinematograph Films Bill', *Parliamentary Papers*, vol. 1 (1927) (*Bills: Public*). In the vocabulary of the British film industry, renters are actually distributors, or the people who rent out films to exhibitors, who show them to the public in movie houses.

[2] 'Cinematograph Films Act, 1927: Report of Committee', p. 9. Walter Edward Guinness, first Baron Moyne, was a prominent Conservative statesman. He had held a variety of Government positions since the early 1920s, and served on numerous committees after his elevation to the peerage in 1932. He was also active in the management of his family's business, Guinness Breweries.

[3] Angus Calder, *The People's War: Britain 1939–1945* (New York: Pantheon Books, 1969), p. 367.

a new body be established, 'entirely independent of any trade connections', to administer subsequent film legislation, with regard both to quotas and to overall quality. Such a council or commission, the Moyne committee stressed, must consist of 'first-class personnel whose ability for their task and absolute impartiality in their decisions could not be called in question'. Succinctly, it must be 'a body untrammelled by the limitations of any existing Government Department'.[1] While the Board of Trade could deal with statistics, it was not, the report implied, qualified to measure cultural excellence.

The legislation that resulted from the committee's report followed the letter, but neglected the spirit, of the recommendations. In 1937, the Chamberlain Government introduced a new Cinematograph Films Bill that extended the quota system, inserted a minimum cost provision to discourage the production of cheap, inferior films, and established a Cinematograph Films Council.[2] The council, however, was a far cry from the small, scrupulously impartial body suggested by the Moyne committee. It consisted of twenty-one members: eleven holding no financial interest in the film industry, and ten representing British film makers, renters, exhibitors, and persons employed in the production of British films. Nor was it the independent administrative authority which the Moyne committee had deemed essential. Appointed by the Board of Trade to whom it reported, it was assigned only such vaguely advisory functions as reviewing 'the progress of the cinematograph film industry in Great Britain', and consulting with the Board on 'any matter relating to the cinematograph film industry in which the advice of the Council is sought by the Board. . .'.[3]

From the new organization's first report, it was abundantly clear that the British film industry would find no vigorous champion in the Cinematograph Films Council. In a classic understatement, the report observed that 'conditions within the British film producing industry are far from satisfactory at the present time'. 'Production is intermittent at best,' it continued less euphemistically,

[1] 'Cinematograph Films Act, 1927: Report of Committee', pp. 34–7.

[2] *Parliamentary Papers*, vol. 1 (1937/38) (*Bills: Public*), 'Cinematograph Films Bill'. The Bill was passed in 1938.

[3] Ibid., pp. 32–3.

and a considerable proportion of the available studio space is idle for many months in the year. Several studios have ceased operation altogether for the time being and some have been converted to other uses. Unemployment among artists, studio technicians and other employees is particularly acute.

Yet the council's members, after discussing various plans to assist the crippled industry, reached conclusions that would have warmed the heart of Samuel Smiles:

> We think . . . that this opportunity should be taken to empha- sise that the progress of the film industry—like that of other industries—must lie in its own hands; that it is no solution of the various difficulties which must arise in this industry, as in others, from time to time, to rely mainly on the State to meet them. We feel that the chief need of the industry is increased co-operation between its various sections, and greater self-reliance.[1]

The Council did not explain how the British film industry, after two decades of floundering between erratic private financing and tardy, inadequate protection from the Government, could hope for greater self-reliance. Apparently some officials, refusing to recognize that the foundations of the welfare state were being laid on all sides, simply clung to old shibboleths.

The British Film Institute, founded in 1933, represented a further expression of official sensitivity to the cinema's tremendous influence on public taste and opinion. Interest in the role of the cinema in national life was growing noticeably by the early 1930s, due in part to the initiative of the British Institute of Adult Education, and the British Film Institute was established 'to encourage the use and development of the cinematograph as a means of entertainment and instruction'. It was not set up as a branch of the Government with civil service personnel, but as a semi-autonomous agency whose board of governors included Government appointees, representatives of the film industry, and educators. The Institute's specific responsibilities were manifold. It sought to advise Government departments and educational

[1] *Parliamentary Papers*, vol. 9 (1938/39) (*Reports from Commissioners, In- spectors, and Others*), 'First Report of the Cinematograph Films Council Re- lating to the Year Ended March 31st 1939', pp. 16, 19.

institutions about the use of film and film production, to serve as
liaison between the film industry and cultural or educational
interests, to promote research in the use of film, to found and
maintain 'a national repository of films of permanent value' and
to perform other broad duties.[1]

It was an ambitious programme, hampered, predictably, by a
shortage of funds. The BFI received no direct grant from Parlia-
ment before the Second World War, and operated on money
from the Cinematograph Fund, established when the Sunday
Entertainments Act of 1932 permitted cinemas to open on Sunday.
Out of their Sunday profits, cinema owners were required to pay
certain sums fixed by the licensing authorities. Five per cent of
these sums was contributed to the Cinematograph Fund, which
the Privy Council supervised, and the rest went to charity.[2] Until
1944, the average amount which the BFI received annually from
the fund—less than £9,000—was scarcely adequate to support the
purposes which the Institute was designed to fill. Nevertheless,
it established a National Film Library, published periodicals,
monographs, and pamphlets devoted to the cinema, and actively
encouraged the use of film in schools and educational pro-
grammes. But without a fixed and regular budget, the Institute's
accomplishments fell far short of its aspirations. No long-term
planning was possible when yearly allotments might vary and
were, in any case, 'extremely modest'.[3] Like so many cultural
enterprises dependent on funding from the Government, the BFI
experienced frustration and disappointment in its early years, as
official attention concentrated on immediate economies at the
expense of future cultural goals. On the basis of the cinema alone,
Parliament and successive ministries could not be said to have
treated the arts of modern technology with any more perception

[1] Privy Council, *Report of the Committee on the British Film Institute* (London:
HMSO, 1948), p. 13.

[2] To placate Sabbatarian sensitivities? See Ibid., pp. 3–4, 9–10. *Parliamen-
tary Papers*, vol. 3 (1931/32) (*Bills: Public*), 'A Bill, as Amended by Standing
Committee B, to Permit and regulate the opening and use of places on
Sundays for certain entertainments'; and *Parliamentary Debates* (Commons),
5th ser., 285 (7 February 1934): 1139–40, and 287 (21 March 1934): 1213.
The Sunday Entertainments Act, 1932, also applied to concerts, lectures,
debates, museums, picture galleries, zoos, botanical gardens, and aquariums,
but not to the theatre.

[3] Privy Council Report, p. 4.

than they had shown in their approach to the old, traditional forms of culture.[1]

[iv]

In sharp contrast, however, to the muddled manner in which the cinema was officially handled stands the Government's response to the challenge of wireless. While few people at first realized the cinema's potential influence on public opinion, or even took it seriously as a form of entertainment, the significance of wireless as an agent of communication was appreciated from the start. Furthermore, wireless, unlike the cinema, could enter into private homes, could speak to the British public with extraordinary intimacy. It is no wonder that official concern over the development of wireless expressed itself in prompt and, for the most part, well-considered policies. The British Broadcasting Corporation, in fact, came to be acclaimed at home and abroad as the model for future public corporations and state-aided utility services. Throughout the interwar period, Parliament dealt with the BBC consistently and wisely, granting it the benefits of monopoly together with the privilege of extensive independence from official control. As a result, Parliament can claim a share of responsibility for what became the most successful cultural experiment ever undertaken in Great Britain. For, while the wireless was by no means exclusively a cultural agency, it had so profound an influence on popular appreciation of the arts that it deserves prominence in any discussion of state-supported culture.

From its earliest days as the British Broadcasting Company, the BBC enjoyed a monopoly of the 'ether'. The development of wireless in the United States immediately after the First World War, with rival broadcasting stations jamming the air waves in frenzied competition, convinced the Lloyd George Government that a firm measure of organization had to be imposed. The Post Office, already responsible for licensing transmitters and receivers

[1] Government support did encourage the development of high quality in one specialized area of film production. Documentaries made by film units attached to Government departments, first the Empire Marketing Board and later the General Post Office, helped to train a skilled group of documentary artists and technicians in the 1930s who proved invaluable during the Second World War.

of wireless signals, under the Wireless Telegraphy Act of 1904, seemed the logical Government department to assume a directing role.[1] In May 1922, it initiated discussions with British firms manufacturing wireless apparatus, and urged the formation of a single broadcast syndicate. The discussions lasted through the summer, and the British Broadcasting Company was formed in October, formally incorporated in December, and licensed by the Post Office in January 1923.

Any British manufacturer of wireless equipment could join the company by the purchase of a £1 share, but control was in the hands of the 'Big Six' guaranteeing firms, including the Marconi Company and Metropolitan-Vickers. A board of directors was established, six of whose members represented the major firms, while two were elected by the remaining shareholders. In return for organizing and providing the original capital for the BBC, and subject to the maintenance of an efficient broadcasting service, the constituent firms obtained from the Postmaster-General exclusive use of the airwaves. The Postmaster-General further agreed to block the import of all foreign receiving sets for two years, and to pay to the BBC half of the yearly ten-shilling licence fee which the Post Office imposed on owners of sets made by BBC member firms. Starting in November 1922, several of the big companies in London, Manchester, and Birmingham provided a primitive broadcasting service, while the BBC still lacked facilities and equipment. The company's small offices in London opened in late December, and by the beginning of the new year a full schedule of broadcast programmes was being prepared.[2]

During its first four years of existence, the BBC grew rapidly under the careful supervision of the company's managing director, John Reith. At the end of 1923, the Post Office ensured the BBC's protected position for another two years, and the company continued to improve the quality, increase the variety, and extend the geographic scope of its broadcasts. News stories, political

[1] For a discussion of the situation in the United States during the 1920s, and its influence on the BBC, see Briggs, *Broadcasting in UK*, vol. 1: *The Birth of Broadcasting* (London: Oxford University Press, 1961), pp. 58–68.

[2] The formation of the BBC is described in detail in Ibid., pp. 93–134. Also see the memoirs of the BBC's first director, John C. W. Reith, *Into the Wind* (London: Hodder & Stoughton, 1949), pp. 81–9; and the statement of the Postmaster-General, F. H. Kellaway, in *Parliamentary Debates* (Commons), 5th ser., 157 (4 August 1922): 1958–64.

broadcasts, children's programmes, and special broadcasts to schools, in addition to a rich variety of cultural entertainment, were featured on the BBC station. With the installation of a high-power, long-wave transmitter at Daventry, Northamptonshire, in 1925, wireless broadcasts became available throughout the country on simple, inexpensive sets. Not long afterwards, the BBC was able to offer its listeners a scheme of alternative regional programmes, and from fewer than 600,000 wireless licences in 1923, the figure surpassed two million in 1926. As one receiving set served whole families and even groups of neighbours, the number of actual listeners was presumably far greater.[1] *Radio Times*, the official organ of the BBC which was launched in September 1923, was one of the 'more spectacular successes in the journalism of the inter-war years', with a circulation of over 800,000 at the end of 1925.[2] The pioneering company, which in December 1922 had a total staff of four, wasted no time in making its presence felt throughout the country. The crucial role which the BBC played during the general strike of 1926, when for several days it remained the only source of news available to millions of people, confirmed its position as an essential public service.

After four years of probation, the future of British broadcasting was set in 1926, when a Post Office departmental committee recommended that a single public corporation, licensed for at least ten years, be responsible for broadcasting in the United Kingdom. The committee, chaired by the Earl of Crawford and Balcarres, was appointed in the summer of 1925 and issued its report the following March. In place of directors representing the wireless industry, the report proposed a small board of eminent men and women, appointed by the Government to serve as governors in the public interest. The BBC's monopoly was to be maintained, but in public, rather than in private commercial, hands.[3] Baldwin's Government accepted the committee's basic suggestions, which, in effect, nationalized broadcasting in the United Kingdom. With Parliament's approval, the new British

[1] Briggs, *Broadcasting in UK*, 1: 18. By the end of 1932, there were five million licences, and over 8,850,000 by the end of 1938.

[2] Ibid., p. 297.

[3] See *Parliamentary Papers*, vol. 8 (1926) (*Reports from Commissioners, Inspectors, and Others*), 'Report of the Broadcasting Committee, 1925', pp. 14–16, for a summary of the Crawford committee's recommendations.

Broadcasting Corporation began operations under Royal Charter in January 1927. Reith, knighted at the end of 1926, became the director-general and continued the activities and programmes which the BBC staff had developed over the preceding years. The decade over which the BBC's new licence extended saw major improvements in wireless technology and the further establishment of the corporation as a principal element in British national life. The inauguration of an imperial service, experiments with television, the King's annual Christmas message, and the weekly publication of the *Listener* were only highlights of the BBC's varied enterprises. By 1936, the BBC, ensconced at Broadcasting House, was an august establishment with an international reputation for excellence.

For over fifteen years, the critical period in the development of BBC attitudes and policies, Reith's conception of a public service corporation significantly moulded the work of the BBC. The son of a Scottish minister and a civil engineer by profession, he was supremely confident of his abilities to guide the infant organization, and his attitudes toward the role of broadcasting in society dominated the BBC until 1938. The recent posthumous publication of his diaries has revealed a man who held most of his fellow creatures in utter contempt and his own capabilities in high esteem. He believed himself endowed with extraordinary talents to marshal and control vast bureaucratic structures, as well as vast human populations. His rancorous misanthropy would hardly seem a strong qualification for the direction of a public service corporation; yet he felt keenly the BBC's responsibilities to the public that bought its receiving sets and listened to its programmes, and he never failed to champion what he saw as the BBC's social mission.

As early as 1923, Reith recommended the reconstitution of the company as a public corporation, conducted as a public service. Later he was to boast proudly of the BBC as the model of 'nationalised rationalisation' in the interwar period.[1] He believed, as did his closest staff members, that the wireless was not designed merely for public amusement, but as an active agent for moral good. The people responsible for broadcasting had duties to society which they could not for one moment ignore. Moral

[1] Reith, *Into the Wind*, pp. 90, 171.

principles counted with Reith at least as much as, and probably more than, the technical basis on which broadcasting depended. He refused to pander to popular tastes which he despised and refused to allow the BBC to become a mere purveyor of popular entertainment, like the cinema or music hall. He was willing to court criticism by pursuing a course openly intended to educate and elevate public taste. Anything less, he felt, would be shirking his responsibilities.[1]

Like Matthew Arnold, Reith wanted to share as widely as possible 'everything that was best in every department of human knowledge, endeavour and achievement'; unlike Arnold, however, he had the means to do so. He was well aware that critics accused him 'of setting out to give the public not what it wanted but what the BBC thought it should have', and, unperturbed, he replied that 'few knew what they wanted, fewer what they needed'. The function of broadcasting was, he asserted, 'to instruct and fashion public opinion; to banish ignorance and misery; to contribute richly and in many ways to the sum total of human well-being'.[2] While many people resented his brand of paternalism, Oxford University was in full sympathy with his efforts. It honoured him with a D.C.L. in 1935, and his citation on that occasion read: 'No one has a greater share in forming the public judgment and taste.'[3] Henry Cole would have envied him his power.

The BBC's contribution to cultural enrichment included educational courses for schoolchildren and adults, broadcasts of church services, lectures and discussions on a wide choice of subjects, and, most prominently, the arts. It would certainly be incorrect to say that popular entertainment had no place in BBC programmes. Light music, jazz, variety programmes, and humorous talks were regularly available to listeners, but show business as such did not particularly interest the directors of BBC policy in the interwar years, for they did not consider it a significant element of national culture. They aimed, instead, to offer cultural programmes of the highest quality. As early as 1923-4, the BBC

[1] Ibid., p. 158. Briggs, while avowedly impressed with Reith's achievements at the BBC, observes correctly that 'Reith and his colleagues had values of their own, which demand careful scrutiny'. *Broadcasting in UK*, 1: 6-7.

[2] Reith, *Into the Wind*, pp. 101, 103.

[3] Quoted in Ibid., p. 230.

included literary, music, film, and drama critics among its broad-casters, and discussion of the arts figured prominently in BBC talk programmes. One of the most popular series in the 1920s was Walford Davies on 'Music and the Ordinary Listener'.[1] In February 1923, broadcast drama was inaugurated with the quarrel scene from *Julius Caesar*, an appropriate introduction to the difficulties which the BBC had to surmount in dealing with theatre interests that feared competition from the wireless. There were broadcast readings of poetry and prose, and at least one librarian greeted the BBC as a 'new ally . . ., creating and deepen-ing the interest of the public in the higher forms of literature'.[2]

While eager to promote all forms of art, the BBC particularly fostered public interest in music. No other art is so exclusively an aural experience, and thus so ideally suited to broadcasting. From the start, music occupied a strikingly large proportion of the BBC's time on the air, and, by 1930, over half of the regional programme hours were devoted to music of many kinds.[3] Opera, chamber music, oratorios, orchestral concerts, song recitals, musical comedy, band performances—the BBC found room for nearly every known variety of music-making. In January 1923, when the infant company was scarcely functioning, it made broad-casting history by relaying a complete live opera from Covent Garden.[4] There were many other great musical moments, such as Paderewski's first broadcast recital in 1925, and a series of concerts conducted by Toscanini.

Nor did the BBC confine its sponsorship of music to special events. It was concerned with the musical life and productivity of the nation, and took a keen interest in the country's musical traditions. When the Promenade Concerts lost their sponsor in 1927, the BBC arranged a contract with Sir Henry Wood and the Queen's Hall management that enabled the popular concerts to continue free of financial uncertainties. Its role in the brief opera

[1] Briggs, *Broadcasting in UK*, 1: 251, 254, and 2: 75–119.

[2] Annual report of the librarian at Lincoln, 1926, quoted in Ibid., 1: 16. The BBC's Advisory Committee on Spoken English, formed in 1926, in-cluded Robert Bridges, the Poet Laureate, as well as Shaw and, later, Kip-ling.

[3] See the figures given in Ibid., 2: 35. The BBC's annual reports, contained in *Parliamentary Papers* (*Reports from Commissioners, Inspectors, and Others*) give some indication of the corporation's extensive encouragement of music.

[4] Rosenthal, *Opera at Covent Garden*, p. 105.

subsidy of 1930–2 has already been described, and the BBC gave significant monetary assistance, not only to Covent Garden, but also to the Sadler's Wells and Carl Rosa opera companies. It broadcast opera frequently, both live performances from theatres and productions in its own studios.[1]

With the establishment of the BBC Symphony Orchestra in 1930, the BBC offered rare opportunities to British musicians and composers alike. Regular employment, both in concert halls and broadcast studios, and the chance to perform with internationally famous conductors, were especially attractive working conditions during the Depression, and the BBC had no trouble staffing its orchestra with 'almost every player of note in the country'.[2] In the 1930s, the BBC Orchestra gave the first public performances of numerous works by British composers, including Ralph Vaughan Williams, William Walton, and Constant Lambert. It also introduced to British audiences works by modern continental composers and 'shortened the time-lag between the composer and the general public most remarkably: it put on the air a great deal of Stravinsky, Hindemith, Schönberg, Sibelius, Bartok . . . who otherwise would have had to wait years rather than months for a hearing'.[3] When the orchestra joined the touring circuit in 1934, it provided yet another stimulus to provincial appreciation of the performing arts. The tours, however, were secondary features of its national role. Simply by playing in a London studio, the orchestra exerted a more profound influence on music appreciation throughout the country than the most frenetic schedule of public performances could possibly achieve. If the BBC management was justly criticized for giving artists a comparatively small role in formulating artistic policy, its spokesmen had one irrefutable reply. Thanks to its efforts, millions of people came to enjoy a richer cultural diet than had ever before been considered possible, or even desirable. It was in large part owing to the work of the BBC that Great Britain began to gain that reputation as a land of cultural distinction that would have

[1] Briggs, *Broadcasting in UK*, 2: 172–3, 178–82; and Reith, *Into the Wind*, p. 128.

[2] Adrian Boult, *My Own Trumpet* (London: Hamish Hamilton, 1973), p. 97. Boult became the BBC's director of music in 1930. After the orchestra's first season, he served as its permanent conductor as well.

[3] Graves and Hodge, *Long Week-End*, p. 237.

amazed most Englishmen half a century before. Of all the many endeavours to extend the audience for art in the 1920s and 1930s, none could compare in sheer magnitude with the BBC.

Parliament and successive Governments in the interwar period generally endorsed the BBC's achievements and were proud of its international renown. The fears expressed in the House of Commons during the summer of 1922, that the new company would act as a monopoly against the public interest, were gradually allayed.[1] As the country reluctantly learned to live with an ever expanding degree of state control over the national economy, which the World War had necessitated, Parliament recognized the merits of the BBC's privileged position. By 1926, when the corporation's first charter was debated in the House of Commons, parliamentary opinion joined most of the press in approving the continuation of a single broadcasting authority and the maintenance of unified control. The House of Commons, in fact, became increasingly concerned, not so much to protect the public interest from the BBC, as to protect the BBC from official interference. In 1933, a motion that 'it would be contrary to the public interest to subject the Corporation to any control by Government or by Parliament other than the control already provided for in the charter and the licence of the Corporation' was resoundingly approved.[2]

The relations between the Post Office and the BBC remained a source of contention throughout the 1920s and 1930s. Fortunately, they do not need much treatment here, as the controlling hand of the Postmaster-General was felt far more heavily in the area of news and political broadcasts than in the development of cultural programmes. A major annoyance, the ban on broadcasting 'statements on topics of political, religious or industrial controversy', was withdrawn by the Baldwin Government in 1928,[3] but the Postmaster-General retained authority over numerous technical aspects of broadcasting, such as wave-lengths and the hours of

[1] See, for example, *Parliamentary Debates* (Commons), 5th ser., 157 (4 August 1922): 1957, 1965–6.

[2] *Parliamentary Debates* (Commons), 5th ser., 274 (22 February 1933): 1811–1868. Charles Emmott, the Conservative Member for Springburn, introduced the motion, which defeated a proposal by Sir Stafford Cripps to appoint a select committee of investigation into the functioning of the BBC.

[3] See Ibid., 1825–6, 1834–5.

transmission. He was also empowered to commandeer broadcasting stations in times of emergency, and, under all circumstances, the BBC was obligated to broadcast official announcements at the request of any Government department.[1] The BBC occupied the difficult position of an essentially independent body, nonetheless supported, through licensing fees, from public funds, and thus subject to the ultimate control of Parliament. While it enjoyed immense authority and power through the monopoly of broadcasting, its growth did not proceed without crises and confrontations. Perhaps most vexing were the endless disputes over finance, with the BBC receiving what Reith considered a woefully inadequate share of the licence revenue. There were times when Reith must have wondered whether the state was supporting the broadcast monopoly or the BBC supporting the Exchequer.[2]

Some of the BBC's fiercest confrontations, in this case with Parliament, came in 1936. The change in tone of the Commons debates between 1933 and 1936, when the House considered the BBC's second charter, suggests the extent to which the BBC had become a national institution and, as such, aroused the kind of resentment that the Department of Science and Art had provoked in the 1850s and 1860s. In 1933, the discussion was generally amicable. Even Sir Stafford Cripps, anxious though he was for a select committee to investigate the corporation, assured the House that 'no one would desire to minimise the very excellent work which the British Broadcasting Corporation have done in all sorts of ways'. Sir Kingsley Wood, the Postmaster-General, warmly endorsed the corporation's determination 'not only to provide entertainment, but to contribute cumulatively to good citizenship by the broadcasting of fine music and of information over as wide a field as possible'. John Buchan, the noted author and the Conservative Member for the Scottish Universities, compared the status of films and broadcasting in Great Britain:

> You have only to look at the films and see the degradation and the confusion to which unrestrained commercial enterprise has brought a great instrument of public service . . .

[1] Briggs, *Broadcasting in UK*, 1: 358.
[2] Reith, *Into the Wind*, p. 225. With no advertising on BBC programmes, the corporation relied heavily on profits from its publications.

. . . The Broadcasting Corporation is a kind of public utility company, the type of corporation of which I hope we may see many more in future . . . It would be fatal to the efficiency of the Broadcasting Corporation or any similar body to be put under any day to day detailed Parliamentary supervision.[1]

By April 1936, however, a group of Labour Members were loudly demanding closer parliamentary supervision of the BBC. Maintaining that the corporation had become impervious to parliamentary, or any other, criticism, they waged their campaign with a measure of partisan bitterness hitherto absent from debates concerning cultural subsidies. Cripps and H. B. Lees-Smith led the attack, concentrating on the rigid control which, they claimed, Reith exercised over the corporation's internal life. Cripps, in particular, lashed out at 'the dictatorial character of the Director-General', and urged the House to take immediate notice of the scandalous state of affairs at Broadcasting House. Both men argued that there was a pressing need for staff associations or trade unions at the BBC, as well as for a cabinet minister, without heavy departmental duties, to take charge of broadcasting.[2] Campbell Stephen, the Independent Labour Member for Glasgow, bitterly criticized the corporation's patronizing superiority of manner and general class bias. 'When listening to a British Broadcasting Corporation programme,' he said:

the impression produced on me is that I am in some slum dwelling and listening to some highly superior slum visitor anxious to do something for the improvement of poor people in the slums. There is far too much of that from highly superior people who are so anxious to improve everybody else . . .

The whole concern appears to be run as though it were an instrument of the well-to-do . . . It is run very largely by people . . . who do not know the working class, do not under-

[1] Debate, 22 February 1933, 1831, 1843, 1846.

[2] *Parliamentary Debates* (Commons), 5th ser., 311 (29 April 1936): 955–80. The demand for a cabinet minister in charge of broadcasting was more a criticism of Post Office management of the BBC than of the corporation itself. Reith himself was eager to have responsibility for broadcasting transferred to a minister of cabinet rank. He thought it would strengthen the BBC's position to have someone fully apprized of its point of view sitting in the cabinet. *Into the Wind*, pp. 187, 226–7.

stand the working-class point of view, but are seeking, evidently, to mould the working class.[1]

In July, during a debate that lasted over seven hours, George Lansbury further developed Stephen's arguments and issued the most outspoken critique of Reith's leadership yet offered on the floor of the House of Commons. 'I myself,' he told the House, 'have always felt, when speaking to Sir John on the two or three occasions on which I have met him, that he would have made a very excellent Hitler in this country, because he seemed to have a great scorn for people like myself, though he never expressed it.'[2] Outrageous though Lansbury's comments may have seemed at the time, Reith's diaries fully confirm his perceptions of the Director-General.

The assault on the BBC in 1936 was not a purely partisan business. Richard Law, the National Conservative Member for Hull, accused the corporation of trying 'to establish a kind of cultural dictatorship over the people of this country through broadcasting'. Other Members, basically in sympathy with the BBC's goals, nonetheless concurred that its staff needed greater job security and personal freedom.[3] There was widespread agreement that a responsible cabinet minister would improve relations between Parliament and the BBC.[4] The 1936 debates did not, however, offer any real critique of the BBC's performance, based on a reasoned evaluation of its services. What criticism there was centred on personalities. Some disgruntled M.P.s saw in Reith and his managerial colleagues at the BBC the personification of a class outlook which they considered glaringly outmoded. In disseminating culture to increasingly broad sections of society, the BBC seemed to share the same smug assumption of superiority that had characterized the activities of the upper classes a century earlier. According to the BBC's critics, its officials were eager to popularize culture only so long as the BBC could supervise the process, filling a self-designated role of national educator and cultural mentor. The acrimony that marked the 1936 debates

[1] Debate, 29 April 1936, 1010–11.
[2] *Parliamentary Debates* (Commons), 5th ser., 314 (6 July 1936): 911.
[3] Debate, 29 April 1936, 1008, 989–92.
[4] The Baldwin Government refused to act on this proposal, and the Postmaster-General kept his authority over broadcasting.

was in large part stimulated by the underlying social biases which its detractors suspected the BBC of harbouring.

Although some of the complaints against the BBC were undoubtedly justified, most M.P.s realized what were the alternatives facing the BBC, controlling as it did the most powerful means of influencing public opinion that the world had ever known. They were grateful that broadcasting in Great Britain had not gone the way of the cinema, and, after all the hubbub, Parliament in 1936 authorized a second charter for the BBC which continued the principal arrangements of the first. John Maynard Keynes summarized a widely shared opinion when he observed, in August 1936: 'Of the institutions which have grown up since the War, we should most of us agree, I think—in spite of all our bickering—that the BBC is our greatest and most successful.'[1]

Recognizing the BBC's extraordinary success, and the pride which was taken in the quality of its broadcast service, the majority of legislators had the good sense not to meddle too officiously in BBC affairs. The Baldwin Government, too, showed good sense in rejecting the suggestion that BBC policy matters be vested in a cabinet minister. Press criticism of the proposal had revealed substantial fear that the BBC would come to resemble a Government department and that its independence might be seriously jeopardized.[2] By allowing the BBC a fair measure of autonomy, Parliament and the Governments of the interwar period proved to the British public that the state could assist in the provision of cultural opportunities without imposing an official cultural policy. Evidence that the Government's involvement in BBC financing did not enable it to control the content of BBC programmes suggested that, contrary to the example of totalitarian regimes, direct state subsidies to art need not subject the artist to bureaucratic authority. The evidence was shortly put to good use on the home front in the Second World War.

[1] Keynes, 'Art and the State—I', *Listener* 16 (26 August 1936): 372.
[2] Briggs, *Broadcasting in UK*, 2: 511.

CHAPTER SEVEN

The Arts in War and Peace

[i]

In a single decade, during and after the Second World War, the British Government did more to commit itself to supporting the arts than it had in the previous century and a half. Sympathetic endorsements no longer resulted in desultory action, and both the War Cabinet and the subsequent Labour ministry pursued a firm policy of cultural subsidies that established the pattern for all future arts funding in the United Kingdom. As T. S. Eliot noted in 1948:

> We observe nowadays that 'culture' attracts the attention of men of politics: not that politicians are always 'men of culture', but that 'culture' is recognised both as an instrument of policy, and as something socially desirable which it is the business of the State to promote.[1]

The state's responsibility to foster national culture was no longer subject to dispute. While opinions varied over the methods, distribution, and machinery of support, surprisingly few protests were raised as the Treasury allocated increasing amounts of public money to the arts. To effect so thorough a change in official and public attitudes, 'there had to be a major war, and a complete upheaval in our society', wrote Sir Benjamin Ifor Evans, a man closely involved in the development of the Arts Council of Great Britain.[2] The advent of the welfare state and the numerous examples of nationalized industries and services had helped to make larger Exchequer expenditures for art, and extensive state involvement in cultural affairs, acceptable to the nation at large. Above all, however, the experience of the Second World War

[1] *Notes towards the Definition of Culture* (London: Faber & Faber, 1948), p. 83.
[2] *Prospects for a Ministry of Fine Arts* (London: BBC, 1959), p. 10.

proved conclusively that eager audiences for art existed across the country, among people of widely varied social and educational backgrounds, in isolated rural communities as well as crowded urban centres. The enthusiastic response to live entertainment of high quality and the warm welcome given to cultural opportunities in small towns, factory canteens, and army camps showed the arts to be a truly popular concern for the first time in the nation's history. In a very direct sense, war made possible the significant progress towards a national policy for art that occurred during the 1940s.

Credit for creating, or revealing, the vast new audience for art belongs primarily to two wartime organizations, the Council for the Encouragement of Music and the Arts, and the Entertainments National Service Association.[1] While their efforts during the war were similar in many respects, they differed in fundamental long-term objectives. ENSA, in fact, had no ultimate goals beyond enlivening the tension and drudgery of war service with music, films, variety shows, and drama. CEMA started with broader aims, which developed throughout the war and ended in the establishment of the Arts Council.

Like most cultural enterprises in Great Britain, CEMA began its work with private financial assistance. Although both the Minister of Information, Lord Macmillan, and the President of the Board of Education, Lord De La Warr, were instrumental in its establishment, initial support came from the Pilgrim Trust, which administered a fund provided by the American millionaire, Stephen Harkness, to benefit British institutions. Dr. Thomas Jones, the trust's secretary, had helped to secure trust money for 'Art for the People'. Eager to extend the scope of the trust's work, he welcomed a proposal by De La Warr, in December 1939, that the trust furnish the means to prevent a cultural blackout during the war. Macmillan, chairman of the trust in addition to his official duties, concurred. Concerned for national morale under the stress of wartime conditions, he gladly endorsed a plan to aid the arts through the difficult period ahead. De La Warr requested £5,000. Macmillan offered £25,000, and the Council for the Encouragement of Music and the Arts was born. With Macmillan as chairman, the original members, chosen by the

[1] Both organizations, of course, built on the invaluable work of the BBC before the war.

Pilgrim Trustees and De La Warr, were Jones, Sir Walford Davies, Sir Kenneth Clark, and W. E. Williams.[1]

CEMA immediately addressed itself to the most obvious problems created during the first winter of the war: the sudden isolation of many rural areas, the concentration of workers in new factory centres and evacuees in unfamiliar surroundings, the suspension of many customary entertainment facilities, the long hours of work and monotonous leisure time.[2] As Lord Keynes later explained, CEMA's role was:

> to carry music, drama and pictures to places which otherwise would be cut off from all contact with the masterpieces of happier days and times: to air-raid shelters, to war-time hostels, to factories, to mining villages. E.N.S.A. was charged with the entertainment of the Services . . . the duty of C.E.M.A. was to maintain the opportunities of artistic performance for the hard-pressed and often exiled civilians.[3]

£25,000 did not long suffice for such an ambitious undertaking. By April 1940, additional funds were needed, and it was then that the Government became an official sponsor of CEMA's activities. It agreed to match private contributions, pound for pound, up to £50,000, and continued to collaborate with the Pilgrim Trust in this fashion through 1941. The following year, however, the Pilgrim Trustees, believing that they had established the council on a firm basis, withdrew further funding, and CEMA, under the jurisdiction of the Board of Education, began receiving its grant-in-aid on the education vote. Macmillan, retiring as chairman, was replaced by Keynes, who guided CEMA's work until his death in 1946. A devoted patron of the arts, Keynes believed firmly that the economic conditions of contemporary society required the state to provide the patronage once offered

[1] At the time, Clark was director both of the National Gallery and of the Film Division of the Ministry of Information, and Williams, director of the British Institute of Adult Education. Arts Council, *First Ten Years*, pp. 3–4, 6; Evans and Glasgow, *Arts in England*, pp. 35–6.

[2] Arts Council, *First Ten Years*, p. 6; and CEMA, *The Arts in War Time: A Report on the Work of C.E.M.A. 1942 & 1943* (London: CEMA, [1944]), p. 3.

[3] Keynes, 'The Arts Council: its Policy and Hopes', *Listener* 34 (12 July 1945): 31. ENSA's mandate also extended to workers in war factories.

by affluent individuals. With his inside knowledge of the Treasury, he played a significant part in gaining widespread official endorsement of CEMA's task, and in raising CEMA's Exchequer grant to £235,000 by 1945–6.[1]

CEMA developed into a complex structure involved in manifold enterprises on behalf of the performing and visual arts. In addition to a slightly enlarged council, appointed by the President of the Board of Education, the organization came to include advisory panels of experts on art, drama, and music, committees for Scotland and Wales, and ten regional offices in England. The London headquarters were staffed by secretarial and financial officers, together with full-time, salaried directors of CEMA's music, drama, and visual arts programmes.

As highly diversified as these programmes were, they all reflected the council's consistent effort to provide the finest standards of art, whether in exhibitions of pictures, concerts, ballet, or drama, which wartime conditions would allow. The insistence on quality entertainment, embodied in its slogan, 'The Best for the Most', underlay its decision to leave support of amateur groups to the Carnegie United Kingdom Trust and instead to concentrate its efforts on established professional companies of recognized standing.[2] With considerable self-importance, CEMA announced in its report, *The Arts in War Time*, that the council 'desires its name to be associated with the greatest works of dramatic, musical and pictorial art, with the most accomplished actors, performers, and productions, with the national orchestras, and with the national art collections'. Despite the pompous rhetoric, however, CEMA's aim was not the preservation of the cultural status quo. From the start, it sought to develop new audiences, and reported proudly on the warm

[1] Charles Landstone, for ten years the associate drama director at CEMA and the Arts Council, described his impressions of Keynes thus:

'After twenty years in the commercial theatre, it was my first real contact with the genuine patron of the arts, big enough to suit his actions to his belief . . . Like everyone else on the staff of the Arts Council, I was to learn that his love of the arts was not only a large part of his life, but that it was welded into his whole philosophy of the economic structure of Society.' *Off-Stage. A Personal Record of the First Twelve Years of State Sponsored Drama in Great Britain* (London: Elek Books, 1953), pp. 39–40.

[2] Arts Council, *First Ten Years*, p. 11; and Evans and Glasgow, *Arts in England*, pp. 23, 38.

receptions accorded CEMA artists in the most unlikely places.[1] It tried, furthermore, to promote local initiative in the arts, encouraging the establishment of arts clubs, and music or drama societies, whenever touring exhibitions or performers aroused sufficient local interest.

The list of cultural events which CEMA directly organized, subsidized, or guaranteed filled the pages of successive annual reports, and can only be touched upon here. The council's aid to music ranged from individual 'Music Travellers', skilled vocalists and instrumentalists 'who went off on their own, like medieval friars, and gave concerts . . . wherever they could raise an audience',[2] to symphony orchestras. With CEMA aid, orchestras like the Hallé, the Liverpool Philharmonic, and the London Philharmonic were able to bring live symphonic music to towns ordinarily unable to house or afford it. 'The quite phenomenal rise in popularity of symphonic music' was noted throughout the country, and when the London Philharmonic toured a number of industrial towns in the Midlands and north of England, playing to working-class audiences, 'they were received with such enthusiasm that the small theatres and music-halls and cinemas, which often had to do duty for non-existent concert-halls, were packed to overflowing night after night'.[3] CEMA also entered into association with chamber and string orchestras,[4] offered guarantees against loss to local chamber music subscription clubs, and financially assisted the famous lunch hour concerts which Dame Myra Hess gave at the National Gallery.

The Council engaged musicians to give concerts wherever good entertainment was needed for solace and recreation. Its

[1] *Arts in War Time*, pp. 20–1, 7–8.

[2] Arts Council, *First Ten Years*, p. 7.

[3] Rollo Myers, 'Music since 1939', in *Since 1939*, 2 vols. (London: Phoenix House, 1948–9), 1: 108. In 1944, the Hallé, Liverpool, and London Philharmonic Orchestras gave 722 concerts to total audiences of over one million. CEMA, *The Fifth Year: The End of the Beginning. Report on the Work of C.E.M.A. for 1944* (London: CEMA, [1945]), p. 30.

[4] For the conditions of association with CEMA, applicable to all orchestral groups that wanted to receive assistance, see CEMA, *Fifth Year*, pp. 28–9. The orchestras had to be properly constituted, nonprofit organizations of certain size and reputation, submitting regular financial statements to CEMA. CEMA's aid took various forms. Sometimes the council offered guarantees against loss on a whole year's work, and in other cases subsidized only a limited number of concerts.

'blitz concerts' in air-raid shelters and rest centres for the home-
less, which began with the intensive German air attacks in
September 1940, won for CEMA's music programmes a large
and appreciative following. Its factory canteen concerts were
equally successful, so much so, in fact, that the Ministry of Labour
and National Service specifically requested CEMA to increase the
number of musicians touring the factories, singly or in small
groups, who entertained the workers during lunch and midnight
breaks. The entertainment might not, at first, seem to have been
precisely what weary war workers would enjoy, and yet CEMA
quickly learned how great was the demand for serious classical
music. A CEMA regional officer in the north reported that Bach's
Toccata and Fugue in D Minor was 'acclaimed in all forms of
applause known to the writer'.[1] In 1942-3, CEMA provided over
4,500 factory concerts, sometimes to audiences as large as 7,000,
and after the war the appreciation of good music which CEMA
had helped to encourage took more permanent form in the
establishment of numerous factory music clubs.[2]

The scope of CEMA's work in music was broadened in 1942,
when ballet and opera were included among its activities. Both
the Sadler's Wells Opera and Ballet Companies became associated
with the council, although they were not immediate recipients of
financial aid. The opera company, reduced in size and with an
orchestra of four instrumentalists, had been touring the provinces
since 1940, visiting some of the smaller industrial towns where
opera was a novelty. It met with such public enthusiasm, both in
London and on tour, that, like the ballet company, it was able to
meet its expenses and even to pay off some debts.[3] CEMA joined
the LCC in producing ballet and opera in London parks during
the summer, brought the ballet to national attention through the
promotion of tours by several distinguished companies, and even
introduced the art of dance into war workers' hostels and fac-
tories.[4]

[1] CEMA, *Fifth Year*, p. 7.

[2] Arts Council of Great Britain, *First Annual Report 1945-6* (London: Arts
Council, 1946), p. 9; and CEMA, *Arts in War Time*, p. 11.

[3] Dent, *Theatre for Everybody*, pp. 125-6. The Old Vic Theatre was seriously
damaged by bombs in May 1941, and the Sadler's Wells Theatre was com-
mandeered as a rest centre for air-raid victims. From 1941, the three Vic-Wells
companies, when in London, performed at the New Theatre, St. Martin's
Lane. [4] CEMA, *Fifth Year*, pp. 13-14.

Throughout the war, the Sadler's Wells Ballet maintained a strenuous schedule of touring, combined with London appearances, and gave far more frequent performances and longer seasons than before 1939. The demand for tickets to its London performances was so great that the New Theatre had to ration seats, while a programme of open-air productions in Bethnal Green, during August 1942, proved that ballet performances could also sell out in the East End of London.[1] Nor was the wartime ballet boom confined to the metropolis. Provincial audiences welcomed the Sadler's Wells Company, even when two pianos were all the accompaniment that it could afford. Later, thanks in large part to provincial patronage, the company was able to employ an orchestra in the larger cities on its tour, and could even mount such expensive productions as *Swan Lake* and *Sleeping Beauty*.[2] During the war, the Sadler's Wells Ballet Company built up the following that subsequently helped to sustain it at Covent Garden, and that justified its semi-official status as a national ballet company.

CEMA's theatrical enterprises encouraged the establishment of nonprofit repertory and provincial touring companies, the lack of which had been vociferously lamented before the war. By 1945, numerous dramatic companies were associated with the council, including the Dundee Repertory Theatre, the Glasgow Citizens Theatre, the Old Vic, and the Pilgrim Players, to name but a few. Many of these groups travelled regularly on touring circuits to provincial towns, and some also took productions to factories and war workers' hostels. Other groups were formed directly under CEMA management, or were engaged specifically to entertain at hostels and small towns which were impractical for the larger companies to visit.[3] In keeping with CEMA's determination to endorse only the finest entertainment, its drama experts and advisors agreed that war workers should benefit from the 'best in production and acting'. They worked to develop a repertory of plays covering a range of styles and moods, and not shirking what they considered their responsibility to acquaint new audiences with the heavier dramatic masterpieces. O'Neill's rather grim *Days Without End* was a great success with audiences of

[1] Clarke, *Sadler's Wells Ballet*, pp. 174, 178, 184.
[2] Dent, *Theatre for Everybody*, pp. 125-6.
[3] CEMA, *Arts in War Time*, pp. 16-17.

Welsh miners, much to the surprise of the London press.[1] Old Vic players, on tour under CEMA sponsorship, brought *Macbeth*, with Dame Sybil Thorndike, to mining villages of South Wales, *Twelfth Night* and *She Stoops to Conquer* to northern England, and other classics of the British and European stage. Throughout their tours, they met with overwhelming response, often playing to capacity audiences, and ultimately CEMA was not able to satisfy all the requests for visits from touring companies that poured in from across the country.

With an eye to the health of the London theatre, CEMA became active in supporting productions in the metropolis and was instrumental in the creation of Tennent Plays, Ltd., a nonprofit branch of the powerful commercial theatrical firm, H. M. Tennent Ltd. Other companies associated with CEMA also performed in London, contributing to the variety of dramatic fare and the flourishing state of the London theatre which was evident by 1943. To be eligible for association with CEMA, theatrical groups, like orchestras, had to be nonprofit organizations, and had to agree to certain obligations.[2] While leaving the associated theatre companies free in all matters of artistic direction, CEMA reserved the right annually to review their finances, plans, and policies. In return, affiliated companies in good standing received support that ranged from full financial responsibility to limited guarantees against loss. CEMA undertook, furthermore, to serve each company 'as sponsor with Government Departments and public bodies, testifying to the value of the work done in the interests of national service'.[3] The pattern of support established by CEMA, in its relations with both the associated orchestras and theatre companies, became the model for Arts Council funding after the war.

In addition to subsidizing drama and managing tours, CEMA also became involved in the direct management of theatres. The undertaking developed almost accidentally and was not intended

[1] Landstone, *Off-Stage*, pp. 50–5. In 1944, the peak year, CEMA had fourteen touring companies on the road. Hostel tours included performances at Royal Ordinance Factories, often in remote areas difficult of access. Evans Glasgow, *Arts in England*, p. 44, estimated that only about two per cent of the hostel audiences had ever seen a stage play before.

[2] See the conditions, cited in full, in CEMA, *Fifth Year*, pp. 32–3.

[3] Ibid. Of particular interest to the associated companies was exemption from the entertainments tax and military deferments.

to serve as a precedent for similar enterprises. The Theatre Royal, Bristol, the oldest working theatre in England, was on the verge of destruction in 1942. When interested Bristol citizens proved unable to raise enough money to purchase and preserve the building, Keynes intervened. On CEMA's behalf, he offered to provide the money needed to complete the purchase, to assume complete responsibility for the repair and maintenance of the theatre, and to lease the building for twenty-one years from a committee of trustees in Bristol acting as landlords. The arrangements were worked out, and CEMA became manager of the historic theatre which, after repairs and redecoration, was ready for opening in May 1943. The Treasury's subsequent protests that CEMA's jurisdiction did not extend to real estate investments availed little against a Keynesian *fait accompli*. CEMA installed Charles Landstone as its manager at the theatre, and presented a series of visiting companies there until a group from the Old Vic became permanently based at the Bristol Theatre Royal after the war. Britain had finally acquired a theatre financed by the state, and it was entirely fitting, in light of long official neglect of the theatre, that the momentous event occurred without full Treasury knowledge or approval. Keynes' comment that the Bristol enterprise arose in a typically haphazard English way, sounds a little disingenuous. He was probably afraid that any more cautious deference to official channels would have left the Theatre Royal to the mercies of the demolition crew.[1]

With all its concern for music, ballet, and drama, CEMA did not neglect the visual arts. Expanding on 'Art for the People', CEMA used travelling exhibitions not only to encourage art appreciation but also to patronize contemporary painters and sculptors. CEMA continued to give funds to the British Institute of Adult Education for the support of exhibitions in small towns, and in 1942 began to organize its own tours, including art from the national collections and the Royal Academy, which the council

[1] CEMA, *Arts in War Time*, p. 10; and Landstone, *Off-Stage*, pp. 43–9. In 1944, CEMA took out a short lease on the Lyric Theatre, Hammersmith, and later the Arts Council managed a theatre in Salisbury. With these few exceptions, however, both CEMA and the Arts Council concentrated on supporting productions and companies, rather than buildings. Ultimately, the growing demands on Arts Council funds, together with the rising costs of theatrical management, forced it to abandon even those undertakings. Arts Council, *First Ten Years*, p. 12.

brought to municipal galleries ignored by the BIAE. In 1942, CEMA and the BIAE together organized over 300 exhibitions in towns throughout Great Britain, at factory canteens, workers' hostels, and army camps. The exhibitions varied widely, from British landscapes of the eighteenth and nineteenth centuries to original contemporary prints, from Breughel to design in the home. Public interest was keen. At least half a million people viewed the CEMA and BIAE exhibitions of 1942, with 10,000 visiting the British landscape collection during one week in Bristol alone. Something of the public appreciation of art during the anxious war years is suggested by the marked increase in sales at the annual Royal Academy exhibition of 1943.[1]

CEMA patronized contemporary artists in numerous ways. The council purchased a collection of contemporary works which it exhibited around the country as examples of art within the budget of the ordinary collector. It inaugurated an important policy of paying fees on a fixed scale to hire works by living artists for touring exhibitions, and charged no commission if such works were sold as a result. Further, it commissioned designs for lithographs which were reproduced in large quantities and displayed in armed forces' and workers' centres, or wherever originals could not be shown safely. In addition, therefore, to the official patronage of artists through the War Artists' Advisory Committee, CEMA offered artists broad opportunities for employment and recognition.[2]

Through its support of CEMA, the British Government acknowledged the importance of the arts in national life. Admittedly, CEMA was only a wartime organization, established in the face of an emergency, with no assurance of continued Govern-

[1] Arts Council, *First Ten Years*, p. 8; BIS, *Entertainment* (1944), pp. 16–18; and CEMA, *Arts in War Time*, pp. 18–20, 34–9.

[2] The War Artists' Advisory Committee was established in 1939, following the example set in the First World War when artists were commissioned to make a pictorial record of the hostilities. The committee, under the jurisdiction of the Ministry of Information and financed by the Treasury, appointed a number of artists, including Paul Nash, William Coldstream, and Graham Sutherland, to branches of the Armed Services where their task was to depict the course of the war in its various aspects. Other artists were commissioned for shorter periods, or were employed at fixed rates, specifically for single works. BIS, *Entertainment* (1944), p. 15; Calder, *People's War*, pp. 510–11; and Robin Ironside, 'Painting since 1939', in *Since 1939*, 1: 175–7.

ment support thereafter. Its function and policy were never precisely specified, although there was an implicit understanding of its aims. It had no clearly articulated terms of reference, and worked from year to year, administering the funds allotted to it by the Treasury. But the war, as it proceeded, incidentally supplied the evidence needed to establish the council permanently. Wartime conditions stimulated public demand for art to an extent far exceeding the expectations of CEMA's most visionary spokesmen. Certainly many people came to CEMA entertainment because there were few alternative forms of recreation, or in order to see celebrities performing in villages which could never expect to attract them in normal times. But such considerations apart, there can be no doubt that the war stimulated the growth of large and lasting audiences for the arts. CEMA reached out to these audiences, aroused their appetites, and helped to create an environment in which the arts figured regularly, sometimes even prominently, in community life. With CEMA encouragement, amateur art activities increased, and many local organizations began planning art centres to accommodate their endeavours after the war. 'At the start,' Keynes told a radio audience in 1945, 'our aim was to replace what war had taken away; but we soon found that we were providing what had never existed even in peace time.'[1] The overwhelming public endorsement of CEMA's work helped to ensure that, after the war, cultural opportunities would merit considerable official attention.

In addition, CEMA proved that substantial state support need not jeopardize artistic independence or curtail the wide variety of cultural pleasures available to the public. Britain, a country traditionally suspicious of state interference to the point of obsession, acquired in CEMA a central authority for channelling public funds to the arts, and yet cultural activities flourished with far greater diversity than had been the case before the war. CEMA was 'a happy British compromise in the question of a Ministry of Fine Arts',[2] nonpolitical in policies and personnel, but dependent on Treasury grants and supervised by a Government department. Its successful maintenance of that compromise throughout the war augured well for future state aid. Particularly significant was the fact that, although Great Britain was coping with the most

[1] Keynes, 'Arts Council', p. 31.
[2] Arnold L. Haskell, 'Ballet since 1939', in *Since 1939*, 1: 41.

desperate war effort in its history, no one objected to spending public money on art at such a time. The arts, instead, were seen as an integral part of the war effort on the home front, and a long tradition of state neglect was finally broken.

CEMA was not alone responsible for this triumphant achievement. A vast extent of cultural services, in Britain and abroad, was provided by the indefatigable troops of the Entertainments National Service Association. ENSA, established to entertain the armed forces and factory workers, was financed by Treasury funds administered through the Navy, Army, and Air Force Institutes, a nonprofit corporation furnishing the three Services with assorted amenities.[1] By the end of 1943, ENSA was providing an average of over three thousand performances a week to the armed forces in Britain. It employed thousands of performers, who received standard national service salaries, and offered entertainment ranging from camp singsongs to full-scale stage productions in garrison theatres. In general, ENSA provided more light entertainment than CEMA, with dance music, variety shows, and films constituting much of its regular fare. But it, too, could be resolutely highbrow, once its audiences proved receptive, and its Symphony Concerts for War Workers obtained the services of some of the finest artists available. Pablo Casals, for example, performed a cello concerto in Chester Cathedral for a three-guinea fee,[2] and the Sadler's Wells Ballet Company toured garrison theatres under ENSA auspices. If some ENSA entertainment was at best amateurish, if the smutty humour in some of its shows fell very flat, by the end of the war ENSA had nonetheless chalked up an impressive record. Over two and a half million performances for servicemen and factory workers was no slight accomplishment, and ENSA contributed substantially to the unprecedented public enthusiasm for live theatre and music that emerged in the 1940s.[3]

Finally, the BBC continued to use its broadcasting monopoly

[1] BIS, *Entertainment* (1944), pp. 5–6; and Dean, *Theatre at War*, pp. 60–2. Basil Dean, the moving force behind ENSA's establishment and its director throughout the war, had been in charge of the Entertainment Branch of the Navy and Army Canteen Board, NAAFI's predecessor, during the First World War.

[2] BIS, *Entertainment* (1944), pp. 13–14, 10–11; and Calder, *People's War*, p. 373.

[3] Calder, *People's War*, pp. 371–3.

in the best interests of national culture, especially music. The BBC Symphony Orchestra, evacuated first to Bristol and later to Bedford, broadcast regularly under a variety of trying conditions, and toured the country to perform at military camps, where its welcome was astounding: when playing for troops at Aldershot, it broke the record for Saturday night takings set by Gracie Fields.[1] The BBC continued to support the Promenade Concerts, and provided entertainment for millions of factory workers through its programme of 'Music While You Work', which was relayed to workers on the job.[2] Keynes, who had good reason to boast of CEMA's accomplishments, nevertheless credited the BBC with the 'predominant part' in creating 'the unsatisfied demand and the enormous public for serious and fine entertainment'.[3]

[ii]

In the years immediately following the war, a number of steps were taken which demonstrated that the lessons taught by CEMA, ENSA, and the BBC had impressed British statesmen of all parties. The first, both in time and significance, was the establishment of the Arts Council, which Sir John Anderson, the Chancellor of the Exchequer, announced in June 1945, during the last weeks of Churchill's caretaker ministry. CEMA, he told the House of Commons,

> was set up to maintain the standard and the national tradition of the arts under war conditions. The experience thus gained seemed to us to show that there will be a lasting need after the war for a body of this kind to encourage knowledge, understanding and practice of the arts in the broad sense of that term. It was accordingly decided to incorporate the Council with this object and with the name of the Arts Council of Great Britain.

The Chancellor of the Exchequer, the Minister of Education, and the Secretary of State for Scotland agreed to transfer responsibility for the council from the Ministry of Education to the

[1] Boult, *My Own Trumpet*, pp. 114–23; and Myers, 'Music since 1939', pp. 108, 119–23.
[2] BIS, *Entertainment* (1944), p. 12.
[3] 'Arts Council', p. 32.

Treasury,[1] and with nonpartisan support, Parliament approved
the arrangements. The attitude of many M.P.s had been tersely
expressed the day before the Chancellor's announcement by
Kenneth Lindsay, the National Labour Member for Ayr and
Buteshire. 'Many good things have come out of the war,' he
observed, after praising CEMA's work. 'For Heaven's sake
nourish them and get on with them.'[2]

State support for art was no longer a controversial question.
Faced with the immense cost of rebuilding Britain, Parliament
did not dispute the allocation of considerable sums to encourage
culture. The Arts Council was a permanent body which, as its
programmes expanded, could not fail to require ever increasing
funds from the national Exchequer. Although its grant for 1946–
1947 was the comparatively modest £350,000, by 1948–9, the
grant-in-aid had passed half a million, and mounted steadily
thereafter. The most obvious reason for the near unanimity with
which the council was founded, and the one which contempor-
aries cited most insistently, was the evident public demand for an
organization devoted to fostering art throughout the country.
For the first time in the history of Parliament, the arts had shown
real promise of voter appeal. It was politically sensible to endorse
public expenditure on the arts in 1945, and, in CEMA, Parliament
had the instrument to do so ready at hand. The nation's lawmakers
were not asked to approve a dangerous, unprecedented step into
uncharted cultural realms, but merely to transform a temporary
arrangement, and one of proven worth and popularity, into a
permanent body dignified by Royal Charter. Over the centuries,
the organs of British Government had developed in just such a
way, through precedent becoming custom and ultimately being
embodied in legal form. The Second World War telescoped the
process in the case of the Arts Council, and, in June 1945, Parlia-
ment and the Government re-affirmed an agency that had already
become a familiar feature of national life.

The establishment of the Arts Council was, therefore, politically
safe and constitutionally sound. There were other arguments in
its favour as well, which perhaps did not have so immediate an

[1] *Parliamentary Debates* (Commons), 5th ser., 411 (12 June 1945): 1482–3.
The Treasury vote already covered a number of cultural and scientific
organizations.

[2] *Parliamentary Debates* (Commons), 5th ser., 411 (11 June 1945): 1349.

impact on the legislators, but nonetheless helped to shape their opinions. There was, first of all, a general recognition that private support after the war would not be substantial. Increased income taxes, surtaxes, and death duties would severely limit the role which the individual patron could play. As the state had reduced the means of assistance through voluntary channels, there was some feeling that it ought to furnish aid through public ones. It had a further responsibility, or at least a strong incentive, to provide facilities for the fruitful use of leisure time. Parliament was well aware that, after the war, shorter working days would mean increased leisure, and there was much interest in the forms of recreation which people would seek out. 'We are convinced,' Sir Stafford Cripps, Chancellor of the Exchequer, told a theatre conference held in London in February 1948, 'that in these days of growing education and progress, and of the shortening hours of labour, culture and entertainment must be prepared to help . . . in whatever way is decided to be best.'[1]

Much of the discussion in the immediate postwar years had implications of social control, although less overt than in the nineteenth century when education and art were valued chiefly as means of inculcating middle-class attitudes in the working-class mind. But while some observers still nervously pondered the social implications of long leisure hours, others, including Keynes, had no sympathy for their anxieties. He might well have had a hand in writing the pamphlet which accompanied the Arts Council's model plan for community art centres in 1945. 'We must rid ourselves of the false idea,' the council urged, 'that art is a palliative for social evils or a branch of welfare work.'[2] Whether one regarded art as palliative or pure pleasure, an agency to promote cultural recreation undeniably had a purpose to serve in postwar Britain.

Apart from these considerations, feelings of a less practical and more emotional nature were also at work. Wartime chauvinism had inspired pride in British values. In the struggle against fascism, the country had rediscovered a sense of national culture,

[1] Cripps' address, quoted in Whitworth, *National Theatre*, p. 236.

[2] *Plans for an Arts Centre* (London: Lund Humphries for the Arts Council of Great Britain, 1945), p. 6. Although the Arts Council was not formally incorporated by Royal Charter until August 1946, the name was in use by the latter half of 1945.

an appreciation of Britain's unique cultural achievements, such as it had not enjoyed since the mid-nineteenth century. The discrepancy between popular amusement and elitist art was reduced temporarily, as serious art became popular during the war, and native artists, both performers and creators, enjoyed a national respect hitherto unknown. The Arts Council was the beneficiary of these sentiments, combined with a realistic appraisal of Britain's international standing. If the glorious days of empire and naval hegemony were gone forever, and if the war had reduced Great Britain to financial dependence on the United States, there was still cause enough for pride in British cultural strength. Even after the wartime sense of cultural unity had faded in the crises of postwar reconstruction, Britain's cultural tradition remained an object of esteem. 'This country has had a great loss of military power and of wealth', Viscount Esher told the House of Lords in February 1949, during a debate on the National Theatre Bill:

> These things have passed to those two remote monsters who live to the East and West of Europe. Their way of life, though very different one from the other, has no real appeal to us. But I am convinced that Shakespeare's countrymen are about to enjoy an Athenian summer of great interest and charm.[1]

To bring about the Athenian summer was the Arts Council's duty, and it set to the task with the policies, programmes, and, to a great extent, the personnel which it inherited from CEMA.[2] The council members, appointed by the Chancellor of the Exchequer upon the advice of the Minister of Education and the Secretary for Scotland, were selected on a nonpartisan basis for their interest in the arts. The council, in turn, appointed panels of experts on music, drama, and art, and two special committees were formed 'to advise and assist the Council in the promotion of the objects of the Council in Scotland and Wales respectively'.[3]

[1] *Parliamentary Debates* (Lords), 5th ser., 160 (17 February 1949): 998.

[2] Keynes was appointed the first chairman, but died in April 1946, before the Arts Council received its charter. He was succeeded by Sir Ernest Pooley, a governor of the Old Vic, with long experience of City guilds and public administration. In 1953, Sir Kenneth Clark became chairman.

[3] *Charter of Incorporation Granted by His Majesty the King to the Arts Council of Great Britain, Ninth day of August 1946* ([Oxford University Press, 1946]), p. 9. In 1948, a fourth panel specifically for opera and ballet was established.

CEMA's regional offices were maintained for a time, but as the Arts Council became increasingly less involved in the direct provision of entertainment and the organization of touring companies, it found less need for a regional organization. The last of the regional offices was closed in 1956, and other means have since been employed for maintaining contact with activities across the country.

Like CEMA, the Arts Council directed its assistance almost exclusively to professional organizations, and subsidized a rich variety of important cultural events. It supported the first Edinburgh Festival, in August 1947, organized the famous Van Gogh exhibition at the Tate Gallery in 1947–8, and, in cooperation with the Miners' Welfare Commission, arranged tours by theatre companies to over one hundred small towns and villages in Wales. It helped local education authorities provide concerts for youth clubs, contributed heavily to the opera and ballet companies at Covent Garden, and maintained CEMA's association with orchestras and dramatic repertory companies.[1] One of its major concerns in the immediate postwar years was the critical shortage of adequate housing for the arts, and it took a strong interest in the planning of local art centres. The council entertained grant applications from all appropriate nonprofit associations,[2] and, while it continued for some years to manage a few galleries, art centres, and theatres, it promoted the development of independent management, hoping ultimately to serve purely as a funding agency.

The Arts Council's Charter officially spelled out the principles on which CEMA had acted throughout the war. It existed, the Charter declared:

> for the purpose of developing a greater knowledge, understanding and practice of the fine arts exclusively, and in particular to increase the accessibility of the fine arts to the public

There was no general literature panel until 1966, although the council had concerned itself with poetry since 1947.

[1] This sampling of Arts Council activity is taken from its *Third Report 1947–48*.

[2] The council was not responsible for supporting the national museums which received aid directly from the Treasury, nor for the British Film Institute. The Arts Council was not authorized to give direct subsidies to any local authority, but could, and frequently did, join with local authorities to support independent cultural groups.

throughout Our Realm, to improve the standard of execution of the fine arts and to advise and cooperate with Our Government Departments, local authorities and other bodies on any matters concerned directly or indirectly with those objects. . . .[1]

From the beginning, the council stressed its intention to bolster local initiative in the arts, deprecating any notions that its role was to spoon-feed culture to the public. Keynes outlined the council's guiding attitudes shortly after its creation, explaining that the Arts Council was

> greatly concerned to decentralise and disperse the dramatic and musical and artistic life of the country, to build up provincial centres and to promote corporate life in these matters in every town and county. It is not our intention to act on our own where we can avoid it. We want to collaborate with local authorities and to encourage local institutions and societies and local enterprise to take the lead . . . We look forward to the time when the theatre and the concert-hall and the gallery will be a living element in everyone's upbringing. . . .[2]

The Arts Council of Great Britain is not a Government department, staffed by civil servants, but an independent, chartered body. Over the years, its staff and officers have repeatedly insisted that the council promulgates no official views on art, nor presumes in any way to act as a Ministry of Culture. The question of autonomy, in the case of an organization dependent on public funds, is one of the most vexing problems facing subsidized culture today, and means were indeed established to subject the Arts Council to a measure of public control. Assessors, appointed by the Treasury, Scottish Office, and Ministry of Education, were allowed to attend meetings of the council, its executive committee, or any of its panels.[3] Both the Committee of Public Accounts and the Select Committee on Estimates were authorized to examine its activities, while the office of the Comptroller and the Auditor-General undertook annual audits of its accounts. More significant than these safeguards, however, was the very fact of its constitution as an independent corporation, together with proof, from the start, of official readiness to leave the Arts Council alone. On its tenth anniversary, the council reported 'no single instance

[1] Charter, p. 3.
[2] 'Arts Council', p. 32. [3] Charter, p. 10.

on record of a Chancellor of the Exchequer requiring or directing, or even advising, the Arts Council to do this or not to do that. . . '. On the contrary, 'when from time to time some action of the Arts Council's is criticised in the House of Commons', the report continued, 'successive Chancellors have invariably declared that they will not interfere with the Arts Council's discretion'.[1] The old British tradition of cultural laissez-faire proved to have its advantageous side after all.

The existence of the Arts Council made possible a second major cultural development in Great Britain in the immediate postwar period: the establishment of the Royal Opera House, Covent Garden, as the national home of ballet and opera. As in the case of CEMA, private initiative laid the plans for the Royal Opera House, and essential public assistance was forthcoming to realize them. During the war, the premises had accommodated a commercial dance hall, to the delight of servicemen on leave and to the disgust of opera lovers. In late 1944, when the lessees, Mecca Cafés, were about to renew their tenancy for another five years, a group of influential men became alarmed over the future of opera and ballet in London. Boosey and Hawkes, the noted firm of music publishers, acted quickly and leased the opera house from the landlord, Covent Garden Properties, Ltd., as of 1 January 1945.[2] A committee was formed to manage the theatre with the explicit aim of establishing 'Covent Garden as a centre of opera and ballet worthy of the highest musical traditions . . . giving to London throughout the year the best in English opera and ballet, together with the best from all over the world.'[3] Its members included Samuel Courtauld, William Walton, Leslie Boosey, Ralph Hawkes, and Sir Kenneth Clark, with Keynes as chairman.

By the end of 1945, the new Covent Garden Opera Trust, as the committee became, had made significant progress towards transforming Covent Garden into a national institution. Boosey and Hawkes had granted the trust a licence as tenants of the opera house, with the agreement that all profits would be used to

[1] Arts Council, *First Ten Years*, pp. 13–14.

[2] A clause in the lease held by Mecca Cafés gave priority to any group renting the theatre for the purpose of presenting opera and ballet. Nonetheless, Mecca Cafés put up a legal fight that was not finally settled until July 1945.

[3] Boosey and Hawkes policy declaration, quoted in Rosenthal, *Opera at Covent Garden*, p. 140.

promote the trust's goals, and the Arts Council had undertaken to support the endeavour, with a starting grant of £25,000. Keynes, in his capacity both as chairman of the Covent Garden Opera Trust and of the Arts Council, must have enjoyed negotiating with himself over the arrangements, which represented the first step in what became the council's largest commitment of funds to a single cultural enterprise. In 1948-9, it gave to the opera house over a quarter of the total amount which the council received from the Treasury—£145,000 out of £575,000—and the grant continued to increase steadily.

The trust's work was further advanced when it persuaded Ninette de Valois and the governors of Sadler's Wells to transfer the Sadler's Wells Ballet Company to Covent Garden on a permanent, resident basis. No other ballet company in Great Britain had so national a following or reputation, and its establishment at the Royal Opera House guaranteed that audiences throughout the country would look to Covent Garden for the best in ballet. There was no similarly acclaimed opera company to install at the theatre, however, and the trust began the long process of forming a national company. Although a distinguished Austrian musician, Karl Rankl, was invited to become the musical director of the new company, the trust held auditions throughout the country to find qualified British singers.

The Sadler's Wells Ballet opened at Covent Garden in February 1946, with an entirely new production of *Sleeping Beauty*, and went on to give the longest season of ballet in the history of the Covent Garden Opera House.[1] The resident opera company gave its first full-scale performance, *Carmen*, in January 1947, and the trust was finally able to implement its plan of presenting opera and ballet throughout the year. While foreign companies and artists were still invited to perform at Covent Garden, the British companies provided the backbone of the season's entertainment. The old system, under which the opera house served to accommodate brief visits by prestigious foreign companies, to the nearly total neglect of native talent, was at last overthrown.[2]

[1] Clarke, *Sadler's Wells Ballet*, p. 209. Titular recognition of the company's contribution to the ballet in Great Britain came in 1957, when it became the Royal Ballet, incorporated under Royal Charter.

[2] In 1949, official involvement in opera and ballet, both once considered thoroughly un-English, was increased when the Ministry of Works replaced

The Labour Government that nationalized the Bank of England, the coal industry, railways, and health services, also nationalized culture. It was more concerned to enrich the country's cultural life, and to bring it within the reach of the people, than any previous Government in the nation's history. Throughout the forties, party publications and ministerial statements included culture among the more traditional preoccupations of social planners. 'We have to organize social services,' explained a party report in 1942,

> at a level which secures adequate health, nutrition, and care in old age, for all citizens; and we have to provide educational opportunities for all which ensure that our cultural heritage is denied to none . . .
>
> The Labour Party believes . . . that there are public amenities both of culture and of recreation, which must be consciously undertaken by the community on behalf of its citizens, instead of remaining, as so largely now, the accident of private generosity.[1]

After July 1945, the Attlee ministry took advantage of its large majority in the House of Commons to create for art a prominent place in the welfare state. Not only through rapidly growing grants to the Arts Council, but also by several important pieces of legislation, the Labour Government of 1945–51 sought to provide for public entertainment and recreation, as well as education, through the arts.

The National Theatre Act of 1949, by its very title, belongs among the Labour Government's nationalization measures. It was, of course, the result of decades of effort by men and women dedicated to the cause of the British theatre, but its remarkably easy passage through Parliament could have only occurred once M.P.s and Peers alike had grown accustomed to the greatly expanded role of the state in postwar society, and after they had

Boosey and Hawkes as lessees of the theatre and continued to sublet it to the nonprofit managing company. For the history of the Royal Opera House after the war, see Arts Council, *First Ten Years*, pp. 19–20; Rosenthal, *Opera at Covent Garden*, pp. 139–44; and Shawe-Taylor, *Covent Garden*, pp. 69–70.

[1] Labour Party, *Reconstruction in War and Peace: Interim Report of the National Executive Committee of the British Labor (sic) Party, approved by the Party Conference [1942] under the title 'The Old World and the New Society'* (New York: League for Industrial Democracy, 1943), pp. 13–14, 19.

accepted the expenditure of large public sums on cultural enterprises. In the case of the National Theatre, municipal support preceded parliamentary, for it was the London County Council that prompted the Government to introduce legislation late in 1948. As early as 1942, the LCC and SMNT Committee had begun negotiations leading at length to an exchange of real estate. In return for the committee's site in South Kensington, the LCC offered acreage on the South Bank of the Thames, between Westminster and Waterloo Bridges, in an area which it planned to develop as a cultural centre after the war. Before the final arrangements had been settled, the position of the SMNT was strengthened by its establishment of a Joint Council with the Old Vic under the chairmanship of Oliver Lyttelton, the Conservative M.P. for Aldershot and a trustee of the SMNT. The Joint Council's purpose was, briefly, 'to stimulate the art of the theatre by every possible means', particularly through pressure on the Government to establish a national theatre,[1] and the fusion of efforts considerably enhanced the likelihood of success. After forty years of talk, plans, and exhortations, the SMNT Committee was at last affiliated with the living theatre, with a nationally renowned repertory company such as had always been envisioned for a national theatre. The Joint Council could justly claim that it had the material ready to implement a national theatre scheme; it only lacked a building to house it, and the money to build it.

Viscount Esher was appointed to conduct negotiations with the Government. As a member of the Joint Council, chairman of the SMNT and Old Vic executive committees, the London Theatre Council, and the British Drama League, as well as a member of the Arts Council executive committee,[2] he was eminently qualified to serve as spokesman for the interests of the theatre, and he effectively argued the case for Government support. His job, however, was not as difficult as it would have been ten years earlier, or as the Joint Council had feared. 'My colleagues were not hopeful,' he told the House of Lords during debate on the National Theatre Bill. 'But I was surprised at the

[1] 'Abstract of an Agreement made the twenty-fifth day of January 1946', by the Old Vic governors and the SMNT trustees, quoted in Whitworth, *National Theatre*, p. 226.

[2] *Dod's Parliamentary Companion for 1949*; Landstone, *Off-Stage*, p. 159; and Whitworth, *National Theatre*, pp. 238–9, 300–1.

warm welcome I received from Mr. Dalton when I saw him about this measure.' After Sir Stafford Cripps replaced Hugh Dalton as Chancellor of the Exchequer in November 1947, Esher 'had to begin again with a new Chancellor of the Exchequer whose formidable austerity', he observed,

> had been rubbed into me by every newspaper in the last five years. I imagined that he was going to be rather like that Puritanical Roundhead, Prynne, who during the Commonwealth wrote a pamphlet and succeeded in getting the theatres closed during the whole period of Cromwell's reign. I did not find Sir Stafford Cripps in the least like that. On the contrary, I found he was just as cordial about the idea as Mr. Dalton had been.[1]

A national theatre was precisely the kind of cultural enterprise which Labour intended to promote. In the early years of the war, Ernest Bevin, Minister of Labour and National Service at the time, had told the Provincial Theatre Council that he looked forward 'at the end of this great struggle, to the living theatre ... becoming one of our great national institutions',[2] and, after the war, the Attlee Government was ready to provide something more substantial than moral support. The national theatre scheme was particularly appealing, too, because it provided an opportunity for cooperation with a local authority, in the kind of joint effort between central and local government which Labour sought to encourage, on a smaller scale, throughout the country. When the LCC pressed for assurances that, if it left room in the South Bank redevelopment plans for a national theatre, the Government would help to finance the building, the Government was willing to agree. In response to a question from Lyttelton, Cripps told the House of Commons in March 1948:

> The Government take the view that the establishment of a theatre to be operated under public auspices, which will set a standard for the production of drama in a national setting worthy of Shakespeare and the British tradition, is a scheme to which the State should contribute. I am, therefore, proposing

[1] *Parliamentary Debates* (Lords), 5th ser., 160 (17 February 1949): 997.
[2] Quoted in Whitworth, *National Theatre*, pp. 232–3.

to ask for powers to provide a substantial part of the capital cost from public funds.[1]

In November 1948, the Government introduced the National Theatre Bill, which authorized the Treasury to contribute up to one million pounds for the purpose of building and equipping a national theatre.[2] Neither Lords nor Commons seemed overawed by the size of the proposed Treasury contribution, and the Bill easily passed through both Houses, where the extraordinary unanimity of opinion inspired considerable comment.[3] There were, of course, some criticisms raised. A few provincial Members expressed resentment over the extensive aid promised to a metropolitan institution; Emrys Hughes, the Labour Member for South Ayrshire, asked when Edinburgh could look forward to similar support in founding a national theatre.[4] Others observed that, in the current economic state of the country, it was not perhaps the most appropriate time to allocate one million pounds for the theatre.[5] But there was no opposition to the fundamental idea that encouragement of art—the performing arts as well as the visual—was a legitimate responsibility of the state. The reasons offered to justify this conviction varied. Some speakers reiterated the time-honoured arguments that man's soul and imagination need nourishment as much as his body. Some espoused the popular nineteenth-century view that the educative value of the arts entitled them to public support. A few still clung to the belief that art's greatest benefit to society was achieved

[1] *Parliamentary Debates* (Commons), 5th ser., 448 (23 March 1948): 2775.

[2] *Parliamentary Papers*, vol. 4 (1948/49) (*Bills: Public*), 'National Theatre Bill', pp. 1–2.

[3] For the Bill's second reading in each House, see *Parliamentary Debates* (Commons), 5th ser., 460 (21 January 1949): 441–507, and (Lords), 5th ser., 160 (17 February 1949): 985–1005.

[4] Commons debate, 494–5. Ellis Smith, the Labour Member for Stoke-on-Trent, was particularly bitter over what he considered the neglect of the provinces. See 466–70. Glenvil Hall, the Financial Secretary to the Treasury, and Oliver Lyttelton were both quick to point out that tours throughout the country were planned as a regular feature of the working National Theatre.

[5] The effective reply to this argument was that the Bill authorized the allocation, not for the immediate present, but for whenever the time came to implement the plan. In any case, implementation would not occur for several years, since the South Bank site was first intended for use in the 1951 Festival of Britain. The Government had nonetheless introduced the Bill in 1948 so that the LCC could proceed with its plans for the area.

through its civilizing influence on the masses.[1] Others brought more contemporary considerations to their colleagues' attention, arguing that the national theatre would be a useful project to have as a source of jobs in the next depression. Whatever their reasons, however, members of both Houses congratulated the Government on introducing the legislation, harassed though it was with the heavy burden of national problems left in the war's aftermath. Years of frustration and disappointment for the advocates of a national theatre were finally rewarded by rare nonpartisan support.[2] Times certainly were changing.

The Labour Government also turned its attention to the British cinema, and introduced two measures of particular importance to that struggling industry. All attempts to maintain the quota system collapsed during the war, as production companies lost manpower, essential materials, and valuable studio space to the demands of the war effort. In 1943–4, over 1,100 cinemas in Great Britain failed to show the prescribed quota of British films, and it is scarcely surprising when the annual output of commercial films fell well below one hundred.[3] But if quantity declined sharply during the war, the quality of films produced by British film makers improved significantly. The Films Division of the Ministry of Information, which took over the GPO Film Unit at the start of the war, issued quantities of non-theatrical film for home consumption. Ministry films ranged from 'trailers' of several minutes illustrating such lessons as 'How to Extinguish an Incendiary Bomb', to feature-length films, released commercially, like the highly acclaimed 'Desert Victory'.[4] During the

[1] It is hard to believe that it was a member of the Labour Cabinet, Lord Jowitt, who said that Britain's working classes 'can emulate, and must emulate, the standards and quality and example given them by their parents and guardians, her old aristocracy'. Lords debate, 988.

[2] The frustration, in fact, was unfortunately not over. Although the National Theatre Act was passed with dispatch in 1949, the building on the South Bank did not open until March 1976. The National Theatre Company was, nevertheless, founded in 1963 and used the Old Vic Theatre as headquarters until the completion of its new permanent home. It receives substantial aid from the Arts Council, as does the Royal Shakespeare Company, granted a Royal Charter in 1961.

[3] *Parliamentary Debates* (Commons), 5th ser., 380 (16 June 1942): 1358; 381 (7 July 1942): 698; 382 (28 July 1942): 297; and 417 (20 December 1945): 1653.

[4] BIS, *Entertainment* (1944), pp. 18–20.

war, documentary films provided an essential service both for public information and national morale. They achieved distinction as an art form in their own right, and for the first time had a captive, but appreciative, audience of millions. Commercial films, too, reached a generally higher level of artistry than had been the case before 1939. Noel Coward's 'In Which We Serve', for example, was selected by the New York Film Critics as the best picture of 1942, and other producers also made films which focused on the daily life of a nation at war. Despite the drastic reduction in the production of entertainment films, the British film industry emerged from the war freer from the influence of Hollywood than it had been for years.

The artistic success and commercial popularity of British films, both privately produced and officially sponsored, and the contribution which the film industry made to the war effort, doubtless sharpened the Labour Government's concern for the industry's plight after the war. The aid which it offered was twofold: increased support to the British Film Institute and financial loans for film production. The Institute's meagre grant from the Cinematograph Fund had already been increased in 1944, and it was fixed at £31,500 for 1947–9.[1] But so long as it remained entirely dependent for its revenue on the Cinematograph Fund, the BFI's financial position was at best little more than precarious. The Privy Council Committee on the BFI, appointed late in 1947, accordingly recommended an important change in the means of support. It suggested that 'the most suitable method of finance for the bulk of the Institute's funds would be a grant from the Exchequer',[2] and the Attlee Government took note of the proposal. In 1949, it introduced, and steered through Parliament, a Bill to augment the Institute's income by direct Treasury grants. The wording of the legislation was vague: it empowered the Treasury 'from time to time [to] make grants to that Institute of such amounts as they think fit out of moneys provided by Parliament'.[3] Nonetheless, the Institute's operating budget expanded considerably as a result of the Act, although it has always remained

[1] Privy Council, Report on the BFI, p. 4.
[2] Ibid., pp. 9–10.
[3] Parliamentary Papers, vol. 1 (1948/49) (Bills: Public), 'A Bill to Provide for the payment to the British Film Institute of grants of moneys provided by Parliament', p. 1.

modest in comparison to Treasury expenditure on Covent Garden.

The Government became indirectly involved in film financing through the Cinematograph Film Production (Special Loans) Act of 1949. This legislation, also introduced by the Attlee Government, established a National Film Finance Corporation which was authorized to make loans to promising film production and distribution companies, unable 'for the time being . . . to obtain adequate financial facilities . . . on reasonable terms from an appropriate source'. The corporation was, inevitably, placed under the jurisdiction of the Board of Trade, which was empowered to lend it up to five million pounds for the purposes of its work. That there was a need for such support became strikingly evident in 1950 when the corporation was financially involved with at least half of the films under production in British studios.[1]

Most important of all the legislation which the Attlee Government initiated on behalf of art was an Act whose main purposes were not essentially cultural at all. Nevertheless, the Local Government Act of 1948 contained provisions that potentially affected the arts throughout Great Britain and furnished the means to enrich the cultural life of the country as no previous measure had ever done. According to section 132, local authorities were empowered to spend annually as much as the product of a 6d. rate for an extensive array of entertainment services, including the provision of facilities for dramatic performances, concerts, and dancing. The restrictions of the 1925 Public Health Act were finally removed, freeing local governments to contribute important assistance to diverse art programmes in their communities.

The involvement of local authorities in the provision of entertainment had already expanded during the war through the 'Holidays at Home' scheme, sponsored by the Ministry of Labour in an attempt to encourage families to spend their summer holidays at home. Fairs, open-air drama, and dances were among the events which local authorities promoted with the aid of both local talent and touring companies. The Education Act of 1944 gave legal authorization to several of these activities by enabling local education authorities to provide public entertainment as

[1] BIS, *Entertainment* (1950), p. 20 and *Parliamentary Papers*, vol. 1 (1948/49) (*Bills: Public*), 'Cinematograph Film Production (Special Loans) Bill', pp. 1–3.

part of their educational responsibilities.[1] But it was not until the Local Government Act of 1948 that local authorities were allowed sufficient funds to sponsor numerous cultural enterprises of a substantial nature. In 1946, the Association of Municipal Corporations had requested Aneurin Bevan, the Minister of Health, to increase their powers with regard to municipal theatres and concert halls, in addition to augmenting the amount that could be spent from local rates for cultural purposes.[2] Bevan met the Association's request in the legislation of 1948, a fitting complement to the National Health Service, Bevan's greatest achievement in office. Section 132 at last eliminated the need for special enabling legislation and gave local authorities uniform opportunities to encourage cultural activities throughout their districts.

Section 132 was permissive, not compulsory, and left it to the individual local authorities to determine what use, if any, each would make of the new powers. As Parliament might well have anticipated, local authorities differed widely in their application of the enabling legislation. Ten years after its passage, Sir Benjamin Ifor Evans reported that, while some local governing bodies had achieved a distinguished record in assisting the arts, others were 'quite scandalous in their neglect of provision for artistic activities'.[3] The overall picture was generally discouraging. In 1953, only a fifth of the local authorities were willing to spend more than the product of a 2d. rate on entertainment, and by the end of the following decade, the situation showed no signs of improvement. There were, of course, some highly promising examples of local initiative. In Coventry, the Belgrade Theatre, which opened in 1958, was the first professional theatre in Great Britain constructed entirely at the expense of a municipal authority. The LCC, which derived its powers from the London County Council (General Powers) Act of 1947, participated in numerous cultural enterprises for the metropolis, from the great urban renewal project on the South Bank of the Thames to open-air sculpture exhibitions in Battersea Park.[4] But, on the whole,

[1] Evans and Glasgow, *Arts in England*, p. 65.

[2] Ruck, *Municipal Entertainment*, p. 24.

[3] *Ministry of Fine Arts*, p. 30. Evans served as vice-chairman of the Arts Council, 1946–51.

[4] Arts Council, *First Ten Years*, p. 26; Peggy Crane, *Enterprise in Local*

local authorities seemed uncertain as to their responsibilities towards art. While the central Government might have a clear sense of the cultural needs and desires of the country at large, it failed to communicate its vision to the many local governments that did not know how to handle their expanded duties. The Arts Council, for fear of seeming to impose a form of *Art Officiel*, avoided anything that might appear as interference with the jurisdiction of local authorities. As late as 1970, there were, for example, 'no booklets to argue local authorities into the need for arts provision or to advise them on the best way of spending money'.[1]

[iii]

The response of local governments to section 132 of the Local Government Act, 1948, reveals some of the enduring problems that have hindered the articulation of an official policy towards art in Great Britain. Although there has grown up since the Second World War a conviction 'that the arts and leisure activities of the community [are] a proper subject for local government',[2] there is still a lingering suspicion that cultural enterprises are not quite serious business. If most people have come to recognize that public expenditure on art is worthwhile, and to appreciate the opportunities which it provides, many still consider such expenditure justifiable only at times when the economy is robust and problems of public welfare amply attended to. In a lecture to the Fabian Society in 1947, J. B. Priestley mocked the attitude of those people who hold that:

art is like the icing on the substantial cake of ordinary sensible

Government: A Study of the Way in which Local Authorities exercise their Permissive Powers, Fabian Research Series, no. 156 (London: Fabian Society, 1953), p. 16; Frederick Dorian, *Commitment to Culture: Art Patronage in Europe, Its Significance for America* (Pittsburgh, Pa.: University of Pittsburgh Press, 1964), pp. 405–9; Michael Green and Michael Wilding, *Cultural Policy in Great Britain*, Studies and Documents on Cultural Policies, no. 7 (Paris: UNESCO, 1970), pp. 11, 16; and Harris, *Government Patronage*, p. 218.

[1] Green and Wilding, *Cultural Policy*, p. 60.

[2] Lily Atkins, *Arts and Leisure in the London Community: The History of the Standing Committee on the Arts of the London Council of Social Service*, with a Foreword by D. J. Hughes (London: London Council of Social Service, 1968), p. 5.

living . . . that the artist is the clever but vague chap you call in after the serious work of the day has been done, to help your digestion, to add a bit of fancywork that the ladies—God bless 'em—will appreciate, to pass the time in the long winter evenings.[1]

But it is an enduring attitude, particularly in a country whose economy has never been robust since the Second World War—a situation that helps to explain why, in most cases, Exchequer grants to art compare unfavourably with similar public expenditure on the continent. Although public support of art in Great Britain has jumped enormously since 1945, even sympathetic Governments have been obliged to remember that enthusiasm for art in Great Britain is always tempered by practical considerations of the many urgent demands on the budget. With no national tradition of official patronage, Government subsidies to art have had to proceed with great deliberation, subject to intense public scrutiny.

The abiding fear of official art has provided yet a further reason for caution. Centuries of governmental indifference to the problems of art support and maintenance have nurtured a feeling that art must be financially independent of the state in order to be entirely free of official regulations and control. Making a virtue of necessity, many Englishmen have come to assume that total absence of state aid is the requisite safeguard of full artistic freedom of expression. The status of artists under totalitarian regimes further confirmed the belief, and as late as 1959, during a debate on arts funding, one M.P. warned the House of Commons against exposing Great Britain

> to the risk of control of the arts, which has been such a terrible feature of the first part of the twentieth century. We saw it horribly exemplified in Germany and Italy before the war, and we have seen it in Russia for thirty years past.[2]

Spokesmen for the arts in Great Britain today repeatedly insist that organizations like the British Council and the Arts Council are independent bodies rather than Government departments,

[1] *The Arts Under Socialism* (London: Turnstile Press, 1947), p. 6.
[2] Ronald Bell, the Member for South Buckinghamshire, *Parliamentary Debates* (Commons), 5th ser., 598 (23 January 1959): 567–8.

and that recipients of Arts Council funds are free from inter-
ference in the development of their artistic policy. Whether any
group receiving taxpayers' money can in fact be completely
independent from some measure of public involvement in its
affairs is a fiercely contested question, as much in the United
States as in Great Britain. But the fact that most Englishmen
consider such independence to be possible is perhaps more
important than the debate itself. Their conviction signifies a great
deal about the strength of habitual attitudes. Mary Glasgow, the
first secretary-general of the Arts Council, explained in 1951 that
'the absence of official control . . . is how we like to do things in
Great Britain',[1] and her explanation would still be valid today.

It is not surprising, therefore, that Great Britain has never
established a Ministry of Fine Arts, even after large public funds
began to be channelled into cultural activities. Although the
inauguration of a Government department responsible for cultural
affairs has been discussed from time to time, there is no widespread
enthusiasm for the idea. Nothing further has been done than to
install at the Department of Education and Science a Minister of
State in charge of artistic enterprises throughout the country. The
Labour Government of 1964, which transferred the Arts Council's
source of funds from the Treasury to the Department of Educa-
tion and Science, appointed Jennie Lee, a parliamentary veteran
and the widow of Aneurin Bevan, to the post which it created. In
addition to answering questions in the House, obtaining grants
for the arts, and supervising the affairs of public museums and
galleries, her role was to provide 'a degree of co-ordination in
cultural planning which [was] quite new to Great Britain'.[2] A
subordinate minister in the Department of Education and Science,
however, does not constitute a Ministry of Culture, and people
intimately involved in public subsidies for art in Great Britain
have continued to deny the need for such a ministry. 'I am still
hostile to the notion of a Ministry of Culture,' Lord Goodman,
chairman of the Arts Council, said in 1966:

> I don't think it fits the scene at all in this country . . . I think
> it would be difficult for a Minister not to impose his own
> cultural notions, this I think is absolutely fatal. What we at the

[1] 'State Aid for the Arts', *Britain To-day*, no. 182 (June 1951), p. 14.
[2] Green and Wilding, *Cultural Policy*, p. 13.

Arts Council have always tried to do is not to seek to lay down an artistic policy, but to seek to lay down a sensible and organized use of money. Dictation of an artistic policy would I think be an unavoidable consequence of a Minister of Culture and if not an unavoidable consequence a constant risk.[1]

Lord Goodman's remarks reflect a deeply rooted distrust of bureaucratic intervention in the world of the artist, a distrust that even now finds expression in a prejudice against specially trained arts administrators.[2] The trial and error methods that dominated official cultural policies for over a century have resulted in a kind of glorification of amateurism, or at best empiricism, that still influences British attitudes towards the Government's role in cultural planning. A wise repudiation of any centralized super-vision of artistic enterprise has unfortunately created an atmos-phere in which efforts at long-range and systematic planning, essential to the encouragement of art programmes dependent on public funds, are only beginning to gain acceptance.

The Arts Council, as a compromise between disorganized voluntary efforts and a central Ministry of Fine Arts, represents the product of decades of controversy in Great Britain. It is still seeking to work out many of the issues that have troubled social and cultural critics over the years. The allotment of funds among England, Scotland, and Wales leaves many Scots and Welshmen dissatisfied. London's share of Arts Council money incurs resent-ment and frequent protests from the provinces. The substantial portion of the council's budget granted each year to such cultural giants as the Royal Opera House, the National Theatre, and the Royal Shakespeare Company, critics claim, leaves insufficient subsidies for badly needed opera, concert, and repertory facilities outside the metropolis.

Nor are critics convinced that the Arts Council has achieved a satisfactory solution to one of its most urgent and difficult problems—the extent to which public funds should promote mass culture or solely encourage efforts of the highest artistic quality. Cyril Connolly had complained during the war that Britain was 'becoming a nation of culture-diffusionists. Culture-diffusion is

[1] Sean Day-Lewis, interview with Lord Goodman, in 'Money for the Muses', *Socialist Commentary* (May 1966), p. 20.

[2] Green and Wilding, *Cultural Policy*, p. 23.

not art.'[1] Recent studies have revealed, however, that the poor and immigrants are not participating in state-funded programmes as fully as authorities had hoped.[2] There is still a sociological barrier between mass amusement and highbrow cultural entertainment. The distinction may have been blurred during the war, but the Arts Council has not yet found ways to reduce it under peacetime conditions. With its abiding concern for the best standards of artistic performance, it has not proved sufficiently innovative in its approach to groups whose social and educational backgrounds have not prepared them to appreciate the finest products of Britain's cultural traditions.

The fact that the Arts Council today is criticized, often severely, is no sign that the council is in decline. The nearly unanimous approval that greeted the organization in 1945 was bound to fade as its novelty wore off, just as some of the intense public appreciation of art during the war diminished once alternative means of recreation again became readily available. But few people would waste time attacking a moribund institution. The Arts Council may move more slowly than it did in the 1940s, may be more encumbered with bureaucratic and administrative duties; nonetheless, it is very much alive and subsidizes an impressive variety of cultural enterprises. It is frequently cited in the United States, whose own governmental attitudes towards art are still being formulated, as an admirable example of a public funding agency for the arts. The dilemma that faced art enthusiasts at the turn of the century, when art seemed to be moving away from social responsibility and wide appeal, has found at least a partial solution. If few people today would echo the Romantics in their grandiose claims for art and artists, since the Second World War art has nevertheless achieved in Great Britain a respected place in community activities. During the war, art proved that, regardless of avant-garde fashions, it had a lasting function in society, as a means of drawing people together, of providing pleasure, recreation, and beauty, in rural villages as well as urban centres.

Early in the nineteenth century, the Napoleonic Wars had helped persuade Parliament to purchase the Elgin Marbles. The

[1] Quoted in Calder, *People's War*, p. 516.

[2] Green and Wilding, *Cultural Policy*, pp. 53, 61; and Peter H. Mann, *The Provincial Audience for Drama, Ballet and Opera; a Survey in Leeds: A Report to the Arts Council of Great Britain* (Sheffield: University of Sheffield, 1969), p. 2.

Second World War ensured not only that the Government would concern itself with cultural facilities in postwar Britain, but also that, in doing so, the old South Kensington mentality of rigid rules and utilitarian functions would no longer prevail. Although funding for the arts still suffers from chronic inadequacy, at least the narrow attitudes, which once limited Government involvement to purposes associated with education, public health, or social improvement, have been transformed. That art provides all manner of entertainment, enriching the leisure opportunities of millions, is widely considered sufficient reason for endorsing public subsidies to art. While the educative value of museums was immediately acknowledged, it took decades, and two world wars, for people to realize that less weighty considerations could justify state support of other cultural resources as well.

There is tangible evidence that living art and artists have at length taken their place beside canvases and marbles as worthy recipients of public money. A National Theatre complex, costing millions of pounds to complete, has opened on the South Bank in London. Great Britain and the United States have commemorated the American bicentennial by initiating a series of exchange fellowships in the creative and performing arts. Articles in the press today rarely debate whether the state should subsidize the arts, but rather how much should be allocated and how best to achieve an equitable distribution of available funds. The British Government's policy towards the arts was evolved within the context of traditional attitudes and biases, and has stayed firmly in step with public opinion. If such a mode of development can explain the weaknesses of that policy, it has also ensured public arts funding a broad basis of support.

In 1845, Sir Robert Peel gave the House of Commons a choice between museums and housing reform. Since 1945, successive Governments have tried to accommodate both cultural and social needs within their budgets. Fundamental changes of viewpoints have accompanied the tremendous changes in social patterns and economic policies which the twentieth century has witnessed. Activities once forbidden to the state now figure in its daily concerns, and the British Government has come to recognize that the services of the welfare state are incomplete without promotion of the arts. It is hoped that this conviction will help the arts survive the Government's recent resolve to attack Britain's

economic crisis through extensive reductions in public expenditure for social-welfare programmes. Decreases in state aid will seriously curtail ongoing cultural programmes and the activities of performing companies, whose existence is already jeopardized by the tremendous rate of inflation that has sent production costs soaring in the 1970s. Today, when the quality of life looms larger than ever as an elusive, and critical, problem facing the British Government, the arts must not be allowed to atrophy.

Bibliography

MANUSCRIPT SOURCES

Henry Cole, *Miscellanies* and *Cole Correspondence*, Victoria and Albert Museum, London.
Peel papers, British Museum, London.

OFFICIAL RECORDS AND DOCUMENTS

Parliamentary Debates, 1st–5th series.
Parliamentary Papers, 1805–1949.
Privy Council. *Report of the Committee on the British Film Institute.* London: HMSO, 1948.
Standing Commission on Museums and Galleries. *Second Report.* London: HMSO, 1938.
—. *The National Museums and Galleries: The War Years and After. Third Report of the Standing Commission on Museums and Galleries.* London: HMSO, 1948.

PRINTED SOURCES

I. *Books and Pamphlets*
Adamson, John William. *English Education 1789–1902.* Cambridge: The University Press, 1930.
Albert. *The Principal Speeches and Addresses of His Royal Highness The Prince Consort with an Introduction Giving Some Outlines of his Character.* London: John Murray, 1862.
Allen, Carleton Kemp. *Bureaucracy Triumphant.* London: Oxford University Press, 1931.
Ames, Winslow. *Prince Albert and Victorian Taste.* New York: Viking Press, 1968.
Appleman, Philip; Madden, William A.; and Wolff, Michael, eds. *1859: Entering an Age of Crisis.* Introduction by Howard Mumford Jones. Bloomington, Ind.: Indiana University Press, 1959.
Archer, William, and Granville-Barker, Harley. *A National Theatre, Scheme & Estimates.* London: Duckworth & Co., 1907.
Arnold, Matthew. *The Complete Prose Works of Matthew Arnold.* Edited by R. H. Super. Vol. 5: *Culture and Anarchy with Friendship's Garland and Some Literary Essays.* Ann Arbor, Mich.: University of Michigan Press, 1965.
—. *Essays, Letters, and Reviews by Matthew Arnold.* Edited by Fraser Neiman. Cambridge: Harvard University Press, 1960.

—. *Irish Essays and Others*. London: Smith, Elder, & Co., 1882.

—. *Matthew Arnold and the Education of the New Order. A Selection of Arnold's Writings on Education*. Introduction and Notes by Peter Smith and Geoffrey Summerfield. Cambridge: The University Press, 1969.

Arts Council of Great Britain. *Annual Reports*.

—. *The Charter of Incorporation Granted by His Majesty the King to the Arts Council of Great Britain, Ninth day of August 1946*. (Oxford: Oxford University Press, 1946).

—. *Plans for an Arts Centre*. London: Lund Humphries for the Arts Council, 1945.

Arts Enquiry. *The Visual Arts. A Report sponsored by the Dartington Hall Trustees*. London: Oxford University Press, 1946.

Ashbee, Charles Robert. *Should We Stop Teaching Art?* London: B. T. Batsford, (1911).

Ashcroft, Thomas. *English Art and English Society*. London: Peter Davies, 1936.

Ashley, Evelyn. *The Life of Henry John Temple, Viscount Palmerston: 1846–1865, with Selections from his Speeches and Correspondence*. 2 vols. London: Richard Bentley & Son, 1876–9.

Ashwell, Lena. *Modern Troubadours: A Record of the Concerts at the Front*. London: Gyldendal, 1922.

Atkins, Lily. *Arts and Leisure in the London Community: The History of the Standing Committee on the Arts of the London Council of Social Service*. Foreword by D. J. Hughes. London: London Council of Social Service, 1968.

Auchmuty, James Johnston. *Sir Thomas Wyse 1791–1862: The Life and Career of an Educator and Diplomat*. London: P. S. King & Son, Ltd., 1939.

Balcon, Michael, and others. *Twenty Years of British Film, 1925–1945*. London: Falcon Press, 1947.

Barnard, Howard Clive. *A History of English Education, from 1760*. 2nd ed. rev. London: University of London Press, 1961.

Barnes, Kenneth R. *Welcome, Good Friends. The Autobiography of Kenneth R. Barnes*. Edited by Phyllis Hartnoll. London: Peter Davies, 1958.

Baumol, William J., and Bowen, William G. *Performing Arts—The Economic Dilemma: A Study of Problems common to Theater, Opera, Music and Dance*. New York: The Twentieth Century Fund, 1966.

Beachcroft, Thomas Owen. *British Broadcasting*. London and New York: Longmans Green & Co., for the British Council, (1946).

Beaumont, Cyril W. *The Vic-Wells Ballet*. London: C. W. Beaumont, 1935.

Beecham, Thomas. *A Mingled Chime, an Autobiography*. New York: G. P. Putnam's Sons, (1943).

Bell, Clive. *On British Freedom*. London: Chatto & Windus, 1923.

Bell, Quentin. *The Schools of Design*. London: Routledge & Kegan Paul, 1963.

Benn, Ernest J. P. *Modern Government 'as a busybody in other men's matters'*. London: George Allen & Unwin Ltd., 1936.

Bentham, Jeremy. *The Works of Jeremy Bentham*. Edited by John Bowring. Vol. 2: *Principles of Judicial Procedure with the Outlines of a Procedure Code* and *The Rationale of Reward*. Edinburgh: William Tait, 1843.

Bevan, Aneurin. *In Place of Fear*. New York: Simon & Schuster, 1952.

Birchenough, Charles. *History of Elementary Education in England and Wales from 1800 to the Present Day.* London: University Tutorial Press, 1938.

Blatchford, Robert. *Merrie England.* Classics of Radical Thought Series. New York: Monthly Review Press, 1966.

Blomfield, Reginald Theodore. *Modernismus.* London: Macmillan & Co. Ltd., 1934.

Blunt, Anthony, and Whinney, Margaret, eds. *The Nation's Pictures: A Guide to the Chief National and Municipal Galleries of England, Scotland and Wales.* London: Chatto & Windus, 1950.

Boult, Adrian Cedric. *My Own Trumpet.* London: Hamish Hamilton, 1973.

Briggs, Asa. *The History of Broadcasting in the United Kingdom.* Vol. 1: *The Birth of Broadcasting.* Vol. 2: *The Golden Age of Wireless.* Vol. 3: *The War of Words.* London: Oxford University Press, 1961–70.

—. *Victorian People. A Reassessment of Persons and Themes 1851–67.* Rev. ed. Chicago: Chicago University Press, 1970.

British Information Services. *Entertainment and the Arts in Great Britain. The Story of Government Encouragement.* New York: British Information Services, 1950.

—. *Entertainment and the Arts in Wartime Britain.* New York: British Information Services, 1944.

Brown, Frank P. *South Kensington and its Art Training.* Foreword by Walter Crane. London: Longmans, Green & Co., 1912.

Buchanan, Robert. *The Fleshly School of Poetry and Other Phenomena of the Day.* London: Strahan & Co., 1872.

Buckley, Jerome Hamilton. *The Victorian Temper: A Study in Literary Culture.* Cambridge: Harvard University Press, 1951; New York: Random House, Vintage Books, 1964.

Bulwer-Lytton, Edward Lytton. *England and the English.* 2 vols. 2nd ed. London: Richard Bentley, 1833.

Burke, Edmund. *Reflections on the Revolution in France.* Edited by Thomas H. D. Mahoney. New York: Liberal Arts Press, 1955.

Burn, W. L. *The Age of Equipoise. A Study of the Mid-Victorian Generation.* London: George Allen & Unwin Ltd., 1964; New York: W. W. Norton & Co. Inc., The Norton Library, 1965.

Calder, Angus. *The People's War: Britain 1939–1945.* New York: Pantheon Books, 1969.

Carey, William. *Some Memoirs of the Patronage and Progress of the Fine Arts, in England and Ireland, during the Reigns of George the Second, George the Third, and His Present Majesty; with Anecdotes of Lord de Tabley, of Other Patrons, and of Eminent Artists, and Occasional Critical References to British Works of Art.* London: Saunders & Otley, 1826.

Carless, Richard, and Brewster, Patricia. *Patronage and the Arts.* London: Conservative Political Centre for the Bow Group, 1959.

Carlyle, Thomas. *The Centenary Edition of Carlyle's Works.* Edited by Henry Duff Traill. 30 vols. New York: Charles Scribner's Sons, 1896–1901. Vol. 10: *Past and Present.* Vol. 20: *Latter-Day Pamphlets.*

—. *Chartism.* London: James Fraser, 1840.

Causton, Bernard, and Young, G. Gordon. *Keeping It Dark or The Censor's Handbook.* Foreword by Rebecca West. London: Mandrake Press, Ltd., (1930).

Cecil, David. *Lord M. or the Later Life of Lord Melbourne.* London: Constable, 1954.

Cecil, Hugh. *Liberty and Authority.* London: Edward Arnold, 1910.

Chamberlain, Joseph, and others. *The Radical Programme with 'The Future of the Radical Party' by T. H. S. Escott.* Edited by D. A. Hamer. Brighton: Harvester Press, 1971.

Churchill, Winston Spencer. *Liberalism and the Social Problem.* Introduction by H. W. Massingham. London: Hodder & Stoughton, 1909.

Clark, G. Kitson. *The Making of Victorian England.* Cambridge: Harvard University Press, 1962; New York: Atheneum, 1971.

Clark, Kenneth. *Another Part of the Wood: A Self-Portrait.* New York: Harper & Row, 1974.

—. *The Gothic Revival. An Essay in the History of Taste.* London: Constable, 1928.

Clarke, Mary. *The Sadler's Wells Ballet: A History and an Appreciation.* London: Adam & Charles Black, 1955.

Coase, Ronald Harry. *British Broadcasting: A Study in Monopoly.* Cambridge: Harvard University Press, 1950.

Cole, Henry. *Fifty Years of Public Work of Sir Henry Cole, K.C.B. Accounted for in his Deeds, Speeches and Writings.* 2 vols. London: George Bell & Sons, 1884.

Coleridge, Samuel Taylor. *The Complete Works of Samuel Taylor Coleridge.* Edited by W. G. T. Shedd. Vol. 6: *On the Constitution of the Church and State, According to the Idea of Each; A Lay Sermon, Addressed to the Higher and Middle Classes, on the Existing Distresses and Discontents*; and *Specimens of the Table Talk of the Late Samuel Taylor Coleridge.* New York: Harper & Bros., 1853.

Colles, Henry Cope. *The Royal College of Music, A Jubilee Record 1883–1933.* London: Macmillan & Co., Ltd., 1933.

Colles, William Morris. *Literature and the Pension List. An Investigation Conducted for the Committee of the Incorporated Society of Authors.* London: Henry Glaisher, 1889.

Collins, Arthur Simons. *The Profession of Letters: A Study of the Relation of Author to Patron, Publisher, and Public, 1780–1832.* London: G. Routledge & Sons, Ltd., 1928.

Council for the Encouragement of Music and the Arts. *Annual Reports.*

Craig, Alec. *The Banned Books of England.* Foreword by E. M. Forster. London: George Allen & Unwin Ltd., 1937.

Crane, Peggy. *Enterprise in Local Government: A Study of the Way in which Local Authorities exercise their Permissive Powers.* Fabian Research Series, no. 156. London: Fabian Society, 1953.

Cruse, Amy. *The Victorians and Their Reading.* Boston and New York: Houghton Mifflin Co., 1935.

Dallas, Eneas Sweetland. *The Gay Science.* 2 vols. London: Chapman & Hall, 1866.

Davies, D. W. *Public Libraries as Culture and Social Centers: The Origin of the Concept.* Metuchen, N.J.: Scarecrow Press, 1974.

Davis, Frank. *Victorian Patrons of the Arts: Twelve Famous Collections and their Owners.* London: Country Life Ltd., 1963.

Dean, Basil. *The Theatre at War.* London: George G. Harrap & Co. Ltd., 1956.

—. *The Theatre in Reconstruction.* (Tonbridge, Kent: Tonbridge Printers Ltd., 1945.)

De Montmorency, J. E. G. *State Intervention in English Education; a Short History from the Earliest Times down to 1833.* Cambridge: The University Press, 1902.

Dent, Edward J. *A Theatre for Everybody: The Story of the Old Vic and Sadler's Wells.* London and New York: T. V. Boardman & Co. Ltd., 1945.

Dorian, Frederick. *Commitment to Culture: Art Patronage in Europe, Its Significance for America.* Pittsburgh, Pa.: University of Pittsburgh Press, 1964.

Dyce, William. *The National Gallery. Its Formation and Management considered in a Letter Addressed, by Permission, to H.R.H. The Prince Albert, K.G., &c., &c.* London: Chapman & Hall, 1853.

Eastlake, Charles Lock. *Contributions to the Literature of the Fine Arts, with a Memoir compiled by Lady Eastlake.* London: John Murray, 1870.

Eastlake, Elizabeth. *Journals and Correspondence of Lady Eastlake.* Edited by Charles Eastlake Smith. 2 vols. London: John Murray, 1895.

Edwards, Edward. *The Administrative Economy of the Fine Arts in England.* London: Saunders & Otley, 1840.

—. *A Letter to Sir Martin Archer Shee, F.R.S., President of the Royal Academy of Arts, &c., &c., &c., on the Reform of the Royal Academy.* London: By the Author, 1839.

—. *Lives of the Founders of the British Museum; with notices of its chief augmentors and other benefactors, 1570–1870.* 2 vols. London: Trubner & Co., 1870.

Eliot, T. S. *Notes towards the Definition of Culture.* London: Faber & Faber, 1948.

Evans, Benjamin Ifor. *Prospects for a Ministry of Fine Arts.* London: British Broadcasting Corporation, 1959.

Evans, Benjamin Ifor, and Glasgow, Mary. *The Arts in England.* London: Falcon Press, 1949.

Fedden, Robin, and Joekes, Rosemary, comps. *The National Trust Guide.* London: Jonathan Cape, 1973.

ffrench, Yvonne. *The Great Exhibition: 1851.* London: Harvill Press, 1950.

Fitzmaurice, Edmond. *The Life of Granville George Leveson Gower, Second Earl Granville, K.G. 1815–1891.* 2 vols. London: Longmans, Green, & Co., 1906.

Foggo, George. *Results of the Parliamentary Inquiry Relative to Arts and Manufactures.* London: T. & W. Boone, 1837.

Foss, Hubert, and Goodwin, Noel. *London Symphony, Portrait of an Orchestra, 1904–1954.* Preface by Ralph Vaughan Williams. London: Naldrett Press, 1954.

Foss, Michael. *The Age of Patronage: The Arts in Society 1660–1750.* London: Hamish Hamilton, 1971.

Fowell, Frank, and Palmer, Frank. *Censorship in England.* London: Frank Palmer, 1913.

G. M. G. *The Stage Censor. An Historical Sketch: 1544–1907.* London: Sampson Low, Marston & Co. Ltd., 1908.

Garnett, Edward. *A Censured Play, The Breaking Point, with Preface and a Letter to the Censor.* London: Duckworth & Co., 1907.

George, Eric. *The Life and Death of Benjamin Robert Haydon 1786–1846.* London: Geoffrey Cumberlege, Oxford University Press, 1948.

Gibbs-Smith, C. H., comp. *The Great Exhibition of 1851: A Commemorative Album.* London: Victoria and Albert Museum, HMSO, 1950.

Gilbert, Bentley B. *British Social Policy 1914–1939.* Ithaca, N.Y.: Cornell University Press, 1970.

—. *The Evolution of National Insurance in Great Britain: The Origins of the Welfare State.* London: Michael Joseph, 1966.

Gladstone, William Ewart. *The State in its Relations with the Church.* 4th ed. 2 vols. London: John Murray, 1841.

Gould, Cecil. *Failure and Success: 150 Years of the National Gallery 1824–1974.* London: The National Gallery, 1974.

Granville-Barker, Harley. *The Exemplary Theatre.* London: Chatto & Windus, 1922.

—. *A National Theatre.* London: Sidgwick & Jackson, Ltd., 1930.

Graves, Robert, and Hodge, Alan. *The Long Week-End: A Social History of Great Britain 1918–1939.* New York: W. W. Norton & Co. Inc., The Norton Library, 1963.

Greaves, Margaret. *Regency Patron: Sir George Beaumont.* London: Methuen & Co. Ltd., 1966.

Green, Michael, and Wilding, Michael. *Cultural Policy in Great Britain.* Studies and Documents on Cultural Policies, no. 7. Paris: UNESCO, 1970.

Green, T. H. *The Political Theory of T. H. Green. Selected Writings.* Edited by John R. Rodman. New York: Appleton-Century-Crofts, 1964.

Gross, John. *The Rise and Fall of the Man of Letters: A Study of the Idiosyncratic and the Humane in Modern Literature.* London: Weidenfeld & Nicolson, 1969; New York: Collier Books, 1970.

Guest, Ivor. *The Romantic Ballet in England, its Development, Fulfilment and Decline.* London: Phoenix House Ltd., 1954.

Halévy, Elie. *England in 1815.* Translated by E. I. Watkin and D. A. Barker. Introduction by R. B. McCallum. London: Ernest Benn, Ltd., 1949; New York: Barnes & Noble, Inc., 1968.

Hall, Samuel Carter. *Retrospect of a Long Life: From 1815 to 1883.* New York: D. Appleton & Co., 1883.

Hamerton, Philip Gilbert. *Thoughts About Art.* Rev. ed. Boston: Roberts Bros., 1871.

Hamilton, Cicely, and Baylis, Lilian. *The Old Vic.* London: Jonathan Cape, 1926.

Hamilton, Walter. *The Aesthetic Movement in England.* 3rd ed. London: Reeves & Turner, 1882.

Harris, John S. *Government Patronage of the Arts in Great Britain.* Chicago: University of Chicago Press, 1970.

Harris, Seymour E. *John Maynard Keynes, Economist and Policy Maker.* New York: Charles Scribner's Sons, 1955.

Harrison, Frederic. *The Choice of Books and Other Literary Pieces.* London: Macmillan & Co. Ltd., 1925.

Harrod, Roy F. *The Life of John Maynard Keynes.* Reprints of Economic Classics. New York: Augustus M. Kelley, Publishers, 1969.

Haskell, Arnold L. *The National Ballet; a History and a Manifesto. With an Overture by Ninette de Valois.* London: A. & C. Black, 1943.

Haydon, Benjamin Robert. *The Autobiography and Memoirs of Benjamin Robert Haydon.* Edited by Tom Taylor. Introduction by Aldous Huxley. 2 vols. New York: Harcourt, Brace & Co., 1926.

—. *Correspondence and Table-Talk, with a memoir by his son, Frederic Wordsworth Haydon.* 2 vols. Boston: Estes & Lauriat, 1877.

—. *Lectures on Painting and Design.* London: Longman, Brown, Green, and Longmans, 1844–6.

Hazlitt, William. *Hazlitt on Theatre.* Edited by William Archer and Robert Lowe. Introduction by William Archer. New York: Hill & Wang, (1957).

Hendy, Philip. *The National Gallery, London.* 4th ed., rev. London: Thames & Hudson, 1971.

Hepburn, James G. *The Author's Empty Purse and the Rise of the Literary Agent.* London: Oxford University Press, 1968.

Hewart, Gordon, Baron Hewart of Bury. *The New Despotism.* London: Ernest Benn, Ltd., 1945.

Himmelfarb, Gertrude. *Victorian Minds.* New York: Harper & Row, Harper Torchbooks, 1970.

Hoare, Prince. *Epochs of the Arts: Including Hints on the Use and Progress of Painting and Sculpture in Great Britain.* London: John Murray, 1813.

Hobhouse, Christopher. *1851 and the Crystal Palace.* New York: E. P. Dutton & Co. Inc., 1937.

Hobsbawm, E. J. *The Age of Revolution 1789–1848.* New York: The New American Library Inc., Mentor Books, 1962.

Hobson, J. A. *The Crisis of Liberalism: New Issues of Democracy.* London: P. S. King & Son, 1909.

Holmes, Charles J. *Self & Partners (Mostly Self) Being the Reminiscences of C. J. Holmes.* New York: Macmillan Co., 1936.

—, and Collins Baker, C. H. *The Making of the National Gallery 1824–1924. An Historical Sketch.* London: The National Gallery, 1924.

Horsfall, Thomas C. *The Study of Beauty and Art in Large Towns. Two Papers.* Introduction by John Ruskin. London: Macmillan & Co., 1883.

Houghton, Walter E. *The Victorian Frame of Mind 1830–1870.* New Haven: Yale University Press, 1971.

Hudson, Derek, and Luckhurst, Kenneth W. *The Royal Society of Arts, 1754–1954.* Foreword by H.R.H. the Duke of Edinburgh and Introduction by the Earl of Radnor. London: John Murray, 1954.

Hutchison, Sidney C. *The History of the Royal Academy, 1768–1968.* New York: Taplinger, (1968).

Hynes, Samuel. *The Edwardian Turn of Mind.* Princeton: Princeton University Press, 1968.

Jackson, Holbrook. *The Eighteen Nineties: A Review of Art and Ideas at the Close of the Nineteenth Century.* Introduction by Karl Beckson. New York: G. P. Putnam's Sons, Capricorn Books, 1966.

Jay, Douglas. *Labour's Plan for 1947.* Labour Discussion Series, no. 13. London: Labour Party, (1947).

Jenkins, Frank. *Architect and Patron: A Survey of Professional Relations and Practice in England from the Sixteenth Century to the Present Day.* London: Oxford University Press, 1961.

Jones, Henry Arthur. *The Foundations of a National Drama. A Collection of Lectures, Essays and Speeches, Delivered and Written in the Years 1896–1912 (Revised and Corrected, with Additions).* Essay Index Reprint Series. Freeport, N.Y.: Books for Libraries Press, Inc., 1967.

Joynson-Hicks, William, Viscount Brentford. *Do We Need a Censor?* London: Faber & Faber, 1929.

Kelly, Thomas. *A History of Public Libraries in Great Britain 1845–1965.* London: The Library Association, 1973.

Kenyon, Frederic George. *Museums and National Life.* Oxford: The Clarendon Press, 1927.

Klingender, F. D. *Art and the Industrial Revolution.* Edited and revised by Arthur Elton. London: Evelyn, Adams & Mackay, 1968.

Klingender, F. D., and Legg, Stuart. *Money Behind the Screen. A Report prepared on behalf of the Film Council.* Preface by John Grierson. London: Lawrence & Wishart, 1937.

Labour Party. *The Future of Local Government: The Labour Party's Post-War Policy.* London: Labour Party, (1942?).

—. *Labour and the Nation.* Rev. ed. London: Labour Party, (1928).

—. *Labour and the New Social Order. A Report on Reconstruction.* London: Labour Party, 1918.

—. *Local Government Reform.* Labour Discussion Series, no. 4. London: Labour Party, (1946).

—. *Reconstruction in War and Peace: Interim Report of the National Executive Committee of the British Labor (sic) Party, approved by the Party Conference under the title 'The Old World and the New Society'.* New York: League for Industrial Democracy, 1943.

—. *What Socialism Will Really Mean to You.* London: Labour Party, 1935.

Ladd, Henry. *The Victorian Morality of Art: An Analysis of Ruskin's Esthetic.* New York: Ray Long & Richard R. Smith, Inc., 1932.

Lamb, Walter R. M. *The Royal Academy; a Short History of its Foundation and Development.* Rev. ed. London: G. Bell, 1951.

Lambert, Richard Stanton, ed. *Art in England.* Harmondsworth: Penguin Books, Ltd., (1938).

Landstone, Charles. *Off-Stage. A Personal Record of the First Twelve Years of State Sponsored Drama in Great Britain.* London: Elek Books, Ltd., 1953.

Lang, Andrew. *Life, Letters, and Diaries of Sir Stafford Northcote, First Earl of Iddesleigh.* 2 vols. Edinburgh and London: William Blackwood & Sons, 1890.

Leeper, Janet. *English Ballet.* London and New York: Penguin Books, Ltd., 1944.

Lees-Milne, James. *Earls of Creation: Five Great Patrons of Eighteenth-Century Art.* London: Hamish Hamilton, 1962.

Le Marchant, Denis. *Memoir of John Charles Viscount Althorp, Third Earl Spencer.* London: Richard Bentley & Sons, 1876.

Leslie, George Dunlop. *The Inner Life of the Royal Academy, with an Account of its Schools and Exhibitions, principally in the reign of Queen Victoria.* London: John Murray, 1914.

Levine, Arnold S. 'The Politics of Taste: The Science and Art Department of Great Britain, 1852–1873.' Ph.D. dissertation, University of Wisconsin, 1972. Ann Arbor, Mich.: University Microfilms, 1972.

Lippincott, Benjamin Evans. *Victorian Critics of Democracy.* Minneapolis, Minn.: University of Minnesota Press, 1938; reprint ed., New York: Octagon Books, 1964.

Lysons, Daniel. *History of the origin and progress of the Meeting of the Three Choirs of Gloucester, Worcester, and Hereford, and of the charity connected with it.* Gloucester: D. Walker, 1812.

Macaulay, Thomas Babington. *The Complete Works of Lord Macaulay.* Albany Edition. Vol. 12: *Speeches, Poems and Miscellaneous Writings.* London: Longmans, Green and Co., 1898.

MacCoby, Simon, ed. *The English Radical Tradition 1763–1914.* London: Nicholas Kaye, 1952.

Macdonald, Stuart. *The History and Philosophy of Art Education.* London: University of London Press, 1970.

Manchester, Phyllis W. *Vic-Wells: A Ballet Progress.* London: Victor Gollancz, Ltd., 1942.

Mann, Peter H. *The Provincial Audience for Drama, Ballet and Opera; a Survey in Leeds: A Report to the Arts Council of Great Britain.* Sheffield: University of Sheffield, 1969.

Markham, Sydney Frank. *A Report on the Museums and Art Galleries of the British Isles (other than the National Museums) to the Carnegie United Kingdom Trust.* Dunfermline: Carnegie United Kingdom Trust, 1938.

Martin, Theodore. *The Life of His Royal Highness the Prince Consort.* 5 vols. London: Smith, Elder, & Co., 1875–80.

Masterman, C. F. G. *The Condition of England.* London: Methuen & Co., 1909.

Miers, Henry. *A Report on the Public Museums of the British Isles (other than the National Museums) to the Carnegie United Kingdom Trustees.* Edinburgh: Carnegie United Kingdom Trust, 1928.

Mill, John Stuart. *Autobiography of John Stuart Mill.* New York: Henry Holt, 1873.

—. *Essays on Politics and Culture.* Edited by Gertrude Himmelfarb. Garden City, N.Y.: Doubleday & Co., Inc., 1962.

—. *Inaugural Address Delivered to the University of St. Andrews.* London: Longmans, Green, Reader, & Dyer, 1867.

—. *Utilitarianism, Liberty, and Representative Government.* Everyman's Library. London: J. M. Dent & Sons, Ltd., 1951.

Miller, Edward. *That Noble Cabinet: A History of the British Museum.* London: Andre Deutsch, 1973.

Millingen, James. *Some Remarks on the State of Learning and the Fine-Arts in*

Great Britain, on the Deficiency of Public Institutions, and the Necessity of a Better System for the Improvement of Knowledge and Taste. London: J. Rodwell, 1831.

Moore, George. *Modern Painting.* London: Walter Scott, Ltd., 1893.

Morris, William. *The Collected Works of William Morris.* Introduction by May Morris. Vol. 22: *Hopes and Fears for Art* and *Lectures on Art and Industry.* Vol. 23: *Signs of Change* and *Lectures on Socialism.* New York: Russell & Russell, 1966.

Munford, W. A. *William Ewart, M.P. 1798–1869: Portrait of a Radical.* London: Grafton & Co., 1960.

National Art-Collections Fund. *Art Treasures for the Nation, Fifty Years of the National Art-Collections Fund.* Introduction by the Earl of Crawford and Balcarres. London: Thames & Hudson, 1953.

—. *Twenty-Five Years of the National Art-Collections Fund, 1903–1928.* Introduction by Sir Robert Witt. Glasgow: The Fund, 1928.

National Association for the Advancement of Art and its Application to Industry. *Transactions.* London: The Association, 1890 and 1891.

Neatby, Kate. *Ninette de Valois and the Vic-Wells Ballet.* Edited by Edwin Evans. Preface by Lilian Baylis. The Artists of the Dance Series, no. 11. 2nd ed. London: British-Continental Press, 1936.

Nicholson, Watson. *The Struggle for a Free Stage in London.* New York: Benjamin Blom, 1966.

Nicoll, Allardyce. *A History of English Drama 1660–1900.* Vol. 5: *Late Nineteenth Century Drama 1850–1900.* 2nd ed. Cambridge: Cambridge University Press, 1959.

Nicolson, Benedict. *The Treasures of the Foundling Hospital, with a catalogue raisonné based on a draft catalogue by John Kerslake.* Studies in the History of Art and Architecture Series. Oxford: Clarendon Press, 1972.

Nicolson, Benedict, and Sitwell, Francis, eds. *Saved for the Nation: The Achievement of the National Art-Collections Fund 1903–1973.* Catalogue of the Exhibition at the Victoria and Albert Museum 4 October–18 November 1973. London: Victoria and Albert Museum, 1973.

Pater, Walter, *The Renaissance.* Introduction by Kenneth Clark. Cleveland and New York: World Publishing Co., Meridian Books, 1961.

Paulu, Burton. *British Broadcasting: Radio and Television in the United Kingdom.* Minneapolis, Minn.: University of Minnesota Press, 1956.

Peters, Robert L., ed. *Victorians on Literature and Art.* New York: Appleton-Century-Crofts, Inc., 1961.

Pevsner, Nikolaus. *Academies of Art, Past and Present.* Cambridge: The University Press, 1940.

—. *High Victorian Design. A Study of the Exhibits of 1851.* London: Architectural Press, 1951.

Political and Economic Planning. *The British Film Industry. A Report on its History and Present Organisation, with Special Reference to the Economic Problems of British Feature Film Production.* London: P.E.P., 1952.

Potter, Edmund. *Pamphlets Published at Various Periods from 1831 to 1855.* Manchester: Johnson & Rawson, 1855.

Pound, Reginald. *Albert, A Biography of the Prince Consort.* London: Michael Joseph, 1973.

Priestley, J. B. *The Arts Under Socialism*. London: Turnstile Press, 1947.

Pugin, Augustus Welby Northmore. *An Apology for the Revival of Christian Architecture*. London: John Weale, 1843; reprint ed., Oxford: St. Barnabas Press, 1969.

—. *Contrasts: or, A parallel between the noble edifices of the middle ages, and corresponding buildings of the present day, shewing the present decay of taste*. 2nd ed. London: Charles Dolman, 1841.

—. *The True Principles of Pointed or Christian Architecture*. London: Henry G. Bohn, 1853; reprint ed., Oxford: St. Barnabas Press, 1969.

Pye, John. *Patronage of British Art, an Historical Sketch: comprising an account of the rise and progress of art and artists in London, from the beginning of the reign of George the Second*. London: Longman, Brown, Green, & Longmans, 1845.

Quinlan, Maurice James. *Victorian Prelude: A History of English Manners 1700–1830*. New York: Columbia University Press, 1941.

Reith, John Charles Walsham. *Broadcast Over Britain*. London: Hodder & Stoughton, 1924.

—. *Into the Wind*. London: Hodder & Stoughton, 1949.

—. *The Reith Diaries*. Edited by Charles Stuart. London: Collins, 1975.

Reitlinger, Gerald. *The Economics of Taste*. Vol. 1: *The Rise and Fall of Picture Prices 1760–1960*. London: Barrie & Rockliff, 1961.

Richards, Charles Russell. *Industrial Art and the Museum*. New York: Macmillan Co., 1927.

Ritchie, David G. *The Principles of State Interference: Four Essays on the Political Philosophy of Mr. Herbert Spencer, J. S. Mill, and T. H. Green*. London: Swan Sonnenschein & Co., 1891.

Roberts, David. *Victorian Origins of the British Welfare State*. Yale Historical Publications. New Haven: Yale University Press, 1960.

Robson, William A. *The Development of Local Government*. 3rd rev. ed. London: George Allen & Unwin, Ltd., 1954.

Rogers, W. G. *Ladies Bountiful*. London: Victor Gollancz, Ltd., 1968.

Rosenblum, Robert. *Transformations in Late Eighteenth Century Art*. Princeton University Press, 1967.

Rosenthal, Harold. *Opera at Covent Garden: A Short History*. London: Victor Gollancz, Ltd., 1967.

—, ed. *The Royal Opera House, Covent Garden, 1858–1958*. London: Royal Opera House, 1959?

Rothenstein, John. *Brave Day Hideous Night, Autobiography 1939–1965*. New York: Holt, Rinehart & Winston, 1967.

—, and Chamot, Mary. *The Tate Gallery, A Brief History and Guide*. London: Tate Gallery, 1951.

Ruck, S. K. *Municipal Entertainment and the Arts in Greater London*. Foreword by W. A. Robson. London: George Allen & Unwin, Ltd., 1965.

Ruskin, John. *The Works of John Ruskin*. Edited by E. T. Cook and Alexander Wedderburn. Vol. 16: '*A Joy for Ever*' (*and its Price in the Market*) and *The Two Paths*. Vol. 17: '*Unto this Last*': *Four Essays on the First Principles of Political Economy, Munera Pulveris*, and *Time and Tide*. Vol. 18: *Sesame and Lilies* and *The Crown of Wild Olive*. Vols. 27–9: *Fors Clavigera, Letters to the Workmen and Labourers of Great Britain*. London: George Allen, 1905, 1907.

—. *Lectures on Art, Delivered Before the University of Oxford in Hilary Term, 1870.* Oxford: Clarendon Press, 1870.

Russell, John. *The Later Correspondence of Lord John Russell 1840–1878.* Edited by G. P. Gooch. 2 vols. London: Longmans, Green & Co., 1925.

Russell, John. *From Sickert to 1948: The Achievement of the Contemporary Art Society.* London: Lund Humphries, 1948.

Samuel, Herbert. *Liberalism, an Attempt to State the Principles and Proposals of Contemporary Liberalism in England.* Introduction by H. H. Asquith. London: Grant Richards, 1902.

Sandby, William. *The History of the Royal Academy of Arts: from its foundation in 1768 to the present time, with biographical notices of all the members.* London: Longman, Green, 1862.

Saunders, John Whiteside. *The Profession of English Letters.* London: Routledge & Kegan Paul, (1964).

Scholes, Percy A. *The Mirror of Music 1844–1944: A Century of Musical Life in Britain as Reflected in the Pages of the Musical Times.* 2 vols. London: Novello & Co. Ltd. and Oxford University Press, 1947.

—. *'Musical Appreciation' in Schools: Why—And How?* Introduction by Hugh P. Allen. 6th ed. London: Geoffrey Cumberlege, Oxford University Press, 1953.

Scott, William. *Autobiographical Notes of the Life of William Bell Scott.* Edited by W. Minto. 2 vols. New York: Harper & Bros., 1892.

Shairp, J. C. *Culture and Religion in Some of their Relations.* New York: Hurd & Houghton, 1871.

Shaw, George Bernard. *Essays in Fabian Socialism.* London: Constable, 1932.

—. *Selected Non-Dramatic Writings of Bernard Shaw.* Edited by Dan H. Laurence. Boston: Houghton Mifflin Co., 1965.

—. *Selected Plays of Bernard Shaw.* 4 vols. New York: Dodd, Mead & Co., 1948–57.

Shawe-Taylor, Desmond. *Covent Garden.* London: Max Parrish & Co. Ltd., 1948.

Shee, Martin Archer. *Elements of Art, A Poem; in Six Cantos; with Notes and a Preface; Including Strictures on the State of the Arts, Criticism, Patronage, and Public Taste.* London: William Miller, 1809.

—. *Rhymes on Art; or, The Remonstrance of a Painter: in Two Parts. With Notes, and a Preface, including Strictures on the State of the Arts, Criticism, Patronage, and Public Taste.* 3rd ed. London: William Miller, 1809.

Shelley, Percy Bysshe. *Political Writings Including 'A Defence of Poetry.'* Edited by Roland A. Duerksen. New York: Appleton-Century-Crofts, 1970.

Southey, Robert. *Sir Thomas More: or, Colloquies on the Progress and Prospects of Society.* 2 vols. London: John Murray, 1829.

Spencer, Herbert. *Education: Intellectual, Moral, and Physical.* New York: D. Appleton & Co., 1896.

—. *The Man versus the State.* Introduction by Albert Jay Nock. Caldwell, Idaho: Caxton Printers, Ltd., 1960.

Steegman, John. *Victorian Taste: A Study of the Arts and Architecture from 1830 to 1870.* Foreword by Nikolaus Pevsner. London: Thomas Nelson & Sons Ltd., 1970.

Stephen, James Fitzjames. *Liberty, Equality, Fraternity*. Edited by R. J. White. Cambridge Studies in the History and Theory of Politics. Cambridge: The University Press, 1967.

Strange, Robert. *An Inquiry into the Establishment of the Royal Academy of Arts. To which is prefixed a letter to the Earl of Bute*. Edited by William Coningham. London: J. Ollivier, 1850.

Swinburne, Algernon Charles. *Notes on Poems and Reviews*. London: John Camden Hotten, 1866.

Symons, Julian. *The Thirties: A Dream Revolved*. London: Cresset Press, 1960.

Tawney, R. H. *The Acquisitive Society*. New York: Harcourt, Brace & Co., (1928).

—. *Equality*. London: George Allen & Unwin, 1931.

Taylor, William Benjamin Sarsfield. *The Origin, Progress, and Present Condition of the Fine Arts in Great Britain and Ireland*. 2 vols. London: Whittaker & Co., 1841.

Thackeray, William Makepeace. *Critical Papers in Art*. London: Macmillan & Co. Ltd., 1904.

Thorndike, Sybil and Russell. *Lilian Baylis*. London: Chapman & Hall, 1938.

Torrens, William M. *Memoirs of the Right Honourable William, Second Viscount Melbourne*. 2 vols. London: Macmillan & Co., 1878.

Vachon, Marius. *Rapport sur les Musées et les Ecoles d'Art Industriel en Angleterre*. Paris: Ministère de l'Instruction Publique et des Beaux-Arts, Imprimerie Nationale, 1890.

Valois, Ninette de. *Invitation to the Ballet*. London: John Lane, 1937.

Waagen, Gustav Friedrich. *Works of Art and Artists in England*. Translated by Hannibal Evans Lloyd. 3 vols. London: John Murray, 1838; reprint ed., London: Cornmarket Press, 1970.

Walker, Ernest. *A History of Music in England*. 3rd ed. Oxford: Clarendon Press, 1952.

Wallas, Graham. *The Great Society, A Psychological Analysis*. New York: Macmillan Co., 1920.

Whistler, James Abbot McNeill. *Mr. Whistler's 'Ten O'Clock'*. Boston and New York: Houghton Mifflin & Co., 1888.

White, Eric W. *The Arts Council of Great Britain*. London: Davis-Poynter, 1975.

Whitley, William T. *Artists and their Friends in England 1700–1799*. London and Boston: The Medici Society, (1928).

Whitworth, Geoffrey. *The Making of a National Theatre*. London: Faber & Faber, 1951.

—. *The Theatre of My Heart*. New ed. London: Victor Gollancz Ltd., 1938.

Wilde, Oscar. *The Soul of Man Under Socialism and Other Essays*. Introduction by Philip Rieff. New York: Harper & Row, Harper Colophon Books, 1970.

Wilkinson, J. Gardner. *On Colour and on the Necessity for a General Diffusion of Taste among all Classes*. London: John Murray, 1858.

Williams, E. Harcourt. *Four Years at the Old Vic, 1929–1933*. London: Putnam, (1935).

—. *Old Vic Saga*. London: Winchester Publications, (1949).

Williams, Raymond. *Culture and Society 1780–1950.* New York: Columbia University Press, 1958.

—. *The Long Revolution.* London: Chatto & Windus, 1961.

Willey, Basil. *Nineteenth Century Studies: Coleridge to Matthew Arnold.* New York: Columbia University Press, 1961.

Wood, Henry Trueman Wright. *A History of the Royal Society of Arts.* Preface by Lord Sanderson. London: John Murray, 1913.

Wood, Neal. *Communism and British Intellectuals.* New York: Columbia University Press, 1959.

Wyndham, Henry Saxe. *The Annals of Covent Garden Theatre from 1732 to 1897.* 2 vols. London: Chatto & Windus, 1906.

Yapp, George Wagstaffe. *Art-Education at Home and Abroad: the British Museum, the National Gallery, and the Proposed Industrial University.* London: Chapman & Hall, 1852.

Young, G. M. *Victorian England, Portrait of an Age.* 2nd ed. London: Oxford University Press, 1953; Galaxy Books, 1971.

—, ed. *Early Victorian England 1830–1865.* 2 vols. London: Oxford University Press, Humphrey Milford, 1934.

Zebel, Sydney H. *Balfour: A Political Biography.* Cambridge: The University Press, 1973.

Ideas and Beliefs of the Victorians. Foreword by Harman Grisewood. New York: E. P. Dutton & Co. Inc., 1966.

Lectures on the Progress of Arts and Science, Resulting from the Great Exhibition in London, Delivered before the Society of Arts, Manufactures, and Commerce, at the Suggestion of H.R.H. Prince Albert. New York: A. S. Barnes & Co., 1854.

Since 1939. 2 vols. London: Phoenix House, 1948–9.

The Tate Gallery. Introduction by Norman Reid. London: Tate Gallery, 1969.

II. *Newspapers and Periodicals*

Newspapers and Periodicals Consulted:

Academy; *Art-Journal*; *Art-Union*; *Artist* (1807); *Athenaeum*; *Blackwood's Edinburgh Magazine*; *British Quarterly Review*; *Builder*; *Contemporary Review*; *Critic*; *Crystal Palace Exhibition Illustrated Catalogue*; *Drama*; *Edinburgh Review*; *Examiner*; *Fortnightly Review*; *Fraser's Magazine*; *Germ* (1850); *Household Words*; *Illustrated London News*; *Journal of Design and Manufactures*; *Journal of the Warburg and Courtauld Institutes*; *Listener*; *Macmillan's Magazine*; *Magazine of Science, and School of Arts*; *Mechanics' Magazine*; *National Review*; *New Statesman*; *Nineteenth Century*; *Pall Mall Gazette*; *Politics for the People* (1848); *Punch*; *Quarterly Review*; *Saturday Review*; *Savoy*; *Spectator*; *Times* (London); *Victorian Periodicals Newsletter*; *Victorian Studies*; *Westminster Review*.

Additional Articles:

Allard, Paul. 'L'Art-Department et l'enseignement du dessin dans les écoles anglaises.' *Gazette des Beaux-Arts* 23 (1 November 1867): 393–418.

Day-Lewis, Sean, and others. 'Money for the Muses.' *Socialist Commentary,* May 1966, pp. 19–26.

Fielding, K. J. 'Charles Dickens and the Department of Practical Art.' *Modern Language Review* 48 (July 1953): 270–7.

Glasgow, Mary C. 'State Aid for the Arts.' *Britain To-day,* June 1951, pp. 6–15.

Howe, E. M. 'Coal, Art and the Beaumonts.' *History Today* 24 (April 1974): 243–9.

King, Karen, and Blaug, Mark. 'Does the Arts Council Know What It is Doing?' *Encounter,* September 1973, pp. 6–16.

Lewis, Anthony. 'The British Miracle.' *New York Times,* 27 June 1974, p. 45.

Martin, Gregory. 'The Founding of the National Gallery, Parts I–V', *Connoisseur* 186 (April–August 1974).

Mérimée, Prosper. 'Les Beaux-Arts en Angleterre.' *Revue des Deux Mondes* 11 (15 October 1857): 866–80.

Peacock, Alan. 'Welfare Economics and Public Subsidies to the Arts.' *Manchester School of Economic and Social Studies* 37 (December 1969): 323–35.

Symons, Arthur. 'The Decadent Movement in Literature.' *Harper's New Monthly Magazine,* November 1893, pp. 858–67.

White, Eric W. 'Public Support for Poetry.' *Review of English Literature* 8 (January 1967): 55–64.

Press Cuttings March 1890–August 1902, Tate Gallery Archives, London.

III. *Reference Works*

Gunnis, Rupert. *Dictionary of British Sculptors 1660–1851.* New rev. ed. London: The Abbey Library, 1968.

Redgrave, Samuel. *A Dictionary of Artists of the English School.* New rev. ed. Amsterdam: G. W. Hissink & Co., 1970.

Wood, Christopher. *Dictionary of Victorian Painters.* Woodbridge, Suffolk: Baron Publishing for Antique Collectors' Club, 1971.

Dictionary of National Biography.

Dod's Parliamentary Companion.

Wellesley Index to Victorian Periodicals. 2 vols.

Index